The Craft of the Cut

The Craft of the Cut

The Final Cut Pro X Editor's Handbook

Marios Chirtou and Mark Riley

A John Wiley and Sons, Ltd, Publication

About the Authors

MARIOS CHIRTOU is a London-based filmmaker and screenwriter who has been making short films and music videos since he first picked up a Super-8 camera back in his teens. His music-promo work includes videos for such artists as Rachel Wallace, Sonz of a Loop Da Loop Era, The Smart E's, and The Demon Boyz and has been broadcast on the BBC, ITV, and across Europe on MTV. With more than 22 years of experience in the broadcast TV industry, Marios recently left MTV to focus on his writing and filmmaking projects, the first of which is a collaboration with Mark Riley on *Pranks* and *The Craft of the Cut*.

MARK RILEY previously studied the highly regarded Television Operations course at Ravensbourne College in the UK and has worked in the broadcast TV industry for over 20 years at companies that include MTV, Technicolor, and APTN. During this time, Mark has produced a slate of independent films through his London-based production company, Ralphs (www.ralphsltd.co.uk), which has been recognized as a finalist of the Orange Small Business Awards and with a nomination for a BAFTA Interaction Award. Mark is immensely proud to have accomplished *The Craft of the Cut* and *Pranks* with his longtime friend Marios, and he's looking forward to continuing to produce exciting and innovative projects in the future.

Credits

VP Consumer and Technology Publishing Director
Michelle Leete

Associate Director–Book Content Management
Martin Tribe

Associate Publisher
Chris Webb

Assistant Editor
Ellie Scott

Development Editor
Elizabeth Kuball

Copy Editor
Elizabeth Kuball

Technical Editor
Philip Barnard

Editorial Manager
Jodi Jensen

Senior Project Editor
Sara Shlaer

Editorial Assistant
Leslie Saxman

Associate Marketing Director
Louise Breinholt

Senior Marketing Executive
Kate Parrett

Marketing Executive
Dave Allen

Project Coordinator
Kristie Rees

Compositors
Melanee Habig
Andrea Hornberger

Quality Control Technician
Melanie Hoffman

Proofreaders
Susan Moritz
Lisa Young Stiers

Indexer
Ty Koonz

Media Project Manager 1
Laura Moss-Hollister

Media Associate Producer
Doug Kuhn

Media Quality Assurance
Josh Frank

*Marios Chirtou would like to dedicate this
book to his parents, Leondis and Nafsika Chirtou.
My love and gratitude to you always.*

*Mark Riley would like to dedicate this book to
Jackie, Josie, and George and to his Mum and Dad
for all their love and support.*

Acknowledgments

The authors would like to extend a special thanks to the following people for all their help and assistance: Tony Riley for his tremendous support and commitment to the project; Tom Henson for offering us a mountain of advice and reassurance; Ray Shah for his kind and generous efforts; Lindsay Mullins for her fantastic photographs that we are so fortunate to have; Yvonne Craven for her valuable continuity advice and notes; Philip Barnard for his technical expertise and attention to detail; and John McMullin for his color grade and wisdom.

Thanks also to the team at Wiley, including Elizabeth Kuball, Ellie Scott, Kate Parrett and Dave Allen for all their help and guidance and Chris Webb for recognizing a great concept and running with it.

Thanks to everyone involved in the making of *Pranks:* Jenny Seagrove, Ellie Darcey-Alden, Joseph Darcey-Alden, Sarah Darcey-Alden, and Phil Alden, for your superb work and kind use of your photographs; John Ferguson and Iain Mackay for some great cinematic moments; Aden Turner for keeping our shoot on track; Suzanne Moxhay for working her magic on the images; Darren Jon Bunting for his knockout score, ably supported by Tim Sadler and Ben Daly; Ken McDowell for his outstanding sound mix; and Libby and Tess Holderness for looking after us so well at Cuckmans Farm.

Finally, thanks to our family and friends: Leondis and Nafsika Chirtou; Ourania Melissinou; Jackie, Josie, George, Tony, and Carole Riley; Emma, Mark, Etienne, and Freya Hookey; Mike Lambourne; Andrew Burrows; Rachel Child; Rachel Bernard; Dominic Lambert; Alison Young; Ian Fitzgerald; Noah and Claude Franklin; and Jürgen and Tessa Alke.

Book and Film Credits

The authors would like to thank the following people for their kind contributions to this book and DVD:

Music composed, arranged and performed by Darren Jon Bunting (DVD)

Continuity Shot List and Continuity Script notes based on contributions by Yvonne Craven (Book and DVD)

Dubbing Mixer - Ken McDowell (DVD)

Colorist - John McMullin (DVD)

Jenny Seagrove photograph courtesy of Simon Mein (DVD)

Stills Photography Design - Suzanne Moxhay (DVD)

Stills Photographer - Lindsay Mullins (Book and DVD)

Contents

Part 2: The Edit

CHAPTER 5
The Assembly Edit. 85

Part 3: The Craft of the Edit

Part 5: Appendixes

Foreword

This book is a unique introduction to the craft of film and video editing.

Unlike other guides, *The Craft of the Cut* offers you the chance to put together an entire short film. In a series of simple exercises, you'll develop your technical skills using Final Cut Pro X and immerse yourself in the hugely rewarding challenge of creating a professional-looking movie. By the end of the book, you'll know Final Cut Pro X inside out and have discovered, hands-on, how editors work in the film and television industry.

As an editor, I am overjoyed to find a book that champions editing both as a technical discipline and a creative endeavor: a combined approach that brings out the best from any source material. Using this book and DVD, you'll have the opportunity to edit high-quality footage from a ghost story called *Pranks,* but the principles apply to all types of projects, be they documentaries, music videos, animations, short films, or features. The craft of editing is an exploration of the infinite possibilities of your media and a drive to create original, accomplished, and entertaining stories.

First off, you'll find out more about video: how it varies and in what form you're likely to come across it. You'll learn how to evaluate the material and understand what works best when assembling shots, scenes, and sequences. This book also demonstrates the most efficient ways of manipulating the footage using Final Cut Pro X. As you progress, you'll sharpen your aesthetic sensibilities, enabling you to judge exactly how film communicates ideas and emotions, and what techniques editors use to achieve the most powerful results.

The *Pranks* film will enable you to explore the incredibly versatile range of tools available in Final Cut Pro X, not only for video editing but also for work on sound, music, titles, and special effects. Thanks to a wide range of additional production resources provided, you'll also learn how an editor works within the framework of a professional film production. You'll be shown how to interpret the director's vision by reading the script and use continuity notes to pick the best shots. This context is an invaluable step up for those of you interested in editing professionally for film and television.

Working though the chapters of this book, you'll discover, as I did in my career as an editor, that the quickest way to pick up techniques and develop existing skills is to get stuck into real projects with defined goals. The practical examples in this book will help you get to grips with basic editing methods and, at the same time, evolve essential ways of thinking — analysis, insight, and problem solving — all of which are central to the editing process. By working

with your hands and your head, you'll be able to create an end product that carries your own personal stamp as an editor.

The beauty of this book is its diverse appeal. Beginners will learn quickly from the simple exercises, while more experienced users can hone their skills and complete a film that showcases their editing talents. Whether you're thinking of a becoming a full-time editor or simply want to take a leap forward with your home movies, this is the book for you.

Philip Barnard

Philip Barnard is a London-based editor with credits on top-rated TV series and documentaries for PBS, HBO, and the BBC, as well as 20 years' experience working on feature films in the UK and Europe.

Introduction

THESE ARE EXCITING times for aspiring filmmakers. Never before has there been this kind of accessibility to the tools you need to create your own movies. A quick visit to YouTube, where thousands of videos are uploaded every day, will attest to this. Moving images are being captured on an array of devices—everything from affordable video cameras to mobile phones. And it's not just the cameras that are within easy reach. Editing software such as Apple iMovie and Windows Movie Maker are just as accessible—they're bundled free with new computers. The ability to shoot and edit your own videos has never been easier. Everyone, it seems, has caught the movie-making bug.

The release of Final Cut Pro X is the next stage in this evolution. Until now, Final Cut Pro had been available only as part of Final Cut Studio, an expensive bundle of applications from Apple that also included Motion, Color, Compressor, and Soundtrack Pro. With the release of this new version, Final Cut Pro X is, for the first time, available separately via the App Store at an amazingly low price. The power of a professional editing system is no longer just the domain of the big Hollywood studios; it's available to anyone who wants to have a go.

Who This Book Is For

Final Cut Pro X offers an affordable entry point to professional editing, but the software can still seem intimidating to the newcomer, and that's where this book comes in. If you're a seasoned iMovie user who has exhausted all the possibilities that iMovie has to offer and you want to take the next step to Final Cut Pro X, then you've come to the right place. This book will guide you, step by step, through a typical edit workflow and familiarize you with all the functions that you'll need to get up and running with this new software.

But what if you don't use Final Cut Pro X? *The Craft of the Cut* is not just a how-to book on Final Cut. Yes, it provides you with everything you need to become proficient with that particular software, but as the title suggests, this book is also about the craft of editing. No matter what nonlinear editing package you use, this book will give you some great advice and techniques to take your editing skills to the next level. We chose Final Cut Pro X to illustrate the concepts in this book because of its affordability and widespread availability, but if you're an Adobe Premiere user or you use any other editing software, you'll still be able to apply most of the concepts explained in this book.

Your choice of software is only part of the picture. Even though we now have these great video tools at our disposal, there is still a great divide between the footage we're able to obtain ourselves and the footage shot by a professional film crew.

If you've ever cut together video of a family event, you'll know how creative and fun video editing can be. Building a sequence, shot by shot, and seeing it become greater than the sum of its parts can be very satisfying. But what if you want to go beyond the typical "baby on the lawn" home movie? What if you're itching to try something more involved?

Perhaps you're an aspiring video editor and you're already making your own short videos with your friends. If you want to learn the craft of editing, you should be practicing on as much material as possible and learning how to tell effective stories visually. As fun as making videos with your friends can be, the quality of footage that you can conceivably produce on a low budget is hardly comparable to that of a real movie production. This level of production is well out of the reach of most aspiring editors—yet having access to professional footage can be extremely valuable while you're learning to construct effective scenes.

So, how can you gain access to this caliber of footage when you're just starting out? We thought of that, too. On the DVD that comes with this book, we've provided you with all the media you'll need to construct a complete narrative short from start to finish. And when we say "all the media," we mean *all* the media. Everything from the complete rushes (including all the multiple takes shot on the set) to audio files, Foley tracks, and music cues is available for you to construct your own version of *Pranks,* a short film we shot exclusively for this book.

What This Book Offers

This book aims to do three things:

- ○ Get you up and running with Final Cut Pro X.
- ○ Give you advice and techniques to improve your editing skills.
- ○ Provide you with all the footage from a complete narrative short to work with.

The best way to learn is by doing. First, you'll get familiar with the film that you're going to cut. You'll read the script and examine all the media that you have to work with. Then you'll work through a typical edit workflow, going through the entire process from import to final output and familiarizing yourself with the functionality that Final Cut Pro X has to offer.

We walk you through each cut that was made for the original movie, but you don't have to follow our recommendations. Editing is mostly about the decisions an editor makes, and by trying out different shots and cuts for yourself, you'll soon develop a feeling for what works and what doesn't. Those decisions are up to you. That's why we're providing all the coverage shot from the film. More important, you'll be doing all this in the context of a complete narrative short. Not only will you learn how to edit, but you'll also learn how to effectively tell a story. You'll be controlling how the story unfolds on the screen, how to create tension and identification in the viewer, how sound and music can affect the emotion of the scene, and so much more.

Excited yet?

How to Use This Book

If you're new to Final Cut Pro X or video editing in general, we suggest that you work through this book from start to finish. We've designed *The Craft of the Cut* so that even a complete novice can grasp the concepts in this book. With the use of extensive screenshots, each chapter expands on the previous one, building your understanding of Final Cut Pro X along the way. By the end of the book, you'll have gained a greater appreciation of how to use the application and you'll have picked up some great editing principles as well. So, if you're a beginner, *The Craft of the Cut* will give you a solid foundation in editing that you can apply to your future work. What you'll learn will even make your home movies better.

If you've already mastered Final Cut Pro X or you're conversant with a different nonlinear editing package, feel free to skip directly to Part III of the book, which is all about the individual scenes that you can edit. And don't forget the DVD. You can use the footage on the DVD with any editing software that can play Apple ProRes 422 (Proxy) files. So, why not have a go at cutting your own version of the film in the application of your choice?

To sum up, *The Craft of the Cut* is for anyone who

- ○ Is new to Final Cut Pro X and wants to get quickly up to speed on how to use this new software

- ○ Wants to improve his editing skills and learn new techniques that he can apply to any project

- ○ Has ever wanted to work with professional footage but has never had the means to do so

With this book, we've tried to reproduce the experience of a typical video edit. Your job is to edit a short film called *Pranks*. If you choose to follow along with this book, you'll be taken through the process that a motion picture editor goes through during post-production. Of course, you'll be able to do this in your own time, without the pressures and deadlines of a normal real-world production, but we've tried to emulate the process as best we can.

You have in your hands everything you need to edit a complete short film. You have clear instructions on how to use Final Cut Pro X, some great advice on how to enhance your video editing, and all the materials to test out what you learn.

If you're just starting out in video editing, *The Craft of the Cut* is the only book you need.

Ready? Let's get to work!

part 1

Preparing to Edit

chapter 1

Familiarizing Yourself with the Film

THE FILM YOU'LL be editing is a 12-minute children's ghost story called *Pranks,* which was written and directed by Marios Chirtou and produced by Mark Riley. The film's original rushes—the raw, unedited footage shot during the film's production—has been made available to you, and by following the exercises in this book, you'll be taken through the process of editing this short film from start to finish.

The task of an editor is to take the individual shots filmed by the production crew, and assemble them into a complete movie that tells a compelling story and entertains an audience. Editing is not simply a case of piecing together the shots into the correct script order; instead, it's an art and craft that has a major impact on the final film. How a film is edited dictates the tone, overall pace, and emotional impact that the film delivers and, when done well, the viewer never even notices the editor's art at work.

This book aims to reproduce many of the common challenges that an editor faces by taking the reader through a typical workflow for editing a film. Each chapter focuses on a different part of the process, everything from organizing the rushes to the final export of the finished film.

The first step in this process is to become familiar with the story that you're about to tell (the shooting script) and the material that has been captured by the production team to tell that story (the rushes, continuity script, and shot list), which is what this first chapter is all about.

The making of *Pranks*

Pranks was shot on location, over a four-day period at a large Victorian house in St. Albans, Hertfordshire, which is 23 miles from London. The cast included the great English actress Jenny Seagrove—whose many successes include the film *Local Hero* (1983), directed by Bill Forsyth, and the long-running BBC drama series *Judge John Deed* (2001–2007), initially directed by Alrick Riley—and 12-year-old Ellie Darcey-Alden, an amazing young actress who took on the lead role of Katie, playing opposite her brother Joseph.

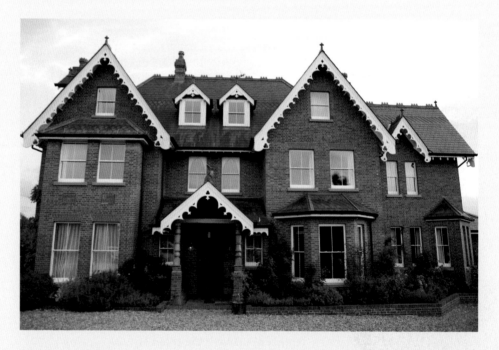

The film was shot on a RED ONE M-X camera by our director of photography, John Ferguson, who gave us the wonderful filmic images that you see in the film's rushes. The 456 GB of shoot media was transcoded to Apple ProRes 422 (Proxy) suitable for editing on Final Cut Pro X and has been made available for you on the DVD.

Reading the Script

Before embarking on an edit, you need to get familiar with the script. You can find a PDF of the script on the DVD accompanying this book. We recommend that you read through the script a few times before you dive in and start working with the footage. It's important to have a clear concept of the project right from the start, before you get too deep in the chaos of all the shots and takes that make up a movie. As you read the script, try to get a sense of the tone, genre, structure, and pace of the story, and pick out what you feel are the important plot points and moments that should be emphasized.

In this section, we cover some key points for you to look for when breaking down the structure of the story. We've also included some profiles so that you get to know the characters better.

Story and structure

Pranks concerns an orphan child named Katie who arrives at an impressive new care home run by Joyce Anders (Figure 1.1). A reclusive child that prefers to keep to herself, Katie

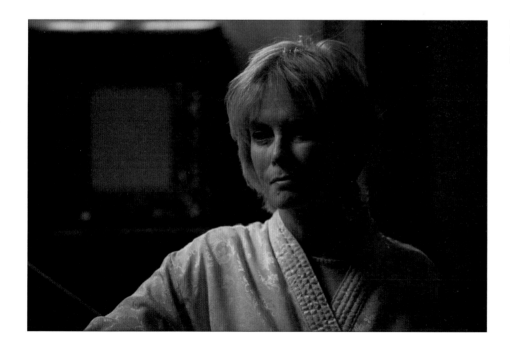

FIGURE 1.1
Jenny Seagrove as Joyce during filming.

moves into her new room unaware that the ghost of a mischievous little boy with a penchant for tricks and games also inhabits her home (Figure 1.2). Katie continuously falls victim to the boy's childish pranks and is unable to convince Joyce that another presence resides in the house with them. This sets her on a quest to obtain proof of the boy's existence, and, along the way, she learns how to open up and have some fun. After a nighttime chase around the house, Katie eventually catches up with the boy, only to have him be scared away by Joyce. The story ends with Katie patiently waiting for his return.

FIGURE 1.2
Ellie Darcey-
Alden as Katie
in a scene
from *Pranks*.

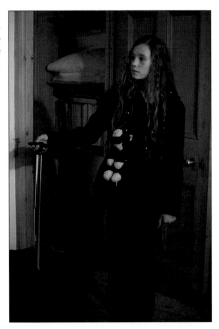

Let's see how the story breaks down in terms of a traditional three-act structure:

○ **Act I:** The first act of *Pranks* is made up of Scenes 1 through 6 in the script and establishes the characters (Katie and Joyce) and the dramatic situation of the story (a reclusive child moves into a new foster home), ending on a turning point that presents a problem for the main character to solve (someone is disrupting Katie's new room).

○ **Act II:** The second act consists of Scenes 7 through 16 and is all about the obstacles and conflicts that the main character faces as she tries to solve the problem encountered at the end of the first act. In Act II, Katie first seeks Joyce's help, only to have her

complaints dismissed out of hand. When the pranks continue, Katie is forced to take matters into her own hands and embarks on a quest to obtain photographic evidence. After a cat-and-mouse chase around the house, the act ends on a second turning point, when Katie begins to come out of her shell and enjoy the games.

- ○ **Act III:** The third act is comprised of Scenes 17 and 18 and resolves the story problem. Katie finally comes face to face with the boy and learns the truth about who he is. The ending shows how Katie has been positively impacted by the events of the story and concludes on a bittersweet note as she waits for his return.

We'll be delving deeper into some of the story points as we work through the edit later in the book, but for now let's take a closer look at the characters.

The characters

Katie is a 12-year-old orphan with a troubled past. For most of her life, she has been hauled from one foster home to another, never staying long enough to form any kind of bond with the caregivers that take her in. Because of this, she has become self-reliant and is reluctant to let anyone get close to her for fear of getting hurt. She especially distances herself from other children, from whom she feels completely alienated. This has caused problems with some of the families she's stayed with, earning her a reputation for not "playing nice" with the other children of the house. Though she is searching for a place to call home, it has to be on her terms, and it's this uncompromising attitude that gets her into trouble every time.

Joyce's life has always been about children. A best-selling author of children's books, she has been living off the royalties from her books since splitting from her husband only a few short years into their marriage. Her compassionate nature led her to put all her energies into setting up a residence for homeless children, fostering many orphans over the years. This came to a tragic end when her son, Jason, became very ill and died. Heartbroken, she could never bring herself to look after another child, becoming reclusive and leading a solitary existence for years. Burdened by the guilt she carries from losing a child in her care, Joyce is oblivious to the fact that the child's spirit still resides in the house with her. Joyce sees this new opportunity to foster another child as a way to make amends with the past. However Katie's tendency to withdraw from everyone makes this difficult for Joyce. Joyce's main objective is to form a bond with Katie and build a relationship with her. She spends the whole story trying to connect with Katie, a goal she manages to achieve with some indirect help from Jason, the child she lost.

Jason's spirit is trapped in limbo inside the house he shares with his foster mother (Figure 1.3). He has spent the past few years wandering the house alone, trying to get his foster mother's attention, but to no avail. With Katie's arrival, he sees a potential new playmate and is anxious to involve her in his games, despite her reluctance to participate.

FIGURE 1.3
Joseph Darcey-
Alden as the
ghost in a scene
from *Pranks*.

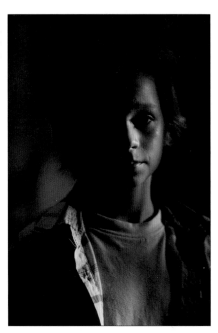

Working with Reports and Logs

Now that you're familiar with the story and characters, the next step is to review the continuity paperwork. Good continuity notes save an editor time (and, therefore, the production money) and allow the editor to make a number of informed decisions during the edit. These notes are provided by the script supervisor, who is responsible for taking detailed notes of everything that is shot during a film's production. This includes everything from matching the actors' eye lines to wardrobe, makeup, and the position of props. It's done to ensure that the continuity of the film matches from shot to shot. The script supervisor also notes clapper information for each shot, any technical issues that arise, and the director's preferred takes.

The script supervisor's work is especially important because movies are usually shot out of sequence and each department looks to them for answers when questions of continuity arise on the set. The script supervisor essentially ensures that the recorded shots match and cut together after they're assembled, so his work is indispensable to an editor.

In the `Documentation` folder on the DVD, you'll find the continuity shot list and continuity script for *Pranks*. These documents provide useful information about the rushes that you have to work with, which you can refer to as you work on the film. Let's take a closer look at both documents.

The continuity shot list

At first glance, the continuity shot list may look like a jumbled set of words, numbers, and abbreviations, but it's actually a treasure trove to an editor. The continuity shot list is like a detailed map of the shoot, which tells you the scene order in which the film was shot, the location in which the scene takes place, and what occurred on set during the recording. These details provide an accurate reference of what took place—good or bad—in each scene during the shoot, and help reveal any changes that might have occurred between takes.

The shot list provides an exhaustive list of all the relevant details from each take and helps the production maintain continuity so that the editor is able to cut the final film. Whether it was an unwanted daily visit on set from any one of the numerous cats in our location, a fantastic performance by the cast, or a change in props, clothing, or weather, these useful points are all noted in a well-documented continuity shot list.

Our script supervisor in charge of continuity on set was Yvonne Craven, who did a brilliant job of keeping track of anything that was worth noting during the recording on her page-per-slate notes. She then typed up a continuity shot list from these notes during the course of the shoot. The continuity shot list works hand in hand with the continuity script, which we discuss in the next section.

So, running through the headings in the continuity shot list, you'll see Mag, Slate, and Take (see Figure 1.4). Historically the Mag number refers to a magazine of film roll, but here, Mag actually refers to the numbered digital flash cards we used during filming. These were downloaded to the hard drives at the DIT workstation before being reused again (Figure 1.5).

Mag No.	Slate No.	Take No.	TITLE: PRANKS DAY 1	Sound	Dur
			SCENE 1: A CHILD'S BEDROOM - INT / DAY		
1	1	5	Toy box – MCU Pan L-R across toys on floor, across toy box past door. Ball bounces into FR L and rolls across floor. Continue pan across bedside table, hold on teddy on bed. OK. Shot upside down for time.	S	0.34
			SCENE 2: THE ANDERS RESIDENCE - EXT / DAY *Inc. improvised dialogue*		
3	2	4	POV through bedroom window of car on drive & Joyce & Katie getting out. OK in cloud.	MOS	0.36
2	3	6	MS Joyce getting out of car and walking round front to open door for Katie. Katie gets out with case. Katie walks ahead of Joyce, pauses, and looks up at window of house. Joyce hurries ahead and opens front door. They go inside. Jenny hesitates before opening door of car. Cloud. OK.	S	0.50
2	4	2	C/A hands & Joyce trying to take case from Katie - handle? OK.	S	0.08
2	5	1	MS Joyce to car and Katie exiting, approaching house towards cam. (Cam to R of front door) Joyce walks round car, Katie gets out, and they walk to cam MS. Katie stops & looks up at window ROF, exits FR L. OK.	S	0.25
2	6	1	POV Katie look up at window, curtain twitches. OK.	MOS	0.01
2	7	1	WS Car pulling up outside house, Car enters ROF and stops. OK.	S	0.15
			SCENE 3: INT HALLWAY / FRONT ENTRANCE - INT / DAY *Inc. improvised dialogue*		
3	8	1	Joyce & Katie enter through front door, Joyce puts bag down & takes coat off and turns to Katie. Katie pauses by doorway with case. Joyce walks past her to front door to close it. Katie goes upstairs with case. Joyce stands, looks up at her. OK.	S	0.43

During filming, each new shot setup is assigned a new slate number. The amount of times or takes the director shoots that particular slate also is listed by the assistant camera operator on a clapperboard. The clapperboard is recorded before each take (or sometimes after); it helps not only identify the take in question, but also with the synchronization of the picture and sound later in the edit (see Chapter 8).

Following the slate and take number, the script supervisor notes whether the shot in question was recorded without sound. This is indicated with the abbreviation MOS, and heralds from the early sync sound days when a sound recordist would be requested to run the "motor only sync" to create mute shots. Finally, the shot's running time also is listed under the Duration heading.

FIGURE 1.5
The DIT
workstation on
location.
Checking the
rushes with the
REDCINE-X
software.

Usually, an editor would reference the continuity shot list with the clapperboard informa-
tion at the start of each shot. However, in order to maximize the space on the DVD, and give
you more footage to edit with, we've excluded the clapperboards from the rushes provided
and the corresponding scene, slate, and take numbers are listed on the file name for each clip
instead. We've also excluded any really bad takes for the same reason.

Let's look at some examples of the kind of information you can glean from the continuity
shot list. Scene 1, Slate 1, Take 5 tells us that it's an interior (INT) shot (an exterior shot is
indicated by EXT), that the shot takes place during the day, and that it is 34 seconds in dura-
tion. We can also see that the shot features a toy box, with the camera moving left to right in
a medium close up (MCU). The continuity notes also alert you that this shot was recorded
upside-down (more on this later in the chapter).

Examining the rest of the shot list reveals other useful information. The jump in the Mag
number that occurs on the shot list—going from 1, to 3, then back to 2 again—was due to a
reshoot made necessary by a change in the weather. Scene 2 Slate 2, Take 4, the point of view
(POV) through the bedroom window, was reshot a second time after the weather turned
cloudy, and no longer matched the sunny shot recorded earlier, causing the jump in the Mag

numbers listed on the shot list. The sunny versions of these shots were omitted from the DVD (and the shot list) for space reasons, but we left the Mag numbers listed in their original order.

You may also have noticed that dialogue is listed with letters next to it—for example, Scene 3, Slate 13, Take 2 lists "Dialogue A–E". This is a simple and effective way for the script supervisor to quickly identify which sections from the dialogue were spoken during a particular slate or take. Letters are used to avoid confusion with slates and take numbers and also are listed on the continuity script.

The last two pages of the continuity shot list ends with a list of ADR recordings (for more on ADR, see Chapter 13) and a continuity key guide that runs through all the abbreviations used. With these facts at hand you can easily start to form a picture of what occurred during each take before you even start to review the rushes.

The continuity script

Let's now take a look at the continuity script, which is also known as a marked-up script, because the script supervisor marks the continuity on the original shooting script. You'll notice there are a number of vertical lines drawn on the script, showing you the script coverage for each individual slate. These show how many slates were taken and also the type of shot used.

For instance, referring to the continuity script for Scene 2 (see Figure 1.6), you can see "6/1" listed, which means Slate 6, Take 1. Below this, a red line indicates the approximate script coverage for this slate. There's also a short reference that this shot depicts Katie's (K) point-of-view (POV). If you now refer back to the continuity shot list and look up Slate 6, Take 1, you can see these same details cross-referenced there also. The shot list also adds the note "Katie look up at window, curtain twitches. OK" and that the shot is 1 second in duration and recorded without sound.

Because we've supplied only the best takes for you to use, the continuity script and shot list show only the actual takes that we've supplied. In usual continuity practice, Slate 4/2 would indicate that for Slate 4, two takes were recorded and available for the editor to use. However, for the purposes of this book, Slate 4/2 signifies that only Take 2 is available for Slate 4. When we have provided more takes for a particular slate, this too is indicated on the continuity script. For example, "Scene 5, 80/2 & 3" shows that Takes 2 and 3 have been supplied for you as well.

It's worth noting that during the shoot, the cast improvised their dialogue in some of the scenes, so both the shooting script and continuity scripts are not verbatim.

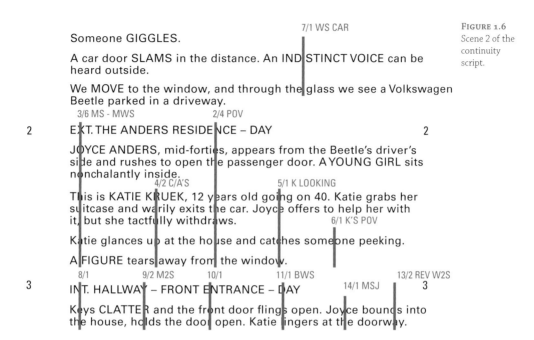

FIGURE 1.6
Scene 2 of the
continuity
script.

The text within Figure 1.6 reads:

7/1 WS CAR

Someone GIGGLES.

A car door SLAMS in the distance. An INDISTINCT VOICE can be heard outside.

We MOVE to the window, and through the glass we see a Volkswagen Beetle parked in a driveway.

3/6 MS - MWS 2/4 POV

2 EXT. THE ANDERS RESIDENCE – DAY 2

JOYCE ANDERS, mid-forties, appears from the Beetle's driver's side and rushes to open the passenger door. A YOUNG GIRL sits nonchalantly inside.

4/2 C/A'S 5/1 K LOOKING

This is KATIE KRUEK, 12 years old going on 40. Katie grabs her suitcase and warily exits the car. Joyce offers to help her with it, but she tactfully withdraws.

6/1 K'S POV

Katie glances up at the house and catches someone peeking.

A FIGURE tears away from the window.

8/1 9/2 M2S 10/1 11/1 BWS 13/2 REV W2S

14/1 MSJ

3 INT. HALLWAY – FRONT ENTRANCE – DAY 3

Keys CLATTER and the front door flings open. Joyce bounds into the house, holds the door open. Katie lingers at the doorway.

Your Role as Editor

Editors often are hired before production and can offer a director valuable input and feedback before and during the shoot. This could be advice on how to create a specific effect or style, which is often dependent on how the film is shot, or even suggestions on the appropriate shooting format based on the film's intended distribution. But primarily, the editor is mainly responsible for crafting the story from the footage he receives and much of his task involves separating the wheat from the chaff. You'll be surprised by how many shots that may appear unusable on first impression don't necessarily need to disappear into the trash bin.

Editors continually face scenarios in which they need to cut around problematic footage. This can be caused by technical problems that inevitably crop up to spoil a shot, or vital scenes from the script that have been left un-filmed due to time limitations on the set. Your job is to work with the material at hand—sometimes even piecing together an actor's performance from different takes—while still continuing to make sense of the narrative.

As you examine the rushes from the DVD, you'll come across the occasional shot that may contain a problem of some kind. For instance, when Katie kicks the alphabet blocks in Scene 8, Slate 59, Take 1, there is a long pause before we actually see her kick the bricks. You might remedy this by speeding up the footage slightly during the pause (see Chapter 14).

Earlier in the chapter, the continuity shot list alerted us that Scene 1 Slate 1 Take 5—a Steadicam shot recorded by our camera operator, Iain MacKay—was recorded with the camera mounted upside-down. A Steadicam can operate either in normal high mode (where the camera is mounted for shots above waist level) or in low mode (where the camera is mounted for shots below waist level). Changing the rig to low mode, just for this shot, would have been time consuming, so the camera team took the initiative to physically flip the rig upside down to mimic the low mode instead. This meant that the resulting shot would also be recorded upside-down, requiring the editor to flip the shot back around again in the edit. We show you how to do exactly that in Chapter 14.

Of course, every film is unique, and as an editor, you face all manner of challenges to solve in the course of a project. Ultimately, you may need to make a decision on whether to use a shot that has some issues. Minor issues, like fleeting continuity errors, can be forgiven by the viewer during the course of a gripping story, but larger issues, like dialogue that's inaudible due to unwanted background noise, may require re-recording. As a general rule, if the footage has a technical issue, but an actor produces a fine performance, it's usually worth going the extra mile to salvage the shot and include it where at all possible.

Creating your cut

After you've had the chance to view all the rushes and complete the exercises from the book, you may begin to feel that there is an alternative way to tell this same story. Go ahead and create an alternative cut of the film, using the existing shots, along with some of the unused takes from the rushes. Rewatch the director's version (Pranks Final Cut) included as a project on the DVD and substitute other shots or play with different shot lengths than those used in the final film. Notice how changing the duration of a clip in the Timeline affects the overall pace of the scene. When we cut to a medium shot, cut to a close-up, just to see what happens. Experimenting like this is a great way to learn.

Above all, have fun!

chapter 2
Final Cut Pro X Essentials

HOPEFULLY YOU'RE EXCITED and itching to get started now that you're familiar with the movie that you'll be working on. *Pranks* will be edited using Final Cut Pro X, and this chapter gets you up and running with the software if you've never used it before. The DVD media that is provided with this book can be used in any nonlinear editor (NLE) that can play Apple ProRes files; however, you'll get the most out of the media and the book if you follow along in Final Cut Pro.

Final Cut Pro X offers an affordable entry point to the world of professional editing, but don't be fooled by its iMovie looks—there's a lot of power under the hood. Final Cut Pro has been completely rewritten from the ground up as a 64-bit application enabling you to access more of your computer's memory and work with larger and more complex projects. It also uses OS X features such as Grand Central Dispatch (GCD) and OpenCL, which take advantage of a computer's multiple cores and graphics processor to speed up some of the more intensive processing tasks.

Final Cut Pro automatically saves as you work and offers unlimited undos, just in case you make a few mistakes along the way. Undoing an action is achieved in the usual way, by selecting Edit➡Undo or by pressing ⌘+Z. You'll be exploring more of Final Cut Pro's capabilities as you edit the movie and work through the book, but before getting started, there are some issues you need to consider in order to run the program effectively on your system.

Getting Up and Running

Final Cut Pro X is available from the Mac App Store. After you purchase it, it's automatically downloaded and installed on your computer. In order to run Final Cut Pro X, Apple recommends that your computer meet the following system requirements:

- ○ Mac computer with an Intel Core 2 Duo processor or better
- ○ 2GB of RAM (4GB of RAM recommended)
- ○ OpenCL-capable graphics card or Intel HD Graphics 3000 or later
- ○ 256MB of VRAM
- ○ Display with 1280 x 768 resolution or higher
- ○ OS X 10.6.8 or higher
- ○ 2.4GB of disk space

After installation is complete, you can find Final Cut Pro inside the Applications folder and launch it just as you launch any other application, by double-clicking its icon. You also can drag the icon from the Applications folder to the Dock (in Snow Leopard) or Launchpad (in Lion). You need to download additional content after the initial installation; you can access that content by launching Final Cut Pro and selecting Final Cut Pro➡Download Additional Content.

To quit Final Cut Pro, select Final Cut Pro➡Quit Final Cut Pro or press ⌘+Q.

Locating your files on the Mac

During the course of working with Final Cut Pro, users create what are known as Events and Projects. Events store all the media related to a particular editing assignment, such as video, audio, and graphics that you intend to use in the edit, and Projects store all the information about how you've chosen to edit your media together into a Timeline. (We'll explain Timelines later, but for now, think about it as the creative canvas on which you'll be working.) When you create a new Event, Final Cut Pro creates a folder with the Event's name and places this folder inside a Final Cut Events folder on your hard drive along with any subsequent Events that are created. Similarly, all new Projects are placed inside a dedicated folder of the same name within the Final Cut Projects folder.

By default, Final Cut Pro places the Final Cut Events and Final Cut Projects folders inside the Movies folder of the current user's Home directory (see Figure 2.1). Additional Final Cut Events and Final Cut Projects folders also can be placed on any external

hard drives attached to the Mac. These folders must be placed at the root level of the hard drive, and only one `Final Cut Events` and `Final Cut Projects` folder is permitted for each drive. You specify a drive from inside the Final Cut Pro interface when an Event or Project is created. Any moving or renaming of Events and Projects should be done from within the interface and not in the Mac's Finder. (We tell you how to move and rename Events and Projects in Chapter 3.) If the `Final Cut Events` and `Final Cut Projects` folders are renamed or moved inside another folder, Final Cut Pro won't be able to read them and the Events and Projects inside won't be available when you launch the program.

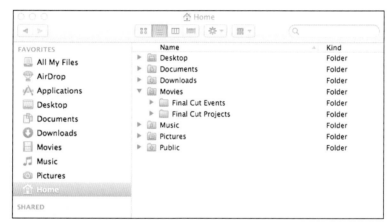

FIGURE 2.1
Final Cut Pro places the Events and Project folders inside the User's Movies folder.

Considering media storage

Before you begin working with Final Cut Pro, take a moment to think about where to store the media files for the projects that you'll be working on. It's considered good practice to store media files on a separate dedicated hard drive and not on the same drive as your Mac's operating system. Setting up a second drive for your media allows the system drive to be in charge of running the OS and applications and leaves the media drive to deal with the edit's video playback. This spreads the workload that your computer has to perform, with each drive being able to "concentrate" on its own thing.

Video files take up a lot of disk space, and some formats need more space than others. Your choice of video format dictates how large a drive you'll need, as well as how the drive needs to be connected to your computer. Editing demands a large amount of video to travel at a sustained rate to and from the media drive. Therefore, the drive's interface must be capable of coping with the bandwidth or throughput that your chosen format requires. Unless you plan to work with uncompressed HD footage, a 7200-rpm drive with a FireWire 800 connection should be enough to get you started for most general video work.

Once you have a dedicated media drive connected to your Mac, you can use it to store the `Final Cut Events` and `Final Cut Projects` folders discussed earlier by selecting the drive in the Event and Project library whenever you create a new Event or Project. Final Cut Pro can be set up to import any new media directly into these folders or can be configured to read media placed elsewhere on the drive. These settings are selected in the Import Preferences window and are discussed in Chapter 3.

Copying the media to your hard drive

This book comes with a DVD containing all the media that you need to follow along with the book. To access this material, make sure that your hard drive has at least 30GB of available disk space and insert the disc into your Mac's DVD drive. The DVD contains a disc image file named `Craft of the Cut`. Copy this file to your Mac by dragging it to the Desktop or an external drive. Once the file has copied, you can eject the DVD.

Make sure Final Cut Pro is not open, and double-click the `Craft of the Cut` disc image to mount it. The disc image appears as a drive under the devices section in the Mac's Finder. Inside, you'll find some folders including the `Final Cut Events` and `Final Cut Projects` folders discussed earlier. When you launch the program, Final Cut Pro treats the mounted disc image just like any normal hard drive, and the Events and Projects from these folders are available from within Final Cut Pro.

If you've moved or deleted any files that are in use, Final Cut Pro views this media as being offline and displays a red background with an exclamation point icon in place of the missing media (see Figure 2.2).

FIGURE 2.2
A Final Cut Pro
Project with
offline media.

To relink missing clips inside an Event, do the following:

1. In the Event Library, click the Event with the offline media and choose File➔Relink Event Files.

2. The Relink Files dialog box displays and here you can choose to relink all the files or just the ones that are missing. Files that have broken links are listed in the Original Files area and you can choose to relink just a single file by selecting it from the list. Click the Locate All/Selected button and navigate to where the media is located on your computer.

3. Click the Choose button and wait a few seconds as Final Cut Pro verifies the files. Matched files are displayed at the bottom of the Relink Files window (you may need to open the disclosure triangle to view these). To have Final Cut Pro copy the media into the Event, check the Copy files to Final Cut Events folder check box.

4. Click the Relink Files button to complete the process.

To relink offline media in Projects, select the Project by clicking the long Project strip in the Project Library, choose File➜Relink Project Files, and follow the same procedure.

You also can change the main Event that a Project is referencing:

1. Select the Project in the Project Library and open the Inspector (if it isn't already open) by choosing Window➜Show Inspector.

2. In the Inspector, select Properties and click the Modify Event References button.

3. In the dialog box that appears, select an Event and click OK.

Exploring the Interface

Final Cut Pro's interface consists of a single window that is made up of three main sections, with each section fulfilling a specific role (see Figure 2.3). The top-left section of the interface consists of the Event Library and Event Browser. This is where a typical workflow starts and where media is imported, organized, and prepared for editing. Below this, in the second section, you'll find the Project Library and Timeline where footage sent from the Event Browser is assembled and cut. The third section, at the top-right of the interface, consists of the Viewer and displays video clips played or skimmed in the Event Browser and Timeline.

When you place the cursor on the dividing line between any of these sections, a resize icon appears, allowing you to change the window's dimension (see Figure 2.4). You simply click and drag the window's border until the window is the size that you require. To return the windows to their default setting, select Window➜Revert to Original Layout.

The main interface window also can be resized by selecting the lower-left corner with the cursor and dragging out a new size. Selecting Window➜Zoom also fills the Mac display with the entire interface.

For Lion users, Final Cut Pro can be used in true distraction-free full-screen mode just like other Lion applications. To use Final Cut Pro in full-screen mode, click the full-screen icon on the top-right of the window (refer to Figure 2.3), select Window➜Enter Full Screen, or press Control+⌘+F.

Event Library Event Browser Viewer Full Screen button

FIGURE 2.3
The Final Cut
Pro interface.

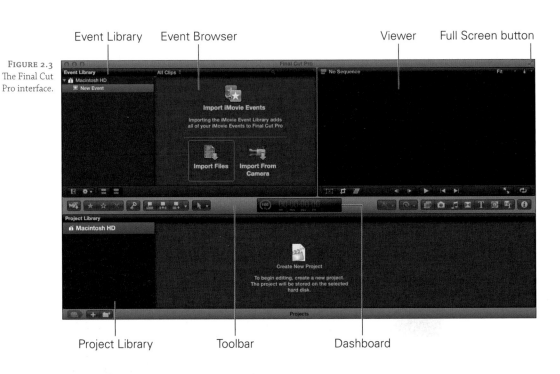

Project Library Toolbar Dashboard

FIGURE 2.4
Resizing an
interface
window.

Hovering the cursor over a button on the interface reveals a tooltip with a short description, giving you a quick reminder of the button's function (see Figure 2.5).

FIGURE 2.5
Tooltips give a
handy reminder
of a button's
function.

What follows is a brief introduction to the main elements of the interface. We cover each area in greater detail throughout the book.

The Event Library

Any media that you import into Final Cut Pro is placed inside a container known as an Event, which lives on a specific hard drive. The Event Library lists all the Events available on your system and is arranged by the drives that the Events reside on. Drives connected to your Mac are represented by icons, and clicking the disclosure triangle reveals the Events and Collections that they contain (see Figure 2.6). If no external drives are attached to the computer, all Events appear inside the current user's Home directory, which is represented by the familiar home icon.

Event Browser

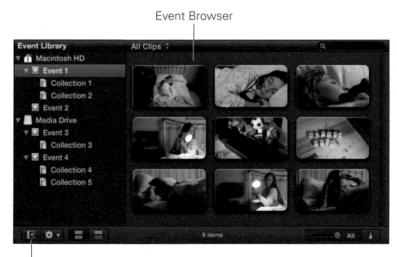

FIGURE 2.6
Various
Collections in
the Event
Library.

Event Library button

An Event folder also may contain subfolders called Collections, which represent a more specific level of organization for your Event media. (For more on Collections, see Chapter 4.) Selecting an Event or Collection displays its contents in the Event Browser, making the media available for use in any Project. Once an Event or Collection is selected, the Event Library may be hidden from view to make more room for the media shown in the Event Browser.

To show or hide the Event Library, click the Event Library button on the bottom left of the Events window, select Window➜Show/Hide Event Library, or press Shift+⌘+1.

The Event Browser

Next to the Event Library is an area known as the Event Browser, which is where most of the organizational work is carried out. The Event Browser is where you review, rate, and tag your

files with keywords and organize the media for easier retrieval when cutting the movie. This is also where you'll be choosing sections from the shots that you want to add to the Timeline. As you edit, you'll be switching back and forth between the Event Browser and Timeline; you can determine which window is active by the lighter shade of gray in the background.

To make the Event Browser the active window, click inside the Event Browser window, select Window➔Go to Event Browser, or press ⌘+1.

The Event Library and Browser can be displayed on a second monitor if you have one connected to your Mac. To do this, select Window➔Show Events on Second Display. To place these back in the main interface, select Window➔Show Events in the Main Window.

The Project Library and Timeline

Much like the Event Library, the Project Library lists all the hard drives connected to your system and the Projects that are contained within them (see Figure 2.7). A Project can contain an entire movie, a sequence, or a single scene, depending on the size of the piece that you're editing and the way you manage your workflow.

FIGURE 2.7
The Project Library displays connected hard drives and the Projects that they contain.

Project Library button

To show or hide the Project Library, click the reel button at the bottom of the Final Cut Pro interface so that it's highlighted in blue, select Window➔Show Project Library, or press ⌘+0.

Projects appear as horizontal filmstrips across the Project Library, but to start editing you must first open the project in the Timeline. The Timeline is where the actual editing takes place. Media can be selected and edited down to the Timeline from any of the Events that are available in the Event Library. Once cutting begins, you'll spend most of your time in the Timeline shaping the material into the finished movie.

To make the Timeline the active window, click inside the Timeline window, select Window➔ Go to Timeline, or press ⌘+2.

The Viewer

The Viewer is Final Cut Pro's dedicated playback window. Video clips that are played or skimmed in the Event Browser, Project Library, or Timeline are displayed in the Viewer. There is a great deal of flexibility in the way a clip can be displayed in the Viewer. Choosing a percentage from the zoom pop-up menu in the top right-hand corner of the Viewer allows you to home in on a specific portion of a clip's full image area, but in most circumstances this can be set to Fit so that the selected clip is displayed in its entirety. Next to this, a switch button allows you to access technical information about the selected image using video scopes and refine the way the clip is displayed by individually selecting the red, green, blue, or alpha channels or by adding an Overlay that indicates the title and action-safe zones of the image (see Figure 2.8). We describe the technical aspects of video later.

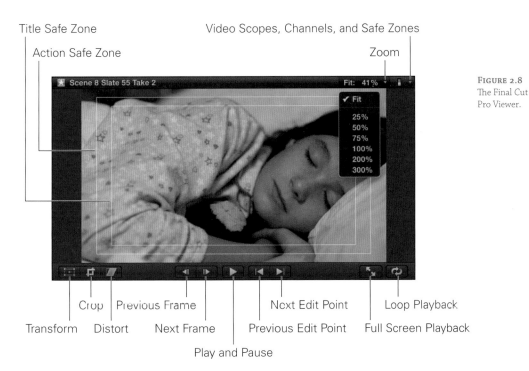

FIGURE 2.8
The Final Cut
Pro Viewer.

The three buttons on the bottom left of the Viewer allow you to transform, crop, and distort an image (see Chapter 14). To the right of these buttons is a group of basic transport controls. The first two buttons allow you to play a selected clip backward and forward frame by frame, the next button toggles between a play and pause function, and the final two buttons in this group allow you to jump backward and forward between edit points that you've set in the Timeline. The last two buttons on the far right display the Viewer window in full-screen mode and loop the playback of a clip selected in the Event Browser.

Selecting Window➡Show Viewer on Second Display displays the Viewer on a second monitor. To place the Viewer back in the main interface, select Window➡Show Viewer in the Main Window.

The Toolbar

The Toolbar is the light gray strip that runs across the middle of the Final Cut Pro interface and provides access to a number of functions used frequently while working with a project. To the left of the Toolbar is a series of buttons relating to the import, organization, and assembly of your media. The first button is the Import from Camera button, which allows you to import footage from a connected device. Next to this are four buttons that help organize your media with ratings and keywords, followed by three buttons for editing your footage down to the Timeline. At the end is the Tool menu, which offers a number of useful editing tools to help trim, shape, move, and manipulate your footage within the Timeline (see Figure 2.9).

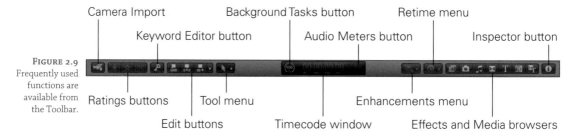

Camera Import Background Tasks button Retime menu

Keyword Editor button Audio Meters button Inspector button

FIGURE 2.9
Frequently used functions are available from the Toolbar.

Ratings buttons Tool menu Enhancements menu

Edit buttons Timecode window Effects and Media browsers

The Dashboard sits at the center of the Toolbar and displays the timecode of the clip that is currently playing in the Event Browser or Timeline. Clicking on the Dashboard's timecode window and entering a value allows you to move the playhead or edit a selected clip by the value that you specify in the window. (You'll learn more about performing tasks with the Dashboard in Chapter 5.) The Background Tasks dial shows the progress of any transcoding and rendering that is taking place behind the scenes. Clicking the dial brings up the Background Tasks window, giving you a more detailed view of the tasks that are being carried out. (You'll find out more about Background tasks in Chapter 3.) The last item in the Dashboard is the Audio Meter button, which toggles the audio meters on and off. When active, the audio meters display on the far right of the Timeline (see Figure 2.10).

The first two buttons on the right side contain menu items relating to color and audio enhancements and the retiming of clips. This is followed by a series of browser libraries where you can access special effects, still images, supplementary sound, music, text generators, backgrounds, and more. We delve deeper into the functions that the Toolbar has to offer throughout this book.

FIGURE 2.10
The audio meters display at the end of the Timeline.

The Inspector

The final button on the Toolbar opens the Inspector in the top right of the Final Cut Pro interface (see Figure 2.11). The Inspector is a context-sensitive window that displays useful information based on what is selected at the time. Tabs within the Inspector provide information about a selected clip's metadata and video and audio properties; changes can be made by adjusting the various parameters that are available. A lot of tweaking takes place in the Inspector, especially when you're working with color correction and effects; we'll be revisiting the Inspector in the coming chapters.

To show the Inspector, click the *i* button on the far right of the Toolbar, select Window➜Go to Inspector, or press Option+⌘+4.

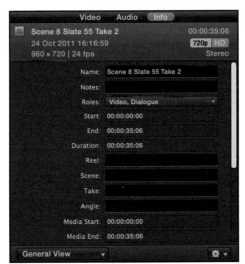

FIGURE 2.11
A selected clip's Info shown in the Inspector.

Working with Keyboard Commands

As with most computer software, Final Cut Pro offers several ways to perform the same task. Identical editing functions may be achieved by pressing an interface button, pressing a keyboard command, or by choosing an item from either a shortcut menu or the menu bar. The methods that you employ will depend on your own personal preference, but most users begin with interface buttons or menus when first starting to learn new software.

As your familiarity with the software package grows, you'll probably start using a few keyboard shortcuts to help speed up your workflow. Most professional editors rely on the muscle memory that they develop from years of using keyboard shortcuts and perform the majority of their editing tasks directly from the keyboard. Incorporating keyboard shortcuts into your workflow increases productivity immensely, so you should look to use some, especially for tasks that you perform often.

Essential keyboard commands

Final Cut Pro ships with many preassigned shortcuts, which are featured throughout the book along with the other available methods for performing each task. Obviously, you aren't expected to memorize all these keyboard commands—they're included only for future reference. The best way to introduce keyboard shortcuts into your workflow is by using one or two commands for the most frequently used tasks and adding to these once they become second nature.

Most keyboard shortcuts are used in combination with a modifier such as the Command (⌘), Option, Control, or Shift keys. When this is the case, the combined keystrokes are indicated with the inclusion of an addition sign. For example, ⌘+N means that you simultaneously hold down the Command (⌘) and N keys. What follows are some of the more essential keyboard shortcuts for you to start off with.

Creating new Events and Projects is something that you'll do with great regularity when working in Final Cut Pro. Both are easy shortcuts to start off with:

○ **Create new Event:** Option+N.

○ **Create new Project:** ⌘+N.

Adding media to a Project's Timeline typically requires one of three functions: a connect, insert, or append edit. You'll be calling on these functions often when assembling your edited sequence, so getting to know the keyboard shortcuts is advantageous. Luckily the Q, W, and E keys are conveniently placed next to each other on the keyboard; by positioning your left hand over them, they'll literally be at your fingertips as you edit. If you learn only three keyboard shortcuts, these are the ones to go for:

○ **Connect clip:** Q

○ **Insert clip:** W

○ **Append clip:** E

The playback controls also are placed together on the keyboard within easy reach of your right hand. Even though there are many ways to play media in Final Cut Pro, using the J, K, and L keys is by far the most fluid and effective. With these keys, you can play, pause, and reverse through a clip at various speeds (see Chapter 4):

○ **Play backward:** J

○ **Stop playback:** K

○ **Play forward:** L

Finally, here are some indispensable keyboard commands that you should definitely incorporate into your workflow when working in the Timeline:

○ **Toggle skimming on and off:** S

○ **Toggle snapping on and off:** N

○ **Zoom to fit:** Shift+Z

○ **Play around the playhead position:** Shift+?

The Command Editor

Many of the functions in Final Cut Pro have keyboard commands assigned to them. You can explore the shortcuts that are available by visiting the Command Editor, where you can search for specific functions and even assign your own shortcuts that can be saved as custom command sets. During an edit, you can switch between command sets directly from the menu bar by selecting Final Cut Pro➡Commands and then selecting a command set from the menu. Command sets can even be exported for use on another computer running Final Cut Pro, so you can switch between a desktop and laptop and still have access to the shortcuts that you are accustomed to.

To open the Command Editor, select Final Cut Pro➡Commands➡Customize or press Option+⌘+K.

The Command Editor consists of three main areas: the Command List, Key Detail, and the color-coded keyboard. To see the commands linked with a key, simply click a character on the virtual keyboard. This highlights the key with a white border and lists any functions that are associated with it in the Key Detail section. The Key Detail's Command column lists all the

actions that can be performed when the selected character is combined with the keys listed in the Modifier column. Figure 2.12 shows the Key Detail results when pressing the W key; it has five functions assigned to it. When used without a modifier, pressing W performs an insert edit, but when used together with the Command (⌘) key, pressing W closes an open window. The W key also is used to insert a gap, insert a placeholder, or show video waveforms, depending on the modifier key used with it.

FIGURE 2.12
The Command
Editor window.

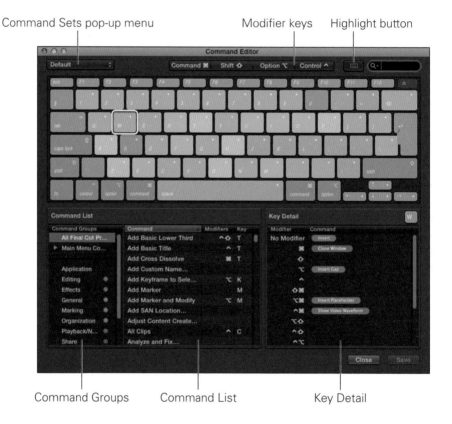

You can look up a keyboard shortcut by function by entering a term in the Search field. The Command List displays the search results for any commands that include the term, along with the keys and modifiers that are connected with them. Figure 2.13 shows nine results for the term *insert* and the key combinations that are required to perform these actions. Clicking the highlight button next to the search field dims the keyboard so that only the keys connected to the search results are visible, making it easy to see the relevant keys. The results can be further refined by selecting one or more of the modifier buttons at the top of the window.

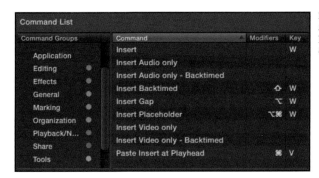

FIGURE 2.13
Search results
listed in the
Command List.

The Command Groups column lists all of Final Cut Pro's functions in color-coded categories that relate to the colors on the virtual keyboard. Choosing a category from the list filters any search results in the Command List to show only commands relating to that category. Selecting Effects, for instance, displays only the functions that deal with effects. The Command Group also groups commands by their menu bar options; these can be found under the Main Menu Commands group by clicking the disclosure triangle. Selecting All Final Cut Pro Commands turns off any filtering and includes all commands in a search.

Not all functions have keyboard commands assigned to them. You may want to allocate your own shortcuts to the tasks that you perform often and save them to your own custom command sets. Final Cut Pro doesn't permit you to add shortcuts to the default command set, so you'll need to create your own in order to reassign any key combinations.

To copy the default command set:

1. Choose Duplicate from the pop-up menu in the top left-hand corner of the Command Editor.

2. Enter a name in the dialog box that appears, and press OK.

Custom command sets also can be imported, exported, and deleted from the same pop-up menu.

If you look at the results for the *insert* search shown in Figure 2.13, you'll notice that there is no keyboard shortcut for "Insert Video only." If this task is something you carry out frequently, you may want to assign a shortcut to save yourself from having to go up to the menu bar each time. For example, you can assign "Insert Video only" the key combination Control+⌘+1. To see whether this key combination is available, make sure Command Groups is set to Final Cut Pro Commands and press the number 1 key on the keyboard and view the results in the Key Detail section. Luckily this combination is not taken by another command, and you can go ahead and assign it to the "Insert Video only" function by selecting

it in the Command List and pressing Control+⌘+1 on your computer's keyboard. If the key combination that you choose is already in use, Final Cut Pro displays a dialog box allowing you to cancel the action or reassign the shortcut to the new function.

Keyboard commands also can be assigned by selecting a key, dragging a function from the Command List, and placing it next to the required key combination listed in the Key Detail's Command column. If you place it on a preexisting command, it will automatically replace it without issuing a warning. Press the Save button to save the new keyboard shortcut to the selected command set.

chapter 3

Importing Media

THIS CHAPTER EXPLORES some of the issues to keep in mind when preparing media for editing, such as selecting the correct preferences settings and understanding some of the background tasks that take place during the import process. Final Cut Pro can be set up to search for technical issues, convert your media to a more playable format, and even organize the files based on criteria that you choose before import. This chapter examines all these settings and demonstrates, using footage from the film *Pranks,* how to import media into an Event in Final Cut Pro (see Chapter 2 for more on Events).

Setting Import Preferences

Before you jump in and start importing media, you need to tell Final Cut Pro how to handle the files that you give it. Do you need to convert some of your media to match the format you're editing in? How do you want the files to be organized? Do you want your video optimized for better playback? What kinds of analysis would you like the software to perform for you? You can answer all these questions by visiting the Preferences window.

To bring up the Preferences window, select Final Cut Pro➡Preferences or press ⌘+, (comma).

The top panel of the Preferences window is split into three tabs: Editing, Playback, and Import (see Figure 3.1). You'll be visiting the Editing and Playback tabs as you work through this book, but for now select the Import tab. Here you'll find the settings that tell Final Cut Pro what to do with all the media that you bring in for editing. The Import preferences are split into four sections: Organizing, Transcoding, Video, and Audio.

FIGURE 3.1
The Import
Preference
settings.

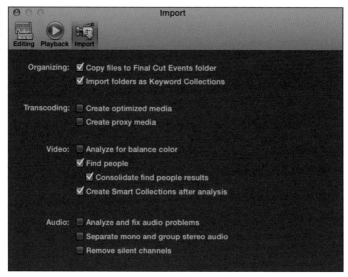

Organizing

Chapter 2 introduced the concept of Events and explained how Final Cut Pro stores these Events inside the `Final Cut Events` folder on your hard drive. Inside the `Final Cut Events` folder is another folder named `Original Media`. Final Cut Pro consults this folder when locating media that you've added to a particular Event.

The Copy Files to Final Cut Events Folder check box determines whether your media is accessed from its original location on your hard drive or whether Final Cut Pro copies it to the `Original Media` folder. With Copy Files to Final Cut Events Folder checked, any media that you import is copied and placed into the Event's `Original Media` folder. This is a great way to stay organized as Final Cut Pro puts all your media in one place where it's easy to find. If the media that you're importing is already stored on the same drive as your `Final Cut Events` folder, you may want to delete it after import; otherwise, you'll have

two copies of the same media taking up valuable disk space. If you prefer to organize the media on your hard drive into a folder structure of your own choosing, leave Copy Files to Final Cut Events Folder unchecked. In this case, Final Cut Pro creates aliases inside the `Original Media` folder that point to the media files on your hard drive.

The next check box, Import Folders as Keyword Collections, helps organize your media inside the Event Library. Keyword Collections provide a powerful way to organize your files; we cover them in more detail in Chapter 4. If you have your media organized into folders before import, checking the Import Folders as Keyword Collections check box gives you a head start in organizing your media. With this box checked, any folder that you import is turned into a Keyword Collection with the same name. Let's say that you keep your sound effects, music, and Foley tracks inside a folder named `audio`. When you import the entire folder, Final Cut Pro assigns the keyword *audio* to all the files inside and groups them into a Keyword Collection also named *audio*. This makes it a breeze for you to pinpoint all your audio files during the edit and helps speed up your workflow considerably.

Transcoding

Transcoding is the process of converting one video format into another. Even though Final Cut Pro can play most video files, there are times when you'll want to transcode your footage to another format before you edit. This is especially true when using heavily compressed video such as H.264, which makes big demands on your computer's processor.

You can transcode your media to a more playback-friendly format by checking the Create Optimized Media check box. The optimized media that this refers to is Apple's ProRes 422 codec. Transcoding to Apple's ProRes 422 yields high-quality images and improves computer performance, but these files also use up more disk space. With this setting checked, Final Cut Pro first determines whether optimization is necessary; then it transcodes to ProRes only if it decides it can't run the media natively. If no optimization is necessary, Final Cut Pro imports the original media and ignores the Create Optimized Media setting.

The next transcoding check box is Create Proxy Media. Checking this setting converts the video that you import into Apple's ProRes 422 Proxy. This is a lower-resolution format that has a smaller file size and data rate than Apple's ProRes 422. Transcoding to this format is useful when you're short on disk space or when you require even better performance from your computer, like when working on a laptop.

If you've checked either of these settings, Final Cut Pro places the video that it converts into a folder named `Transcoded Media`. This folder is found inside the `Final Cut Events`

folder on your hard drive. You can choose to check both settings and transcode to both optimized and proxy media if you can spare the disk space. In this way, you can use the proxy format to edit your movie, maximizing your computer's performance, and then switch to ProRes when you require higher-quality images, such as when doing color correction. Individual video clips may be transcoded at a later date, but it's a good idea to perform your transcoding tasks when you import media into Events.

To switch from proxy to optimized playback during an edit, select the Playback tab in the Preferences window (see Figure 3.2) and choose between Use Proxy Media and Use Original or Optimized Media in the Playback section.

If you chose to optimize your video during import, selecting Use Original or Optimized Media plays back at the higher-quality Apple ProRes 422 during the edit. If the media was not optimized, checking Use Original or Optimized Media plays back the original video files. This setting also gives you an additional option for Playback Quality, allowing you to select between High Quality and Better Performance from the pop-up menu. To follow the examples in the book, check Use Original or Optimized Media.

FIGURE 3.2
The Playback
Preference
settings.

Video

Final Cut Pro has some amazing analysis tools that help spot video and audio problems and even detect the number of people that appear in a shot. The next two sections in the Import

window let you choose which of these you'd like Final Cut Pro to look out for when you import files.

Checking Analyze for Balance Color, tells Final Cut Pro to look for color and contrast issues in the video that you're importing. These issues aren't automatically fixed, but instead the problematic areas are tagged with keywords allowing you to easily locate the footage later in the Event Library. (We cover how to correct these issues in other chapters of this book.)

Final Cut Pro also can detect a shot's size and how many people are in it. This analysis is performed when you check the Find People check box. When you check this box, be sure to also check Create Smart Collections after Analysis, because this groups the analyzed clips into Smart Collections, breaking down the shots by how many people it detects (one person, two persons, or group) and also by the size of the shot (close, medium, or wide). These collections are placed inside a folder in the Event Library called People. (Smart Collections are covered in more detail in Chapter 4.)

In a lengthy video clip, you may have many different people coming in and out of a shot. The shot size also could change from a medium shot to a close-up and back again. This kind of material makes it difficult for Final Cut Pro to accurately analyze for people and shot size. Final Cut Pro solves this with the Consolidate Find People Results option. With this box checked, long (or complex) clips are tagged broadly by the number of people (or shot size) that predominates the shot. So, if a lengthy shot has two people in it for the most part, Final Cut Pro tags it as a two shot.

Audio

You also can prime Final Cut Pro to look out for sound problems. With Analyze and Fix Audio Problems checked, Final Cut Pro looks for volume deficiencies, background noise, and hum on your audio tracks. Final Cut Pro goes ahead and fixes any bad cases, but these fixes are not permanent and can be changed after the files have been imported. With the Separate Mono and Group Stereo Audio box checked, Final Cut Pro identifies the type of audio and imports it as either mono or stereo tracks. If Remove Silent Channels is checked, Final Cut Pro ignores any unused audio channels and doesn't import them.

Video and Audio analyses can be performed after the media has been imported, so you don't need to decide right away.

To analyze media after it has been imported, select the clips that you would like analyzed in the Event Browser and select Modify➡Analyze and Fix or Control-click on a clip in the Event Browser and select Analyze and Fix.

Choosing the appropriate Import Preference settings as you prepare Final Cut Pro for import can be a great aid and timesaver later in the edit. You'll revisit these settings in a short while and see how they impact the footage that you bring into Final Cut Pro.

Importing the Rushes

Let's import some media to work with. To follow along with the book, make sure that your computer is up to the required specifications outlined in Chapter 2 and that you've copied the *Craft of the Cut* disc image from the supplied DVD onto your Desktop or external hard drive.

Double-click the disc image file to open it and select it in the Finder to view the contents. Inside the disc image, you'll find a `Media Files` folder, which contains all the video and audio files that you need to complete the edit for the short movie *Pranks* discussed in Chapter 1. You'll also find some `Final Cut Events` and `Final Cut Projects` folders; the latter contain the precut Projects that you'll be using later in the book. To view the precut Project sequences, launch Final Cut Pro.

In editing, a sequence refers to the arrangement of individual shots or scenes on a Timeline. You'll start off by working on a short sequence called Bump in the Night. In this sequence from the movie *Pranks,* the main character, Katie, is unable to sleep because an unseen presence is playing tricks on her. Bump in the Night has already been assembled for you in the precut Project sequences provided on the DVD; however, you'll be starting from scratch and create your own version. As you work on this sequence, you'll become familiar with some of the core concepts behind Final Cut Pro, and by the time you've completed Bump in the Night, you should be acquainted with the main tools and functions that Final Cut Pro has to offer. This gives you a solid foundation to tackle the other sequences in the movie.

In the next section, you'll import the Bump in the Night footage. Any media that you bring in needs to be associated with an Event, so before we bring in this footage, let's take a look at what Events are and how to create them.

Creating new Events

Events are collections of imported media files that are used to organize your footage. They're a great way to keep all related material together in one place. One Event could hold all the

footage from a wedding video that you plan to edit, while another Event could contain video from a recent vacation. How you use Events to group your media is entirely up to you.

Final Cut Pro requires at least one Event to be present in the Event Library and automatically creates one for you when you launch the software for the first time. You won't be able to delete this Event until you've created a second one to take its place. Events are identified by their star symbol icon in the Event Library. When a new Event is created, it displays the name *New Event* followed by the creation date. You can highlight and rename an Event at any time by clicking it twice.

Let's create a new Event for the Bump in the Night sequence that you're going to work on. If you have more than one hard drive, first select the drive where you want to store the new Event by clicking its icon in the Event Library list.

To create a new Event, select a drive in the Event Library and choose File➜New Event, select a drive in the Event Library and press Option+N, or Control-click in the Event Library and select New Event.

A new Event appears in the Event Library, highlighted and ready for renaming. Type **Pranks** and press Return.

Any Events that you create are added to the `Final Cut Events` folder on your hard drive. If you switch over to the `Final Cut Events` folder in the Finder, you should see a new folder named `Pranks` inside. This is where Final Cut Pro stores the various transcoded media, render files, and analysis files for the *Pranks* Event once you start to import files and work on the edit. For the moment, there should be only a single database file named `CurrentVersion`.

If you need to make any changes to an Event, such as moving, copying, deleting, or merging two Events together, it's important that you do this from within Final Cut Pro rather than in the Finder. Let's look at how these actions are performed inside the Event Library.

To move an Event to a different hard drive:

1. Select the Event that you want to move in the Event Library.

2. Choose File➜Move Event. This brings up the Move Event window (see Figure 3.3) where you can choose a new location.

3. Choose a drive from the pop-up menu and click OK.

Empty Events cannot be moved. An Event needs to hold at least one file before it can be moved to another location.

To copy an Event to another drive, drag the Event's icon onto the new drive's icon in the Event Library or select the Event and press ⌘+D.

FIGURE 3.3
Moving an
Event to a
different drive.

This brings up the Duplicate Event window, which gives you the option to rename the Event. Clicking OK makes a second copy of the Event and all its files to the location you chose in the pop-up menu.

To combine two Events together, drag one Event's icon onto another or ⌘-click on the Events that you want to merge in the Event Library and choose File➜Merge Events.

This brings up the Merge Events window, which allows you to rename the merged Event and change where it's stored.

To delete an Event, select the Event in the Event Library and choose File➜Move Event to Trash, select the Event in the Event Library and press ⌘+Delete, or Control-click the Event and select Move Event to Trash.

Deleting Events sends the Event and all its associated files to the system's Trash. If you accidentally delete files that you need, you can retrieve them from the computer's Trash and re-import them into Final Cut Pro (as long as the Trash hasn't been emptied, of course).

Importing files

With a new Event created, you can now bring in the Bump in the Night footage to work with. Clicking an empty Event displays two icons in the Event Browser: Import Files and Import From Camera (see Figure 3.4).

To open the Import Files window, click the Import Files icon in the Event Browser, choose File➜Import➜Files, or press Shift+⌘+I.

From this window, navigate to your media and choose the files that you want to import. You can bring in a single file, choose multiple files by ⌘-clicking each one, or import a folder with its entire contents. You also can bring in files by dragging them onto an Event's icon directly from the Finder. In this case, Final Cut Pro uses the settings chosen in the Import Preferences window discussed earlier.

FIGURE 3.4 The import options available in an empty Event.

In the Import Files window, navigate to the Media Files folder on the disc image and select the Bump in the Night folder (found inside the Video folder). From here, you can choose to import the files to an existing Event or create a new one.

○ **To add files to a new Event,** select Create New Event. Type a name for the Event and choose a location from the pop-up menu.

○ **To add files to an existing Event,** select Add to Existing Event and choose an Event from the pop-up menu.

Because you've already created an Event, select Pranks from the pop-up menu. The other settings in the window should be familiar from earlier in the chapter. These are the same settings that were covered in the "Setting Import Preferences" section. Having these settings presented again allows you to choose new options for each import. The video clips have already been transcoded to ProRes 422 Proxy for you, so you don't need to check any of the Transcoding settings.

For the purposes of this tutorial, select the Bump in the Night folder, check the settings shown in Figure 3.5, and click Import. Final Cut Pro imports all the files from the Bump in the Night folder into the Pranks Event that you created.

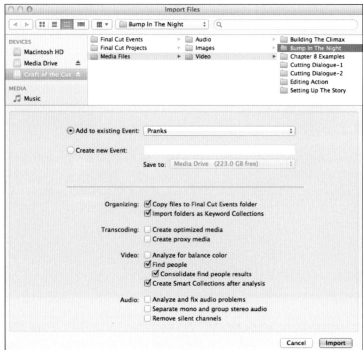

FIGURE 3.5
Choose these
settings when
importing the
Bump in the
Night folder.

Keeping an eye on background tasks

Once you click Import, Final Cut Pro executes all the instructions that you've given it in the Import Preferences settings. From the settings chosen above, Final Cut Pro copies the selected media from the Media Files folder into the Final Cut Events folder, makes a Keyword collection named Bump in the Night, and creates a Smart Collection for the people and shot sizes that it detects in the footage. The progress of these tasks displays as a percentage in the Background Processes dial in the Dashboard (see Figure 3.6).

To get a more detailed view of these processes, bring up the Background Tasks window, by clicking the Dashboard dial in the Toolbar, choosing Window➔Background Tasks, or pressing ⌘+9.

FIGURE 3.6
The Background
Processes dial in
the Dashboard.

The Background Tasks window displays a progress bar for each of the tasks that Final Cut Pro is performing. You can view these by clicking the disclosure triangle for each section (see Figure 3.7). These tasks include copying and transcoding media to ProRes, rendering and generating thumbnails, and performing the various analyses that you've specified in the Import Preferences settings. Any task can be paused or canceled by clicking the buttons beside the progress bar. You don't need to wait for these processes to complete in order to begin your edit; Final Cut Pro pauses any background tasks when you start to work and restarts them when it's idle.

FIGURE 3.7
The progress
of various tasks
can be
monitored in
the Background
Tasks window.

Understanding how Events are organized

Select the Pranks Event in the Event Library. The Event Browser displays all the material that you've imported from the DVD either as thumbnails or a list. If you click the Event's disclosure triangle, it reveals other files beneath it. These are collections of the various analyses that you asked Final Cut Pro to perform during the import process. The blue icons represent Keyword Collections and were automatically created by Final Cut Pro when you checked the Import Folders as Keyword Collections setting in the Import Preferences. When each folder was imported, the items inside were tagged with a keyword (in this case, the name of the folder) and grouped into a Keyword Collection. Selecting the Bump in the Night collection displays all the contents imported from the Bump in the Night folder on the DVD.

You may have noticed that a folder has been created named People inside the Pranks Event. This folder contains a number of Smart Collections, which are identified by their purple icons. These Smart Collections are the result of the analysis that you asked Final Cut Pro to perform when you checked the Find People and Create Smart Collections after Analysis

check boxes in the Import Preference settings. Final Cut Pro analyzed all the clips from the DVD and organized them into collections based on the size of the shot and how many people appear in each clip. Keywords and Smart Collections are covered in more depth in Chapter 4.

Grouping Events

Click the gear button beneath the Event Library to change how Events are grouped and displayed. This brings up a pop-up menu with various options on how to sort and order your Events (see Figure 3.8).

FIGURE 3.8
The various
options available
for displaying
Events.

The Event Library lists all the hard drives connected to your Mac and the Events that are stored on them. Having the drives displayed is useful when you want to create a new Event on a specific drive, but during an edit, you may want to keep the drives hidden in order to focus on the Events themselves.

To show only Events and hide the drives, uncheck Group Events by Disk.

If you always use a specific drive to store Events and want to keep the drives hidden from view, select the drive from the Event Library before unchecking Group Events by Disk. Now, any new Events that you create will always be stored on the chosen drive.

The next option in the pop-up menu is Group Events by Date. This sorts Events by date order based on when the content inside an Event was created. From this menu, you can choose Group Events by Year or Group Events by Year and Month. If the content inside an Event was created over a long period of time, checking Show Date Ranges in Event Library displays this range underneath the Events. The date range for the Event shown in Figure 3.9 shows that the Event's clips were filmed between September 19, 2008, and October 24, 2011. Arrange Events by Most Recent displays Events in order, starting with the most recent first. This option also applies to any date ranges displayed beneath an Event.

The sort order of the clips in the Event Browser also can be rearranged and is discussed during the Filmstrip and List View section in the next chapter.

Importing Media from Other Sources

Importing files from a hard drive isn't the only way to get footage into Final Cut Pro. You'll often want to import video captured from a variety of other sources. Whether it's from an HDV camcorder, the latest DSLR, or your iPhone, there are more ways than ever to shoot video footage, and Final Cut Pro supports an extensive range of formats and codecs.

To see if the camera or format that you want to use is supported by Final Cut Pro, choose Help➜Supported Cameras. (You need to have an Internet connection to access to the Final Cut Pro X Help pages.)

Let's take a short break from the *Pranks* edit and look at some other ways to get media into Final Cut Pro.

File-based cameras

Final Cut Pro's support of a File-based workflow makes it easy to import media from the many popular devices that record video to a memory card.

To import video footage from a file-based camera, connect the camera to your Mac and click the Camera Import button on the far left of the Toolbar, select an empty Event and click the Import From Camera icon in the Event Browser (the Import From Camera icon is not visible if there is already media in the selected Event), select File➜Import From Camera, or press ⌘+I.

This brings up the Camera Import window, which lists all the cameras that are connected to your Mac, including the computer's iSight camera. Selecting your camera from the list presents thumbnails of all the camera's clips in the bottom pane. Each thumbnail displays a frame grab from the clip. You can skim or play the clip by moving the selector tool over this thumbnail. (More about this in Chapter 4.) You can extend or decrease how much of the clip is displayed by changing the thumbnails' duration with the slider at the bottom right of the pane. The switch button beside the slider brings up the Clip Appearance panel, which allows you to change the clip height and display audio waveforms.

Imported clips display an orange bar on their thumbnails, and checking the Hide Imported Clips check box hides them from view. A selected clip can be viewed in the preview window by using the playback controls or by skimming over the thumbnails. You also can use the J, K, and L keys (see Chapter 2).

If no clips are selected in the Camera Import window, the Import All button is displayed at the bottom of the window. Clicking this button imports all the clips from the camera. If you don't want to import everything, you can pick clips by ⌘-clicking the thumbnails. A yellow selection box appears over each clip that you select for import. The Import Selected button is displayed, and only the highlighted clips are imported. To deselect the highlighted clips, click an empty section of the window.

You also can import a section of a clip by setting In and Out points for the area that you want to import or by dragging the handles on either side of the yellow selection range. (Setting In and Out points is covered in Chapter 4.)

Figure 3.10 shows the Camera Import window with an iPhone selected on the left. As you can see from the yellow selections around the thumbnails, three movie clips are selected for import into Final Cut Pro. The first clip has had In and Out points set, so only the segment highlighted by the yellow selection range will be imported. Clicking the Import Selected button brings up the familiar Import Settings window. From here, you can select or create an Event and choose the analysis and transcoding settings that you require. Click Import to start the process and close the Camera Import window.

FIGURE 3.10
The Camera
Import window.

DSLRs

In some cases, such as when you're importing media from a DSLR camera, you may not see your camera listed in the Camera Import window. When this is the case, you'll need to use the Import Files method instead of Import From Camera.

Connect your DSLR camera or card reader to your computer and choose File➜Import➜Files from the menu bar. Navigate to the mounted camera and select the movie files that you want to import from inside the flash card's DCIM folder.

Figure 3.11 shows the Import Files window ready to import some movie files from a Nikon D90 flash card. As you can see, six movie files have been selected inside the DCIM folder ready to be imported into Final Cut Pro. Also note that the Copy Files to Final Cut Events Folder box has been checked. This ensures that the media from the camera flash card is copied to your hard drive. Video shot on DSLR cameras use the H.264 codec and, as mentioned earlier, places a heavy burden on your computer's processor. For this reason, Create Optimized Media also has been checked to transcode the video into ProRes. To complete your import, check any other settings that you require and click Import.

FIGURE 3.11
Importing from
a DSLR camera.

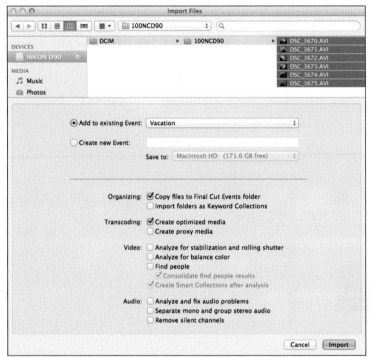

Tape-based cameras

Even though Final Cut Pro has been designed to work with the latest file-based cameras, you can still import footage from a tape-based camera, such as an HDV camcorder.

To import footage from a tape-based camera, connect the camcorder to your Mac with a FireWire cable and put the camcorder into VTR or Play mode. Bring up the Camera Import window by employing one of the methods discussed earlier and select your camcorder from the list.

Figure 3.12 shows the Camera Import window with a Canon HV30 camcorder selected and the video to be captured displayed in the Viewer. You can use the J, L, and K keys or the viewer's playback controls to play, fast-forward, and rewind through the tape. Search through the tape and stop at the beginning of the footage that you want to import. Clicking Import brings up the Import Settings window. Choose the settings that you require, and click Import.

Final Cut Pro captures the camcorder's real-time playback into the Event specified in the Import Settings window. After you've captured the footage, you can stop the import process by clicking Stop Import or by pressing the Esc key on the keyboard. Close the Camera Import window and click the Event to see the captured footage. Final Cut Pro splits the media into clips based on when the camera was stopped during filming. You can now use these clips in your edit. (Final Cut Pro will automatically name the files according to the date and time they were captured.)

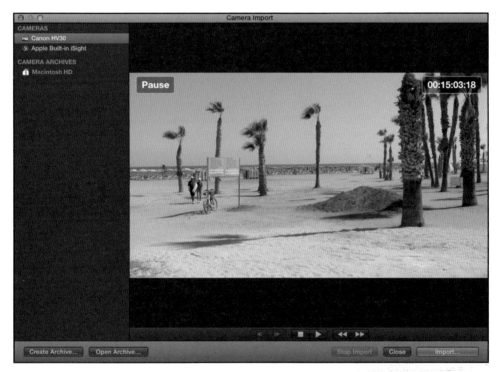

FIGURE 3.12
Importing from a tape-based camera.

Another way to import tape-based media is by creating a camera archive from tape and then importing the archived files into Final Cut Pro. Archiving digitizes your captured footage into individual clips, allowing you to pick and choose shots just like a file-based camera. The advantage of this method is that, once an archive is created, you can re-import the media into future Projects without having to go through real-time tape capture again. It's also a great way to back up your footage.

iMovie Projects

If you previously used iMovie to edit your movies, you can import individual Projects and continue working on them in Final Cut Pro.

To bring in an iMovie Project into Final Cut Pro:

1. Choose File➜Import➜iMovie Project.

2. Navigate to the Project file that you want to import, and click Import.

Final Cut Pro imports the edited iMovie timeline and any Events and clips that are associated with it into Final Cut Pro.

To have all your iMovie Events available in Final Cut Pro, choose File➜Import➜iMovie Event Library and click OK. An alert message informs you that any previously imported iMovie Events are ignored and only iMovie Events unavailable to Final Cut Pro are imported. Click OK to continue. The size of your iMovie library determines how long the import process takes. Once the import is complete, all the clips and Events created in iMovie are available for use inside Final Cut Pro's Event Library.

chapter 4

Organizing and Preparing Media

YOU'VE IMPORTED THE media into Final Cut Pro, and you're no doubt eager to start editing, but before you begin piecing together footage, you need to become familiar with the different shots that you have to work with. This task is usually accomplished during the logging process of the workflow, when an editor or an assistant views the material and logs its content for easier retrieval later in the edit. A film project has large amounts of media associated with it, and keeping track of all the different files can be a demanding task. Organizing your media upfront will be a great aid later when you're searching for a specific shot, but you can't quite remember what it was called. Final Cut Pro provides a comprehensive set of tools to help in this regard, and this chapter explores all the different methods that are available to you.

Viewing Media in the Event Browser

Selecting an Event or Collection in the Event Library displays its contents in the Event Browser. This is where you review and evaluate your media as you prepare for the edit. Selecting an Event displays all the media associated with that Event, including the files from all the different Collections that the Event might contain. Selecting a Collection displays only the media associated with that Collection.

Taking the time to create Keyword or Smart Collections before you begin to cut really boosts your productivity during an edit. As you've seen, Final Cut Pro does some of the work for you by creating Collections based on the analysis settings in the Import Preferences. Collections allow you to easily find the clips that you require without having to wade through countless irrelevant files. If you're working on the Bump in the Night sequence for instance, selecting the Bump in the Night Collection displays only the clips required for that sequence and excludes everything else. Multiple Collections are viewed by Shift-clicking or ⌘-clicking them in the Event Library; this provides a very effective way to work with and access your material.

Working in Filmstrip View

The media in the Event Browser can be displayed in one of two ways: as filmstrip thumbnails or as a list. These views are selected by clicking one of the two view buttons beneath the Event Library. In Filmstrip View, each file in the Event Browser is represented by a filmstrip thumbnail. This view should be familiar to anyone who has used iMovie.

To switch the Event Browser to Filmstrip View, click the Filmstrip View button in the Toolbar, select View➜Event Browser➜As Filmstrips, or press Option+⌘+1.

Displaying clips as filmstrips is useful when you need to visually skim through a clip to find a specific piece of action in a shot. The slider at the bottom of the Event Browser controls how much of the filmstrip displays. Moving the slider completely to the right, to the All position, displays the entire clip as one thumbnail, with the thumbnail representing the entire duration of the clip. Moving the slider to the left extends the filmstrip into several thumbnails, with each thumbnail representing the duration listed on the slider. Moving the slider to 5 seconds, for example, creates a filmstrip where each thumbnail represents a 5-second section of the clip. Moving the slider completely to the left displays the clips using thumbnails of half a second in duration. The smaller the duration set with the slider, the longer the film-strip becomes, with the filmstrip continuing on to several rows in the Event Browser. When this is the case, the filmstrip displays a jagged edge at the end of each row. You can see this clearly in Figure 4.1 where the first clip extends onto the second row.

You can make additional changes to how the thumbnails display by clicking the switch next to the slider. This brings up the Clip Appearance panel (Figure 4.2) allowing you to adjust the height of the thumbnails to show more or less of them in the Event Browser. You also can choose to display a clip's audio waveform by checking the Show Waveforms check box. Audio waveforms are displayed as a blue area beneath a clip and are useful when you want to visu-ally find the beginning of a sound or piece of dialogue. To close the Clip Appearance panel, click anywhere on the interface.

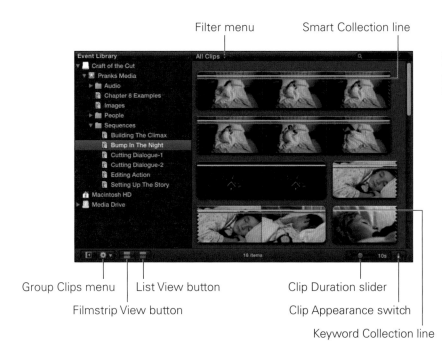

Filter menu Smart Collection line

FIGURE 4.1
The Event
Browser in
Filmstrip View.

Group Clips menu | List View button Clip Duration slider

Filmstrip View button Clip Appearance switch

Keyword Collection line

FIGURE 4.2
The Clip
Appearance
panel.

Media can be grouped and sorted in the Event Browser just as in the Event Library. To group clips in the Event Browser, click the gear button in the Toolbar, choose Group Clips By, and select an item from the menu. You also can simply select View➜Event Browser➜Group Clips By, and select an item from the menu.

Final Cut Pro provides many ways to group your media, including by creation date, duration, and file-type. The grouping that you select depends on the media that you need to access at a given moment. If you're interested only in footage shot on a certain day, for example, grouping the media by Content Created organizes the clips by the dates on which they were recorded, allowing you to access the day's filming that you require. If you want to separate your video clips from the audio files, grouping by File Type divides the media into different file-type categories. When a grouping is selected, it displays as a header in the Event Browser;

clicking on the header's disclosure triangle shows or hides the media beneath it. These results display in either ascending or descending order. Figure 4.3 shows the media in the Event Library grouped by duration. The three headers organize the clips by their length, displaying the number of files that they contain in brackets. The third group in this example contains six clips ranging from between 10 seconds and 30 seconds in duration.

FIGURE 4.3
Media grouped by duration in the Event Browser.

Media can be arranged within these groupings even further by sorting them by their creation date, alphabetically by name, by take number, or by duration. To arrange clips in Filmstrip View, click the gear button in the Toolbar, choose Arrange Clips By, and select one of these categories from the menu. You also can simply select View➜Event Browser➜Arrange Clips By and select an item from the menu.

The Filmstrip View is a visual way to see all your media at once, but it isn't the only way to display media, as you'll see in the next section.

Working in List View

If you're coming to Final Cut Pro X from a previous version of Final Cut Pro, working in List View will be very familiar.

To switch the Event Browser to List View, click the List View button in the Toolbar, select View➜Event Browser➜as list, or press Option+⌘+2.

As the name implies, media from a selected Event or Collection displays as a list in the Event Browser. Selecting a file from the list displays it as a single thumbnail filmstrip in the pane above (Figure 4.4). This allows you to focus on each individual clip without the visual distraction that occurs in the Filmstrip View.

FIGURE 4.4
The Event Browser in List View.

Media is grouped in the same way as in the Filmstrip View by clicking on the gear button and choosing an item from the Group Clips By menu. The Arrange Clips By menu option is not available in List View because List View provides an even more powerful way to arrange the listed media. This is done using the column headers above the list; it works in the same way as the column headers in the Mac's Finder. Selecting a column sorts the media below by the category of the column. Clicking the "name" column, for example, lists the media alphabetically by the filenames. Clicking a column header a second time reverses the sort order.

Many column headers are available in List View, and you'll need to scroll through to the side in order to access them all. The placement of the headers can be changed by simply clicking on a header and dragging it to the position that you require. Control-clicking on a header brings up a shortcut menu allowing you to hide columns or add further categories (Figure 4.5).

To hide a column in List View, Control-click the column in the Event Browser and select Hide Column from the shortcut menu. To add a column, including one that was previously hidden, Control-click any column in the Event Browser and choose the column you want to add from the shortcut menu.

FIGURE 4.5
Adding additional columns in the Event Browser.

Skimming clips

Media played or skimmed in the Event Browser displays in the Viewer. To view a clip by skimming, simply roll your cursor across the clip's thumbnail. As you do this, the skimmer's position is represented by a pink vertical line that follows the cursor. Skimming is useful when you want to view a clip's contents quickly without having to play the entire clip in real time.

To toggle the skimmer on or off, select View➜Skimming or press S.

To toggle the skimmer's audio on or off, select View➜Audio Skimming or press Shift+S.

Audio skimming only works when Skimming is first selected. Turning Skimming off also turns off Audio Skimming. Both skimming options also can be turned on or off by clicking on the two skimming buttons in the Timeline. To access these buttons, you first need to have a Project open in the Timeline (Figure 4.6).

Turning on "skimmer Info" displays additional information as you skim through a shot, such as the clip's name, any Collections it belongs to, and the skimmer's position in the clip (Figure 4.7).

FIGURE 4.6
The Skimming buttons in the Timeline.

To switch the skimmer Information on or off, choose View➜Show/Hide skimmer Info or press Control+Y.

FIGURE 4.7
Skimmer info displays as you skim over a clip.

Playing selections

Skimming is not the only way to view the media inside the Event Browser. A clip can be viewed normally by playing it back in real time and this can be done in several ways. First select the clip that you wish to view by clicking on its thumbnail. This highlights the clip with a yellow selection box and displays it in the Viewer. A series of vertical film sprockets, running along the left side of the image in the Viewer, represents the first frame of a clip (Figure 4.8). The same is true of a clip's last frame, which has sprocket holes displayed on the right side.

FIGURE 4.8
The first frame
of a clip in the
Viewer.

○ **To play a clip,** use the Viewer's playback controls or press the Spacebar to start and stop the clip.

○ **To play a clip backward,** press Shift+Spacebar.

○ **To play a clip from the beginning,** press Control+Shift+I.

As the clip plays, a white vertical line in the clip's thumbnail represents the playhead position. This is independent from the skimmer's vertical line, and the two can be used in conjunction with each other.

○ **To move both the playhead and the skimmer to the start of a clip or selection,** press Shift+I.

○ **To move the playhead and the skimmer to the end of a clip or selection,** press Shift+O.

An even better way to play a selected clip is to use the J, K, and L keys. As mentioned in Chapter 2, the L key plays forward, the J key plays backward, and the K key stops playback. But these keys don't stop there. Here are some other useful actions that you can perform with these keys:

○ Pressing the L key twice doubles the speed at which the clip plays.

○ Pressing the L key multiple times increases the playback speed exponentially by the number of key presses. The same is true of pressing the J key multiple times, except the playback is in reverse.

○ Pressing the K and L keys together plays the clip forward in slow motion.

○ Pressing the J and K keys together plays the clip backward in slow motion.

When playing back at different speeds, Final Cut Pro retains the pitch of the audio, which is very useful when reviewing clips with dialogue. Using the J, K, and L keys is a very fluid way to control playback in Final Cut Pro and becomes second nature after a bit of practice. As you play your clips, use the up and down arrows on the keyboard to go to the previous or next clip in the Event Browser. Final Cut Pro jumps to the start of the next clip with uninterrupted playback.

Marking In and Out points

Most rushes have a lot of unusable material that you'll want to exclude from the edit. This can be anything from a clapper at the start of shot to an actor fluffing his lines. As you skim and play through the rushes, you'll form opinions on which pieces you'd like to use in the finished movie. Selecting these pieces is as simple as clicking a clip's thumbnail and dragging out the section that you want to use. As you drag, a yellow selection box representing the chosen area appears over the clip's thumbnail; after a selection is made, you simply add it to the Timeline. If you want to alter a selection, you do so by dragging its yellow handles to a new position; a small floating box with the selection's duration updates as you drag (see Figure 4.9). When dragging the end of a selection, the timecode reader in the Dashboard displays the position of the selection's Out point; when dragging the start of a selection, the timecode reader displays the position of the In point.

FIGURE 4.9
Dragging out a selection on a clip.

A more traditional way to make a selection is to place either an In point or an Out point at the playhead position on the clip. This can be done on the fly as the clip plays. To place an In point at the playhead position, choose Mark➜Set Selection Start or press I. To place an Out point at the playhead position, choose Mark➜Set Selection End or press O. To play a selection, choose View➜Playback➜Play Selection or press /.

If you make a selection and then click another clip in the Event Browser, the selection is lost when you return back to the clip. You can get around this by marking the selection as a Favorite and clicking on the thumbnail's green Favorite line to recall the selection. More on Favorites in the next section.

Evaluating the Rushes

One of the first steps you'll employ to organize your media is the use of ratings. This can be done as soon as you start to review and get acquainted with the rushes that have been shot for the movie. You'll be using the individual shots from these rushes to build the story from the script, so it's important that you're familiar with all the material that you have to work with. As you view the rushes, you'll be making value judgments on each shot based on a variety of criteria, assessing everything from performances to technical issues. Through ratings, you can single out the shots, or portions of a shot, that you intend to use and reject the rest. Deciding which parts to use is up to you, the editor.

Developing a strategy

The media for each video project that you work on is generally imported into its own Event, but you'll most likely be accessing that media via the various collections within the Event. Collections are a useful way to pare down the media presented in the Event Browser to just the applicable files that you need to access at a given time. You can create as many Collections as you wish, but it's easy to go overboard and clutter the Event Library with too many collections. Take some time beforehand to develop a strategy on how to use collections and what they should contain. A documentary project, for instance, could be comprised of interviews, B-roll, archival footage, and still images with a Collection created for each one of these elements. For a film project, collections could be used to organize the clips into characters, cutaways, scenes, and sequences. In the *Pranks* Event on the DVD, the clips are organized into six Collections, with each Collection consisting of a different sequence from the movie and placed inside a folder called Sequences. In this way, an editor working on a specific sequence

can select the relevant collection in the Event Library and have just the clips from that sequence presented in the Event Browser.

Working efficiently in the Event Browser is all about scaling the material down to the most pertinent media for the job at hand. As powerful as Collections are, they aren't the only way to do this. Final Cut Pro employs many methods, such as filters, ratings, and metadata, to get your material down to a more manageable form.

Selecting Favorites

Select the Bump in the Night Collection in the Event Library and view all the clips that make up this sequence. As you examine the clips, think about what you like or dislike about each shot and look for possible ideas on how these shots can be used to tell the story. In some cases, there will be more than one version of each shot, such as with Scene 8 Slate 57. As you can see, the actress's performance in these two takes is quite different. A good actor tweaks his or her performance with every take, giving the editor a variety of subtle nuances to work with in the edit. These small, understated moments in a performance are gold to an editor, and you should be on the lookout for them as you review your rushes.

Final Cut Pro makes it very easy for editors to quickly flag their preferred shots as they review the rushes. This is done by rating a clip as a Favorite and can be applied to an entire clip or selected segments within a clip.

To rate a clip or selection as a Favorite, select the clip or selection in the Event Browser and press the green star button on the Toolbar, choose Mark➜Favorite, or just press F.

A green horizontal line marking the range of the Favorite area displays on the clip's thumbnail. Figure 4.10 shows a clip with three segments rated as Favorites, as depicted by the green lines over the clip's thumbnail. By filtering the Event Browser to show only Favorites, the green sections of the clip display and the unmarked areas are hidden from view (we tell you how to filter clips in the Event Browser later in the chapter).

Clicking on a line displays the rated area as a yellow selection range over the clip's thumbnail. Clips in the Event Browser have a number of different-colored horizontal lines over their thumbnails, either running across the entire clip or in small sections. Each color identifies the clip with a rating, a keyword, or a Collection. To show or hide the horizontal lines on the clips thumbnails, choose View➜Show/Hide Marked Ranges.

Favorite Section

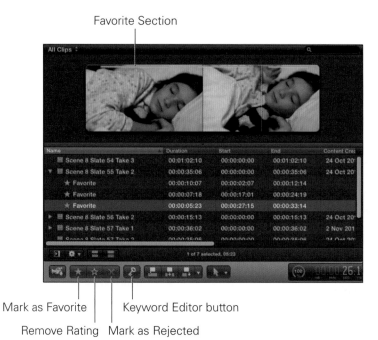

Mark as Favorite | | Keyword Editor button

Remove Rating Mark as Rejected

Let's rate some Favorite clips for the Bump in the Night sequence that you'll be editing later in the book. Make sure the Filter pop-up menu is set to All Clips and select the Bump in the Night Collection in the Event Library to view the clips in the Event Browser. Drag a selection range or set In and Out points at the times specified below. Then rate these areas as Favorites using any of the methods listed earlier.

1. **Scene 8 Slate 55 Take 2:** Make a selection between 17:09 and 18:07, and rate it as a Favorite. Make a second selection between 24:00 and 34:01, and rate that as a Favorite as well.

2. **Scene 8 Slate 56 Take 2:** Make a selection between 00:00 and 04:02, and rate it as a Favorite. Make a second selection between 08:00 and 12:20, and rate that as a Favorite as well.

3. **Scene 8 Slate 57 Take 2:** Make a selection between 01:20 and 02:17, and rate it as a Favorite.

4. **Scene 8 Slate 58 Take 2:** Make a selection between 06:15 and 09:23, and rate it as a Favorite.

5. **Scene 8 Slate 59 Take 1:** Make a selection between 05:13 and 14:07, and rate it as a Favorite.

6. **Scene 9 Slate 60 Take 3:** Make a selection between 02:12 and 35:03, and rate it as a Favorite.

Rejecting clips

In the same way that you can rate a clip as a Favorite, you also can rate a clip as Rejected. This can be done to an entire clip or just a selected section of a clip. If there is a clip that features a fluffed line or technical issue, you don't have to discount the entire shot because of a small section that doesn't work. You can choose to reject just the problematic area and keep the good parts of the shot. To rate a clip as Rejected, select the clip or selection in the Event Browser and press the red X button on the toolbar, choose Mark➔Reject, or just press Delete.

Select the Bump in the Night Collection in the Event Library, and rewatch the two takes for Scene 8 Slate 57. As the actress looks around the room in the first take, you'll see that the camera has trouble keeping her in frame. She almost moves completely out of shot at 10 seconds and 14 frames into the clip. It's unlikely that this section will be used in the edit, so to avoid having to watch the unusable section every time you review this shot, it would be best to rate it as Rejected. Select Scene 8 Slate 57 Take 1 in the Event Browser, and drag a selection starting at 10 seconds and covering an area of about 1 second and 10 frames. Rate this section as Rejected using one of the methods listed earlier. The Rejected clip displays a red horizontal line on the clip's thumbnail that covers the rejected area. Rejecting clips doesn't delete them from within Final Cut Pro, but it does allow you to filter the Event Browser so that they're hidden from view.

Removing ratings

If you change your mind about a Favorite or Rejected clip, you can easily unmark it. To remove all ratings from a clip, select the entire clip in the Event Browser. To remove a specific instance of a rating, click its horizontal line on the clip's thumbnail to display the selected area that you want to remove. To unrate a clip or selection, press the white star button on the Toolbar, choose Mark➔Unrate, or just press U.

Naming clips

As you become more familiar with the footage that you have to work with, you may want to rename some of the clips in the Event Browser to something more meaningful to you. This is

especially true if the clips have the original filenames imported from the camera. This is as simple as clicking a clip's name field and typing a new name. If the Event Browser is set to Filmstrip View, the clip names are displayed beneath the thumbnail filmstrips. To show or hide the filenames in Filmstrip View, choose View➔Show/Hide Clip Names or press Option+Shift+N.

You also can rename a clip by selecting it and typing inside the name field of the Inspector's Info window (see Chapter 2 for more on the Inspector).

You may have noticed that when you're working in List View, the clips listed in the Event Browser have disclosure triangles on them. Opening these triangles reveals various icons beneath the clips. These icons identify the various ratings, keywords, and Collections associated with the clip and correspond to the horizontal lines on the thumbnails discussed earlier in this chapter, in the "Selecting Favorites" section. The clip in Figure 4.11 has both a green star icon and a red X icon beneath it, which tells you that some sections have been rated as a Favorite and others Rejected. Clicking on an icon highlights these areas as selection ranges over the clip's thumbnail. Figure 4.11 has the Rejected icon selected with the Rejected area selected over the clip.

FIGURE 4.11 A clip marked with both Favorite and Rejected sections.

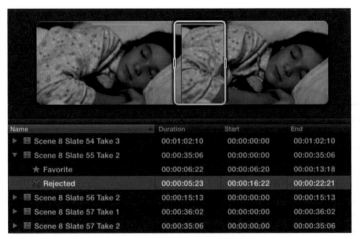

To rename the Favorite and Rejected symbols beneath a clip, select the symbol, press Return to highlight the symbol's name field, and type a new name. You also can rename clips using a clip's metadata; how to create and apply a custom name preset is covered in "Customizing metadata properties," later in this chapter.

Filtering clips

After you have reviewed the rushes and rated the sections that you like and dislike, the Event Browser can be filtered to display just the clips that you want to see. You do this with the Filter pop-up menu, which is available in both Filmstrip View and List View (see Figure 4.12).

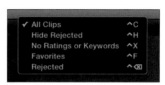

FIGURE 4.12
The Filter pop-up menu.

You can choose to filter an entire Event or selected Collections within an Event by first selecting them in the Event Library.

○ **To display all the media associated with a selected Event or Collection,** set the Filter pop-up menu to All Clips or press Control+C.

○ **To hide media that has been rejected,** set the Filter pop-up menu to Hide Rejected or press Control+H.

○ **To display media that has not yet been rated or tagged with a keyword,** set the Filter pop-up menu to No Ratings or Keywords or press Control+X.

○ **To display media that has been given a Favorite rating,** set the Filter pop-up menu to Favorites or press Control+F.

○ **To display media that has been given a Rejected rating,** set the Filter pop-up menu to Rejected or press Control+Delete.

Filtering to show either Favorites or Rejected media displays just the rated sections of the clips. Each rated section in a clip is treated as a separate clip in the Event Browser with the unrated parts hidden from view. Figure 4.13 shows a clip in the Event Browser that has three sections rated as Favorites and two sections rated as Rejected. With the Filter pop-up menu set to Favorites, the three Favorite sections of the clip display as three independent clips, each having the same name (Figure 4.14). If the Filter pop-up menu were then set to Rejected, the two Rejected sections of the clip would display as two individual clips in the same way (Figure 4.15).

FIGURE 4.13
A clip that has
three sections
rated as
Favorites and
two sections
rated as
Rejected.

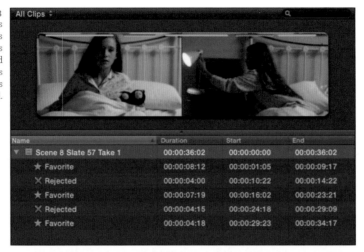

FIGURE 4.14
The three
Favorite
sections display
as three
independent
clips when the
Filter pop-up
menu is set to
Favorites.

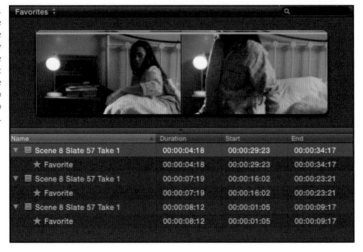

Select the Bump in the Night Collection in the Event Library and set the Event Browser's Filter to Favorites. The Event Browser should now display only the eight Favorites selections that you rated earlier in the chapter. Two of the clips—Scene 8 Slate 55 Take 2 and Scene 8 Slate 56 Take 2—have two different sections rated in each clip, so they appear as two clips with the same name.

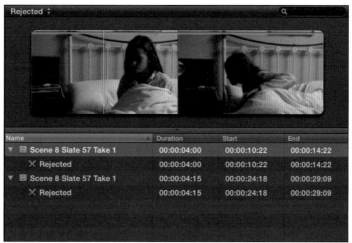

FIGURE 4.15
The two Rejected sections of the clip display as two individual clips when the Filter pop-up menu is set to Rejected.

If you take the time to evaluate and rate your media accordingly, employing the Filter pop-up menu is a valuable way to separate the wheat from the chaff and have only the parts of the footage that you intend to use display in the Event Browser.

Using Collections to Organize Your Footage

Clips imported into an Event usually are organized inside of Final Cut Pro using either a Keyword or Smart Collection. This is because clips can't be arranged directly into folders as they can in other traditional editing software. This may seem like a disadvantage at first, but once you start to use Collections to organize your clips, it'll become apparent just how flexible this way of working is. The beauty of this system is that a clip can belong to more than one Collection at the same time and can be accessed from various places in the Event Library without the need to create a duplication of the clip in each place.

Collections can be created in a number of different ways, either by keywords that you assign to clips or automatically by Final Cut Pro itself through the various analyses that it performs.

Working with automatic collections

Final Cut Pro creates automatic collections based on the choices that you've made in the Import Preferences settings. You've already seen this in action in Chapter 3 when you imported the Bump in the Night media. The `People` folder shown in Figure 4.16 contains a

Smart Collection created from the analysis Final Cut Pro performs during the import process. The `People` folder contains six collections that organize the clips into Close Up Shot, Group, Medium Shot, One Person, Two Persons, and Wide Shot. Having clips arranged in this way can be very useful during an edit when you're searching for clips of a particular shot size or that contain a certain number of people. The best part is that Final Cut Pro automatically does this all for you.

FIGURE 4.16
Smart
Collections
created during
import.

A clip's association with a Collection can be identified in the Event Browser by the color of the horizontal lines displayed over the clip's thumbnail. A clip displays a purple line if it's associated with a Smart Collection and a light blue line if it's associated with a Keyword Collection. It also can be identified by the icons beneath the clip. A key icon links a clip to a Keyword Collection, and a gear icon links it to a Smart Collection. A clip can belong to both a Keyword Collection and a Smart Collection at the same time (see Figure 4.17). The selected clip in this example is associated with both the Bump in the Night Collection and the Medium Shot and Two Persons Smart Collections.

FIGURE 4.17
A clip belonging
to both a
Keyword
Collection and a
Smart
Collection.

Name	Duration	Start
▶ ▦ Scene 8 Slate 56 Take 2	00:00:15:13	00:00:00:00
▼ ▦ Scene 8 Slate 57 Take 1	00:00:36:02	00:00:00:00
⚙ Medium Shot, Two Persons	00:00:36:02	00:00:00:00
⚲ Bump In The Night	00:00:36:02	00:00:00:00
▶ ▦ Scene 8 Slate 57 Take 2	00:00:35:06	00:00:00:00
▶ ▦ Scene 8 Slate 58 Take 2	00:00:13:02	00:00:00:00
▶ ▦ Scene 8 Slate 59 Take 1	00:00:15:05	00:00:00:00

Assigning keywords

When you imported the `Bump in the Night` folder earlier, Final Cut Pro tagged all the items inside with a keyword based on the name of the folder. In this case the folder's contents were tagged with the Bump in the Night keyword. Final Cut Pro created a collection derived from this keyword and placed it inside the Event Library. This is because you had Import folders as Keyword Collections checked in the Import Preferences settings. If you wanted to bring in further files tagged with this keyword, you would first select the collection inside the Event Library and import the files directly into it by using one of the import methods discussed in Chapter 3.

As handy as these automatically generated collections are, the true power of this system comes from using your own keywords. You can create your own keywords using the Keyword Editor and assign these to clips inside the Event Browser. Final Cut Pro will then generate a collection inside the Event Library that's derived from the keywords that you create. To show or hide the Keyword Editor, press the key button on the Toolbar, choose Mark➜Show/Hide Keyword Editor, or press ⌘+K.

You can assign a keyword to an entire clip or to just the selected sections within a clip.

- ○ **To assign a keyword to a clip,** select it in the Event Browser, type a keyword in the Keyword Editor, and press Return.

- ○ **To assign a keyword to a selection within a clip,** drag a selection over the area you want to tag, type a keyword in the Keyword Editor, and press Return.

- ○ **To assign a keyword to multiple items at the same time,** Command-click on the clips that you want to tag inside the Event Browser, type a keyword in the Keyword Editor, and press Return.

A clip can have more than one keyword assigned to it. If a clip has been tagged with the keyword Night and also with the keyword Exterior, it appears in both of the Night and Exterior Collections. The Keyword Editor displays all the keywords associated with a clip in its name field. The clip shown in Figure 4.18 has two keywords linked to it: Bump in the Night and Katie.

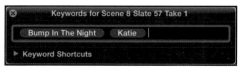

FIGURE 4.18
Two keywords displayed in the Keyword Editor.

Deleting keywords

You can delete a keyword from an entire clip or just from the selected sections within a clip:

○ **To remove a keyword from a clip,** choose a clip in the Event Browser, select the keyword that you want to delete in the Keyword Editor, and press Delete.

○ **To remove all keywords from a clip,** choose a clip in the Event Browser and press the Remove All Keywords button in the Keyword Editor or just press Control+0.

○ **To delete a Keyword Collection,** Control-click on the Collection in the Event Library and choose Delete Keyword Collection or select the Collection in the Event Library and press ⌘+Delete. Deleting a Keyword Collection removes the keyword from any previously tagged media.

Working with Keyword Collections

Once a keyword is created, Final Cut Pro adds it to a list of keyboard shortcuts inside the Keyword Editor. You can access this list by clicking on the disclosure triangle beneath the Keyword Editor's name field (see Figure 4.19). This allows you to quickly tag a clip by using a keyboard shortcut. You can populate this list of shortcuts by clicking on the name field beside each number and typing in a keyword of your own. A keyword is easily removed from the list by selecting it and pressing Delete.

FIGURE 4.19
Keywords
shortcuts
displayed in the
Keyword Editor.

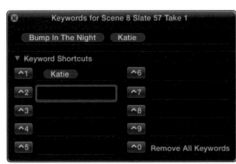

To assign a keyword to a clip using a keyboard shortcut, select the clip in the Event Browser and press Control plus one of the nine numbers listed in the Keyword Editor. To tag a clip with an already existing keyword, drag the clip from the Event Browser onto a Keyword Collection in the Event Library.

Any keywords that you create depend on the kind of projects you're working on and on how you want to organize your rushes. For example, you may want a collection of all the interior shots or all the clips featuring a particular character from a movie. Let's see this in action by creating a collection of all the clips that features the Katie character:

1. Select the Bump in the Night Collection in the Event Library.

2. Select all the clips that feature the Katie character by ⌘-clicking on them in the Event Browser.

3. Press ⌘+K to call up the Keyword Editor if it isn't already visible.

4. Type **Katie** into the Keyboard Editor's Name field and press Return.

 Final Cut Pro assigns the Katie keyword to all the selected clips and creates a collection of these shots inside the Event Library.

Finding your footage

Even with the use of Collections to narrow down the material available in the Event Browser, you still can find yourself sifting through a large amount of files on some larger Projects. Searching for a specific file that is lost inside a vast Event or Collection is as simple as selecting the Event or Collection that you want to look through and typing a term in the search field at the top of the Event Browser. This filters down the list of files to display only the items that include the term in the file's name or notes field.

However, there is a more powerful way to search for clips in the Event Browser, and that's by using the Event Browser's Filter window.

To bring up the Filter window, you can either select the magnifying glass icon in the search field at the top of the Event Browser or make sure the Event Browser is active and choose Edit➜Find or press ⌘+F.

The Filter window allows you to specify various search conditions and works similarly to Smart Playlists in iTunes and Smart Mailboxes in Apple Mail. The Filter Window opens with a default Text search field, which searches for text in the clip title, but you can refine your search even further by adding other criteria including keywords, ratings, and media type. To add search criteria to the Filter window, click the + (plus) icon and select a rule from the pop-up menu.

As you refine your search by adding more items from the pop-up menu, these rules appear as icons in the Event Browser's search field and the search results dynamically update below. To clear the search results in the Event Browser click on the small x in the search field.

A rule can be disabled and not included in a search by unchecking the check box beside it; it can be removed altogether by clicking on the minus symbol next to it. You also can use Boolean search terms such as *All, Any, Include,* or *Not Include* to further refine your search criteria. The Filter search shown in Figure 4.20, for instance, finds only media that meet all the conditions specified in the Filter window. In this case, the results would show only the files that include the words *Scene 8* in the filename, have been tagged with either a Katie or Spider keyword, and have been rated as a Favorite.

FIGURE 4.20
A filter search using text, keywords, and ratings.

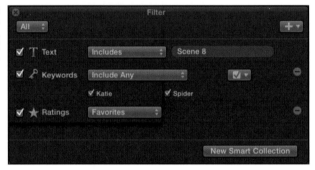

Creating Smart Collections

Once you've set up your search criteria in the Filter window, you can save it as a Smart Collection for future use. The great thing about Smart Collections is that they dynamically update as you add more files with the attributes set out in their Filter window. However, even though you can use the Filter window to search through multiple Events or drives selected in the Event Library, a Smart Collection can be created only from a single Event. If you intend to create a Smart Collection from your Filter results, you should choose an Event from the Event Library before you configure the Filter window.

To create a Smart Collection, click the New Smart Collection button in the Filter window (a Smart Collection is created from the conditions set in the Filter window), or choose File➜ New Smart Collection or press ⌘+Option+N.

To add or change search items for a Smart Collection, double-click it in the Event Library to bring up its Filter window.

Organizing Collections into folders

Folders can be created inside Events to help organize the various Collections that you create during an edit. Final Cut Pro doesn't allow Events and individual clips from the Event Browser to be placed into folders; it allows only Keyword Collections and Smart Collections to be placed into folders. As you can see in Figure 4.16, six Keyword Collections from *Pranks* have been organized into a folder named Sequences. There is also a folder named People that contain the Smart Collections created by Final Cut Pro during import.

To create a new folder, select an Event in the Event Library and choose File➜New Folders, Control-click on an Event and select New Folder, or just press Shift+⌘+N. A new folder appears inside the Event with the name field highlighted. Type a name for your folder and press Return.

Working with Metadata

Metadata is information about the media that you bring in to Final Cut Pro. This can be information generated by the camera that was used to capture the media or information that has been manually entered by the user during the logging process. You've already had a glimpse of the metadata that Final Cut Pro displays when you sorted the various columns in List View earlier in the chapter. These columns allow you to sort your media based on metadata such as a file's creation date or duration.

Some of the metadata that shows up in Final Cut Pro will be exchangeable image file (EXIF) information that is generated by the camera used to record the footage. This metadata can include information about the make and model of the camera that the media was recorded on, as well as technical details such as exposure and shutter speed. Other metadata fields will be empty, giving you the facility to enter your own information as you review or log the rushes. This could be details of a shot's scene and take number, notes provided by the continuity person, or general comments about the clip that you would enter in the notes field.

Working with metadata in the Inspector

The best way to access the metadata associated with a file is by selecting the file in the Event Browser and choosing the Inspector's Info tab. This displays a variety of information about the selected file, such as the clip's codec and sample rate.

The information that the Info tab displays depends on the view selected from the pop-up menu below the Inspector (see Figure 4.21). The Basic View provides the main information

that you would need about a clip, such as its codec, frame size, frame rate, and so on. More metadata can be displayed by choosing either General View or Extended View from the pop-up menu at the bottom of the Inspector window. You also could choose to show just the file's audio or EXIF information if that's all you were interested in.

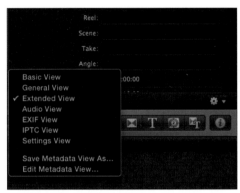

FIGURE 4.21
The different Views available for the Info tab.

Just as useful to an editor is information about a file's status. This includes details on where the file is located on your drive, the type of media it represents (original or proxy), and which Events the clip is associated with.

To show or hide a file's status in the Inspector's Info tab, choose Show/Hide File Status from the gear button at the bottom right of the Inspector window (see Figure 4.22).

FIGURE 4.22
Accessing Show File Status from the gear button.

Customizing metadata views

The default metadata views should provide all the information that you'll need about a clip, but Final Cut Pro gives you the option to further customize these views or create your own views from scratch.

To open the Metadata Views window, choose Edit Metadata View from the Views pop-up menu. In the Metadata Views window, you'll find a staggering amount of metadata to scroll through and use to customize the views that appear in the Inspector (see Figure 4.23). You can reduce this list of metadata items to the specific attributes that you require from the Properties pop-up menu. From here, you can choose to display just the properties associated with a particular type of metadata, such as video or audio.

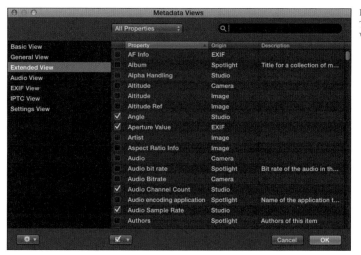

FIGURE 4.23
The Metadata
Views window.

Let's look at the things you can do in the Metadata Views window:

○ **To add metadata to a view,** select the view that you want to customize from the list in the Metadata Views window, and check the box beside the item you want to add.

○ **To remove metadata from a view,** select the view that you want to customize from the list in the Metadata Views window, and uncheck the box beside the item you want to remove.

○ **To create your own view,** select the gear button at the bottom of the Metadata Views window and choose New Metadata View from the pop-up menu. Give your view a name, and check the metadata that you want to include from the list of properties on the right. Your new view is now available in the view pop-up menu in the Inspector.

○ **To duplicate a view,** click on a view from the list and select the gear button from the Metadata Views window. Choose Save Metadata View As from the pop-up menu and name the duplicate view.

○ **To delete a view,** click the view you would like to delete in the Metadata Views window, select the gear button, and choose Delete Metadata View from the pop-up menu.

Customizing metadata properties

In case the metadata attributes listed in the Metadata Views window aren't enough, Final Cut Pro allows you to add your own custom field to the list. New custom fields that you create will appear only in the All or Custom Properties options in the Properties pop-up menu.

To create a custom metadata field, select the gear button from either the Metadata Views window or the Inspector and choose Add Custom Metadata Field from the pop-up menu. Add a name and description in the window that appears, and click OK.

Some of the metadata listed in the Inspector also can be used to rename your clips. For example, if you've entered scene, shot, and take information for all your media, you can have Final Cut Pro apply this metadata to rename any clips that you select in the Event Browser. You also could rename clips by their date and time or add a counter that generates an incremental number to a group of clips with the same name.

To apply a custom name, select the clips that you want to rename in the Event Browser, choose Apply Custom Name from the gear button beneath the Inspector, and select a preset from the pop-up menu.

You also can create your own naming presets with a naming format of your own choice. This is done in the Naming Preset window by choosing Naming Tokens and arranging them into the order that you require. Let's say a scene has a group of cutaways that you would like to label with the scene number, the name *cutaway*, and an incremental number for each clip. Here's how you would create your own naming presets:

1. Choose Apply Custom Name from the gear button beneath the Inspector and select New from the pop-up menu. This brings up the Naming Preset window (see Figure 4.24).

2. Select the Untitled preset in the list and give your preset a name. For this example, enter **Scene/Cutaways with Counter** and press Return.

3. In the Format field, select Current Name and press Delete to remove it.

4. Type the word **Scene** into the Format field and press the Spacebar.

5. Drag the following name tokens from the Naming Preset window into the Format field, making sure to separate each one with a space: Scene, Custom Name, and Counter. Adding a space after each name token separates each label in the preset's name. A preview of the naming format displays directly beneath the Format field (see Figure 4.25).

FIGURE 4.24
The Naming
Presets window.

FIGURE 4.25
A preview of
the naming
format.

6. Type the name **Cutaway** into the Custom Name field in the Naming Preset window. The Counter name token adds an incremental number to each clip that the preset is applied to. You can choose the number that the counter starts from and the number of digits it displays in the area below the Custom Name field (see Figure 4.26).

FIGURE 4.26
The Custom
Name field.

7. Click OK. Your new preset is now available in the Apply Custom Name pop-up menu.

8. Before you apply this custom name preset to any clips, make sure that you've entered the relevant scene numbers for each clip in the Scene field of the Inspector (available by selecting the General View). If you apply this custom name preset to a clip whose Scene field is blank, the clip's new name will not include any scene information.

9. Select the clips that you want to apply the custom name preset to in the Event Browser, choose Apply Custom Name from the gear button beneath the Inspector, and select your new preset from the pop-up menu (in this case, Scene/Cutaways with Counter).

10. The selected clips have now been renamed using the naming format set out in your preset (see Figure 4.27).

FIGURE 4.27
Renamed clips
using a custom
name preset.

Name	Duration
▶ ▦ Scene 8 Cutaway 1	00:00:15:01
▶ ▦ Scene 8 Cutaway 2	00:00:31:13
▶ ▦ Scene 8 Cutaway 3	00:00:25:03
▶ ▦ Scene 8 Slate 54 Take 3	00:01:02:10
▶ ▦ Scene 8 Slate 55 Take 2	00:00:35:06
▶ ▦ Scene 8 Slate 56 Take 2	00:00:15:13
▶ ▦ Scene 8 Slate 57 Take 1	00:00:36:02
▶ ▦ Scene 8 Slate 57 Take 2	00:00:35:06

The Naming Presets window provides a useful selection of naming tokens that can be used to rename your media in a variety of different ways. How you apply these tokens will depend on the naming format that you want to use and the metadata that is available for the clips that you want to rename.

Assigning Roles

Final Cut Pro automatically assigns a Role to the media that you import and labels it as Video, Titles, Dialogue, Music, or Effects. Roles can be used to group files in the Event Browser according to these categories or as a way to single out a particular type of media in a complex Timeline. Media assigned with Roles also can be exported as media stems, allowing you to export a Project's dialogue or sound effects as separate audio files. A clip's Role can be viewed or reassigned in the Event Browser, the Inspector, or the Timeline Index.

To reassign a Role to a clip, select the clip and choose Modify➜Assign Role and choose an item from the menu; in the List View of the Event Browser, click a clip's Role under the Role

column and choose an item from the shortcut menu; in the Info pane of the Inspector, select an item from the Roles pop-up menu; or, in the Clips pane of the Timeline Index, click a clip's Role under the Role column and choose an item from the shortcut menu.

You aren't limited to the five default Roles that are available in Final Cut Pro—you can easily create your own Roles or Subroles in the Role Editor (see Figure 4.28). A Subrole is a smaller subset of a Role that can relate to anything that you want to label in your Project. Subrole categories such as Cutaway, B-roll, Interview, or Visual Effects could be created as part of the much larger Video Role, for instance.

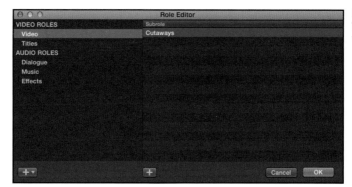

FIGURE 4.28
The Role Editor window.

To call up the Role Editor choose Modify➔Edit Roles. To create a new Role, select either a New Audio Role or New Video Role from the + (plus) pop-up menu on the left, give the Role a name, and press OK. And to create a new Subrole, select a Role from the list on the left, click the + (plus) button at the bottom of the Subrole window on the right, give the Subrole a name, and press OK.

As you'll see in Chapter 5, Roles and Subroles become very useful when used in conjunction with the Timeline Index.

There are countless ways for you to organize and arrange your media inside of Final Cut Pro, but you don't need to apply all of them. Experiment with some of the techniques outlined in this chapter and decide on which techniques work the best for you. The methods that you ultimately settle on will depend on the personal workflow that you develop as you continue to use Final Cut Pro and the approaches that allow you to become more productive.

part 2

The Edit

chapter 5

The Assembly Edit

AFTER VIEWING THE rushes and going through the logging process, applying ratings, creating collections, and adding notes to your clips, you should be familiar with your footage. You also should have formed some ideas about which takes you intend to include in the finished movie. The next stage in an edit is to assemble shots onto the Timeline in the rough order that they will appear onscreen. Typically, these are master shots that play out a scene in its entirety, usually in a wide angle, and assembling these shots in order provides an editor with a rough structure to build on. With this first assembly in place, an editor can then add tighter angles and try out different shot combinations to find the optimum way to tell the story.

In this chapter, you'll learn about Projects, timelines, and the Primary Storyline and use some basic editing techniques to assemble the Bump in the Night sequence.

Understanding Projects and Timelines

Before you can begin to assemble clips, you need to create a Project in which to edit your media. Projects that you create are displayed in the Project Library beneath the drive icon they're stored on. Newly created Projects are placed inside the `Final Cut Projects` folder on your hard drive, similar to the way that Events are placed in the `Final Cut Events` folder.

All Projects that are available on your connected drives are displayed in long filmstrips across the Project Library (see Figure 5.1). The Project's duration, its frame rate, and the date it was last modified appear beneath the Project's name on the left side of the filmstrip. Selecting then playing or skimming over these filmstrips previews the contents in the Viewer without having to open the Project in the Timeline.

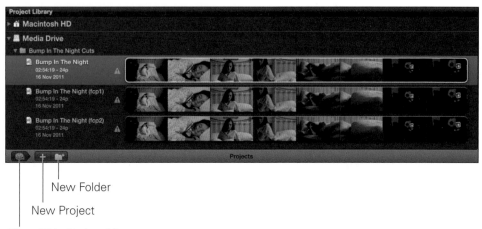

FIGURE 5.1
The Project
Library window.

New Folder

New Project

Show/Hide Project Library

To begin editing, you need to first open up the Project in the Timeline so that you can add clips. A Project is basically a repository for the edit decisions that you make and can consist of a single scene, a sequence, or an entire movie, and how you use Projects is entirely up to you. For *Pranks,* you'll create a Project for each of the six sequences that make up the movie, and these sequences will be combined into a complete edit at the end.

To open a Project in the Timeline, double-click a Project in the Project Library.

When the Timeline is the active window, the Viewer displays the edited clips and you can play and skim over them as normal. You can manually drag the playhead over the Timeline's duration ruler with the cursor, which has the same effect as skimming, only without the audio.

Creating new Projects

Before creating a new Project, select a drive listed in the Project Library on which to store your new Project. If the selected drive contains no other Projects, a Create New Project icon is displayed in the Project Library.

To create a new Project, click the Create New Project icon in the Project Library (see Figure 5.2), click the plus sign below the Project Library, choose File→New Project, or just press ⌘+N.

FIGURE 5.2
Click the Create New Project icon to create your first Project.

Creating a new Project brings up a dialog box where you can give your Project a name and choose an Event to associate it with from a pull-down menu (see Figure 5.3). Choose an Event that contains the main media that you'll be working with. This does not restrict you to just the files in the chosen Event, however, because you're still able to use clips from other Events in the Project's Timeline.

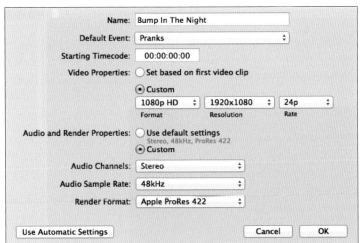

FIGURE 5.3
Creating a new Project.

Clicking the Use Custom Settings button opens a new window where you can override Final Cut Pro's default options. Use this window to set a starting timecode for your Project and also set the video, audio, and render properties. The default video properties are Set Based on

First Video Clip. This takes the format, resolution, and frame rate settings of the first video clip that you bring into the Timeline and uses them as the Project's settings. If you're using a number of different video formats in the edit, select the Custom dial in the window to manually assign the settings that you require. Choosing a format from the drop-down list presents the resolutions and frame rates available for that format. Some of these properties can be changed later in the Inspector, but you need to decide on the Project's frame rate before you begin to edit, because it can't be altered after clips are added to the Timeline. The default Audio and Render Properties sets the audio channels to Stereo, the audio sample rate to 48 kHz, and the render format to Apple ProRes 422, but these, too, can be changed by clicking the Custom dial. Depending on the quality of the footage that you're working with and the capabilities of your hardware, you have the option here to choose a higher-quality codec such as Apple ProRes 4444 for the Project's render format.

After you choose your settings and click OK, Final Cut Pro creates the new Project and opens it in the Timeline, ready for you to start adding clips. To go back to the Project Library, click the reel button at the bottom of the interface, choose Window➜Show Project Library, or just press ⌘+0.

A Project's attributes can be shown by selecting the Project in the Project Library, opening the Inspector, and selecting the Properties tab. This window displays useful information about a Project, such as its settings, its location, and the Events that it's referencing. There is also a Notes field for adding a short description.

To modify a Project's settings, click the wrench button at the bottom of the Inspector (see Figure 5.4). This brings up the same settings window used to create the Project. You can change any setting except for the Project's frame rate.

FIGURE 5.4
To access a Project's settings, click the wrench button.

To delete a Project, select the Project in the Project Library and choose File➜Move Project to Trash, Control-click the Project and choose Move Project to Trash, or just select the Project and press ⌘+Delete.

Create a new Project using the default settings and name it "Bump in the Night." You'll be using this Project to compile a rough assembly of this sequence later in the chapter.

Duplicating Projects

There will be times when you'll want to try out different ideas as you cut without affecting the work that you've already done. The best course of action in this case is to make a duplicate of the Project and use this to experiment with. This would leave your previous work untouched so that you can go back to it if you want. You also may want to duplicate a Project for other reasons—for example, copying to a new hard drive for backup purposes or to continue working on a different computer.

To duplicate a Project, select the Project in the Project Library and choose File➜Duplicate Project, Control-click the Project and choose Duplicate Project, or just select the Project and press ⌘+D. This brings up the Duplicate Project window (see Figure 5.5). There are three duplication options available:

○ **Duplicate Project Only:** As the name implies, this duplicates just the Project and none of the Events that the Project is referencing. Use this option if you're copying the Project in order to create an alternative cut.

○ **Duplicate Project and Referenced Events:** If you're moving the Project to a drive that will be used with another computer, you need to duplicate the referenced Events as well; otherwise, Final Cut Pro won't have access to the media that the Project has been using. This option copies across all the media inside the Events that the Project is referencing and allows you to continue working on the edit elsewhere. Any Events that the Project is referencing are listed at the bottom of the Duplicate Project window.

○ **Duplicate Project + Used Clips Only:** If you've finished editing and you want to back up the completed Project to another drive, this option is the way to go. It creates a new Event that contains only the media used in the Project. If the Project that you're duplicating uses clips from several Events, these clips are incorporated into the new Event. Use this option only if you don't intend to do any further work on the edit, because it doesn't give you access to any of the unused media.

FIGURE 5.5
The Duplicate
Project window.

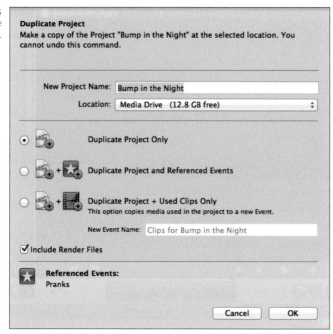

Final Cut Pro automatically generates new render files for the duplicated Project. If you want to start working on the duplicated Project immediately and not wait for these render files to be created, you can choose to copy across the existing render files by checking the Include Render Files check box. After you click OK, a duplicate of the Project appears in the Project Library and the progress of any copying or rendering can be viewed by clicking the Background Tasks dial in the Toolbar. A duplicated Project is identified by the (fcp1) suffix appended at the end of its name, with the digit increasing every time the Project is duplicated. You can easily rename a Project by clicking its Name field and entering a new name.

All the Projects that you create are visible in the Project Library, so the area can soon become very cluttered. To help with this, you can create folders to organize your Projects inside. To create a Project folder, make sure the Project Library is active and choose File➜New Folder, Control-click a drive in the Project Library and choose New Folder, Control-click a Project in the Project Library and choose New Folder, or make sure the Project Library is active and press ⌘+Shift+N.

To delete a Project folder, Control-click a folder in the Project Library and choose Move Folder to Trash or select a folder in the Project Library and press ⌘+Delete.

Understanding Storylines

When you open an empty Project for the first time, you see a dark gray band that extends across the Timeline (see Figure 5.6). This is known as the Primary Storyline. The gray band functions as a container that holds the clips that you place into the Timeline. The Primary Storyline forms the main spine of the sequence that you'll be working on, and any media that you bring into the Timeline will be either added to the main body of the Primary Storyline or attached to it as a Connected clip or as part of a Secondary Storyline (we tell you about Secondary Storylines in Chapter 7).

FIGURE 5.6
The Primary Storyline in a Project.

This method of assembling footage is radically different from the track-based system used in more traditional nonlinear editing systems (NLEs). Because Final Cut Pro X has no real tracks, it may be helpful to visualize the Primary Storyline as a single master track that can have smaller blocks of media secured to it. Let's say you wanted to add a cutaway shot or B-roll to the Timeline in Final Cut Pro. Instead of placing the clip on a second video track above the main track as you would with other NLEs, the clip is fastened to the Primary Storyline as a floating isolated piece. These connected elements can be pieces of video or audio and are placed either above or below the Primary Storyline. One advantage of this way of working is that these attached elements stay in place as you trim and make adjustments to the main clips inside the Primary Storyline. In the next section, you'll learn how to bring clips into the Timeline and compile them into the Primary Storyline.

Compiling the Assembly Edit

There are numerous ways to add clips to the Timeline and build a rough cut to work with. For the *Pranks* Project, you'll start by compiling the master shots of the Bump in the Night clips in the correct order to create a first assembly of the sequence. You do this by using some

basic methods such as appending, inserting, and overwriting clips to the Primary Storyline. This forms the main body of the piece and gives you a foundation to build on as you add more clips and progress through the edit. You then use the various tools that come with Final Cut Pro to trim and adjust this rough cut into shape.

The first initial clips that you bring into the Timeline are used to build the Primary Storyline. The first clip that you add is automatically placed at the beginning and each subsequent clip that you append is tacked on to the end. Attempting to move a clip away from the end of a sequence only springs it back to its original position. Similarly, Final Cut Pro automatically closes any gap left by a clip deleted within the Primary Storyline. Because of this, each clip is always joined together in one long sequence without any spaces. This is the Magnetic Timeline at work, and it prevents accidental gaps from occurring in the Timeline. You'll learn more about how to work with the Magnetic Timeline in the "Working in the Magnetic Timeline" section, later in this chapter.

The three types of edits that you'll most frequently use are Append, Insert, and Connect. These are represented by three edit buttons on the Toolbar. These edits always are applied to a Storyline, because you can't perform an Append or Insert edit to a Connected clip. A clip's video and audio is edited to the Timeline at the same time, but sometimes you want to use only the video or audio portion of a clip. You can specify this before performing the edit by selecting All, Video Only, or Audio Only from the drop-down list beside the three edit buttons (Figure 5.7).

Insert Edit button

Connect Edit button | Append Edit button

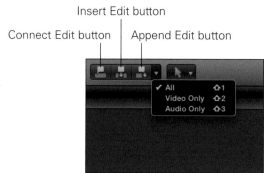

FIGURE 5.7
Edit buttons available directly from the Toolbar.

To play the area around an edit point, choose View→Playback→Play Around, or just press Shift+? (question mark).

Appending clips

The simplest way to assemble your clips when creating a rough cut is by using an append edit. An append edit adds only a clip, or a selected area of a clip, to the end of a Storyline. This is usually the Primary Storyline, but you also can append to a Secondary Storyline by selecting it in the Timeline before you perform the edit. This is a fast way to throw a group of clips onto the Timeline and form a foundation for your sequence.

To append a clip or selection from the Event Browser to a Storyline, you can manually drag the clip directly to the end of the Storyline, or select the clip and then click the Append button on the Toolbar, choose Edit➜Append to Storyline, or just press E.

You can append more than one clip at a time by selecting the clips first in the Event Browser. Appending a group of selected clips arranges them on the Timeline in the order in which they were selected, so with this in mind, Command-click the clips in the chronological order that they are to appear on-screen.

For the exercises in this book, set the Event Browser to List view and click the Name field to list the clips in ascending order.

Let's create a first assembly for Bump in the Night by appending the four master clips from the sequence onto the Timeline:

1. Select the Bump in the Night Collection in the Event Library and make sure the Event Browser's filter is set to show All Clips.

2. Open the Bump in the Night Project that you created earlier in the chapter by double-clicking on it in the Project Library.

3. Using any of the methods outlined earlier, append Scene 8 Slate 54 Take 3 and *Scene 8 Slate 57 Take 2* to the Primary Storyline.

4. Select Scene 9 Slate 60 Take 3 in the Event Browser, click on its green horizontal line to select the Favorite area that you assigned in Chapter 4, and append this to the Primary Storyline.

5. Append Scene 9 Slate 61 Take 2 to the Primary Storyline.

Because no selected area was specified for three of the clips, their entire media is placed into the Primary Storyline (see Figure 5.8). If you play back the sequence, you'll notice that the

actress performs the same action twice in the first two shots. She bolts up in bed—first in an overhead wide shot and then again in the second tighter angle. This is not a problem, because you'll be using Final Cut Pro's trimming tools to tighten up this section in Chapter 6.

FIGURE 5.8
Clips appended to the Primary Storyline.

Performing overwrite edits

An overwrite edit is used to replace existing media on a Storyline with media from another source. When performing an overwrite edit, the edit occurs at the skimmer position if skimming is enabled and at the playhead position if skimming is turned off. The length of the overwritten section is dependent on the duration of the clip or selection chosen in the Event Browser, but you also can specify an area to overwrite on the Storyline itself by using the Range tool (we tell you about the Range tool in Chapter 6). You can perform an overwrite edit anywhere on a Storyline, including across the intersection between two clips. Ordinarily, the first frame of the new clip or selection is aligned with the skimmer or playhead position, but with Final Cut Pro it's also possible to back-time an overwrite so that the last frame coincides with the skimmer or playhead position.

To overwrite a clip at the start of the skimmer or playhead position on a Storyline, select a clip or selection in the Event Browser and choose Edit➜Overwrite or just press D. To overwrite a clip to the end of the skimmer or playhead position on a Storyline, select a clip or selection in the Event Browser and press Shift+D.

Let's add some more shots to the first assembly that you created in the previous section by overwriting two clips over the Primary Storyline. To do this, you'll be using the selections you rated as Favorites in Chapter 4.

1. Select the Bump in the Night Collection in the Event Library and change the Event Browser's filter to Favorites so that only the rated sections appear in the Event Browser.

2. Open the Bump in the Night Project in the Timeline by double-clicking it in the Project Library.

3. Position the playhead at 25 seconds and 18 frames on the Primary Storyline.

4. There are two Scene 8 Slate 56 Take 2 clips in the Event Browser. This is because you rated two different sections of this take earlier and Final Cut Pro separated them into two separate clips when you applied the Favorites filter. Select the first clip.

5. Choose Edit➡Overwrite or press D.

6. The clip is added to the Primary Storyline, replacing a section of the first clip in the Timeline. Play back the edit to see the results.

Now you'll perform a second overwrite edit, but this time you'll back-time it so that it ends at the playhead position on the Timeline:

1. Position the playhead at 30 seconds and 19 frames on the Storyline.

2. Select the first favorite clip of Scene 8 Slate 55 Take 2 in the Event Browser.

3. Press Shift+D.

4. The clip is overwritten to the Storyline ending at the position of the playhead. Play back the edit to see the results.

Performing insert edits

A clip can be inserted anywhere along a Storyline by using an insert edit. An insert edit cuts the Storyline at the skimmer or playhead position and slots the clip into the split, pushing any media to the right out of the way. Any clips connected to the Storyline move along with it and stay attached to their original clips. As with the overwrite edit, the skimmer takes precedence over the playhead position when inserting a clip in a storyline. You also can manually drag a clip from the Event Browser and insert it between two clips in a Storyline. The two clips move out of the way, allowing you to insert the clip in between them. However, you can't manually drag a clip into the middle of another clip in a Storyline unless it has been cut first with the Blade tool. (See Chapter 6 for more on the Blade tool.)

To insert a clip at the playhead position in a Storyline, select a clip or selection in the Event Browser and then click the Insert button on the Toolbar, choose Edit➡Insert, or just press W. You also can insert clips at the skimmer position with the W key.

Let's continue the Bump in the Night edit by inserting two more clips into the Primary Storyline:

1. Select the Bump in the Night Collection in the Event Library and change the Event Browser's filter to Favorites so that only the rated sections appear in the Event Browser.

2. Open the Bump in the Night Project in the Timeline by double-clicking it in the Project Library.

3. Position the playhead at 1 minute and 26 seconds on the Storyline.

4. Select Scene 8 Slate 58 Take 2 in the Event Browser.

5. Choose Edit➜Insert from the menu bar or press W.

6. The clip is inserted into the Primary Storyline. Play back the edit to see the results.

Now you'll add another clip by manually dragging it between two other clips in the Primary Storyline:

1. Position the playhead at 1 minute, 41 seconds, and 1 frame on the Primary Storyline.

2. Select Scene 8 Slate 59 Take 1 in the Event Browser and drag it to the playhead position between Scene 8 Slate 57 Take 2 and Scene 9 Slate 60 Take 3.

3. As you drag the clip between the two clips, a blue bar appears at the edit point and the clips to the right side slide out of the way to accommodate the new clip (see Figure 5.9).

4. Play back the edit to see the results.

FIGURE 5.9
Dragging a clip into the Primary Storyline.

Working in the Magnetic Timeline

Now that you've added some clips to your Project, let's look at some ways to work inside the Timeline window. When a Project is opened in the Timeline, the Project's name is displayed at the top of the window to the right of two navigation arrows. These forward and back arrows work in the same way as a web browser's page history buttons and allow you to move

through previously opened Projects or Compound clips. Clicking and holding down an arrow reveals a history menu, and selecting a Project from the list opens it in the Timeline window (see Figure 5.10).

FIGURE 5.10
The Project
History menu.

The duration of the sequence that you're working on is displayed at the bottom of the interface along with the Project's properties.

Selecting a group of clips in the Timeline displays the combined duration of the selected clips in the same location.

The Select tool is used for selecting and moving clips in the Timeline and is available from the Tool menu on the Toolbar (see Figure 5.11) or by pressing A. Each tool in the Tool menu is used to perform a different task in the Timeline, and you'll be examining all these tools as you work through the following chapters.

FIGURE 5.11
The Tool menu.

Clicking on a clip with the Select tool highlights the clip with a yellow box, indicating that it has been selected. You can select multiple clips by drawing a border around them with the Select tool or by Command-clicking or Shift-clicking on them in the usual way. To deselect

everything that is selected, just click anywhere on the gray area in the Timeline window. When you select a clip, the playhead jumps to the clip's position in the Timeline; you can avoid this by pressing the Option key as you select the clip.

You can move a clip around in the Timeline by dragging and dropping it between other clips. The Magnetic Timeline automatically opens and closes to let in the new clip and prevents any unintended gaps in the process. You've already seen this in action earlier when you manually inserted a clip directly from the Event Browser. Dragging and dropping clips like this is a quick and easy way to swap clips around in a sequence.

As you move clips around in the Timeline, you may want to turn on snapping, because this helps you align clips to other clips or markers in the sequence. Moving a clip with snapping turned on displays a yellow vertical line that snaps to the edit points as you move a clip over them and makes it easy to align the clip at the line's position in the sequence (see Figure 5.12). You may want to turn off snapping when skimming over a sequence so that you can move over the clips without them sticking.

To turn snapping on or off, click the Snapping button at the top of the Timeline window (see Figure 5.13), choose View➜Snapping, or just press N.

FIGURE 5.12
Moving clips with snapping turned on.

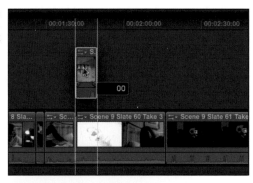

FIGURE 5.13
The Snapping button is highlighted in blue when switched on.

Navigating in the Timeline

Sometimes when working in the Timeline, you'll need to zoom into a specific edit point in order to make some fine adjustments and then zoom back out to see a big-picture view of the edit. Final Cut Pro allows you to zoom down to a single frame; this is represented by a light gray bar in the duration ruler at the top of the window (see Figure 5.14).

Mastering the ability to quickly zoom in and out of the Timeline can really speed up your workflow. There are several ways to zoom inside of Final Cut Pro. Your best bet is to use keyboard shortcuts. When skimming is enabled, using the keyboard shortcuts zooms in at the skimmer position in the Timeline. If skimming is disabled, it zooms in at the playhead position.

To zoom in at the playhead position in the Timeline, choose View➡Zoom In or press ⌘+= (equal sign). To zoom out at the playhead position in the Timeline, choose View➡Zoom Out or press ⌘+- (hyphen sign).

If you need to zoom even further into the Timeline, perhaps to do some intricate work on an audio track at the sample level, you can do this by enabling the Zoom to Samples feature. When it's enabled, this feature allows you to use the zoom tools to explore your Timeline at scale smaller than that of an individual frame of video.

FIGURE 5.14
The light gray bar represents a single frame.

To enable Zoom to Samples, choose View➡Zoom to Samples, press Control+Z, and use the Zoom In and Zoom Out tools to explore the Timeline at the sample level.

To fit the entire Timeline contents inside the window, choose View➡Zoom to Fit or press Shift+Z.

Zooming also can be achieved with the Zoom slider at the bottom of the Timeline window or the Zoom tool available from the Tool menu. Clicking inside the Timeline window with the Zoom tool magnifies the area with every click, but this feature is not just restricted to the Timeline—clicking over the Viewer magnifies the image in the same way. Zooming out with the Zoom tool is also possible by holding down the Option key as you click. A quick and easy way to fit a specific group of shots inside the Timeline window is to draw a border around them with the Zoom tool (see Figure 5.15). This displays just the clips selected and can be very useful when you want to concentrate only on a specific section of a sequence. To initiate the Zoom tool, choose the magnifying glass icon from the Tool menu or press Z.

If you're zoomed inside a sequence and you need to scroll horizontally back and forth along the Timeline, you can do so by using the Hand tool. If you own a Magic Trackpad you can achieve the same result with a two-finger swipe. To initiate the Hand tool, choose the hand icon from the Tool menu or press H.

FIGURE 5.15
Use the Zoom tool to fit a group of clips in the Timeline.

Changing the clip appearance

The Clip Appearance panel, which you access via the switch located next to the Zoom slider, can change how clips display inside the Timeline. This is similar to the Clip Appearance panel found in the Event Browser, and you can specify how clips are presented by selecting one of six display options. These allow you to view more of the video image in the clips or more of the blue audio waveforms. The height of the clips also can be increased or decreased using the slider. If you're using a laptop and you're short on screen space, you can hide the video and audio completely and view the clips as thin blue blocks by selecting the last option on the far right of the panel (see Figure 5.16).

Connected clips and Storylines are attached to the Primary Storyline via small connection links, and these can be shown or hidden using the Show Connections check box. Hiding these connections can really clean up the Timeline window if you have a lot of Connected

clips in your Project, but even with this check box disabled, you can still view a clip's connection link by selecting the clip in the Timeline. You also can choose to display either the clip names or role names from the pop-up menu.

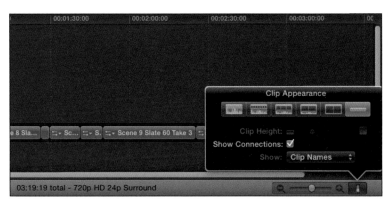

FIGURE 5.16
Display options in the Clip Appearance panel.

Using the skimmer and playhead

Working with both the playhead and skimmer in the Timeline may be a little confusing to begin with, and your first instinct may be to turn skimming off. However the two work really well together and you can take advantage of the skimmer's speed to quickly locate material inside a lengthy sequence. For example, when you've used the skimmer to find the point in the Timeline that you want to view, you can click the mouse to jump the playhead to the skimmer's position or press the Spacebar to play the sequence from the same location.

Another way to work with the skimmer and playhead together is to use them to toggle between two different clips in the Timeline. You can use this to juxtapose the two clips in the Viewer to see if they would cut together or to compare the before and after result of a filter applied to a clip. To see this in action, park the playhead on the first clip and then move the skimmer to the second clip on the Timeline. If the cursor is inside the Timeline window, the Viewer displays the clip at the skimmer position (in this case, the second clip). If the cursor is then raised above the Timeline window to the Toolbar, the Viewer displays the clip at the playhead position (the first clip).

Keyboard navigation in the Timeline

The playhead can be moved to specific points within the Timeline by using the keyboard's arrow keys or by typing numerical values into the Dashboard. Pressing the down arrow on

the keyboard moves the playhead forward to the beginning of the next clip in a sequence, and pressing the up arrow moves it backward to the previous clip. The Home and End keys on an extended keyboard can be used to jump the playhead to the start or end of the sequence, and nudging the playhead frame-by-frame is also possible with the Left and Right Arrow keys.

○ **To move the playhead forward by one frame,** press the Right Arrow key.

○ **To move the playhead backward by one frame,** press the Left Arrow key.

○ **To move the playhead forward by ten frames,** press Shift+Right Arrow.

○ **To move the playhead backward by ten frames,** press Shift+Left Arrow.

Pressing the plus and minus keys followed by typing a numerical value jumps the playhead from its current position by the amount you specify. Pressing either of these keys lights up the Dashboard's timecode field in blue and displays a playhead icon with a back or forward arrow, depending on the key you've pressed (see Figure 5.17). To move the playhead, simply type a numeric value in minutes, seconds, or frames and press Return.

FIGURE 5.17
The playhead icon in the Dashboard.

For example, pressing the plus key, pressing 4, and then pressing Return moves the playhead forward by four frames. Pressing the minus key, pressing 4, and pressing Return moves the playhead back by four frames. To move the playhead by seconds rather than frames, enter a period after the number. If you press 4, followed by a period, and then 7, the playhead moves by four seconds and seven frames. Entering two periods moves the playhead by minutes. If no periods are entered, Final Cut Pro recalculates the number you enter based on the Project's frame rate. For example, if the Project's frame rate is 24 fps, entering the number 30 is automatically calculated as one second and six frames. You also can move the playhead to a particular timecode in the Timeline.

To move the playhead to a specific timecode location, click the Dashboard's Timeline field (or press Control+P, enter a timecode location, and press Return).

Finding clips with the Timeline Index

As you add more clips during an edit and the length of the edited piece gets longer, locating a specific clip in the Timeline can become a bit of a chore. That's where the Timeline Index

comes in. The Timeline Index lists all the items used to build a sequence; you can use this list to quickly locate where they are on the Timeline. The list can be viewed as Clips, Tags, or Roles by selecting the relevant tab at the top of the panel.

To show or hide the Timeline Index, click the Timeline Index button at the bottom left of the interface (see Figure 5.18), choose Window➜Show/Hide Timeline Index, or just press Shift+⌘+2.

FIGURE 5.18
Opening the
Timeline Index.

Timeline Index button

The Timeline Index also can be opened by making the Timeline window active and pressing ⌘+F.

With Clips selected, the index chronologically lists all the clips used in the Project. This can be quite long depending on the number of clips that are in the Timeline. Entering the name of the clip that you're searching for in the Search field filters the list to display only the clips containing the text that you've entered. You can limit this even further by choosing to display Video, Audio, or Titles by selecting one of the tabs at the bottom of the panel. After you've found the clip that you're looking for, clicking it in the Timeline Index moves the playhead to the clip's location in the Timeline.

Selecting Tags from the top of the Timeline Index lists all the various markers, keywords, and to-do items related to the Timeline; you can locate these in the same way by clicking an item in the list. These also can be limited to display only markers, keywords, analysis keywords, incomplete to-do's, or completed to-do's by selecting the applicable tab at the bottom of the panel.

Viewing roles in the Timeline Index lists the media by the roles assigned to them and clicking an item in the list highlights their thumbnails in the Timeline window. Identifying clips in the Timeline by their roles allows you to concentrate on a specific category of media. An example of this would be to highlight just the dialogue, music cues, and sound effects when you're working on the movie's soundtrack. You can single these out further by reducing the vertical size of the clips assigned to the roles that you aren't interested in by using the minimize button next to the role's name in the Timeline Index. A role can be disabled and grayed out in the Timeline by unchecking its check box; this provides a quick way to hide video and mute audio elements during playback, which can be useful when you want to mute all the music elements in a sequence or deactivate connected cutaway clips from appearing in the Viewer.

The Video, Music, and Effects roles in the sequence shown in Figure 5.19 have had their clips minimized to make the dialogue clips stand out more. The music roles also have been disabled so that they don't play back with the sequence, which is why they are grayed out in the Timeline.

Selected role

FIGURE 5.19
Working with roles in the Timeline Index.

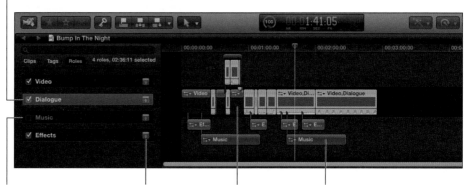

Disable check box Minimize button Minimized role Disabled role

Using markers and to-do's

Markers are a way to indicate a specific reference point on a piece of media and can be used in a variety of different ways. Markers can be used to specify a particular frame on the Timeline where you want to add media, such as indicating where a sound effect or music cue should begin. They also can be used to remind you of an action that you need to carry out on a certain clip. Markers can be added to media residing in the Event Browser as well as the Timeline, and they're placed at the skimmer's position on a clip.

To add a new marker at the skimmer position in a clip, choose Mark➡Markers➡Add Marker or press M.

Once a marker has been added, it appears as a blue icon at the top of the clip and can be renamed by calling up the marker's dialog box, adding text to the entry field, and pressing Done (see Figure 5.20).

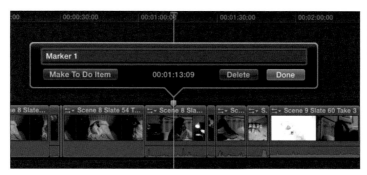

FIGURE 5.20
Naming a marker in the Timeline.

If you've added a marker to a clip in the Event Browser, a marker icon is displayed beneath the clip in List View and also can be renamed by selecting the icon and pressing Return to highlight it (see Figure 5.21). Clips that have been given markers in the Event Browser retain their markers when they're edited down to the Timeline.

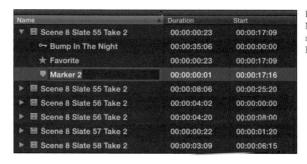

FIGURE 5.21
Naming a marker in the Event Browser.

To open a marker's dialog box, select the marker and choose Mark➡Markers➡Modify Marker or press M. You can also Control-click a marker and choose Modify Marker or just double-click the marker.

To add a new marker at the skimmer position in a clip and open the dialog box, choose Mark➡Markers➡Add Marker and Modify, press M twice on the keyboard, or press Option+M.

To move a marker to the right by one frame, select the marker and then choose Mark➡Markers➡Nudge Marker Right or press Control+. (period).

To move a marker to the left by one frame, select the marker and then choose Mark➡Markers➡Nudge Marker Left or press Control+, (comma).

Markers added to clips on a Timeline are automatically placed on the Primary Storyline. To place a marker on a Connected clip or Secondary Storyline, you need to select these in the Timeline window before adding the marker. You can use markers to navigate the playhead along the Timeline by using the marker positions on an edited sequence.

To move the playhead to the next marker in the Timeline, choose Mark➡Next➡Marker or press Control+' (apostrophe).

To move the playhead to the previous marker in the Timeline, choose Mark➡Previous➡Marker or press Control+; (semicolon).

The playhead also can be moved to a marker's position by clicking on a marker in the Timeline or by selecting a marker from the Tag list in the Timeline Index.

You can copy, cut, and paste markers on a Timeline just like regular text in a word processor by Control-clicking on a marker and choosing either Copy or Cut from the shortcut menu. You can then paste the marker at the skimmer's position by choosing Edit➡Paste or pressing ⌘+V.

To delete a marker, select the marker and choose Mark➡Markers➡Delete Marker, open the marker's dialog box and click the Delete button, or Control-click on the marker and choose Delete Marker. You also can select the marker and press Control+M.

To delete all the markers in a group of selected clips, select the clips that contain the markers you want to delete and choose Mark➡Markers➡Delete Markers in Selection or press Control+Shift+M.

Markers can be turned into to-do items that act as reminders for actions that you need to implement at a future time. This could be anything from a reminder to fix problematic audio to a prompt to add a specific filter to a clip. Turning a marker into a to-do item turns it from

blue to red, indicating that the item has yet to be completed. Checking off an item as completed turns the marker's icon to green. To-do items really come into their own when used with the Timeline Index (see Figure 5.22). Here you can choose to list just the incomplete items and jump directly to the item in the Timeline when you want to carry out the action specified in the to-do. Selecting the red check box next to the to-do item marks the item as complete and removes it from the incomplete list in the Timeline Index.

To turn a marker into a to-do item, open a blue marker's dialog box and click the Make To Do Item button or Control-click a blue marker and choose To Do.

To mark a to-do item as completed, open a red marker's dialog box and select the Completed check box, Control-click a red marker and choose Completed, or select the red marker's check box in the Timeline Index.

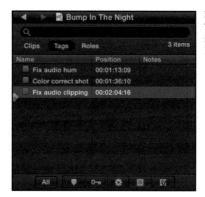

FIGURE 5.22
To-do markers in the Timeline Index.

Using placeholders

A placeholder is a temporary clip that can be used to stand in for a shot that has yet to be filmed. The Placeholder clip can be tailored to your Project by adjusting its parameters in the Inspector's Generator panel. Parameters that can be customized include the shot's frame size, background, and the number of people featured in the shot; these can be chosen from the various pop-up menus in the Inspector (see Figure 5.23). A description of the shot can be added to the blank text field that runs across the bottom of the image using the Text Inspector. (To do this, select the Placeholder and make sure the Inspector is visible by clicking the Inspector icon in the Toolbar or pressing ⌘+4.) Both the text and the font can be modified in the Text tab of the Text Inspector.

FIGURE 5.23
Working with
placeholders in
the Inspector.

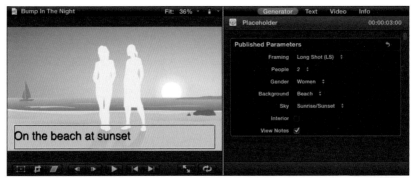

FIGURE 5.23 Working with placeholders in the Inspector.

To insert a Placeholder, choose Edit→Insert Placeholder or press ⌘+Option+W. You also can drag or double-click the Placeholder icon in the Generator Browser. (To show or hide the Generator Browser, click the Generator Browser icon in the Toolbar.) This inserts a Placeholder clip at the skimmer position on the Timeline, shunting subsequent clips further down the Timeline. The duration of the Placeholder can be adjusted by manually dragging its Out point. Once the missing shot has been filmed, you can simply swap it with the Placeholder clip by using a Replace edit. (See Chapter 6 for more on the Replace edit.)

chapter 6
Editing the Rough Cut

WITH THE CLIPS roughly assembled in the correct order in the Timeline, you have a basic framework to work from and can begin to shape the sequence further. You can trim unwanted material from these clips and add additional shots comprising of different takes and angles until the scene or sequence begins to come together. From here, you can determine the flow and pace of a scene and make further adjustments accordingly, either by increasing the frequency of the cuts or easing up on them to allow the scene to breathe.

In this chapter, you'll continue to work with the Bump in the Night sequence and learn how to use Final Cut Pro's trimming tools to fine-tune the edit points in your sequence. You'll also learn how to use Connected clips to place additional shots in the Timeline.

Trimming Clips

Trimming is the process of adjusting a clip's edit point so that a shot flows smoothly into the next shot. Trimming involves shortening or lengthening a clip in the Timeline to either fine-tune an edit point or remove unwanted material. Extraneous material, such as a repeated action or line of dialogue, often occurs in two neighboring shots in a first rough assembly. You came across this earlier in the Bump in the Night assembly when the actress appeared to bolt up in bed twice, having repeated this action in two consecutive clips. You'll be removing this unnecessary material using some of Final Cut Pro's trimming tools in the next section.

A clip in an edited sequence may contain extra media that isn't being used in the Timeline. This unused media is known as a clip's *handles;* it occurs when a selected portion of a clip is added to the Timeline. To see whether a clip has handles, simply click on a clip's edit point with the Select tool. If extra media is available, a yellow bracket is displayed around the side of the clip. If no handles are available or you run out of media during the trimming process, the bracket is red (see Figure 6.1).

FIGURE 6.1
The red bracket indicates that no extra media is available.

Final Cut Pro can be set up to provide a clearer view of the two clips being trimmed. Simply press ⌘+, (comma) to bring up the Preferences window. Then choose the Editing pane and select the Show Detailed Trimming Feedback check box (see Figure 6.2).

FIGURE 6.2
Selecting the detailed trimming feedback in Preferences.

This displays both clips in the Viewer as they're trimmed and provides a view of the first clip's Out point (the designated final frame) right beside the second clip's In point (the designated first frame). The following sections explore four different ways to trim a clip in the Timeline—Ripple, Roll, Slip, and Slide—as well as how to use the Precision Editor.

Performing a Ripple edit

A Ripple edit takes place when the end of a clip is adjusted and the other clips in the edited sequence shift backward or forward along the Timeline to accommodate the change. When a clip is trimmed by either shortening or lengthening its start or end point, the overall duration of the edited sequence is also adjusted because of this backward and forward shift. Because the Magnetic Timeline works to prevent any gaps, any change made to the duration of a clip in the Timeline is essentially a Ripple edit. This is different from previous incarnations of Final Cut Pro, which required you to switch to a specific Ripple tool; here, you can achieve the same result with the Select tool.

Hovering over a clip's edit point with the cursor brings up a left/right arrow with a filmstrip icon that points to the clip that is about to be trimmed (see Figure 6.3). Placing the cursor to the left of the edit point causes the filmstrip to point to the left, indicating that the end of the first clip is about to be trimmed. Placing the cursor more to the right of the edit point causes the filmstrip to point to the right, indicating that the start of the second clip is about to be trimmed.

FIGURE 6.3
The filmstrip points to the left, indicating that the clip's Out point will be trimmed.

To perform a Ripple edit, you simply click and hold the end of a clip and drag either backward or forward along the Timeline. As you drag, the duration that you're trimming by displays above the clip, and the clips on either side of the edited sequence ripple to the new position of the edit point.

Let's use this method to perform a Ripple edit in the Bump in the Night sequence:

1. Open the Bump in the Night Project in the Timeline.

2. With the Select tool, hover over the Out point of the fourth clip in the sequence (Scene 8 Slate 54 Take 3). The filmstrip icon appears and points to the left, and the red bracket surrounds the end of the clip.

3. Make sure snapping is enabled (press N), and move the playhead to 54 seconds and 11 frames in the Timeline.

4. Drag the clip to the left by 7 seconds and 23 frames so that the clip snaps to the playhead (see Figure 6.4). As you drag, notice how the clips to the right of the sequence move along with the edit and that both clips are displayed side-by-side in the Viewer.

FIGURE 6.4
The clip's Out point snaps to the playhead.

Another way to perform a Ripple edit is to enter a numerical value in the Dashboard to change a selected clip's duration in the Timeline. To change the duration of a clip, select an entire clip in the Timeline and choose Modify➜Change Duration or press Control+D. The Dashboard highlights in blue, displaying the duration icon. Now you can enter a new duration with the keyboard and press Return. The end of the clip trims to reflect the new duration, and the other clips in the edited sequence ripple to the new edit point.

You also can trim a clip's Out point to the skimmer or playhead's position in the Timeline. To do this, select the end of the clip, skim to the position where you want to trim to, and press Shift+X.

There's an even faster method of trimming to the skimmer position that doesn't require you to select an edit point first. To trim a clip's In point to the skimmer's position on a clip, press Option+[. To trim a clip's Out point to the skimmer's position on a clip, press Option+]. If skimming is disabled, the same keyboard shortcuts trim to the playhead's position. You also can choose Edit➜Trim Start or Edit➜Trim End to trim to the playhead's position on a clip.

Let's use this method to perform a second Ripple edit on the Bump in the Night sequence and remove the second instance of the actress bolting up in bed:

1. Open the Bump in the Night Project in the Timeline.

2. Place the skimmer over Scene 8 Slate 57 Take 2 at 01:06:05 in the Timeline.

3. Press Option+[to trim the start of the clip to the skimmer's position.

4. Play back the edit to see the result. The repeated action of the actress bolting up in bed has now been removed.

Performing a Roll edit

There are three more ways to trim a clip in the Timeline and all three can be accessed via the Trim tool, available in the Tool menu (or by pressing T).

If you hover over an edit point with the Trim tool, you'll notice the familiar filmstrip icon pointing left or right, signifying a Ripple edit. This is because a Ripple edit also can be performed with the Trim tool. When you place the cursor over the middle of the edit point, the filmstrip icon points in both left and right directions (see Figure 6.5). This icon signifies a Roll edit.

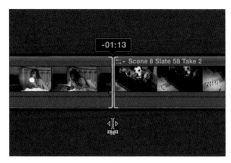

FIGURE 6.5
A Roll edit adjusts both sides of an edit point.

A Roll edit adjusts both sides of an edit point at the same time by trimming the end of the first clip and the beginning of the second clip simultaneously. Because both sides are adjusted by equal amounts, a Roll edit doesn't affect the overall duration of the edited sequence. Using the Trim tool to select both sides of an edit point displays a yellow bracket around the end of the first clip and the start of the second clip if extra media is available. This allows you to perform a Roll edit to the skimmer position using the same Shift+X keyboard shortcut used with the Ripple edit.

Let's use Bump in the Night to perform a Roll edit between the fifth and sixth clips in the sequence. The cut between these two shots happens as the actress shines the lamp into the room. Let's use the Roll tool to shorten the first clip while lengthening the second clip at the same time.

1. Open the Bump in the Night Project in the Timeline.

2. With the Trim tool, select both sides of the edit point at 01:06:07 in the Timeline between Scene 8 Slate 57 Take 2 and Scene 8 Slate 58 Take 2.

3. Drag the edit point 1 second and 13 frames to the left to 01:04:18 in the Timeline. Notice how only the edit point moves along the edited sequence, and the rest of the clips remain unaffected.

4. Play back the edit to see the result.

Performing a Slip edit

The third type of edit that can be performed using the Trim tool is a Slip edit. This changes the content that is referenced within a clip's In and Out points. As the duration of the clip itself is not changed, the clip retains the same position in the Timeline and the duration of the overall edited sequence remains unaffected. Clicking inside a clip with the Trim tool initiates a Slip edit and displays inward-pointing brackets around both ends (see Figure 6.6). This allows you to hold down on the clip and drag left or right to slip the content to an earlier or later part of the footage.

FIGURE 6.6
A Slip edit
changes the
content within a
clip's In and Out
points.

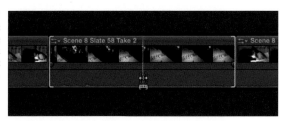

View the sixth clip in the Bump in the Night sequence (Scene 8 Slate 58 Take 2). This shot represents Katie's point of view, with the camera panning from the toy box to the alphabet blocks on the floor. Let's say you want to remove the camera pan and replace it with a static shot of the alphabet blocks from later in the clip. Let's try that now:

1. Open the Bump in the Night Project in the Timeline.

2. With the Trim tool selected, click inside the sixth clip in the sequence (Scene 8 Slate 58 Take 2) so that both ends of the clip are selected.

3. Hold and drag the clip all the way to the left until the clip runs out of media and a red trim bracket is displayed at the Out point. Watch the Viewer as you drag, the clip's new start point is displayed on the left, and the new end point is displayed on the right.

4. Play back the clip to see the result. Most of the camera pan has been removed, but the last part of the movement is still visible at the beginning of the clip. To eliminate this, use a Ripple edit to trim 15 frames off the start of the clip.

Performing a Slide edit

The last type of edit that can be performed using the Trim tool is a Slide edit. This moves the position of a clip earlier or later in an edited sequence without altering the content of the clip itself or the overall duration of the sequence. Instead, a Slide edit trims the clips that reside before and after the clip being moved. A Slide edit is useful when you want to move a clip to a specific point in the Timeline, such as when positioning a clip to the beat of a music track. To initiate a Slide edit, hold down the Option key as you click inside a clip in an edited sequence. This selects the edit points and adds brackets to the two adjacent clips, because these are the clips being trimmed by the Slide (see Figure 6.7).

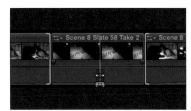

FIGURE 6.7
A Slide edit moves the position of the clip in the edited sequence.

View the seventh clip in the Bump in the Night sequence (Scene 8 Slate 57 Take 2). In this shot, Katie gets out of bed to take a closer look at the alphabet blocks on the floor. This is followed by a close shot of the blocks just before she kicks them (Scene 8 Slate 59 Take 1). Let's slide the close shot of the blocks earlier in the Timeline and trim the end of the clip where she gets out of bed:

1. Open the Bump in the Night Project in the Timeline.

2. With the Trim tool selected, hold down the Option key and click inside the eighth clip in the sequence (Scene 8 Slate 59 Take 1) so that the ends of the two adjacent clips are selected.

3. With the Option key still held down, hold and drag the clip 2 seconds and 10 frames to the left so that it starts at 1 minute, 18 seconds, and 7 frames in the Timeline. As you drag, notice how the clip before is being shortened and how the clip after is being extended.

4. Play back the clip to see the result.

Using the keyboard to make Ripple, Roll, Slip, and Slide edits

Ripple, Roll, Slip, and Slide edits also can be performed using the keyboard. Use the Trim tool to select an edit point and ensure that the brackets surround the ends of the clips that you want to trim. Enter plus or minus on the keyboard, followed by the amount that you want to trim by in minutes, seconds, and frames, and then press Return.

The keyboard also can be used to trim a clip frame-by-frame using the comma and period keys. Select the edit point with the Trim tool to set up a Ripple, Roll, Slip, or Slide edit. Then, to trim to the left in one-frame increments, press , (comma); in ten-frame increments, Shift+, (comma). To trim to the right in one-frame increments, press . (period); in ten-frame increments, Shift+. (period).

Using the Precision Editor

Another way to trim clips inside the Timeline is with the Precision Editor. This provides a magnified view of the edit point that is being trimmed and allows you to perform a Ripple and Roll edit from inside the window. The benefit of using the Precision Editor is that it not only clarifies the view at the edit point, but also displays the unused media of the clips being trimmed, enabling you to search for a specific piece of action within the clip's handles.

To open the Precision Editor, double-click the edit point between two clips in the Timeline, or select an edit point and then choose Clip➡Show Precision Editor or press Control+E.

The Precision Editor opens up in two lanes and displays the outgoing clip on the top and the incoming clip on the bottom (see Figure 6.8). A thin vertical line representing the current edit point joins the two clips, and any handles that the clips have continue past the line and display in a darker shade. To play a clip, including any of its unused media, place the cursor in the clip's lane and press the Spacebar, or use the regular J, K, and L keys to control playback. You also can skim over a clip by running the cursor across a lane in the usual way. To view the transition between the clips, place the cursor in the dark horizontal bar that separates the two lanes or use the skimmer to skim across it. Other edit points in the sequence are represented by small, light gray buttons that run along the bar; these can be opened in the Precision Editor by scrolling through each one using the keyboard's up and down arrows or by directly clicking on a button.

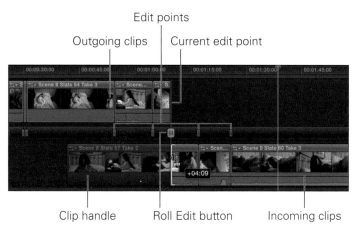

Edit points

Outgoing clips | Current edit point

Clip handle | Roll Edit button | Incoming clips

FIGURE 6.8
The Precision Editor.

Hovering over a clip turns the cursor into a hand icon. If you click and hold a clip, the start or end point is highlighted as a yellow bracket. This enables you to perform a Ripple edit by dragging the clip earlier or later in the Precision Editor and repositioning the edit point at the location required. Another way to perform a Ripple edit is by clicking and holding the yellow bracket and dragging the edit point to the position on the clip where you want it to start or end. To perform a Roll edit and trim both clips at the same time, click and drag on the gray button separating the clips at the edit point. (**Note:** Clicking the gray button separating the clips selects the Out point of the outgoing clip and the In point of the incoming clip.)

A quick and easy way to perform a Ripple edit inside the Precision Editor is to skim to the point where you want to trim and click. This trims the clip to the skimmer position in the sequence. You also can trim numerically in the Dashboard or use the same Ripple keyboard shortcuts that were discussed earlier.

To exit the Precision Editor, press the Close Precision Editor button at the top of the screen, double-click the edit point, or press Return or Esc.

Let's use the Precision Editor to trim a clip in the Bump in the Night sequence. After Katie shines the lamp and sees the scattered alphabet blocks on the floor, there is some superfluous action as she puts the lamp back on to the dresser. This slows down the pace of the scene, so let's trim this out:

1. Open the Bump in the Night Project in the Timeline.

2. Double-click the edit point between the sixth and seventh clips in the sequence (Scene 8 Slate 58 Take 2 and Scene 8 Slate 57 Take 2) to open the Precision Editor. This should be at 1 minute, 9 seconds, and 1 frame in the Timeline.

3. Perform a Ripple edit on Scene 8 Slate 57 Take 2 on the bottom lane. Click on the clip to select it, and drag the yellow bracket to the right by 4 seconds and 9 frames while you watch the clip on the second screen. Stop trimming the clip just before Katie is about to get out of bed. (To help make a frame-accurate edit, you could place the playhead or a marker at exactly 4 seconds and 9 frames into the clip, so when you drag the edit point, provided that Snapping is activated, Final Cut Pro will snap the new edit point to the playhead or marker.)

4. Play back the clip to see the result, and press Return to exit the Precision Editor.

Manipulating Media in the Timeline

Trimming individual clips in an edited sequence is the main preoccupation of the editor, because these little tucks and tweaks are what help make a scene play. Even the trimming of a few frames from a clip can be enough to make two shots flow perfectly together, so becoming conversant with the trimming tools discussed in the previous section will stand you in good stead for future projects.

As you work on the rough cut, you'll most likely encounter a myriad of other challenges that require more than trimming. Some shots may need to be substituted for different takes and angles or even be eliminated altogether, while others may need to be reordered into different arrangements until the best shot sequence is found. This is all part of the discovery process that an editor goes through when shaping the material she has into a compelling piece of work. The next section explores the other tools and functions that Final Cut Pro provides an editor to manipulate media.

Cutting clips with the Blade tool

In a film cutting room, the film is placed inside a splicer and a razor blade is used to physically cut the celluloid. The digital equivalent of this in Final Cut Pro is the Blade tool, which can be used to cut the clips in the Timeline in a similar way. This is useful if you need to split a clip in order to delete an unwanted section or to drag another clip in between the cut. To delete a section, you first cut the clip with the Blade tool at the point where you want to delete, select the unwanted portion, and press the Delete key on the keyboard.

To initiate the Blade tool, choose it from the Tool menu or press B.

To cut a clip at the skimmer or playhead position in the Timeline, choose Edit➔Blade or press ⌘+B.

Performing a three-point edit

Three-point editing is a long established editing technique where the editor sets three edit points to specify what section of a clip is used and where it's placed in an edited sequence. This is done by setting In and Out points for the source clip and a third point in the Timeline to determine the clip's placement. A fourth edit point is inferred by the source clip's duration. This is similar to the overwrite edit performed in Chapter 5, where the skimmer position in the Timeline specified the start or end point for the clip selected in the Event Browser.

Three-point editing also works the other way around by setting In and Out points in the Timeline and specifying a single edit point for the source clip. You already know that to set In and Out points for a clip in the Event Browser you simply drag a selection with the mouse, but how do you do this to clips in the Timeline? The same menu bar items (Mark→Set Selection Start/End) and keyboard shortcuts (I and O) apply to marking a range in the Timeline, but you need to use the Range Selection tool, available in the Tool menu or by pressing R, to manually drag a selection (see Figure 6.9).

FIGURE 6.9
Dragging out a selection with the Range Selection tool.

The Range Selection tool is identified by the yellow selection icon beneath its cursor. It allows you to drag a selected range over one or more clips in a Storyline. Another way to make a selection without invoking the Range Selection tool is to place the skimmer over a clip and press the X key. This selects the entire clip and the yellow selection handles can be used to modify the selection's in and out-points.

After a selection has been made, the In and Out points specify the area in the Storyline where the clip is to be placed and all that remains is to set one more edit point (either In or Out) for the source clip. Performing an overwrite edit places the source clip's In point at the In point of the selected range in the Timeline. To place the source clip's Out point at the selected range Out point, you would perform a back-timed overwrite edit instead (Shift+D). This method of three-point editing also is used for editing Connected clips to a Storyline.

The Range Selection tool has many other uses as well. You can use it to remove a selected area with the Delete key or trim a selected area to the In and Out points of a selected range.

To trim to the selected area in a Storyline, make a selection on a clip or across a group of clips and choose Edit➜Trim to Selection or press Option+\ (backslash).

Replacing clips

As you flesh out the rough cut by adding and trimming clips, you may decide that a particular shot doesn't work well in the context of the edited sequence and that you want to swap it with another take or a different shot entirely. You can easily do this by performing a Replace edit. A Replace edit is similar to an Overwrite edit, except that it replaces an entire clip in the Timeline. The simplest way to do this is to drag a clip from the Event Browser directly onto the clip that you want to replace. As you hold the clip over the one that you're replacing, both clips turn white and display a plus sign icon (see Figure 6.10). Releasing the clip reveals a pop-up menu allowing you to choose the type of Replace edit that you want to perform (see Figure 6.11).

FIGURE 6.10
Performing a
Replace edit.

FIGURE 6.11
The options
available for a
Replace edit.

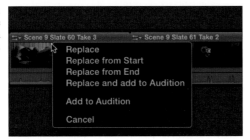

Choosing Replace from the pop-up menu exchanges the clip in the Timeline with the clip from the Event Browser, and the other clips in the sequence shift in the Timeline to accommodate the new clip's duration. Choosing either Replace from Start or Replace from End retains the duration of the clip in the Timeline without affecting the other clips in the sequence. Use these choices if you want to start or end a shot at a specific point in the new

clip. For example, if you want the new clip to end on a particular piece of action or dialogue, set an Out point at the desired moment by making a selection in the Event Browser, and then drag the new shot over the old one on the Timeline; then choose Replace from End. As you've probably guessed, this is another example of three-point editing because this method aligns the chosen Out point at the end of the clip in the Timeline and back-times the rest of the media to fill the duration of the replaced clip. If the new clip is shorter than the clip being replaced, an alert dialog box appears. Choosing Continue performs a standard Replace edit and switches the clip in the Timeline with the new shorter clip. (The other pop-up menu options Replace and Add to Audition and Add to Audition are discussed in the next section.)

To perform a Replace Edit, do one of the following:

○ Drag a clip or selection from the Event Browser onto the clip that you want to replace in the Timeline. When the clips turns white, release the mouse and choose an option from the pop-up menu.

○ Press Shift + R to perform a basic Replace edit.

○ Press Option + R to perform a Replace from Start edit.

Auditioning clips

The Replace edit function is a great way to try out different takes, but there's an even more flexible way to achieve the same result by adding a clip as an audition. Rather than replace the clip outright, an audition retains both clips inside a single clip in the Timeline and you can switch between the two at any time. This allows you to make fast comparisons between two takes and keep both clips in an edited sequence until you decide on which to use. As you saw in the previous section, dragging a clip onto another in the Timeline turns both clips white and displays a pop-up menu when you let go of the cursor. Selecting Replace and Add to Audition adds the clip to the audition and makes it the current clip in the Timeline. Selecting Add to Audition adds the clip to the audition without changing the current clip.

An audition is identified by the spotlight icon that displays on the clip. Clicking the icon reveals a new window that allows you to scroll through the clips that the audition contains (Final Cut Pro calls these picks) and select the one that you want to use in the edited sequence (see Figure 6.12).

To open a clip's audition window from the Timeline, click the spotlight icon displayed on the clip or select a clip and choose Clip➡Audition➡Open or press Y.

To scroll through the picks in an open audition window, choose Clip➡Audition➡Next Pick/ Previous Pick or use the keyboard's left and right arrow keys.

You can scroll through the picks without opening the audition window by either selecting the clip and choosing Clip➔Audition➔Next Pick/Previous Pick or Control-clicking on an audition and choosing Audition➔Next Pick/Previous Pick.

Picks

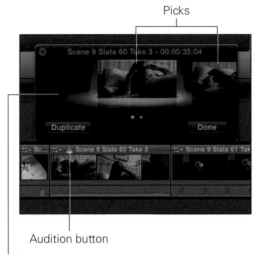

FIGURE 6.12
Selecting picks
from an
audition.

Audition button

Audition window

A pick's media can be previewed in the Viewer by skimming over its thumbnail in the Audition window. A clip can be removed from an audition by selecting it in the window and pressing Delete. After you've selected the pick that you want to use, click Done and the pick appears in the edited sequence. If the chosen pick is a different duration than the one it's replacing, the Magnetic Timeline adapts to accommodate the new length.

To preview the different picks in the Timeline, click the audition and then choose Clip➔ Audition➔Preview or press Control+⌘+Y.

After Preview is initiated, the Audition window opens and the playhead backs up two seconds and then plays the selected pick in the Viewer. Pressing the keyboard's left or right arrows during playback jumps the playhead back to the starting position and plays the next or previous pick inside the audition. This is an extremely fast way to compare different picks and see how they work in the context of an edited sequence. You can use this method to compare how a clip looks with different effects or filters applied by creating duplicate versions of the same clip inside an audition and applying a different effect to each one.

To duplicate a clip as an audition in the Timeline, select the clip and choose Clip➔Audition➔ Duplicate as Audition or press Option+Y. This creates an audition within the selected clip, containing two identical picks inside. To add further duplications, open the audition, select

the clip in the window, and click Duplicate. If an effect has been applied to a clip in the Timeline, the clip can still be duplicated inside an audition in its original state without the effect applied.

To duplicate the original clip as an audition in the Timeline, select the clip and choose Clip➡ Audition➡Duplication from Original or press Shift+⌘+Y.

You also can create auditions in the Event Browser before editing them down in the Timeline (see Figure 6.13). To create an audition in the Event Browser, select the clips that you want to add to the audition by Shift- or ⌘-clicking on them and then choosing Clip➡Audition➡ Create or pressing ⌘+Y. A new audition clip appears in the Event Browser displaying the spotlight icon; the picks inside can be opened and viewed in the usual way.

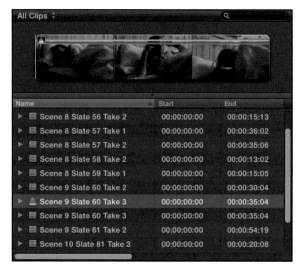

FIGURE 6.13
An audition in the Event Browser.

After you've decided on the final pick that you want to use, you can permanently change the audition back into a normal clip by finalizing it. To finalize an audition, select the clip and then choose Clip➡Audition➡Finalize Audition or press Option+Shift+Y.

Let's see this in action by creating an audition for the Bump in the Night sequence:

1. Select the Bump in the Night Collection in the Event Library and set the Event Browser's filter to All Clips.

2. Open the Bump in the Night Project in the Timeline.

3. Select Scene 9 Slate 60 Take 2 in the Event Library and drag it over Scene 9 Slate 60 Take 3 in the Timeline until both clips turn white.

4. Release the cursor and choose Replace and Add to Audition from the shortcut menu. Take 2 replaces Take 3 in the Primary Storyline and a spotlight icon appears at the top left of the clip.

5. Click the icon to view the Audition window.

6. Press Control+⌘+Y to play the clip in the Viewer and, as it plays, use the right arrow to switch between the two clips in the audition.

7. When you've finished comparing the two picks, choose the clip that you prefer and click Done to close the Audition window. Press the Spacebar to stop playback.

8. Press Option+Shift+Y to finalize the audition.

Mind the Gap

Any time you make a change in an edited sequence, the Magnetic Timeline adapts to the change by shifting the surrounding clips up and down the Primary Storyline, preventing any unintentional spaces. This is a good thing for the most part, but there are times when you'll want to make a change without altering the position of the other clips or adjusting the overall duration of the sequence. Let's say you're editing a music video where all the clips are placed at precise points on a music track and you want to remove a clip from within the sequence. If you were to remove the clip, the Magnetic Timeline would automatically close the gap left behind by the deleted clip and move any ensuing clips down the sequence. This would mean that the clips would no longer be in their original positions in the Timeline and be out of time with the music. To prevent this, you can use the Replace with Gap function.

To delete a clip in a Storyline, select the clip and choose Edit➡Delete or press Delete.

To delete a clip and leave a gap in a Storyline, select the clip and choose Edit➡Replace with Gap or press Shift+Delete.

Using the Replace with Gap function replaces a clip with a gap of the same duration and doesn't disrupt the placement of the other clips in the sequence. A gap plays as black in the Viewer and is simply a temporary placeholder to be eventually replaced with another clip at a later date. This is done by using Replace from Start or Replace from End to keep the gap's current duration the same.

A gap is not an empty space—it's really a blank clip that behaves just like other clips in the Timeline (see Figure 6.14). Although they don't work with Connected clips, gaps can be inserted into a Primary or Secondary Storyline.

To insert a gap in a Storyline at the skimmer or playhead position, press Option+W.

FIGURE 6.14
A Gap clip in the Primary Storyline.

Inserting a gap pushes the rest of the clips in a sequence out of the way just like a regular clip, and the gap's duration can be adjusted in the same way, by dragging its edit points with the Select tool. Gaps are useful when you want to leave room in a sequence for unavailable media or add pauses to audio narration that will be used as a foundation to edit clips on. However, gaps really become interesting when you start using them in conjunction with the Position tool.

Working with the Position tool

There are times during an edit when you want to remove a clip from a sequence and place it out of the way in the Timeline for later use. If the clip is moved using the default Select tool, the clip automatically appends to the end of the Primary Storyline and any attempts to move it spring it right back again. You could, of course, insert a large gap before the clip after you've moved it, but an easier way is to move the clip using the Position tool (available on the Tool menu or by pressing P). This automatically places a gap between the clip and the rest of the sequence, allowing you to keep the clip in the Timeline until it's ready for use at a later time.

Another useful function of the Position tool is that it allows you to paste one clip over another just like an overwrite edit. To do this, drag a clip from the Timeline or the Event Browser directly onto another clip in a sequence; after the blue boundary box appears, let go of the clip to overwrite it in the sequence (see Figure 6.15).

FIGURE 6.15
Overwriting a clip with the Position tool.

One thing to bear in mind is that unlike the Select tool, which ripples the clip along the Timeline, moving a clip's edit point with the Position tool overwrites the clip's media with a gap (see Figure 6.16). Using the Position tool to drag a clip inside a Storyline also creates a gap behind it and overwrites any clips that it rolls over.

FIGURE 6.16
The Position tool overwrites a clip's media with a gap clip when moving a clip's edit point.

Making the Connection

Chapter 5 looked at all the various ways of adding clips to the Timeline to build the Primary Storyline. However, clips also can be added above or below the Primary Storyline in the form of Connected clips. As you know, the Primary Storyline is the dark gray band that extends across the Timeline, and Connected clips attach to clips inside with a blue connection link (see Figure 6.17). This ensures that any time a clip is moved in the Primary Storyline, any media connected to the clip (such as an audio clip of a sound effect, or a lower-third title graphic that needs to appear below a shot of a presenter) moves along with it. Attaching this media as a Connected clip ensures that it always remains at the exact position on the clip that it's linked to, even if a change is made to the edited sequence. This applies not only to video but also to audio clips, such as sound effects, music cues, and audio ambience, which are often used as Connected clips in the Timeline.

FIGURE 6.17
A Connected clip attached to the Primary Storyline.

When the edited sequence is played back in the Viewer, a Connected clip obscures any video media below it and becomes the dominant clip. This makes Connected clips perfect for use as cutaways, B-roll footage, stills, or anything that needs to be superimposed on top of another clip in the Primary Storyline.

Connecting clips to the Primary Storyline

Connected clips attach only to the Primary Storyline and not to Secondary Storylines or other Connected clips. They can be placed above these in the Timeline (see Figure 6.18), but the blue connection link is actually attached to the Primary Storyline below. This is important to realize because deleting a clip in the Primary Storyline also deletes any clips that are connected to it. Stacking Connected clips in this way replaces the need for tracks as used in traditional NLEs. You no longer place a clip on a second or third video track; instead, you fix it to another clip in the Primary Storyline.

Connection links

FIGURE 6.18
Connection links are always attached to the Primary Storyline.

When performing a connect edit, a clip or selection in the Event Browser is connected to the playhead or skimmer position on the Primary Storyline. After a clip is connected, it can be repositioned anywhere in the Timeline by clicking and dragging the clip with the cursor. As you drag, the Viewer displays the Connected clip's current position in the Primary Storyline.

To connect a clip or selection to the Primary Storyline, manually drag a clip directly on top of the Primary Storyline, or select a clip and press the connect button on the Toolbar.

If the Connected clip contains audio, the sound is heard along with any other audio tracks beneath it. To disable a clip's audio tracks, select the clip in the Timeline and open the Inspector's

Audio tab. The clip's audio tracks are listed beneath the disclosure triangle of the Channel Configuration heading (see Figure 6.19), and deselecting the check box beside each track makes them inaudible during playback. You also could disable a clip's audio (or video) before adding the clip to the Timeline by using the Video Only or Audio Only functions discussed in Chapter 5.

FIGURE 6.19
A selected clip's audio in the Inspector.

Clips can be connected to an empty Primary Storyline that contains no clips. In this case, a gap clip is created in the Primary Storyline beneath the Connected clip so that it has something to connect to. Moving the gap also will move the Connected clip. Deleting the gap also will remove the Connected clip.

Let's continue working on the Bump in the Night sequence by adding some Connected clips to the work that you've done so far:

1. Select the Bump in the Night Collection in the Event Library, making sure that the Event Browser's filter is set to Favorites.

2. Open the Bump in the Night Project in the Timeline.

3. Select the second favorite section from Scene 8 Slate 56 Take 2 in the Event Browser and position the playhead at 38 seconds and 6 frames on the Primary Storyline.

4. Edit Scene 8 Slate 56 Take 2 to the Timeline by clicking the connect button on the Toolbar or using the keyboard shortcut Q. The clip connects to Scene 8 Slate 54 Take 3 in the Primary Storyline and covers a small section of the clip. If you play this back

now, Scene 8 Slate 56 Take 2 appears in the Viewer when the playhead reaches the Connected clip's position in the Primary Storyline and then cuts back to Scene 8 Slate 54 Take 3 after it passes it.

5. Select the second favorite section from Scene 8 Slate 55 Take 2 in the Event Browser and position the playhead at 43 seconds and 3 frames on the Primary Storyline right after the Connected clip.

6. Edit Scene 8 Slate 55 Take 2 to the Timeline by pressing Q.

7. Play back the section to see the result. The transition between the two Connected clips could do with some trimming, and the Out point of the second Connected clip doesn't work when it cuts back to Scene 8 Slate 54 Take 3 on the Primary Storyline. This section needs some trimming so that it cuts together more smoothly, and you'll be doing this in Chapter 7.

Working with Connected Clips

Connected clips placed next to each other don't behave in the same way as clips inside the Primary Storyline. The usual trimming tools—such as Ripple, Roll, Slip, and Slide—can't be applied to Connected clips and neither can transition effects. If a Connected clip's In or Out point is selected with the cursor, the duration of the clip can be lengthened or shortened in the usual way but doesn't ripple any other Connected clips beside it. This may seem limiting at first, but Final Cut Pro provides a way around this by giving you the ability to group Connected clips into a Secondary Storyline. You'll be exploring Secondary Storylines in Chapter 7, but in the meantime let's look at other things that can be done with Connected clips.

A clip's connection link is usually placed at the first frame of the clip being connected to, but it can be moved to another position further down. This is useful when you want to delete the clip that it's attached to, but keep the Connected clip in the Timeline. All you need to do is move the connection link to another point in the clip so that it's attached to a different clip below it. You do this by Option+⌘-clicking inside the Connected clip at the spot where you want the connection link to move to.

If the Timeline becomes cluttered with a large amount of Connected clips, you can tidy them by overwriting them to the clips below in the Primary Storyline. To overwrite a clip to the Primary Storyline, select the Connected clip and choose Edit➜Overwrite to Primary Storyline or press ⌘+Option+ the down arrow.

Likewise, a clip from the Primary Storyline can be lifted up and turned into a Connected clip. When this is the case, Final Cut Pro creates a gap beneath the lifted clip in the Primary

Storyline (see Figure 6.20). To lift a clip from the Primary Storyline, select the clip and choose Edit➜Lift from Primary Storyline or press ⌘+Option+ the up arrow.

FIGURE 6.20
Lifting a clip from the Primary Storyline creates a gap beneath the clip.

chapter 7

Completing the Cut

BY NOW YOU should be very familiar with working in the Primary Storyline. You've learned how to edit clips from the Event Browser onto the Primary Storyline and how to manipulate these clips with the various tools that Final Cut Pro provides. You've also learned how to attach individual clips to the Primary Storyline as Connected clips, ensuring that they always remain linked with the clip that they're attached to.

In this chapter, you'll complete the Bump in the Night sequence and learn how to incorporate Secondary Storylines and Compound clips in your projects. You'll finish off by adding a few transitions to the sequence and learning how to work with the transition parameters in the Inspector.

Adding Cutaways

The beginning of the Bump in the Night sequence is a little bland because it just features a single shot of Katie sleeping. Let's create a little suspense by foreshadowing what's to come with some spooky cutaway shots of the toy box:

1. Select the Bump in the Night Collection in the Event Library and make sure the Event Browser's filter is set to show All Clips.

2. Open the Bump in the Night Project in the Timeline by double-clicking on it in the Project Library.

3. In the Event Browser, select the cutaway clips by ⌘-clicking on them in the following order: Cutaway Slate 65 Take 1, Cutaway Slate 66 Take 1, and Cutaway Slate 68 Take 1.

4. Place the playhead at the beginning of the edited sequence in the Timeline and press Q to connect the three cutaway clips to the Primary Storyline (see Figure 7.1).

5. Select the three cutaway clips in the Timeline and choose Edit➜Overwrite to Primary Storyline to overwrite the Connected clips to the Primary Storyline.

6. Play back the section to see the result. The toy shots add just the right amount of creepiness to the beginning of the sequence.

FIGURE 7.1
Cutaway shots
connected to the
Primary
Storyline.

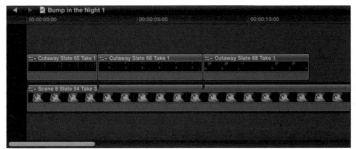

Secondary Storylines

As useful as Connected clips are, they do have their limitations when it comes to manipulating them further in the Timeline, because the standard trimming tools can't be applied to them. This is fine if you have only separate Connected clips along the Timeline, but if there is a set of clips side by side, you'll probably want the ability to trim the Connected clips as you would in the Primary Storyline. You can easily achieve this by selecting the Connected clips and turning them into a Secondary Storyline.

To create a Secondary Storyline, select a group of Connected clips and choose Clip➔Create Storyline or press ⌘+G. This places the Connected clips inside a container, treating them as a single unit. Think of a Secondary Storyline as a smaller version of the Primary Storyline that connects above or below the Primary Storyline with a blue connection link, just like a Connected clip. You're now free to trim the clips inside using the Ripple, Roll, Slip, and Slide tools (the Precision Editor is not available for Secondary Storylines) and manipulate them in much the same way as in the Primary Storyline. Connected clips don't necessarily need to be next to each other in order for them to be turned into a Secondary Storyline. Any spaces between Connected clips are automatically generated into transparent gaps, which play back the clips that are directly beneath them.

Manipulating clips in a Secondary Storyline

You'll mainly want to use Secondary Storylines to group related Connected clips so that they can be treated as a single unit. A typical use would be for a documentary that has a photographic montage, usually with the Ken Burns effect, that plays together with voiceover narration. The stills would be prepared inside a Secondary Storyline, allowing you to trim the individual photographs or apply effects and then move the complete montage along the Timeline until you find its optimal placement. Another common use would be to group two adjoining audio clips inside a Secondary Storyline so that a transition, such as a cross-dissolve, can be applied between them.

Individual clips inside a Secondary Storyline are selected by clicking on them with the cursor and can be rearranged by moving them around just as in the Primary Storyline (see Figure 7.2). A clip can be removed by dragging it out from within the storyline or by selecting the clip and pressing Delete. The remaining clips shift inside the Secondary Storyline to close the gap left by the deleted clip, and the duration of the storyline is adjusted to reflect the change. Pressing Shift+Delete replaces the clip with a gap, maintains the positions of the remaining clips in the storyline, and keeps the duration intact.

FIGURE 7.2
A selected clip inside a Secondary Storyline.

To select the Secondary Storyline as a whole, click the gray bar that runs across the top so that the entire storyline is highlighted with a yellow border. Click and hold this bar to drag the storyline anywhere in the Timeline. After it has been selected, you can append, insert, and overwrite clips from the Event Browser directly inside the Secondary Storyline by using the same buttons and keyboard shortcuts that you're used to.

Working with Secondary Storylines

In the previous chapter, you added two Connected clips to the Bump in the Night sequence (Scene 8 Slate 56 Take 2 and Scene 8 Slate 55 Take 2). If you play back these clips, you'll see that the transition between them needs trimming because there is some extraneous material at the start of the second clip. At the end of the first clip, the actress begins to move her arm to swat away the spider, but in the clip that follows, her arm remains stationary for a beat or two before it moves. A Ripple edit would easily solve this, but if you grab the In point to Scene 8 Slate 55 Take 2 and drag to remove the unwanted material, the first clip doesn't ripple along with the edit; instead, it leaves a space between the two clips (Figure 7.3).

FIGURE 7.3
Trimming a
Connected clip
doesn't ripple
the edit and
leaves a space.

To get around this, you need to first turn the Connected clips into a Secondary Storyline:

1. Select the Bump in the Night Collection in the Event Library, and make sure the Event Browser's filter is set to show Favorites.

2. Open the Bump in the Night Project in the Timeline by double-clicking it in the Project Library.

3. ⌘-click on the two Connected clips (Scene 8 Slate 56 Take 2 and Scene 8 Slate 55 Take 2) in the Timeline to select them.

4. Choose Clip➜Create Storyline or press ⌘+G.

5. Select the In point for Scene 8 Slate 55 Take 2 and drag it to the right by 1 second and 21 frames. This time the preceding clip ripples along with the move just as in the Primary Storyline (see Figure 7.4).

6. Press Shift+? (question mark) to play the result. The extra material at the start of the second clip has been removed.

FIGURE 7.4
Performing a Ripple edit inside a Secondary Storyline.

Let's add another clip to the Secondary Storyline:

1. Select the Secondary Storyline in the Timeline so that it's highlighted in yellow.

2. Select Scene 8 Slate 57 Take 2 in the Event Browser.

3. Press E to append the clip to the end of the Secondary Storyline (see Figure 7.5).

4. Play back the Secondary Storyline section to see the result.

Remember to always select the storyline that you're adding clips to first; otherwise, Final Cut Pro automatically places the clips in the Primary Storyline.

FIGURE 7.5
Performing an Append edit inside a Secondary Storyline.

Breaking apart clip items

A Secondary Storyline can be dismantled back into its individual Connected clips by using the Break Apart Clip Items function. This removes any dissolves or fades that have been applied because Connected clips can't have transitions. A dialog box appears alerting you to this and giving you the choice to Break Apart or Cancel the operation (see Figure 7.6).

To disassemble a Secondary Storyline, select the Secondary Storyline and choose Clip➜Break Apart Clip Items or press Shift+⌘+G.

A Secondary Storyline also can be overwritten to the Primary Storyline by choosing Edit➜Overwrite to Primary Storyline or pressing ⌘+Option+Down Arrow. In this case, any transitions that have been applied are retained and incorporated into the Primary Storyline.

FIGURE 7.6
Breaking apart a
Secondary
Storyline loses
any transitions
that have been
applied.

Adding audio clips to the Timeline

Let's add two more Connected clips to the Bump in the Night sequence. This time, you'll add sound effects of a child's giggling to further communicate the idea that there is someone in the room playing tricks on Katie. To access the audio files, double-click the Craft of the Cut disc image to mount it.

1. Open the Audio folder inside the Pranks Media Event in the Event Library and select the Collection named Joseph Darcey-Alden (Jason).

2. Open the Bump in the Night Project in the Timeline by double-clicking on it in the Project Library.

3. Select the audio file Jason Giggles-01 in the Event Browser and position the playhead at 30 seconds and 4 frames on the Primary Storyline.

4. Edit Jason Giggles-01 to the Timeline by pressing Q. The audio file attaches below the Primary Storyline as a Connected clip.

5. Select the audio file Jason Giggles-02 in the Event Browser and position the playhead at 42 seconds and 15 frames on the Primary Storyline.

6. Edit Jason Giggles-02 to the Timeline by pressing Q on the keyboard. You should now have two Connected clips below the Primary Storyline, as shown in Figure 7.7.

7. Play back the section to see the results.

FIGURE 7.7
Two audio clips connected to the Primary Storyline.

Compound Clips

As you've seen, Secondary Storylines provide a convenient way to group related clips into a single editable unit. Nevertheless, a few drawbacks arise once you start incorporating individual audio clips into your sequence. In the previous section, you added two sound effects as Connected clips to the Bump in the Night sequence. The second of these audio clips (Jason Giggles-02) occurs during the playback of the Secondary Storyline and is associated with that part of the screen action. However, the audio clip itself is attached to the Primary Storyline and if you were to move the Secondary Storyline further along the Timeline, the audio would remain where it was and not move along with it. This would mean that the sound effect would no longer play with the intended image on-screen and would need to be manually moved to the correct location.

Open the Bump in the Night Project in the Timeline, select the Secondary Storyline that you created earlier, and press Shift+⌘+G to Break Apart Clip Items and return the storyline back into Connected clips. With the three clips still selected, ⌘-click on the second audio clip to add it to the selection (see Figure 7.8). If you now choose Clip from the menu bar, you'll notice that Create Storyline is grayed out and can't be chosen. This is because separate audio clips can't be included inside a Secondary Storyline (unless the audio is already part of a video clip). Even so, it would be really useful to be able to group these related clips into one unit. This is where Compound clips come to the rescue.

FIGURE 7.8
A connected
audio clip
cannot be added
to a Secondary
Storyline.

Compound clips are a way to nest related items in the Timeline inside a single object or container (yes, another one); they offer some distinct advantages to Secondary Storylines. Unlike Secondary Storylines, which only work with Connected clips, Compound clips can include all kinds of video and audio elements, including both Primary and Secondary Storylines and even other Compound clips. In addition to this, Compound clips can be opened up so that only the elements that they contain are presented in the Timeline. Once a Compound clip is open, further clips can be added to it from the Event Browser, and these clips can be trimmed and manipulated just like a normal Project in the Timeline.

To create a Compound clip in the Timeline, select the items that you want to include and choose File➜New Compound Clip or press Option+G.

You can enter a name for the Compound clip in the Name field of the Inspector's Info panel.

Working with Compound Clips in the Timeline

Once a Compound clip has been created, it behaves just like a normal clip. Compound clips inside the Primary Storyline, can be trimmed using the standard Ripple, Roll, and Slide tools. If they're connected to the Primary Storyline, they act just like Connected clips. The clips that a Compound clip contains can't be individually selected as they can with a Secondary Storyline and you'll need to open the Compound clip in its own Timeline in order to access them.

Compound clips are useful when you have a series of clips that need to be treated with the same effect. Let's say you're working on a group of clips that form a flashback or dream sequence and you want to apply a specific filter to all the clips to set them apart from the main action. If you were to group these clips into a Compound clip, you could apply the filter to this single object and any changes that you made to the filter in the Inspector would be applied to all the clips inside.

Another useful application of Compound clips is when you have a particularly lengthy project and you want to clean up the Timeline by grouping the clips into individual sections. Clips nested inside a Compound clip could represent a scene in the movie, and this "scene" Compound clip could likewise be nested inside another Compound clip that represents a sequence. This technique could be used to simplify a complex project such as a feature and also make it more manageable to work with. For example, the Project Timeline could consist of just six to eight "sequence" Compound clips, and each of these could contain five or more "scene" Compound clips. When opening a "scene" Compound clip in the Timeline, you would only be presented with the clips that make up that scene, allowing you to focus on just this "mini-project." As you'll see in the next section, this workflow can be planned in advance in the Event Browser.

Let's continue with the Bump in the Night sequence and nest the Secondary Storyline with the Jason Giggles-02 sound effect inside a Compound clip.

1. Open the Bump in the Night Project in the Timeline by double-clicking it in the Project Library.

2. Select the three Connected clips above the Primary Storyline and turn them back into a Secondary Storyline by pressing ⌘+G.

3. Select the Secondary Storyline by clicking the top gray bar, and ⌘-click on the second audio clip (Jason Giggles-02) to add it to the selection.

4. Press Option+G to create a new Compound clip.

The selected items are nested inside a new Compound clip that is connected to the Primary Storyline (see Figure 7.9). Notice that the Jason Giggles-02 audio clip is no longer visible in the Timeline, but if you play back this section, the sound effect is still audible because it's now inside the Compound clip. If you were to move this Compound clip anywhere in the Timeline, the Jason Giggles-02 sound effect would move along with it and remain in sync with the picture.

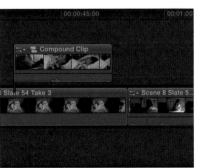

FIGURE 7.9
A Compound clip connected to the Primary Storyline.

If you need to do any further editing to the clips inside, you have to open the Compound clip in the Timeline. To open a Compound clip in the Timeline, select it and choose Clip➜Open in Timeline or just double-click the Compound clip.

Once the Compound clip is open, you can see that the Secondary Storyline is now the Primary Storyline in this Timeline window with the Jason Giggles-02 audio attached as a Connected clip (see Figure 7.10). Also notice how the Compound clip's boundary is represented by a light gray background with dotted sides.

FIGURE 7.10
The Compound clip open in the Timeline. The Secondary Storyline has become a new Primary Storyline and has an audio clip attached as a Connected clip.

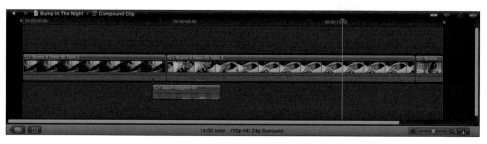

At the top left of the Timeline window, you can see the Timeline History path next to the two navigation arrows that you explored in Chapter 5. Clicking the left arrow takes you out of the Compound clip and back into the original Bump in the Night Project Timeline. A faster way to navigate through the Timeline History and jump in and out of a Compound clip is to use keyboard shortcuts. ⌘+[(left bracket) takes you back through the Timeline History and ⌘+] (right bracket) takes you forward through the Timeline History. Try this now to jump in and out of the Compound clip you've just made.

A Compound clip can be disassembled back to its original individual clips by using the same Break Apart Clip Items commands used for Secondary Storylines. Let's break out of this Compound clip and create another one that incorporates the Primary Storyline.

1. Open the Bump in the Night Project in the Timeline.

2. Control-click on the Compound clip and choose Break Apart Clip Items from the shortcut menu. The Compound clip converts back to its individual parts, and the original Secondary Storyline is now back as three Connected clips. This is because the Secondary Storyline became a Primary Storyline in its own right within the Compound clip that was created. Any "true" Secondary Storyline inside a Compound clip remains as such when broken apart.

3. Select the three Connected clips and press ⌘+G to create a new Secondary Storyline.

4. Select the Secondary Storyline and ⌘-click on the Jason Giggles-02 and Scene 8 Slate 54 Take 3 clips to select them (see Figure 7.11).

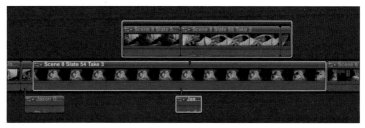

FIGURE 7.11
A clip from the Primary Storyline included in the selection.

5. Press Option+G to create a new Compound clip. The new Compound clip now appears inside the Primary Storyline (see Figure 7.12).

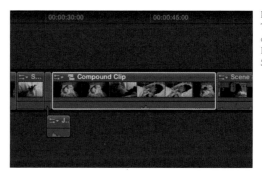

FIGURE 7.12
The Compound clip inside the Primary Storyline.

6. Double-click the Compound clip to open it in the Timeline. Scene 8 Slate 54 Take 3 is the sole clip in the Primary Storyline, and the Secondary Storyline connects to it just as before (see Figure 7.13). If this Compound clip were to be broken apart, the Secondary Storyline would remain unaffected.

FIGURE 7.13
The Compound clip open in the Timeline. The Secondary Storyline and audio clip are connected to the Primary Storyline as before.

Compound clips provide an effective way to work with groups of clips in the Timeline, but you need to watch out for any overlapping clips when creating Compound clips for your

Project because these can inadvertently create unwanted black segments in your edited sequence. Let's use the Bump in the Night sequence to demonstrate this.

1. Open the Bump in the Night Project in the Timeline.

2. ⌘-click on Scene 8 Slate 55 Take 2 (the sixth clip in the Timeline) and Jason Giggles-01 to select them (see Figure 7.14).

FIGURE 7.14
Avoid overlaps
when creating
Connected clips.

3. Press Option+G to create a new Compound clip and press Shift+? (question mark) to play it back. The Compound clip has been extended, and a large portion of it plays as black in the Viewer.

Let's look at what happened here so that you can avoid this in the future. Figure 7.14 shows that the Jason Giggles-01 clip overlaps the next section. Because of this, Final Cut Pro created a gap clip above the overlapping portion when the Compound clip was created. You can clearly see this if you open the Compound clip in the Timeline (see Figure 7.15). The gap is the main clip in the Primary Storyline during the length of the overlapping portion of the audio, which is why it plays back as black in the Viewer. To escape this problem, you need to select the adjacent clip and include it as part of the Compound clip. If you were to now Break Apart Clip Items, the gap would be re-created in the Primary Storyline. Press ⌘+Z to undo the Compound clip and return the individual clips back to the Timeline.

FIGURE 7.15
A gap clip
created by an
overlapping
audio clip.

Working with Compound Clips in the Event Browser

Compound clips can just as easily be created in the Event Browser and can be used to group related clips before editing them to the Timeline. For example, if you have a video clip that is intended to play with a specific piece of music or sound effect, the two could be paired together inside a Compound clip and would play back simultaneously when viewed in the Timeline. Another use would be to group together all the favorite footage in a particular segment of a scene, such as the spider attack section of the Bump in the Night sequence (see Figure 7.16).

FIGURE 7.16
The selected spider attack clips ready to be placed inside a new Compound clip.

To group clips inside a Compound clip in the Event Browser; select the clips that you want to include and choose Files➜New Compound clip or press Option+G. A dialog box appears allowing you to name the Compound clip and also specify its video and audio properties (see Figure 7.17). These can be different from the main Project properties (for more on Project properties, see Chapter 5).

Click OK and a new Compound clip appears in the Event Browser. If you play or skim over this Compound clip, you'll see that it's made up of all the clips that you selected. The original clips remain in the Event Browser in addition to the newly created Compound clip and stay unaffected even if the Compound clip is deleted. This is because the Compound clip is only referencing the clips, similar to the way that a Project references clips in the Event Browser. Figure 7.18 shows a Compound clip in the Event Browser named Spider Attack. Notice how the Compound clip's icon is different from the standard clip icon. A Compound clip in the Event Browser can be opened in the Timeline in the usual way (see "Working with Compound Clips in the Timeline," earlier) and the clips inside can be trimmed just as in a normal Project.

FIGURE 7.17
You can name
new Compound
clips inside the
Event Browser.

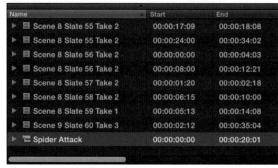

FIGURE 7.18
A new
Compound clip
inside the Event
Browser.

Name	Start	End
▶ ▦ Scene 8 Slate 55 Take 2	00:00:17:09	00:00:18:08
▶ ▦ Scene 8 Slate 55 Take 2	00:00:24:00	00:00:34:02
▶ ▦ Scene 8 Slate 56 Take 2	00:00:00:00	00:00:04:03
▶ ▦ Scene 8 Slate 56 Take 2	00:00:08:00	00:00:12:21
▶ ▦ Scene 8 Slate 57 Take 2	00:00:01:20	00:00:02:18
▶ ▦ Scene 8 Slate 58 Take 2	00:00:06:15	00:00:10:00
▶ ▦ Scene 8 Slate 59 Take 1	00:00:05:13	00:00:14:08
▶ ▦ Scene 9 Slate 60 Take 3	00:00:02:12	00:00:35:04
▶ ▤ Spider Attack	00:00:00:00	00:00:20:01

A Compound clip behaves just like another clip in the Event Browser and can be appended, inserted, overwritten, and connected to the Primary Storyline in the Timeline (see Figure 7.19).

FIGURE 7.19
A Compound
clip created in
the Event
Browser and
added to the
Timeline.

Another way to incorporate Compound clips into your workflow is by creating an empty Compound clip in the Event Browser for each scene in your movie (see Figure 7.20). You could open each scene separately in the Timeline, add the relevant clips, and trim them as usual without creating a Project. After you've finished editing each scene, you can then create a new Project and append them to the Timeline in the correct order.

FIGURE 7.20
How Compound clips can be used as individual scenes for your project.

To create an empty Compound clip in the Event Browser, select an Event in the Event Library and choose File➜New Compound Clip or press Option+G. A dialog box appears allowing you to follow the procedure outlined above.

Adding Transitions

A transition is how one shot changes to another in an edited sequence. Whenever you add a new clip to the Timeline, it "cuts" to and from the clips that it's placed next to. This change-over from clip to clip can be altered by adding a transition effect between the edit point of the two clips. Transition effects can be as subtle as a simple fade or cross-dissolve or as audacious as a garish star wipe with thick pink borders.

So far, you've been using cuts from one shot to another in the Bump in the Night sequence. For most projects, a simple cut, fade, and cross-dissolve is all that's necessary. In fact, transition effects are best used sparingly because they can make a production look tacky if they're overused.

Adding simple dissolves

Final Cut Pro supplies a whole host of transitions, and the types you choose will mainly depend on your project's needs. However, the transition effects that you'll most often turn to are the fade-in/fade-out and cross-dissolve. A fade-in starts on black and gradually illuminates to the shot's full exposure, and a fade-out does the same in reverse. Fade-in and fade-outs are regularly used together and can be used to signify the passage of time or the completion of a dramatic point in the story, such as the end of an act break.

The default transition in Final Cut Pro is the cross-dissolve. A cross-dissolve superimposes the end of one shot and the beginning of another with a fade-in and fade-out and is also typically used to convey the passage of time.

To apply a cross-dissolve between clips in the Timeline, select an edit point from one of the clips and choose Edit➜Add Cross Dissolve or press ⌘+T.

When you add a transition, an orange render bar appears in the Timeline and disappears after the effect has rendered in the background (see Figure 7.21). To apply a cross-dissolve to both ends of a clip, select the entire clip in the Timeline and choose Edit➜Add Cross Dissolve or press ⌘+T. To remove the transition, simply select it in the Timeline and choose Edit➜ Delete or press Delete. When you place a cross-dissolve on clips that contain audio, the cross-fade effect is also applied to the audio. It's possible to apply a cross-dissolve to just the video or audio components, by first expanding or detaching the clip (see Chapter 8).

When you apply a transition to a Connected clip, Final Cut Pro turns the clip into a Secondary Storyline before adding the effect. You can easily copy a transition to another edit point on the Timeline by selecting the transition and dragging it to the new edit point while pressing the Option key. You can use the standard Cut, Copy, and Paste commands to do the same thing.

FIGURE 7.21
An orange render bar above a newly added transition.

Chapter 6 introduced you to the concept of clip handles, which are the extra parts of a clip's media that aren't being used in the Timeline. Clip handles also come into play when applying transitions. This is because transitions require an overlap between the transitioning clips, and this overlap is usually created by using any handles that the clips may have. If media handles aren't available, Final Cut Pro displays a warning dialog box giving you the option to use the media utilized in the Timeline to perform the transition (see Figure 7.22). If you select the dialog box's Create Transition option, Final Cut Pro ripples the transitioning clips in the Timeline to create an overlap for the transition to take place and shortens the edited sequence by the amount of the transition. This is obviously not desirable in most cases because it alters the timing of the entire work, so you need to take care when selecting this option. If media handles are available, Final Cut Pro uses them to perform the transition and leaves the duration of the edited sequence intact.

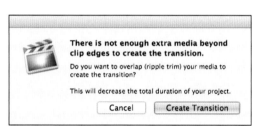

FIGURE 7.22
Final Cut Pro
displays a
warning when
media handles
are not available
for a transition.

Changing transition durations

Final Cut Pro's default duration for a transition is 1 second, but this can be changed to another value of up to 10 seconds. To change the default duration, open Preferences by pressing ⌘+, (comma) and select the Editing tab. In the Transitions section, you'll find an entry box named Default Length, where you can enter a new duration with the up/down arrows or by highlighting the Duration field and typing in a new value. This becomes the new default and any transition effect that you now apply in the Timeline will have the duration specified in Preferences. This duration can still be amended once a transition is applied to a clip in the Timeline; this is done by selecting one of its edges and dragging to the left or right to lengthen or shorten the transition (see Figure 7.23). The shorter the duration, the faster the transition effect occurs. You also can alter a transition's duration numerically by entering a value in the Dashboard. This works in the same way as altering a clip's duration in the Dashboard (see Chapter 6).

To numerically change a transition's duration, select the transition and choose Modify→ Change Duration or press Control+D. The Dashboard highlights in blue and displays the duration icon, ready for you to enter a new duration and press Return.

FIGURE 7.23
How to lengthen
a transition by
dragging its
edges.

A clip can still be trimmed even after a transition has been applied to its edit point. The light gray bar across the top of a transition includes ripple and roll icons that allow you to trim the clips beneath the transition. If you hover the cursor over the two vertical dashes on either side of the transition, the familiar ripple symbol displays. Clicking down on this icon allows you to Ripple edit the clips below by dragging the edit point in the usual way. Hovering the cursor over the middle icon reveals the roll symbol, and clicking down on this icon allows you to perform a roll edit in the same way (see Figure 7.24). The Precision Editor also can be used to trim the clips beneath a transition. To access the Precision Editor, Control-click on the transition and choose Show Precision Editor from the shortcut menu.

Ripple Icon Roll Icon

FIGURE 7.24
A Roll edit
beneath a
transition.

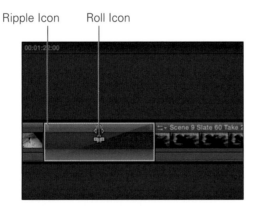

Selecting transitions in the Transition Browser

The occasional cross-dissolve should be all that you need for most projects, and you can get by with simple cuts for a large part of your edited sequence. However, sometimes you may want to call on a less conventional transition, and Final Cut Pro provides you with many different options. To see what other transition effects are available, click the Transition Browser button in the Media Browser area of the Toolbar (see Figure 7.25) or choose Window➜Media

Browser➡Transitions. A new window opens with a wide selection of transition effects presented as thumbnails. To search for a particular transition, use the Search field at the bottom of the window or click the button to the left of this field to open the Transition Library. Here you'll find the transitions listed and arranged in categories such as: Blurs, Wipes, Stylized, and so on. Selecting a category from the list displays that group of transitions on the right-hand side.

Transition Browser Button

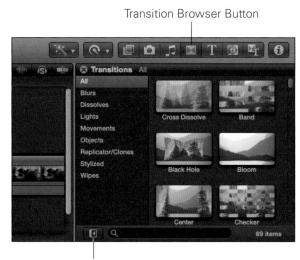

FIGURE 7.25
How to open the
Transition
Browser.

Transition Library Button

Skimming over the thumbnails allows you to preview each transition in the Viewer so that you can examine the effect before applying it to a clip. As fun as some of these transition effects are, it's easy to get carried away and use too many in your project, so remember to use them in moderation.

To apply a transition from the Transition Browser, select an edit point or clip in the Timeline and double-click a transition in the Transition Browser. If you prefer, you can drag a transition from the Transition Browser directly onto an edit point in the Timeline.

You can replace a transition on a clip with a different one by simply dragging the new transition over the old one. The transition highlights in white, and a green plus sign displays. Releasing the mouse replaces the old transition with the new one.

Manipulating transitions in the Inspector

Transitions have parameters that can be manipulated in the Inspector after a transition has been added to a clip in the Timeline. If you select a cross-dissolve that's been applied to a clip

and open the Inspector (⌘+4), you'll find some settings that can be adjusted that change the look and style of the transition (see Figure 7.26). A pop-up menu allows you to alter the *look* of the cross-dissolve, and you can choose from a variety of looks, such as cold, warm, additive, and so on. How much of this look is applied can be controlled with the amount slider below.

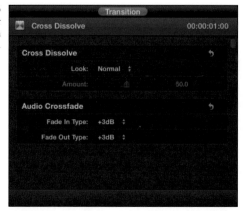

FIGURE 7.26
The Inspector settings for a cross-dissolve.

Another regularly used transition is a fade. To examine some of the parameters available when adding fade-ins and fade-outs to your scenes, open the Bump in the Night sequence, select the first clip's In point (Cutaway Slate 65 Take 1), and add the Fade to Color transition from the Transition Browser (you can find it in the Dissolve category). Select the transition in the Timeline and open the Inspector to view its parameters (see Figure 7.27). Here you can change the Midpoint, Hold, and Color of the fade. The Midpoint parameter controls where the fade occurs during the transition. A smaller value causes the fade to occur earlier and a larger value moves the fade later. The Hold parameter controls how long the transition stays on the color before fading up to the image. The most common fade is a fade to black (and sometimes white) but you can choose a different color by clicking on the Color parameter. This brings up the standard Apple color selector where you can choose any color that you require.

Some transition types allow you to control their parameters via on-screen controls in the Viewer. The Black Hole transition swallows the outgoing clip into the center of the screen as the incoming clip is revealed behind it. If you select this transition in the Timeline, a circular icon displays in the center of the Viewer allowing you to reposition where the effect occurs on-screen (see Figure 7.28). You can easily position the icon so that the outgoing clip disappears into a specific spot on the incoming clip, such as an open box or inside a character's

open mouth for instance. Each transition has its own unique parameters, so it's worth experimenting with them after applying a transition to your clips.

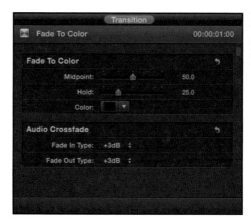

FIGURE 7.27
The Inspector setting for a Fade to Color transition.

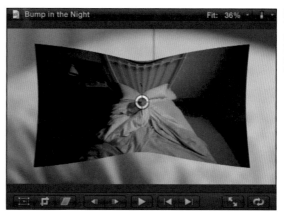

FIGURE 7.28
The on-screen controls for the Black Hole transition in the Viewer.

If you've been following along with the Bump in the Night exercises in the previous chapters, you should now be familiar with enough tools and functions to start honing your editing skills on other projects. Bump in the Night is far from complete—some of the clips in the sequence could still do with some more trimming—but you know enough now to complete this task by yourself. With your first picture cut under your belt, you're ready to tackle some of the other sequences in the *Pranks* movie, which we'll be exploring in the coming chapters. Before that, let's take a closer look at working with audio in your projects.

chapter 8
Editing Audio

WE THINK OF movies as a mainly visual medium because of their power to tell stories with pictures, but the sound that accompanies the visuals can be just as important in getting a story's message across to an audience. This chapter is all about the different ways that you can work with audio in the Timeline, starting off with other ways to get sounds into your project.

Accessing the Music and Sound Browser

Chapter 3 showed you how to import audio clips into the Event Browser that are specific to the project that you're working on. However, you have access to many other sounds from right inside Final Cut Pro; these sounds are available via the Music and Sound Browser (see Figure 8.1). To open the Music and Sound Browser, click the music symbol button in the Media Browser area of the Toolbar or choose Window➔Media Browser➔Music and Sound. Here you'll find the Final Cut Pro Sound Effects that are available with the program, the iLife Sound Effects (if the iLife suite is installed on your Mac), and your entire iTunes Library, including any playlists that you may have created.

FIGURE 8.1
The Music and Sound Browser.

Final Cut Pro comes with a bounty of sound effects, which are organized into categories, such as Ambience, Foley, Sci-Fi, and more. Clicking a folder reveals its contents in the pane below; you can choose to display these contents as a list or as icons by Control-clicking on a file and choosing Display as List or Display as Icons from the shortcut menu. There's a search field for finding a specific sound by name, and you can preview a sound by selecting it from the list and pressing the Play button or the Spacebar. You can add a sound to an edited sequence by dragging it from the Music and Sound Browser directly onto the Timeline. This automatically imports the sound into the Event that the Project references, making it available in the Event Browser as well.

Working with Audio

A clip's audio waveform provides a visual way to see the peaks and valleys of a piece of sound. The waveform's height (or amplitude) displays the level or loudness of the sound and updates dynamically when the audio's volume is changed. If a clip's volume is increased to the point

where it begins to distort or clip the sound, this too is reflected visually in the waveform (see Figure 8.2).

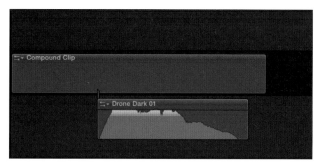

FIGURE 8.2
The red portion of the waveform displays audio clipping.

When working with audio in the Timeline, you should use the Clip Appearance panel to increase the size of the audio waveforms so as to make them easier to work with (see Chapter 5). Some quiet sections in a sound can still be hard to see in a clip because the height of the waveform is too small. In this case, you can have Final Cut Pro superimpose a reference waveform over the clip, allowing you to see the form of the sound more clearly (see Figure 8.3). To do this, press ⌘+, (comma) to bring up the Preferences window, choose the Editing pane, and select the Show Reference Waveforms check box.

FIGURE 8.3
A superimposed reference waveform displays over a clip.

Each clip that contains audio is assigned a channel configuration when it's imported into Final Cut Pro; this can be viewed in the Inspector's Audio pane under the Channel Configuration section. Chapter 6 demonstrated how to use this section to disable a clip's audio, but you also can change a clip's channel configuration here by selecting a new one from the pop-up menu (see Figure 8.4). This allows you to break a Stereo file into two Dual Mono clips or separate a Surround 5.1 file into six individual Mono clips (see Figure 8.5). After you've changed a clip's channel configuration in the Inspector, you can use Break Apart Clip Items to separate it into individual clips in the Timeline (see Figure 8.6). If a channel has

been disabled in the Inspector (by unchecking its check box), the separated clip in the Timeline also will be disabled and appear grayed out.

FIGURE 8.4
How to change a
clip's channel
configuration.

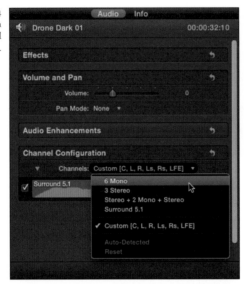

FIGURE 8.5
A Surround 5.1
clip changed to
six mono tracks.

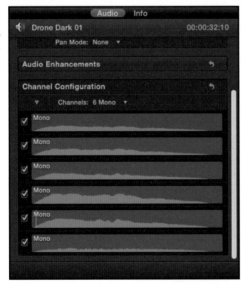

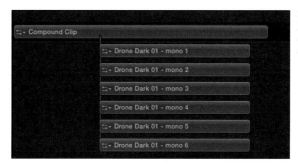

FIGURE 8.6
Breaking apart
six mono tracks
in the Timeline.

Using the audio meters

Even though audio clips can be trimmed and manipulated in the Timeline in much the same way as video clips, audio has its own special requirements that you need to be aware of. One such consideration when working with audio is the setting of proper audio levels for your clips. The level or volume of an audio clip is measured in decibels (dB) and can be monitored with audio meters. You've probably already noticed the audio meters that are included in the Dashboard, but these are far too small for serious monitoring. Luckily, Final Cut Pro also provides larger meters for just this use.

To show Final Cut Pro's main audio meters, click the Dashboard's audio meters, choose Window➡Show Audio Meters, or press Shift+⌘+8. The audio meters appear to the right of the Timeline and display a 5.1-channel layout or a two-channel stereo configuration depending on the Audio Channel setting in the current Project's Properties (see Chapter 5). The most crucial factor to keep in mind when monitoring audio is that your final audio output should never exceed zero dB, because this results in digital distortion or clipping. When playing back audio clips in the Event Browser or Timeline, green bars show that the audio level is safely below zero dB and yellow bars indicate that the level is getting close to zero. Red means that the level has exceeded zero dB and is a sign that you need to lower the volume to avoid clipping. The audio meters also displays the audio's peak level as small white lines above the colored indicator bars (see Figure 8.7).

As you build your movie's soundtrack by adding more music, sound effects, and background ambience, you need to keep an eye out for the audio output level. Even though the level of each individual audio clip may be below zero, the combined level of all these audio elements can easily push the audio meters into the red. A good starting level for audio clips such as dialogue is at around −12 dB. Speech levels tend to fluctuate depending on the actor's performance and can go from the quietest whisper to a shrieking scream. Making sure the dialogue's level averages out at around −12 dB for the most part is good practice.

You can control any wild variations of volume by adding keyframes in the Timeline (see Chapter 13).

Red indicates that the level
has exceeded zero dB.

Peak indicators

FIGURE 8.7
Audio's peak
levels are shown
as small white
lines above the
colored indicator
bars.

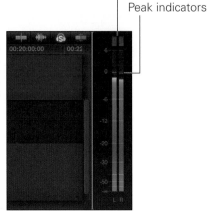

Once you have a lot of audio clips in the Timeline, it may be difficult to ascertain an individual clip's audio level when played together with all the other audio elements. Final Cut Pro gives you the ability to listen to a clip in isolation and monitor its volume by soloing the clip. To solo a clip in the Timeline, select the clip and then click on the Solo button at the top right of the Timeline window (see Figure 8.8), choose Clip➔Solo, or press Option+S. This grays out all the other clips in the Timeline, allowing you to concentrate on just the soloed clip. To add another clip to a soloed selection, Control-click on the clip that you want to add and choose Add to Soloed Clips from the shortcut menu. You can remove a soloed clip in the same way by choosing Remove from Soloed Clips from the menu.

Solo button

FIGURE 8.8
Audio tracks
grayed out in
the Timeline
when Solo is
activated.

Another way to manage which audio clips are audible is by disabling them in the Timeline. Disabling an audio clip acts just like a mute button and silences the clip during playback. Video clips also can be disabled, preventing the clip's video from appearing in the Viewer. This is a good way to exclude a clip from a sequence without deleting it from the Timeline.

To disable a clip in the Timeline, select the clip and then choose Clip➜Disable or press V. You can re-enable clips using the same method.

Controlling audio volume

Each audio clip displays a black horizontal line that runs across the length of the clip. This line represents the clip's audio level. If you place the cursor over the line, an icon displays allowing you to manually adjust the level by dragging it up or down (see Figure 8.9). Dragging the line up increases the clip's volume; dragging the line down decreases the clip's volume. The change in decibels displays over the clip as you drag and shows how much of the clip's volume is being changed relative to its original level. This is not an indication of the clip's actual audio level because this can be shown only in the audio meters when playing back the clip. If you alter a clip's volume while playing it in the Timeline, Final Cut Pro's audio meters dynamically update as the change occurs. This is by far the best way to set audio levels as you can monitor the effect of the change as it's being made.

FIGURE 8.9
Changing a clip's volume in the Timeline.

Here are all the ways that you can change a clip's audio level:

- ○ Drag the horizontal audio level line that runs across the clip up or down.
- ○ Select a clip in the Timeline, open the Inspector's Audio panel, and change the level with the Volume slider or by inputting a plus or minus value in the entry field next to the slider (see Figure 8.10).
- ○ Select a clip in the Timeline and choose Modify➜Volume➜Up/Down.
- ○ Select a clip in the Timeline and press Control++ (plus) to raise the level or Control+− (minus) to lower the level.

FIGURE 8.10
Changing audio
levels in the
Inspector with
the Volume
slider.

Expanding and detaching audio

Many times during an edit, you'll want to separate a clip's video and audio so that you can manipulate them both individually. You can do this in two ways: by expanding the audio from the video or by detaching the audio from the clip. When a clip is expanded, it splits into two separate elements in the Timeline while still remaining linked together. This allows you to trim or extend the video and audio elements individually without losing sync between them. This is especially useful when performing what's referred to as an L- or J-cut (also known as a split edit), which is used to overlap a clip's audio into the previous or following clip (see Figure 8.11). Detaching audio from a clip completely separates it from its video component, allowing you to move it anywhere in the Timeline. You would use this method only if retaining audio sync with the picture was of no consequence or if you needed to manipulate the audio independently.

FIGURE 8.11
An expanded
clip used to
create an L-cut.

To expand a clip in the Timeline, double-click the clip's blue audio waveform. If you prefer, you can select the clip and choose Clip➔Expand Audio/Video or press Control+S. To expand all clips in the Timeline, make sure no clips are selected and choose View➔Expand Audio/Video Clips➔For All. To expand just the split clips in the Timeline, make sure no clips are selected and choose View➔Expand Audio/Video Clips➔For Splits.

To return an expanded clip to its original state, double-click the clip's expanded audio waveform. If you prefer, you can select the expanded clip and choose Clip➔Collapse Audio/Video or press Control+S. To return all expanded clips to their original state, choose View➔Collapse All Clips.

L- and J-cuts are an effective way to mask the cuts in a dialogue scene so that the shots flow smoothly when cutting back and forth between characters. You'll be putting split edits to good use in Chapter 10, but first let's look at a typical example of how you would use them in the context of a scene. Let's say you had a shot of a character speaking followed by a shot of another character listening and you wanted to continue the first character's dialogue over the second character's shot. This would be an ideal situation to use a L-cut. To achieve this you would expand the first clip to separate the video from audio, and then extend the audio portion by dragging its Out point past the second clip. As you can see from Figure 8.12, this looks like the letter L, which is why it's known as a L-cut.

FIGURE 8.12
A L-cut.

Detaching audio separates the video and audio portions of a clip and turns them into individual clips in the Timeline (see Figure 8.13). The audio becomes a Connected clip attached below the video and can be moved or even deleted. Suppose you wanted to add an audio cross-fade between two adjoining clips without affecting the video. You could do this by detaching the audio for both clips and then placing them inside a Secondary Storyline so you can add a cross-fade. Care should be taken when detaching audio because doing so makes you vulnerable to sync problems; once a clip has been detached, it can't be rejoined with its video component.

To detach the audio from a clip in the Timeline, select the clip and choose Clip➔Detach Audio or press Control+Shift+S.

FIGURE 8.13
A clip with
detached audio
in the Timeline.

Syncing double-system sound

Double-system recording describes the process of recording audio separately from the camera during filming. This process requires that the picture and sound be synced together later during editing using either timecode or a clapper as a reference. Final Cut Pro syncs clips automatically by matching their markers, timecodes, or the first frames of the clips and forming what's known as a Synchronized clip.

To synchronize two clips together, select the clips in the Event Browser and choose Clip➜ Synchronize Clips or press Option+⌘+G. A Synchronized clip appears in the Event Browser in addition to the original clips. A Synchronized clip is, in essence, just a Compound clip and behaves as such once it's added to the Timeline.

Let's see this in action by using a clapper to sync picture and sound from the *Pranks* rushes:

1. Double-click the *Craft of the Cut* disc image to mount it and launch Final Cut Pro.

2. Select the *Pranks Media* Event in the Event Library and type **clapper** into the Event Browser's Search field. A video and audio clip named "Scene 7 Slate 17 Take 3 with clapper" displays in the Event Browser.

3. Play the video clip and place a marker on the frame where the top of the board impacts with the bottom (see Figure 8.14).

FIGURE 8.14
Placing a marker
where the
boards meet.

4. Play the audio clip and place a marker at the point where you hear the clap of the board. This can be seen as the long thin spike in the clip's waveform (see Figure 8.15).

FIGURE 8.15
Placing a marker
on the audio
peak of the clap.

5. Select both clips and choose Clip➡Synchronize Clips. A new Synchronized clip appears in the Event Browser (see Figure 8.16).

FIGURE 8.16
A Synchronized
clip in the Event
Browser.

6. Play back the clip. Picture and sound should now be in sync.

Occasionally, Final Cut Pro may fail to synchronize the two markers together. In these cases, simply double-click the Synchronized clip to open it in the Timeline and access the two clips, enable Snapping from the View menu (keyboard shortcut N) and manually drag the audio clip until its marker aligns with the marker on the video clip.

Creating audio fades

An audio fade is the aural equivalent of a video fade and describes the gradual increase or decrease of an audio clip's volume. Occasionally, the transition between two audio clips in the Timeline can be abrupt and produce undesirable clicks or pops on the soundtrack. You can smooth out these unwanted sounds by applying a short audio fade to the two neighboring clips. You also can create a cross-fade by adding fades to two overlapping audio clips.

An audio clip in the Timeline has audio-fade handles on each end of the clip, allowing you to create either a fade-in or fade-out (see Figure 8.17). If you hover your mouse over the handle, the cursor turns into two arrows; you can manually drag the handle either to the right (to create a fade-in) or to the left (to create a fade-out). The duration of the fade displays in a pop-up as you drag, making it easy to adjust the timing of the fade.

FIGURE 8.17
Using a fade handle to create an audio fade.

Control-clicking on a fade handle brings up a pop-up menu that lets you pick one of four different types of fade shapes (see Figure 8.18). Each shape has a different effect on the fade that can easily be determined by the images in the pop-up menu:

○ The default shape is a +3 dB fade, which starts off slowly and quickly diminishes at the end.

○ The −3 dB fade starts off rapidly and slowly diminishes at the end.

○ The S-curve fade starts off slowly, ramps up in the middle, and then slowly diminishes at the end.

○ The Linear fade keeps a constant rate over the duration of the fade.

Which of these fade shapes you should apply will depend on the situation and on how smooth or abrupt you want the fade to be.

FIGURE 8.18
The different fade shapes available in Final Cut Pro.

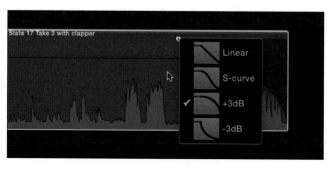

Making Audio Enhancements

Final Cut Pro comes with a host of plug-ins that you can use to enhance or correct your audio clips. These plug-ins can be found in the Effects Browser by choosing Window➜Media Browser➜Effects or by pressing ⌘+5. Here you'll find a wealth of assorted audio plug-ins, including such effects as compressors, limiters, and reverbs, as well as a whole range of different EQs (see Figure 8.19). If you have Apple's Logic Pro on your computer, its plug-ins also can be accessed here for use in Final Cut Pro along with any other Audio Units (AU) plug-ins that you have installed.

FIGURE 8.19
A selection of EQ plug-ins found in the Effects Browser.

To apply an audio effect from the Effects Browser, either select a clip in the Timeline and double-click on the audio effect in the Effects Browser or drag an effect from the Effects Browser directly onto a clip in the Timeline.

Once an audio effect has been applied to a clip, the plug-in's parameters can be adjusted in the Inspector's Audio panel. You can turn on or off an effect by checking or unchecking the check box next to its name; you can remove it completely by selecting it in the Inspector and pressing Delete. Clicking the arrow icon resets the parameter to its default position.

To see what effects have been applied to a clip directly from the Timeline, select the clip and press Control+A to see them listed below the clip (see Figure 8.20). You can turn off any effect from here by clicking the check box next to the effect's name and even alter an effect by choosing a parameter from the pop-up menu.

In this section, we look at how to use audio effects by using equalization as an example.

FIGURE 8.20
A clip's effects
directly in the
Timeline.

Using equalization

Equalization (EQ) allows you to shape the tone of a sound by adjusting the balance of the frequencies that it contains and is typically used to correct problematic audio that has excessive high or low frequencies or to keep different sounds competing with each other in a mix. Final Cut Pro comes with a built-in Graphic Equalizer that allows you to apply equalization to any audio clip in the Event Browser or Timeline. To bring up the Graphic Equalizer, select the clip that you want to modify, open the Inspector's Audio pane, and click the Equalization icon underneath the Audio Enhancements section (see Figure 8.21). If you can't see the EQ icon, hover the cursor over the Audio Enhancements pane and click Show to reveal the settings below.

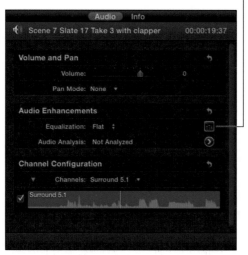

FIGURE 8.21
Press the EQ
button to bring
up the plug-in's
interface.

The frequency range displays as ten vertical bands across the Graphic Equalizer, ranging from 32 Hz to 16 kHz. You can change this to 31 bands (20 Hz to 20 kHz) from the pop-up menu for more precise equalization. You can increase or decrease the volume of each frequency band by dragging the band's fader up or down; the volume displays in decibels in the lower-right side of the window. You can select a group of frequencies by dragging a blue selection over their faders with the mouse, allowing you to alter more than one band at the same time (see Figure 8.22). If you need to reset the Graphic Equalizer, click the Flatten EQ button to return all the frequencies to zero dB. EQ presets also are available for common uses such as Bass Reduce and Voice Enhance; you can access them from the Equalization pop-up menu under Audio Enhancements in the Inspector.

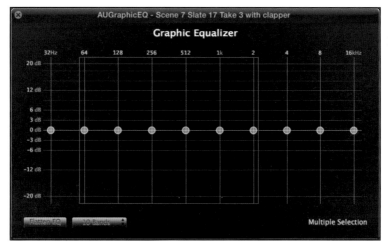

FIGURE 8.22
Dragging a blue selection over the EQ's faders.

The Graphic Equalizer isn't the only way to apply equalization to your audio clips; many other EQ plug-ins can be found in the Effects Browser. Figures 8.23 and 8.24 show a Parametric Equalizer plug-in along with its controls in the Inspector. A Parametric Equalizer allows for finer adjustments and more detailed control than a Graphic Equalizer; it has three main controls. The Center Frequency slider selects which frequency band is being affected and the Q slider specifies how narrow or wide that frequency band is. How much of the chosen frequency is boosted or cut is determined by the Gain control slider. The Parametric Equalizer graphic interface (see Figure 8.23) can be brought up in the same way as the Graphic Equalizer: by clicking on the EQ icon at the top of the Parametric EQ control panel in the Audio Inspector.

FIGURE 8.23
The Parametric
Equalizer
interface.

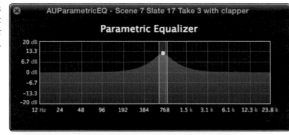

FIGURE 8.24
The Parametric
Equalizer
controls in the
Inspector.

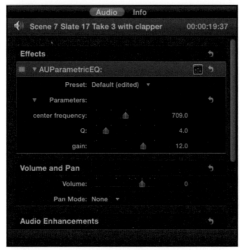

Another cool equalization function in Final Cut Pro is the Match Audio feature. This essentially applies the EQ settings from one clip onto another. To bring up the Match Audio window, select the clip that you want to change in the Timeline and choose Modify→Match Audio or press Shift+⌘+M. This brings up a two-window display with the chosen clip on the right side (see Figure 8.25). Select another clip from either the Event Browser or the Timeline that has the sound that you want to match and click the Apply Match button. To exit the Apply Match window without applying changes, click Cancel or press Escape. To remove an Audio Match, select the clip, open the Inspector's Audio panel, and choose Flat from the Equalization pop-up menu underneath Audio Enhancements.

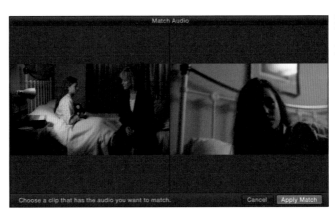

FIGURE 8.25
The Match
Audio two-
window display.

Fixing audio problems

In addition to applying plug-in effects from the Effects Browser to improve the audio of your clips, you can have Final Cut Pro perform its own enhancements for you. Chapter 3 discussed how to set the Import Preferences so that Final Cut Pro can detect and correct problematic audio during the import process. Conversely, you can perform the same analysis and corrections after the clips have been imported. Let's first look at how to do this for clips in the Event Browser.

To analyze audio for clips in the Event Browser, select a clip and choose Modify➔Analyze and Fix. This brings up a dialog box where you can choose the type of analysis that you want Final Cut Pro to perform. Check the Analyze and Fix Audio Problems check box and click OK. After the analysis has been performed, open the Inspector's Audio pane to see if any issues have been detected. If Final Cut Pro discovers a problem, a yellow warning displays in the Inspector (see Figure 8.26).

The results of any issues are presented in the Audio Enhancements panel, which can be accessed by clicking on the circle icon next to the warning. Final Cut Pro checks for three things—Loudness, Background Noise Removal, and Hum Removal—and these appear in their own sections in the Inspector (see Figure 8.27). A green check mark icon indicates that no problems were found with the audio, and a yellow exclamation point icon is an indication of potential problems. To fix a problem, click the check box for the relevant correction so that it turns blue or click the Auto Enhance button at the bottom of the window.

FIGURE 8.26
Potential audio
problems in the
Inspector.

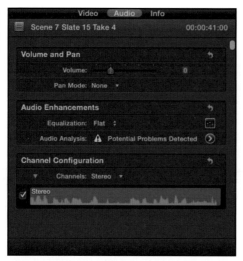

FIGURE 8.27
Enhancements
in the Inspector.

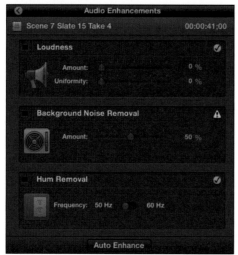

Once a correction has been applied to a clip, you can tweak it further using parameters in the Inspector:

○ Loudness behaves just like an audio compressor, with the Amount slider controlling how much compression is applied (and affecting the overall loudness of the audio).

○ The Uniformity slider adjusts the dynamic range between the quietest and loudest parts of the sound, with the highest percentage giving the least dynamic range.

○ Background Noise Removal detects consistent background sounds such as traffic noise or crowds and attempts to remove them; how much of this is removed is controlled with the Amount slider.

○ Hum Removal fixes interference from electrical sources; you can choose between 50 Hz and 60 Hz (for Europe or North America).

Audio analysis also can be performed directly from the Inspector itself. Let's run through this using an example from the *Pranks* rushes:

1. Double-click the *Craft of the Cut* disc image to mount it and launch Final Cut Pro.

2. Select the Cutting Dialogue-1 Collection in the Event Library and select Scene 7 Slate 15 Take 4 in the Event Browser.

3. Play Scene 7 Slate 15 Take 4 and carefully listen to the audio. Background noise can be heard from the camera.

4. Open the Inspector's Audio pane and click Show to reveal the Audio Enhancements section (see Figure 8.28)

FIGURE 8.28
Press the Show button to reveal the Audio Enhancements section.

5. The Audio Analysis field shows that the clip is Not Analyzed.

6. Click the circle icon next to Audio Analysis to analyze the clip and open the Audio Enhancements window.

7. The yellow exclamation point icon indicates that Final Cut Pro has detected the background noise on Scene 7 Slate 15 Take 4. Click the Auto Enhance button to apply the fix.

8. Play back the clip to hear the result. Most of the background noise has been removed; however, it has also added a flanging effect to the actress's speech. In the Audio Enhancements window you can see that the amount added is 50%, which is quite excessive (see Figure 8.29).

FIGURE 8.29
50% Background
Noise Removal
in the Inspector.

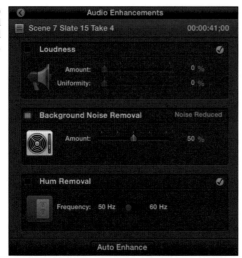

9. Use the slider to reduce the Amount of the effect until the actress's speech has improved. This will bring back some of the background noise and you'll need to experiment until an acceptable compromise is found.

These fixes don't apply only to clips in the Event Browser because the same audio enhancements can be applied directly to clips in the Timeline.

To apply audio enhancements to a clip in the Timeline, select a clip and choose Modify➔Auto Enhance Audio or press Option+⌘+A.

To open the Inspector's Audio Enhancements window, select a clip and choose Window➔Go to Audio Enhancements or press ⌘+8.

When applying some of the effects and processes discussed in this chapter, your monitoring setup will play a big part in your ability to work effectively with audio. A pair of reference loudspeakers or at least some good headphones will give you an advantage over your computer's speakers. You'll learn some more audio techniques in Chapter 13, but for now it's time to get back to the *Pranks* edit and put together some new scenes.

part 3

The Craft of the Edit

chapter 9
Setting Up the Story

IN THE FOLLOWING four chapters, we'll walk you through the thought process that went into the edit decisions for some of the key scenes from *Pranks.* Of course, this is just one approach to editing the film. Given the same footage, every editor will potentially end up with his or her own interpretation of a scene, and we encourage you to create your own versions after completing the examples in the following chapters.

This chapter concerns the first act of the movie, which is all about setting up the story. This is where the setting is established, the principal characters are introduced, and the main dramatic situation of the story is presented. The first act ends on a turning point that presents an inequity for the main character and provides her with a problem to solve for the rest of the story. This is also known as the *inciting incident,* which is defined as the event that spurs the main character into action. Resolving the problem at the end of the first act becomes the main character's goal or purpose and the question of whether the character will achieve this goal is what the viewer is waiting to find out.

The First Act

Before we take a look at the coverage that we have available to work with (coverage refers to the different takes, angles, and shot sizes recorded during production), let's look at the components that make up the first act of *Pranks*. Act I consists of Scenes 2 through 6 and breaks down like this:

- ○ **Scene 2 - EXT. THE ANDERS RESIDENCE - DAY:** This scene shows the arrival of the characters and establishes the setting for the story. The viewer is introduced to the main character and protagonist (Katie, the character whose actions drive the story) and given a sense that someone is watching the characters as they get out of the car (setting up the antagonist that Katie will eventually face).

- ○ **Scene 3 - INT. HALLWAY - FRONT ENTRANCE - DAY:** This scene provides some exposition about the present circumstances (Katie is a reserved child who has come to live with a new foster mother) and also establishes the relationship between the two principle characters.

- ○ **Scene 4 - INT. KATIE'S ROOM - DAY:** Katie chooses a room for herself and tidies away some discarded toys. This scene simply sets up the turning point that occurs in Scene 6 but also lays the groundwork for what the two adversaries will be fighting over: ownership of the bedroom.

- ○ **Scene 5 - INT. HALLWAY - EVENING:** Katie explores the house and comes across a photo that shows a young boy holding the ball she has just seen in the bedroom, providing a further clue to the identity of Katie's adversary.

- ○ **Scene 6 - INT. KATIE'S ROOM - EVENING:** Katie finds that the toys that she had previously tidied away have been disturbed by someone. The end of this scene brings the act to a close and establishes the main question of the story: Who is behind the disturbances in Katie's room and what will she do about it?

Scene 1 consists of a single shot that is to be used for the opening titles of the movie and is excluded here for this reason. In this chapter, we'll be walking you through Scenes 2 and 3, but the footage for all the scenes is available for you to practice on.

Note: For the rest of the exercises in the book, we'll be working directly from the mounted disc image provided on the DVD. If you prefer to work directly from your computer's hard drive or you find that the disc image is running out of space, move the Events and Projects from the disc image to a drive of your choice (see Chapters 3 and 5).

To make the scenes easier to work with, let's use keywords to group them into separate Collections. Double-click the *Craft of the Cut* disc image to mount it and launch Final Cut

Pro. Open the Event Library and select the Setting Up The Story Collection inside the Pranks Media Event. Make sure the Filter pop-up menu is set to All Clips and enter the words **Scene 2** into the Event Browser's Search field to display only the Scene 2 clips (see Figure 9.1). Press ⌘+A to select all the clips and press ⌘+K to show the Keyword Editor. Type **Scene 2** in the Keyword Editor's name field and press Return to tag the selected clips with the Scene 2 keyword (see Figure 9.2).

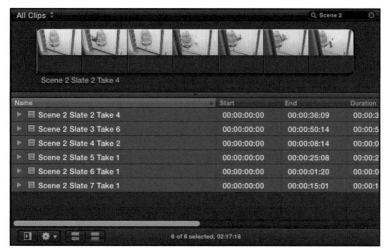

FIGURE 9.1
Displaying all the Scene 2 clips in the Event Browser.

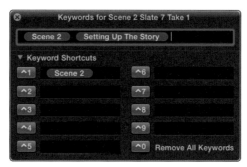

FIGURE 9.2
Using the Keyword Editor to tag the selected scenes with a Scene 2 keyword.

Follow the same procedure for Scenes 3 through 6 so that you have a Keyword Collection for each scene. When you've finished, click the X in the Event Browser's search field to clear the search results. Control-click the Pranks Media Event and choose New Folder from the shortcut menu. Name the folder "Act 1 Scenes," and place the five new Keyword Collections inside (see Figure 9.3) .

FIGURE 9.3
Organizing the
Scene
Collections
inside a folder in
the Event
Library.

Evaluating the footage

In order to follow along with the examples in this chapter, you'll first need to rate some sections of the clips as Favorites. ⌘-click on the Keyword Collections for Scene 2 and 3 to display the clips for these scenes in the Event Browser, and mark the following sections as Favorites using these timecodes:

- ○ **Scene 2 Slate 2 Take 4:** Between 03:10 and 10:04

- ○ **Scene 2 Slate 4 Take 2:** Between 03:20 and 05:10

- ○ **Scene 2 Slate 7 Take 1:** Between 02:06 and 06:17

- ○ **Scene 3 Slate 10 Take 1:** Between 15:07 and 17:16

- ○ **Scene 3 Slate 13 Take 2:** Between 14:17 and 16:09

- ○ **Scene 3 Slate 14 Take 1:** between 09:00 and 12:13

In the Project Library, create a new Project and name it "Setting Up The Story."

Exploring the edit

Before we start to edit the footage, let's take a closer look at Scene 2 and break it down into smaller story points to see how it works. We also recommend that you reread this scene in the shooting script.

Scene 2

Scene 2 begins with a car pulling into the grounds of a rather austere-looking house. This arrival is being watched through the top bedroom window, suggesting that there is another resident inside. Each new piece of information that an audience receives at the start of a story should pose a question in the audience's mind and keep them hanging on for the answer. At this point, the audience should be wondering who these people are, who is watching them, and what their relationship with each other is?

In this short scene, we meet our two main characters, Joyce and Katie, for the first time. The main focus is on Katie, a 12-year-old girl who has just arrived to live with her new foster parent. We immediately get a glimpse of Katie's character when she refuses Joyce's offer to help her with a bag. As subtle as this detail is, it gives the audience their first clue about Katie's independence and suggests that, even at such a young age, Katie is used to depending on herself. Further glimpses into Katie's outlook and persona are revealed during the course of the story, allowing us to form an impression of who this character is and wonder how the events of the story will impact her.

A character starts with a certain belief or attitude, which is challenged during the course of the story by a series of events. These events cause the character to either grow and change her viewpoint or dogmatically hold on to her previous convictions despite everything that is going on around her. This journey of growth (or lack thereof) that the character goes through is known as a *character arc* and is usually summed up at the end of a story when the audience gets to see whether the character has changed for the better or not. The small detail with the bag signals the start of Katie's character arc. As we shall soon learn, she is a child who prefers her own company to others, and it's this attitude that's to be challenged in the story. Once Katie gets out of the car, she spots a figure behind one of the bedroom windows, which instantly puts her on edge. This sets up the first obstacle that Katie is faced with: the possibility of another person in the house.

Select the Keyword Collection Scene 2. To create this short scene, we have the following footage to play with:

- **Scene 2 Slate 2 Take 4:** A point-of-view shot from the upstairs window, looking down on the characters as they get out of the car.

- **Scene 2 Slate 3 Take 6:** A Steadicam shot that starts on Joyce getting out of the car to open the door for Katie and then follows both characters as they make their way to the house.

- **Scene 2 Slate 4 Take 2:** An insert shot of Katie's suitcase. Joyce offers to help Katie with the case, but Katie pulls away.

○ **Scene 2 Slate 5 Take 1:** A wider angle facing the front of the car. Katie gets out and walks into a tight medium shot as she stops to look up at the house.

○ **Scene 2 Slate 6 Take 1:** Katie's point of view of the curtain stirring in the upstairs window.

○ **Scene 2 Slate 7 Take 1:** A wide establishing shot of the house as the car pulls in to the drive (see Figure 9.4).

FIGURE 9.4
An exterior establishing shot of the house.

Now that we know the story points we need to communicate for Scene 2 and have examined the footage we have to work with, let's edit the scene:

1. Most scenes start with an establishing shot that communicates to the audience where the scene is taking place. This can be a distant exterior shot that sets up the location of the story or a wide interior that establishes the spatial relationship of the characters in the scene. Scene 2 Slate 7 Take 1 is a wide shot that establishes the setting and shows the arrival of the main characters, so it's an obvious shot to begin this scene with. Set the Event Browser's Filter pop-up menu to Favorites, and then select Scene 2 Slate 7 Take 1 and choose Edit➜Append to Storyline.

2. Select and play Scene 2 Slate 2 Take 4 in the Event Browser. This point-of-view shot from the upstairs window shows Joyce getting out of the car and makes it seem as if someone is watching the arrival of our characters. Placing this clip next in the sequence should immediately raise some questions for the viewer: Who are these characters that have just arrived? Who is secretly watching them from the upstairs window? What is the relationship between them? Every question that a new shot raises keeps the viewer hanging on for the answer. Select Scene 2 Slate 2 Take 4 in the Event Browser and press E to append the clip to the end of the Primary Storyline (see Figure 9.5). Press the Home key to go to the beginning, and press the Spacebar to play back the sequence.

FIGURE 9.5
The first two clips are added to the Primary Storyline.

3. Set the Event Browser's Filter pop-up menu to All Clips, and then select and play Scene 2 Slate 3 Take 6. This Steadicam shot follows Joyce as she walks around the car to open the door for Katie. Joyce tries to help Katie with her bag, but the offer is declined and the clip ends with them walking up to the front door of the house. This clip covers all the action for the rest of the scene and can, therefore, be treated like a master shot. A master is a shot that runs through the entire action of the scene, usually from a wide angle that includes all the characters in view. A director usually shoots a master first before covering the scene with closer angles. This style of filmmaking harks back to the Hollywood films of the 1930s and 1940s. Shooting a master gives the editor a continuous shot to base the rest of the coverage on and also ensures that the entire scene is covered if there is no time to shoot everything during production.

 If we look at the footage that we have to work with, you can see that there are only two angles that cover most of this scene: Scene 2 Slate 3 Take 6 and Scene 2 Slate 5 Take 1. The rest of the footage is comprised of short insert or point-of-view shots and should be more than enough for such a short scene. Let's use Scene 2 Slate 3 Take 6 as a foundation and use sections of other clips and angles to build up the scene. Select Scene 2 Slate 3 Take 6 in the Event Browser and press E to append the clip to the Timeline.

4. If you play back the last two clips in the Timeline (Scene 2 Slate 2 Take 4 and Scene 2 Slate 3 Take 6), you'll see that both clips show Joyce getting out of the car and slamming the door. We obviously need to trim these clips so that Joyce's action isn't repeated. The best place to perform a cut between two clips is during a character's action or movement because this helps to hide the edit and causes the shots to flow together seamlessly and helps speed up the pace of a scene. For example, editors usually cut near the beginning of an action, just after someone starts to walk. What you need to bear in mind when cutting during motion is that most shoots are recorded with a single camera with the actors repeating their performance, sometimes days apart, for each camera angle. Obviously, it would be impossible for an actor to reproduce an identical performance for each take; there will be variations in the speed and energy of the movement between each clip. However, with a little careful manipulation, these differences usually can be hidden within the cut and the viewer will be none the wiser.

If you re-watch the two clips, you'll see that there are two possibilities for cutting on action: We can cut as the car door slams shut or as Joyce starts to walk around the vehicle. Let's cut on Joyce's walk. If you try to match two clips during movement, you'll soon find that it's very difficult to precisely identify the same point in both clips as it occurs during motion. The easiest way to approach cutting on action is to make an edit at the end of an action and then roll the edit point back so that it occurs during the motion.

We can use the end of the door slam to achieve this here. First, find the point where the car door slams shut during Scene 2 Slate 2 Take 4. Even though this clip has no sound, you can visually see that this occurs at 10 seconds 19 frames in the Timeline. Place the playhead at that position and make sure snapping is enabled (the snapping icon should be highlighted in blue at the top right of the Timeline). Select Scene 2 Slate 2 Take 4's Out point and perform a Ripple edit by dragging it to the left by 12 frames until it snaps to the playhead at 10 seconds 19 frames in the Timeline (see Figure 9.6). If you find the playhead jumping to the clip's Out point when you try to select it, hold down the Option key as you perform this.

FIGURE 9.6
Trimming the end of a clip with a Ripple edit.

5. Next, we'll find the same point where the door slams shut in the following clip (Scene 2 Slate 3 Take 6). This will be even easier because we also have the sound of the door shutting to help us and we can use the clip's audio waveform to visually see where this occurs (see Figure 9.7). You'll find this at 18 seconds 3 frames in the Timeline. Place the playhead at that position or, if you prefer, press M to set a marker at the same location.

FIGURE 9.7
Using the clip's audio waveform to position the playhead at the beginning of the door slam.

Select Scene 2 Slate 3 Take 6's In point and perform a Ripple edit by dragging it to the right by 7 seconds 8 frames (see Figure 9.8). Press Shift+/ (forward slash) to play back the edit, and you'll see that the cut occurs exactly on the door slam.

FIGURE 9.8
Trimming the start of a clip with a Ripple edit.

6. Now that we've made an edit at the end of an action, we can simply roll the edit point so that it occurs during motion. From here we can roll the edit point back so that it occurs during the door slam or forward so that it occurs just after Joyce starts to walk around the car. Because we've decided to use Joyce's walk, let's roll the edit point forward. Choose the Trim tool from the Tool menu and select both sides of the edit point between Scene 2 Slate 2 Take 4 and Scene 2 Slate 3 Take 6 (see Figure 9.9). Roll the edit point forward by about 12 frames so that it occurs just after Joyce starts to walk around the car. Press A to switch back to the Select tool and play back the edit to see the result.

7. We've lost the sound of the door slam because this now occurs during the point-of-view shot from the window and this clip doesn't contain any audio. However, we can use the audio from the following clip in its place and this should still be in sync because we previously lined up the door slams in both clips. First, we need to expand the audio track for Scene 2 Slate 3 Take 6. To do this, double-click on the clip's blue waveform area or select the clip and choose Clip➔Expand Audio/Video. With the audio of Scene 2 Slate 3 Take 6 expanded, select the clip's audio In point, making sure that the video In point is unselected (see Figure 9.10).

FIGURE 9.10
Selecting the
clip's audio In
point with the
video
unselected.

Drag the audio In point to the left so that the audio track extends across the entire length of the previous clip (Scene 2 Slate 2 Take 4). The audio portion of Scene 2 Slate 2 Take 4 should now start at 4 seconds 12 frames on the Timeline (see Figure 9.11). Double-click the clip's expanded waveform to collapse the audio track and play back the sequence. As you can hear, the door slam is now perfectly in sync during the point-of-view shot through the window.

8. Continue to play back the sequence in the Timeline. When Joyce offers to help Katie, we can't clearly see her hand reaching for the bag in the shots that are currently in the Timeline. Luckily, we have a tighter insert shot that we can use to make this action more obvious. Set the Event Browser's Filter pop-up menu to Favorites, and then select and play Scene 2 Slate 4 Take 2. We previously rated a short section of this clip as a favorite so that we can use it for just such a purpose.

We only need to use the video portion of this clip because the dialogue is already included in Scene 2 Slate 3 Take 6 in the Timeline. To solely add the video portion of the clip, choose Edit➜Source Media➜Video Only or press Shift+2. The start of Scene 2 Slate 4 Take 2 shows Katie about to get out of the car, so let's find this same position in the Primary Storyline. This occurs at 24 seconds 1 frame in the Timeline during Scene 2 Slate 3 Take 6. Position the playhead at that location and choose Edit➜Connect to Primary Storyline or press Q to add Scene 2 Slate 4 Take 2 as a Connected clip (see Figure 9.12). Choose Edit➜Source Media➜All to switch the source media back and play the edit.

FIGURE 9.12
Adding a Connected clip to the Primary Storyline.

9. The start of the Connected clip works well, but the cut back to Scene 2 Slate 3 Take 6 could use some trimming. However, because Scene 2 Slate 4 Take 2 is a Connected clip, we need to make it part of the Primary Storyline before we can do so. Control-click on Scene 2 Slate 4 Take 2 in the Timeline and choose Overwrite to Primary Storyline. Scene 2 Slate 4 Take 2 is overwritten to the sequence, and because the clip has no sound, the audio from the previous clip expands across the length of the clip (see Figure 9.13).

FIGURE 9.13
Overwriting the
Connected clip
to the Primary
Storyline.

Now we're free to manipulate the In point of the following clip to tighten up the cut. Select the In point for the second instance of Scene 2 Slate 3 Take 6 in the Timeline and ripple to the right by 11 frames (see Figure 9.14). Press the Home key to go to the beginning, and press the Spacebar to play back the sequence.

FIGURE 9.14
A Ripple edit
tightens up
the cut.

10. The next part of the scene's action concerns Katie walking up to the house and spotting someone at the window. In the current sequence in the Timeline, Katie has her back to the camera and we can't see any facial expressions when she stops to look up at the house. This is an important moment, because it sets up a potential obstacle for Katie that will be revealed later in the story. The audience, therefore, needs to see that Katie is concerned about the possibility of another person in the house.

Set the Event Browser's Filter pop-up menu to All Clips. If we look through our footage in the Event Browser, we can see that Scene 2 Slate 5 Take 1 covers this part of the action with Katie facing the camera. Let's find a good place to add this clip in the Primary Storyline. Position the playhead at 33 seconds 11 frames in the Timeline just before Katie stops to look up at the house. Press ⌘+1 to make the Event Browser active and skim through Scene 2 Slate 5 Take 1, stopping when Katie once again pauses to glance up at the house (see Figure 9.15). This is at 15 seconds 12 frames into the clip. Press I to mark an In point and press D to overwrite Scene 2 Slate 5 Take 1 to the Primary Storyline. Play back the section to see the result.

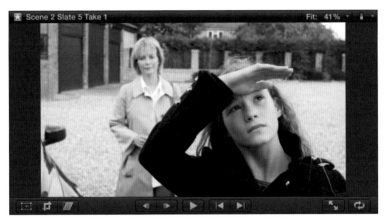

FIGURE 9.15
A medium shot of Katie as she stops to glance up at the house.

11. When Katie looks up at the house, the viewer will expect a shot of what she's looking at to follow. Cutting to a character's point of view is a good way to put the viewer in the character's shoes and create some identification with them. Select and play Scene 2 Slate 6 Take 1 in the Event Browser. This is a short point-of-view shot of the curtain stirring in the upstairs window. Obviously, the best place to add this in the sequence is just after Katie looks up at the house, which is at 35 seconds 23 frames in the Timeline. Place the playhead at that spot and press Q to add Scene 2 Slate 6 Take 1 as a Connected clip. Select the Connected clip and press ⌘+Option+Down Arrow to overwrite it to the Primary Storyline.

You may be wondering why we didn't simply overwrite Scene 2 Slate 6 Take 1 to the Primary Storyline without taking the extra step to add it as a Connected clip first. Overwriting the clip directly from the Event Browser would also replace the audio across the section of the Primary Storyline that we're overwriting. By adding Scene 2 Slate 6 Take 1 as a Connected clip first and then overwriting it in the Timeline, we can keep the original audio intact (see Figure 9.16).

12. Press the Home key to go to the beginning and press the Spacebar to play back the sequence. The last clip in the sequence cuts back to Scene 2 Slate 3 Take 6, which shows our characters walking to the front door. We could use this clip to finish the scene (after a bit of trimming), but it really doesn't give the viewer any new information and it causes the scene to just fizzle out at the end. Is there a stronger way to finish this scene? If you play back the sequence, you'll see Katie glance up at the window and then walk out of the frame, with Joyce in the background watching after her (Scene 2 Slate 5 Take 1 in the Timeline). The despondency in Joyce's expression should raise further questions for the viewer and, as a result, give us a much stronger way to finish the scene.

Position the playhead at 40 seconds 21 frames in the Timeline, just before Joyce starts to follow Katie out of the frame. Choose the Range Selection tool from the Tool menu and draw a selection from the playhead position to the end of the sequence (see Figure 9.17). Press A to switch back to the Select tool and then press Delete to remove the selection.

You've now completed Scene 2 of *Pranks*.

Scene 3

In the next scene, Katie confronts Joyce about what she thinks she's seen at the window, but Joyce reassures her that they're the only two people staying there and manages to coax her into the house. This scene provides additional insights into Katie's character by demonstrating how anxious she gets at the possibility of sharing the house (and her new foster mother) with another child. This reluctance to mix with others is a concern for Joyce, and she puts this forward to Katie when she tucks her into bed in a later scene. Joyce's insistence that they're both alone in the house also should create some mystery and raise some questions for the viewer. Is Joyce lying? If not, who did Katie see at the window? Did Katie imagine what she saw or is someone hiding in the house? The scene ends with Katie relenting and walking upstairs to choose a room.

Now that we know what the scene is about, let's look at the footage that we have to edit the scene. Select the Keyword Collection Scene 3. This scene is made up of the following clips:

○ **Scene 3 Slate 8 Take 1:** A wide master shot that covers the entire scene (see Figure 9.18)

FIGURE 9.18
A wide master shot of the hallway interior.

○ **Scene 3 Slate 9 Take 2:** A medium shot that starts off as a single on Katie and then changes to a two-shot that includes Joyce (see Figure 9.19)

○ **Scene 3 Slate 10 Take 1:** A tighter angle of the above shot that is predominately of Katie at the door

○ **Scene 3 Slate 11 Take 1:** A higher-angle, wide shot of the entire scene

FIGURE 9.19
A medium two-shot of both characters.

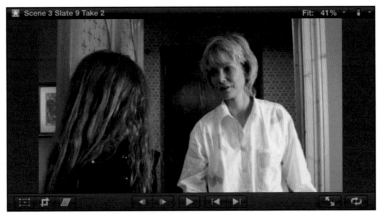

○ **Scene 3 Slate 12 Take 2:** A close-up of Joyce that covers the end of the scene

○ **Scene 3 Slate 13 Take 2:** A medium, reverse angle of the two-shot that also covers the entire scene

○ **Scene 3 Slate 14 Take 1:** A medium single on Joyce that covers the first part of the scene

The following section continues on with the Setting Up The Story Project that you created earlier. If it isn't already open, double-click the Project to open it in the Timeline.

1. Watch all the footage that we have for Scene 3, and you'll notice that we have four clips available that cover the entire scene from different angles. Any of these clips can be used as a possible master, but Scene 3 Slate 8 Take 1 provides the best perspective for establishing the interior of the house, so it would be useful to start off with this shot first. There is one continuity difference between Scene 3 Slate 8 Take 1 and the rest of the takes: Joyce doesn't walk over to the stairs and lean on the handrail at the end of the scene. This doesn't matter because, by that point, we'll most likely be in closer coverage and won't be including the end of this clip anyway.

 Set the Event Browser's Filter pop-up menu to All Clips. Before adding Scene 3 Slate 8 Take 1 to the Timeline, let's trim the front of the clip so that it starts just as the front door opens. In the Event Browser, position the playhead at 18 frames into the clip and press I to mark an In point. Press E to append Scene 3 Slate 8 Take 1 to the end of the Primary Storyline.

2. Now that we've established the new setting for the audience, we need to put our focus back on Katie to keep the viewer's connection with the main character. The viewer should now be curious about Katie's impression of her new home, so the natural choice

for the next shot would be a closer angle on Katie. Scene 3 Slate 9 Take 2 would be the next suitable choice, but before adding this clip to the Timeline, let's find the right point to cut to it in the sequence. A good place to cut to a tighter shot of Katie would be just as she is about to enter the house. Position the playhead at 45 seconds in the Timeline and press D to overwrite Scene 3 Slate 9 Take 2 to the Primary Storyline. A section from Scene 3 Slate 8 Take 1 remains at the end of the sequence. Select this and press Delete to remove it (see Figure 9.20). Play back this section.

FIGURE 9.20
Select the last clip in the Timeline to delete it.

3. We need to trim the front section of Scene 3 Slate 9 Take 2 to remove Joyce's entrance because this is already covered in the previous clip. Select the In point for Scene 3 Slate 9 Take 2 in the Primary Storyline and perform a Ripple edit by dragging to the right by 7 seconds 4 frames (see Figure 9.21). Scene 3 Slate 9 Take 2 should now start at 45 seconds in the Timeline. Press Shift+/ (forward slash) to play back the edit.

FIGURE 9.21
Trimming the start of Scene 3 Slate 9 Take 2 with a Ripple edit.

4. Play Scene 3 Slate 9 Take 2 in the Timeline and use the J, K, and L keys to position the playhead at 49 seconds 13 frames, just after Katie says the line "I saw someone at the window." Set the Event Browser's Filter pop-up menu to Favorites, and then select and play Scene 3 Slate 14 Take 1. This is a medium reverse angle of Joyce's response to Katie's question and is a suitable shot to cut to next. Overwrite Scene 3 Slate 14 Take 1 to the Primary Storyline by pressing D, and then play back the edit. We can smooth out the cut to Joyce's angle by trimming the clip's In point so that it starts over the tail end of Katie's line.

Select the first instance of Scene 3 Slate 9 Take 2 in the Timeline and press Control+S to expand the clip's audio. Select Scene 3 Slate 9 Take 2's video Out point and drag it to the left by 15 frames so that the video portion ends at 48 seconds 22 frames (see Figure 9.22). This action also pushes the clip's audio track into the following clip (Scene 3 Slate 14 Take 1).

FIGURE 9.22
Dragging the end of the video pushes its audio track into the next clip.

5. Katie doesn't respond to Joyce's answer to her question; instead, she regards her suspiciously. We could cut back to Scene 3 Slate 9 Take 2 to see this, but we have a tighter shot of Katie that would help accentuate the point even further (see Figure 9.23). With the Filter pop-up menu still set to Favorites, select and play Scene 3 Slate 10 Take 1 in the Event Browser. This is a medium shot of Katie that matches the framing of Scene 3 Slate 14 Take 1. Matching the angle and size of the shot helps keep the cut invisible and makes for a gentler edit than cutting back and forth between a wide shot and a closer angle. Once you move from a master into closer coverage, you should avoid cutting back to a wider angle unless there is action or new information that can be delivered only by cutting back to the master.

FIGURE 9.23
A tighter angle on Katie as she regards Joyce suspiciously.

At the end of Scene 3 Slate 10 Take 1, you can hear Joyce say the word *honestly*. We don't need this line of dialogue, because we're essentially using this shot of Katie as a cutaway and we can take Joyce's line from another clip. Press Shift+2 to select Video Only as the Source Media and position the playhead at the end of Scene 3 Slate 14 Take 1, which should be at 52 seconds 12 frames in the Timeline. Press D to overwrite Scene 3 Slate 10 Take 1 to the Primary Storyline and press Shift+1 to switch the Source Media back to All.

6. We need to cut back to Joyce for her line "Really Katie, it's just you and me" and for that we have two choices. It would be preferable to cut back to Scene 3 Slate 14 Take 1 to continue the matching shots, but we also need to see Joyce walk over to the front door after she says the line. This part of the action is more clearly covered in Scene 3 Slate 13 Take 2, which has a slightly wider framing to allow Joyce to walk toward the door. Position the playhead at 54 seconds 22 frames in the Timeline just after Scene 3 Slate 10 Take 1. With the Filter pop-up menu still set to Favorites, select Scene 3 Slate 13 Take 2 in the Event Browser and press W to insert the clip in the Primary Storyline.

7. Skim over to 40 seconds 21 frames in the Timeline and play the section that you've assembled for Scene 3 up to this point. You probably noticed that the first part of Joyce's dialogue for Scene 3 Slate 13 Take 2 is missing and the line starts midway with ". . . it's just you and me." This isn't a problem—we can run the first part of the dialogue during the shot of Katie at the door (Scene 3 Slate 10 Take 1). To do that, select Scene 3 Slate 13 Take 2 in the Timeline and press Control+S to expand the clip's audio (or double-click on the clip's audio component). Select the audio In point for Scene 3 Slate 13 Take 2 and drag it to the left by 2 seconds 10 frames until it snaps to the start of Scene 3 Slate 10 Take 1 (see Figure 9.24). Play this section to see the result. Joyce's dialogue is now intact, and the overlap with Katie's shot helps smooth out the edit.

FIGURE 9.24
Snapping the audio track to the start of the previous clip.

8. Scene 3 Slate 13 Take 2 cuts back to our original two-shot (Scene 3 Slate 9 Take 2). Although this is a good shot to follow next, some cleanup is required. Joyce repeats the line "Katie, it's just you and me" at the start of the clip, and this extraneous dialogue

needs to be removed. But before we sort out the audio, let's first tighten up the beginning of the clip so that it starts just after Joyce enters the frame. Select the In point for Scene 3 Slate 9 Take 2, and take off the first 17 frames by dragging it to the right (see Figure 9.25). Press Shift+/ (forward slash) to play back the edit.

FIGURE 9.25
Trimming off the first 17 frames of the clip.

The picture cut works better, but we still need to remove Joyce's repeated line. Expand the audio of Scene 3 Slate 9 Take 2 and play back the clip. You can see from the clip's audio waveform that the repeated line ends at 57 seconds 17 frames in the Timeline. We only need to remove this portion, because we still need to keep Joyce's following line "Go on in. Have a look." Select the audio In point for Scene 3 Slate 9 Take 2 and drag it to the right by 1 second and 2 frames so that the audio portion starts at 57 seconds 17 frames in the Timeline (see Figure 9.26). Play back this section and you'll notice an abrupt dip to silence during the missing audio. This is because when we removed the dialogue, we also removed the background audio along with it. We can easily fix this by adding background ambience later when we build up our soundtrack (see Chapter 13). Choose View➤Collapse All Clips to tidy up the audio in the Timeline.

FIGURE 9.26
A missing portion of the clip's audio that causes an abrupt dip in silence.

9. Continue to play the rest of Scene 3 Slate 9 Take 2. Joyce coaxes Katie into the house, and we can continue to use Scene 3 Slate 9 Take 2 for this part of the action. During the clip, Joyce hands Katie her bag and invites her to go upstairs and choose a room

for herself. For the next section, we need to show Katie walking up the stairs to her bedroom. If you look through the footage that we have available in the Event Browser (set the Event Browser's Filter pop-up menu back to All Clips so that it lists everything), you'll see that there are three clips that include this action: Scene 3 Slate 8 Take 1 (our original master shot), Scene 3 Slate 13 Take 2, and Scene 3 Slate 11 Take 1. Remember that Scene 3 Slate 8 Take 1 has a continuity flaw: Joyce doesn't walk over to the stairs to lean on the handrail at the end of the scene. We could, of course, finish the scene with this shot, but it would be nice to end on the close-up of Joyce at the stairs, as shown in Scene 3 Slate 12 Take 2 (see Figure 9.27).

FIGURE 9.27
A close-up on Joyce to finish off the scene.

The next option, Scene 3 Slate 13 Take 2, provides us with different dilemma. If you compare Scene 3 Slate 9 Take 2, the shot we're cutting from, with Scene 3 Slate 13 Take 2, you'll notice that the actors' positions in the frame are reversed. In clip Scene 3 Slate 9 Take 2, Joyce is on the right side and Katie is on the left; but in clip Scene 3 Slate 13 Take 2, Joyce is on the left side and Katie is on the right (see Figures 9.28 and 9.29). This has happened because the camera broke the 180-degree rule during production (also known as *crossing the line*). The 180-degree rule states that the camera should stay on one side of a 180-degree field to keep the screen direction and spatial relationship of the characters or objects on-screen consistent between shots. If we were to edit these two shots together, the cut would be jarring and confusing to the viewer because the left/right relationship of the characters wouldn't be maintained. Directors sometimes deliberately break the rule to cause disorientation in the viewer, but for our purposes this wouldn't be a suitable shot to use next. (You also may have noticed the boom mike that clearly comes into view at the end of the clip, which also renders the shot unusable.)

FIGURE 9.28
The camera is on the correct side of the line for this shot.

FIGURE 9.29
This angle breaks the 180-degree rule, switching the positions of the characters in the frame.

This leaves us with Scene 3 Slate 11 Take 1, which is the high wide angle from the top of the stairs. Press I to mark an In point at 28 seconds 18 frames into the clip, just as Joyce hands Katie her case. Position the playhead at 1 minute, 8 seconds, and 19 frames in the Timeline and press D to overwrite Scene 3 Slate 11 Take 1 to the Primary Storyline.

10. Let's finish the scene as planned with the close-up on Joyce at the stairs. Select and play Scene 3 Slate 12 Take 2 in the Event Browser. A third of the way into the clip, Katie walks across the shot and covers up most of the frame with her body as she does so. We can use this to our advantage and create an artificial wipe into this clip. Mark an In point at 4 seconds 1 frame into Scene 3 Slate 12 Take 2 and position the playhead at 1 minute 17 seconds 5 frames in the Timeline. Press D to overwrite Scene 3 Slate 12

Take 2 into the Primary Storyline. Skim to 1 minute 20 seconds 17 frames in the Timeline and press Option+] (right bracket) to trim the end of the clip. Skim over to 40 seconds 21 frames in the Timeline and play the completed scene.

Now that you've followed along with the examples for Scenes 2 and 3, have a go at editing the rest of the scenes in Act I. All the footage is available in the Setting Up The Story Collection in the Event Library. If you get stuck, open the completed Project we've provided and try to re-create what we've done. The footage has been included on the DVD for you to experiment. The best way to learn is by trying out different shots and takes and seeing for yourself what works.

chapter 10
Cutting Dialogue

IN THIS CHAPTER, you'll be editing two dialogue scenes from the movie *Pranks*. (One of the scenes you worked on in Chapter 9 had dialogue, but the coverage employed in that example wasn't representative of the usual dialogue scene.) You'll regularly come across dialogue scenes when working on narrative-based movies and, depending on the scene and the number of characters involved, they'll typically be covered in a very similar way. A dialogue scene between two characters, for instance, usually will be covered with a two-shot on both characters, a closer single on each, and perhaps a pair of over-the-shoulder shots. Of course, every scene is unique and won't necessarily follow this pattern, but this kind of coverage is standard for the type of shots filmed for most dialogue scenes.

Dialogue Scene One

This first dialogue scene takes place after Katie realizes that there is something strange going on in her new room. Toys that she had previously tidied away inside a toy trunk have mysteriously reappeared where she found them. Katie is convinced that there is another presence in the house and aims to find out who it is. The main function of this scene is to articulate Katie's objective in the story, by posing it as a question. Who is playing tricks on Katie and how will she deal with this? This is what Katie (and hopefully, the audience) wants to find out by the end of the movie.

With her goal now in place, Katie's first course of action is to raise her concerns with her new foster mother, but she faces her first obstacle when Joyce doesn't take her seriously. Instead, the scene begins with Joyce dismissing Katie's suspicions by explaining away the strange events and leaving Katie to deal with the situation herself.

During the scene, we also get to learn a little more about Katie through her conversation with Joyce. When asked whether she minds being the only child in the house, Katie simply shrugs. She also spurns Joyce's offer to play with her if she gets lonely. Clearly Katie doesn't seem to play nice with others and this scene continues to establish her attitude, which is paid off at the end of the story when Katie sees the error of her ways through her interactions with Jason.

Joyce's objective is also important to the scene. As Katie's new foster mother, she undoubtedly wants to develop a bond with Katie and be seen by her as a parental figure that Katie can depend on. This is clearly demonstrated through all the offers of help that Joyce has been making in the story so far. As both characters seem to have opposing attitudes, watching them deal with the strange events in the house brings some extra conflict to the story.

Now that we know what the scene is about, let's look at the footage that we have to work with.

Evaluating the footage

This is a straightforward dialogue scene between two characters that is simply covered with four angles and uses fairly standard coverage. The footage is basically comprised of a two-shot on both characters and a single on each. You'll come across variations on this type of coverage when dealing with other dialogue scenes in future projects, so this is a good scene to cut your teeth on.

Double-click the *Craft of the Cut* disc image to mount it and launch Final Cut Pro. Open the Event Library and select the Cutting Dialogue-1 Collection inside the Pranks Media Event to display the clips that you'll be working with in the Event Browser.

The Cutting Dialogue-1 Collection is made up of the following clips:

- **Scene 7 Slate 15 Take 4:** A wide two-shot master that covers the entire scene from start to finish and features both characters in the shot (see Figure 10.1)

- **Scene 7 Slate 16 Takes 1 and 2:** Two takes featuring Katie's side of the dialogue presented in a medium close-up

- **Scene 7 Slate 17 Take 3:** A medium close-up of Joyce's side of the dialogue

- **Scene 7 Slate 18 Take 2:** A second medium shot of Katie turning over in bed to end the scene

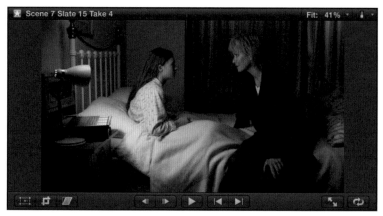

FIGURE 10.1 A typical example of a two-shot master featuring two characters.

To follow along with the next exercise, you'll first need to rate some Favorite clips for Cutting Dialogue-1. Drag a selection range or set In and Out points at the times specified below; then rate these areas as Favorites:

- **Scene 7 Slate 16 Take 1:** Between 26:23 and 36:12 (the end of the clip)

- **Scene 7 Slate 16 Take 2:** Between 06:03 and 10:22 and between 19:05 and 30:23

- **Scene 7 Slate 17 Take 3:** Between 00:00 (the start of the clip) and 07:19 and between 18:19 and 31:11

- **Scene 7 Slate 18 Take 2:** Between 06:02 and 19:08 (the end of the clip)

Before proceeding to the next section, choose a hard drive in the Project Library, create a new Project, and name it Cutting Dialogue-1.

Exploring the edit

Before you begin to edit Scene 7, reread this scene in the shooting script. You'll notice that some of the dialogue in the script doesn't always match what was spoken in the footage you just evaluated. This is because the actors improvised some of the dialogue during the shoot. This is a good example of how a movie's story can evolve during its journey from script to screen. With that in mind, let's cut the scene.

1. Make sure the Event Browser's Filter pop-up menu is set to All Clips, and then select and play Scene 7 Slate 15 Take 4 a few times to get an idea of how the scene plays out. This scene is fairly short at only 41 seconds in duration, and the dialogue between the two actresses provides a good rhythm for us to work to. The performances should always guide the editing of a scene, especially when cutting dialogue, and you should look to the characters' actions and reactions as indications of when to cut to a new shot. Scene 7 Slate 15 Take 4 is a wide-angle master that covers the entire scene; it's a perfect shot to start off with because it gives us a good foundation to build the rest of the coverage on. The rest of the edit is simply a case of replacing sections of the master with closer angles. Select Scene 7 Slate 15 Take 4 in the Event Browser and press E to append the clip to the Primary Storyline.

2. Switch the Event Browser's Filter pop-up menu to Favorites and play Scene 7 Slate 17 Take 3 (first favorite). In this medium close-up of Joyce, her delivery of the line "Katie listen. There's no one here . . ." differs greatly from how the line was delivered in the master shot (see Figure 10.2). Joyce comes across as more compassionate here than she does in the master, and because Joyce's intention in the scene is to form a connection with Katie, this is a far more preferable take. Place the playhead at 7 seconds and 12 frames on the Timeline, just after Joyce delivers the line "Katie, listen to me," and press W to insert Scene 7 Slate 17 Take 3 into the Primary Storyline.

FIGURE 10.2
A single medium
shot of Joyce.

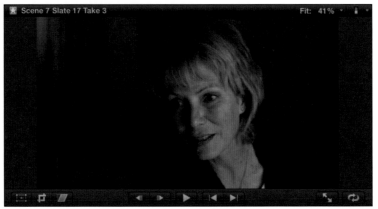

3. Play back the first two shots in the Timeline, and you'll hear Joyce repeat the line "Katie, listen" a second time. This is easily remedied with a Ripple edit. Select the edit point at the start of Scene 7 Slate 17 Take 3 and drag it 2 seconds and 3 frames to the right (see Figure 10.3).

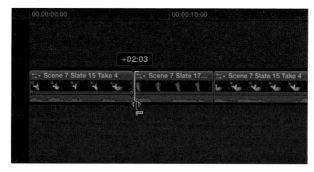

FIGURE 10.3
A Ripple edit removes Joyce's repeated line.

4. Press Shift+/ (forward slash) to play back the edit. The second instance of "Katie, listen" has been eliminated, but the edit on Joyce's line ("There's no one here . . .") is quite abrupt because the line is delivered exactly on the cut. We can smooth this out with a simple Roll edit. Press T to bring up the Trim tool, and click on the edit point between Scene 7 Slate 15 Take 4 and Scene 7 Slate 17 Take 3 (the first two clips in the Timeline). Roll the edit forward by 5 frames so that the edit starts on "no one here" (Figure 10.4). Play back the edit to hear the result.

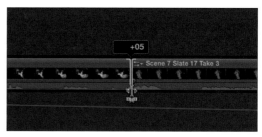

FIGURE 10.4
A Roll edit smooths out a hard cut on dialogue.

5. The edit is still not smooth enough because we're cutting the clip's audio in the middle of the line. Press A to switch back to the Select tool and make sure snapping is turned on (pressing N toggles snapping on and off). Control-click the first clip (Scene 7 Slate 15 Take 4) and choose Expand Audio/Video from the shortcut menu to expand the clip's audio track. Select the audio Out point for Scene 7 Slate 15 Take 4, and drag the audio to the left by 19 frames to eliminate the word "There's . . ." (see Figure 10.5).

FIGURE 10.5
Trimming the
audio to
eliminate
extraneous
dialogue.

Double-click the waveform portion of the second clip (Scene 7 Slate 17 Take 3) to expand the audio, select the front end of the audio track, and drag it 19 frames to the left so that it joins the first clip's audio (see Figure 10.6). Select the first two clips in the Timeline and press Control+S to collapse the audio tracks. Play back the edit to hear the result. The edit works a lot better now because Joyce gets her point across to Katie without the cut sounding overly harsh.

FIGURE 10.6
Extending a
clip's audio track
into the
previous clip.

6. Select Scene 7 Slate 16 Take 2 (first favorite) in the Event Browser and press / (forward slash) to play the clip. This is a medium close-up of Katie listening to Joyce explain away her concerns that there is someone else in the house. This would be a good shot to cut to next because the audience will be curious to see Katie's reaction to Joyce's answer (see Figure 10.7). Does she believe what Joyce is saying? Katie remains unconvinced but decides not to pursue the issue further. The shot ends on her line "Can you pass me Kitty?" (referring to her stuffed toy cat, a line improvised by the actress and not in the script). Place the playhead at the end of the second clip (Scene 7 Slate 17 Take 3) at around 13 seconds and 5 frames on the Timeline and press D to overwrite Scene 7 Slate 16 Take 2 to the Primary Storyline.

FIGURE 10.7
A single medium
shot on Katie.

7. Select the second clip in the Timeline (Scene 7 Slate 17 Take 3) and press Control+S to expand its audio track. Select the video Out point and ripple to the left by 1 second and 22 frames so that we cut to Katie when Joyce says "living in this house for ages" (see Figure 10.8).

FIGURE 10.8
Selecting a clip's
video Out point
for Scene 7 Slate
16 Take 2.

If you expand the audio for Scene 7 Slate 16 Take 2, you can see that it overlaps the previous clip's audio (see Figure 10.9). Select the audio In point for Scene 7 Slate 16 Take 2 and drag it to the right by 1 second and 22 frames so that it joins with the audio track of the clip before it (see Figure 10.10). Select the two clips that have their audio expanded in the Timeline and press Control+S to collapse them.

FIGURE 10.9
A clip's
audio track
overlapping into
the next clip.

8. Play back the first four clips in the edited sequence. Katie repeats the line "Can you pass me Kitty?" when the scene cuts back to the master shot. Let's remove the extra dialogue with a Ripple edit. Select the fourth clip's In point (Scene 7 Slate 15 Take 4) and ripple to the right by 4 seconds and 2 frames, to just before Joyce reaches for the toy (see Figure 10.11). We need to cut back to the master because there's new information (Joyce reaching for the toy) that isn't visible in the closer coverage of the scene. This wider angle also provides a short breather before Joyce's next attempt to bond with Katie by offering to play with her if she gets lonely.

9. Select and play Scene 7 Slate 17 Take 3 (second favorite) in the Event Browser. This is a different section of Joyce's medium close-up where she makes her offer to play with Katie. There's a touching element of expectancy in the actress's performance in this clip, so it would be good to cut to this shot at this moment in the scene. Press ⌘+2 to select the Timeline. Click the Dashboard so that it turns blue, and enter **25.23** to place the playhead at 25 seconds and 23 frames on the Timeline. Press W to insert the second instance of Scene 7 Slate 17 Take 3 in the Primary Storyline.

10. Select Scene 7 Slate 16 Take 2 (second favorite) in the Event Browser and play the clip. This is another section from Katie's medium close-up that shows her taking Kitty from Joyce and shrugging at Joyce's question ". . . are you sure you're not going to be lonely?" We can use this as a cutaway by adding the shot to the Primary Storyline as a Connected clip. Place the playhead at 23 seconds and 23 frames on the Timeline and select Video Only from the Toolbar's Source Media pop-up menu so as to exclude the clip's audio when we add it to the edited sequence (see Figure 10.12).

FIGURE 10.12
Selecting Video
Only from the
Toolbar menu.

Press Q to connect the second instance of Scene 7 Slate 16 Take 2 to the Primary Storyline. Press Shift+1 to return the Source Media back to All and play back the section to see the result. The Connected clip could do with some trimming because it's a little long and covers most of Joyce's dialogue. Select the end of the Connected clip and drag it to the left by 6 seconds so that it ends just before Joyce says "... I can always do things with you if you like" (see Figure 10.13).

FIGURE 10.13
Trimming a
Connected clip.

11. Select Scene 7 Slate 16 Take 1 in the Event Browser and play the clip. This is a different take of Katie's medium close-up that shows her refusal of Joyce's offer with the line "That's okay. I've got Kitty." Let's place this just after Joyce says "... I can always do things with you if you like." Place the playhead at 32 seconds and 12 frames on the Timeline and press W to insert Scene 7 Slate 16 Take 1 into the Primary Storyline. To smooth out the cut, select Scene 7 Slate 16 Take 1 in the Timeline and press Control+S to expand its audio. Select the video In point for Scene 7 Slate 16 Take 1 and ripple to the right by 8 frames. Double-click the audio portion of the clip to collapse it (see Figure 10.14).

FIGURE 10.14
Smoothing the
cut by rippling a
clip's video.

12. Once Katie says, "That's okay. I've got Kitty" the audience will want to see Joyce's reaction to Katie's brush-off. If you play back the rest of the sequence from this point, you'll see that the single on Katie (Scene 7 Slate 16 Take 1) plays on to the end of the scene where Katie rolls over in bed to go to sleep. There's also a second instance of the line "That's okay. I've got Kitty" when we cut back to Joyce's single (Scene 7 Slate 17 Take 3) that we also need to eliminate. Position the playhead at 35 seconds on the Timeline just after Katie says, "That's okay. I've got Kitty" and press M to place a marker on the Primary Storyline. Place a second marker at 44 seconds and 15 frames just after Katie repeats the line. Make sure snapping is turned on and press R to select the Range tool. Drag out a selection range between the two markers on the Primary Storyline (across clips Scene 7 Slate 16 Take 1 and Scene 7 Slate 17 Take 3), and then press the Delete key to remove this section from the Timeline (see Figure 10.15).

FIGURE 10.15
Dragging out a
selection range
with the Range
tool.

13. Let's smooth out the transition between Scene 7 Slate 16 Take 1 and Scene 7 Slate 17 Take 3 by moving the edit point a little earlier to when Katie says the word "Kitty." Press T to bring up the Trim tool so that we can move the edit point with a roll edit. If you look at the end of the audio waveform for Scene 7 Slate 16 Take 1, you can clearly see the peaks for each word in Katie's line "I've got Kitty." The first two peaks represent the words "I've" and "got" and the third and fourth peaks represent the two syllables in the word "Kitty" (see Figure 10.16). Click the edit point between Scene 7 Slate 16 Take 1 and Scene 7 Slate 17 Take 3, and roll it to the left by 12 frames to place it between the second and third peaks in the audio waveform (see Figure 10.17). Press A to go back to the Select tool.

FIGURE 10.16
Each syllable of
Katie's dialogue
is clearly
represented by
the peaks in the
clip's waveform.

FIGURE 10.17
Rolling the edit
point between
the peaks in the
audio waveform.

14. If you play back the edit, you'll hear an overlap occur over the word "Kitty." If you expand the audio for Scene 7 Slate 16 Take 1, you can see that it overlaps across the length of Scene 7 Slate 17 Take 3. We can keep this because it helps smooth the transition between the two clips, and we can eliminate the word "Kitty" that occurs during Scene 7 Slate 17 Take 3 instead. The easiest solution here is to remove the audio from Scene 7 Slate 17 Take 3 entirely, because this is now essentially just a cutaway shot of Joyce's reaction. Control-click Scene 7 Slate 17 Take 3 in the Timeline, and choose Detach Audio from the shortcut menu. This action disconnects the audio from the clip and displays it as a separate clip in the Timeline (see Figure 10.18). Select the detached audio clip and press Delete to remove it.

FIGURE 10.18
A clip's detached
audio in the
Timeline.

15. If you play the sequence from this point, you'll see that the master shot that follows Joyce's reaction contains a lot of repeated material that we've already covered with closer angles. Let's remove this extraneous footage. Position the playhead at 36 seconds and 10 frames in the Timeline (over Scene 7 Slate 17 Take 3) and press I to add an In point. Skim to 47 seconds and 20 frames on the Timeline and press O to add an Out point. Press Delete to remove this selection.

16. The edited sequence now cuts from the single on Joyce, depicting her reaction to Katie's snub, to the wider two-shot as Katie rolls over into bed. The cut to the wider angle works here because it reinforces Katie's brush-off through the body language of the two performers, and you can clearly feel Joyce's disappointment as she is left there to sit alone. Let's punctuate the scene with the second medium shot of Katie rolling over into bed. Position the playhead at 38 seconds and 2 frames on the Timeline, and make sure the Filter pop-up menu in the Event Browser is still set to Favorites.

Select Scene 7 Slate 18 Take 2 and press D to overwrite the clip to the Primary Storyline. The shot ends with Joyce turning off the bedside lamp and walking out of the room. This action is unnecessary, because the final point of the scene has been made once Katie rolls over into bed. Position the playhead at 41 seconds and 2 frames on the Timeline and press ⌘+B to cut the clip. Select the second half of Scene 7 Slate 18 Take 2 (the last clip in the sequence) and press Delete to remove it.

17. Let's tidy up the Timeline. Control-click the Connected clip (Scene 7 Slate 16 Take 2), and choose Overwrite to Primary Storyline from the shortcut menu to place it inside the main sequence. Choose View➡Collapse All Clips to collapse any expanded audio tracks, and press Shift+Z to fit the entire sequence in the Timeline. Play back the entire sequence to see the result.

Dialogue Scene Two

The second dialogue scene that you're going to work on follows on from the Bump in the Night sequence that you edited during the first part of the book. Bump in the Night demonstrated that Katie's suspicions are correct and that there is another presence residing in the house. Katie still needs to persuade Joyce of this. The scene begins with Joyce continuing to justify the strange occurrences in the house, even going so far as to suggest that Katie could have dreamed it all. Katie is convinced that the person who is playing tricks on her is someone named Jason, as revealed through the alphabet blocks in the previous scene. Katie confronts Joyce with this information, and Joyce is visibly alarmed when Jason is mentioned by name. Joyce's reaction provides a vital clue for the audience, because she clearly knows whom Katie is referring to, even though Joyce refuses to believe her. With her second attempt to seek Joyce's help rejected, the pressure is on for Katie to deal with Jason herself. Let's cut the scene.

Evaluating the footage

Double-click the *Craft of the Cut* disc image to mount it and launch Final Cut Pro. Open the Event Library and select the Cutting Dialogue-2 Collection inside the Pranks Media Event to display the clips that you'll be working with in the Event Browser.

The Cutting Dialogue-2 Collection is made up of the following clips:

○ **Scene 11 Slate 19 Take 3:** A wide master of the entire scene that features both characters (see Figure 10.19)

○ **Scene 11 Slate 20 Take 1:** A medium shot of Joyce's side of the dialogue that runs through the entire scene

○ **Scene 11 Slate 21 Take 3:** A medium shot of Joyce's side of the dialogue starting from "It wasn't a dream"

◯ **Scene 11 Slate 22 Take 2:** A medium shot of Katie's side of the dialogue that covers the first half of the scene up to "It wasn't a dream"

◯ **Scene 11 Slate 23 Takes 2 and 3:** A medium shot of Katie's side of the dialogue that runs through the entire scene

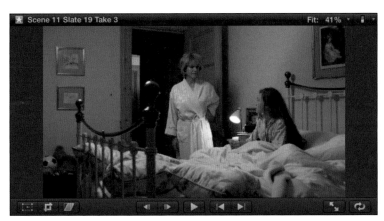

FIGURE 10.19
A wide master featuring both characters.

To follow along with the next exercise, you first need to rate some Favorite clips for Cutting Dialogue-2. Drag a selection range or set In and Out points at the times specified below; then rate these areas as Favorites:

◯ **Scene 11 Slate 20 Take 1:** Between 00:00 (the start of the clip) and 02:08 and between 40:00 and 49:22 (the end of the clip)

◯ **Scene 11 Slate 21 Take 3:** Between 02:18 and 20:11

◯ **Scene 11 Slate 22 Take 2:** Between 00:00 (the start of the clip) and 06:16

◯ **Scene 11 Slate 23 Take 2:** Between 07:10 and 10:01

◯ **Scene 11 Slate 23 Take 3:** Between 13:19 and 27:21

Create another new Project and name it Cutting Dialogue-2.

Exploring the edit

Cutting dialogue scenes obviously require a good deal of audio manipulation to get the scene flowing smoothly. The next exercise focuses on the various ways of working with audio in the Timeline and incorporates a lot more L-cuts and J-cuts in the edit.

1. Set the Event Browser's Filter pop-up menu to All Clips and play Scene 11 Slate 19 Take 3 to view the shot. Once again, we'll start by laying down the master shot to give us a foundation to work from; however, this doesn't mean that every scene needs to start with a wide angle. By this stage of the story, the bedroom location has been well established, so the viewers should have no trouble orientating themselves to where the scene is taking place. The master is placed here first to provide a frame of reference to build the rest of the coverage on. Select Scene 11 Slate 19 Take 3 in the Event Browser and press E to append the clip to the Primary Storyline.

2. Most of the master shot that we've just added to the Timeline will be replaced with closer angles of the action. In fact, the only time we'll cut to the master is when Katie walks over to the bed because we need to be in a wider angle in order to see this action performed. Switch the Event Browser's filter pop-up menu to Favorites, and play Scene 11 Slate 22 Take 2. This is a medium shot of Katie searching for evidence of a disturbance and insisting that there is someone in the room playing tricks on her. The clip ends with Katie placing the ball back in the toy box, and we can use this action to cut to the master just before she walks over to the bed. Position the playhead at 8 seconds and 3 frames in the Timeline, and press Shift+D to overwrite Scene 11 Slate 22 Take 2, which will align the Out point with the playhead position on the Primary Storyline.

3. Let's roll the edit point back to smooth out the transition between Katie's medium shot and the wider master. Select Scene 11 Slate 22 Take 2 in the Timeline and press Control+S to expand its audio. Press T to bring up the Trim tool and select the video-only portion of both sides of the edit point between Scene 11 Slate 22 Take 2 and Scene 11 Slate 19 Take 3 (see Figure 10.20). Roll the edit point to the left by 10 frames so that the cut happens during Katie's action of placing the ball back in the toy box. Press A to switch back to the Select tool, and press Shift+/ (forward slash) to play back the edit.

FIGURE 10.20
Selecting the video edit points before a roll edit.

4. Select Scene 11 Slate 20 Take 1 in the Event Browser (first favorite) and play the clip. In this medium shot, Joyce suggests a possible explanation for how the camera could be snapping photos by itself, continuing the question raised in the previous scene. This would be a good shot to start the scene off. Click the Dashboard so that it turns blue

and enter **4.10** to place the playhead at 4 seconds and 10 frames on the Timeline (over Scene 11 Slate 22 Take 2). Press Shift+D to overwrite Scene 11 Slate 20 Take 1, which will align the Out point with the playhead position.

5. Press the Home key to go to the beginning and press the Spacebar to play back the sequence. We still have two extraneous clips at the start of the sequence that need to be eliminated. Select the first two clips in the sequence and press Delete to remove them (see Figure 10.21). The edited sequence should now start with Joyce's medium shot (Scene 11 Slate 20 Take 1).

FIGURE 10.21
Selecting the first two clips in the sequence to be deleted.

6. Double-click the audio waveform to expand the first clip in the Timeline (Scene 11 Slate 20 Take 1) and select the video Out point (see Figure 10.22). We'll smooth out the edit point by rippling the picture to the left by 10 frames, but this time we'll do it numerically using the keyboard. Make sure that the playhead is at the end of Scene 11 Slate 20 Take 1, click the Dashboard so that it turns blue, enter **–10**, and press Return. This takes the playhead back by 10 frames and places it at 1 second and 23 frames in the Timeline. Press Option+] (right square bracket) to perform the ripple edit.

FIGURE 10.22
Selecting a clip's video Out point before a Ripple edit.

7. Select Scene 11 Slate 23 Take 2 in the Event Browser and play the clip. Katie spins round at the start of the clip to say, ". . . it wasn't a dream." This is a good shot to cut to from the master after she walks to the bed because it gives us an action to cut on (Katie's turn to face Joyce) and allows us to move into tighter coverage for the sequence (see Figure 10.23). Position the playhead at 14 seconds and 6 frames in the Timeline

and press D to overwrite Scene 11 Slate 23 Take 2 to the Primary Storyline. Play back the edit to see the result.

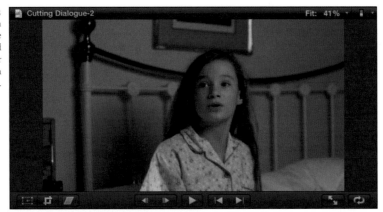

FIGURE 10.23
This medium shot of Katie provides a good example for cutting on action.

8. The cut from the master to Katie's medium shot could clearly do with some work. We're trying to create the effect that Katie is interrupting Joyce, but at the moment Joyce's dialogue cuts off abruptly and there is a short gap of silence before Katie speaks. To fix this, select Scene 11 Slate 19 Take 3 (the third clip in the Timeline) and press Control+S to expand its audio. Press ⌘+= (equal sign) to zoom in closer to the edit point and drag the end of the audio Out point to the right by 4.35 frames (see Figure 10.24).

FIGURE 10.24
Dragging a clip's audio over to the following clip.

This creates an overlap between the two characters' dialogue, but the end of Joyce's speech still cuts off rather abruptly. Let's smooth this out further with an audio fade. Select the audio fade handle at the end of Scene 11 Slate 19 Take 3 (you may need to adjust the Clip Height in the Clip Appearance panel to make this clearer to see) and drag it to the left by 4 frames (see Figure 10.25). Press Shift+/ (forward slash) to play

back the edit. The sound works well now, but the picture cut can still be refined further. The timing of the edit doesn't need any adjusting, so we can simply move the picture's edit point with a Roll edit. Expand the audio for Scene 11 Slate 23 Take 2 and press T to bring up the Trim tool. Select the video-only portion of both sides of the edit point between Scene 11 Slate 19 Take 3 and Scene 11 Slate 23 Take 2, and roll the edit point to the right by 8 frames. Press A to switch back to the Select tool and play back the first four clips in the sequence.

FIGURE 10.25
Adjusting the audio fade handles to smooth out the sound.

9. After Katie counters Joyce's explanation with "... it wasn't dream," it would be appropriate to see Joyce's response. Make sure the Filter pop-up menu is still set to Favorites in the Event Browser, and then select and play Scene 11 Slate 21 Take 3. This medium shot of Joyce's reaction is just the shot we need to cut to next in the sequence (see Figure 10.26). Position the playhead at the end of the fourth clip (Scene 11 Slate 23 Take 2) in the sequence (this should be at 16 seconds and 22 frames in the Timeline) and press D to overwrite Scene 11 Slate 21 Take 3 to the Primary Storyline.

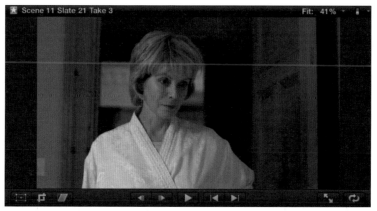

FIGURE 10.26
This medium shot provides us with a good reaction to cut to.

10. Again, let's smooth out the edit by cutting to the audio of Scene 11 Slate 21 Take 3 before the picture. Expand the audio for Scene 11 Slate 21 Take 3 and select the video In point so that the ripple symbol points to the right; then ripple the picture by dragging to the right by 1 second (see Figure 10.27). Play back the edit. The beginning of Joyce's line "okay" now starts during Katie's medium shot. Press T to select the Trim tool and select the video portion of both edit points (the fourth edit in the sequence) and press the period key four times to roll the edit point 4 frames forward. Press A to switch back to the Select tool.

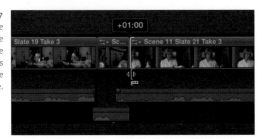

FIGURE 10.27
Rippling the video to the right so that the audio starts before the picture.

11. Press the Home key to take the playhead to the start of the Primary Storyline and play the sequence up to Joyce's medium shot where she asks, "Do you want me to stay with you until you fall asleep?" We obviously need to cut to Katie for her reply to Joyce's question, but there's a great reaction toward the end of Joyce's clip (Scene 11 Slate 21 Take 3) that we should keep for later. Position the playhead at 30 seconds and 12 frames in the Timeline (over Scene 11 Slate 21 Take 3 just before Joyce says, "What?") and press ⌘+B to slice the end of the clip. Control-click the second half of the sliced clip and choose Lift from Primary Storyline from the shortcut menu. This action turns Joyce's reaction at the end into a Connected clip and places a gap clip beneath it in the Primary Storyline (see Figure 10.28). Now we're free to overwrite onto the first part of the sliced clip without affecting the end section.

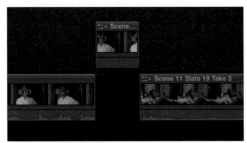

FIGURE 10.28
Lifting a clip from the Primary Storyline.

12. Select Scene 11 Slate 23 Take 3 (Favorite) in the Event Browser and play the clip. So far, we've been using Take 2 of Katie's medium shot, but we prefer the actress's performance in Take 3 for the second half of the scene. Her expression as she pulls up the bed covers really sells her frustration with Joyce's skepticism, so let's include it in the sequence. Position the playhead at 21 seconds and 21 frames in the Timeline, just before Joyce says, ". . . stay with you until you fall asleep?" and press D to overwrite Scene 11 Slate 23 Take 3 to the Primary Storyline.

13. If you play back the edit, you'll hear overlapping dialogue during Scene 11 Slate 23 Take 3. Expand the audio for both Scene 11 Slate 21 Take 3 and Scene 11 Slate 23 Take 3 (the fifth and sixth clips in the Timeline), and you'll see that the audio for Scene 11 Slate 21 Take 3 overlaps into Scene 11 Slate 23 Take 3 (see Figure 10.29). This can easily be fixed with a simple audio trim.

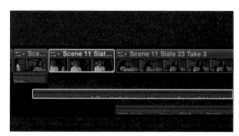

FIGURE 10.29
An expanded clip showing an overlap into the following clip.

Select Scene 11 Slate 23 Take 3 and press V to disable the clip. Scene 11 Slate 23 Take 3 becomes dimmed in the Timeline and is rendered invisible and inaudible when played back (figure 10.30). Position the playhead at 25 seconds and 12 frames in the Timeline and press M to place a marker just after Joyce says, "...until you fall asleep?" Make sure snapping is turned on then select the Out point for Scene 11 Slate 21 Take 3's audio and drag it to the left so that the end of the audio snaps to the marker. Select Scene 11 Slate 23 Take 3 and press V to enable the clip.

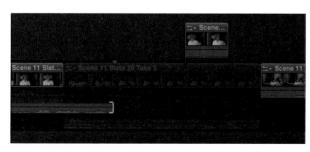

FIGURE 10.30
Disabling a clip in the Timeline.

14. Select Scene 11 Slate 21 Take 3 and press V to disable the clip. Play back Scene 11 Slate 23 Take 3 in the sequence and stop just after Joyce says, "fall asleep," at 24 seconds and 23 frames in the Timeline. Select the In point for the audio of Scene 11 Slate 23 Take 3, and drag it to the right so that the end of the audio snaps to the playhead (see Figure 10.31). Select Scene 11 Slate 21 Take 3 and press V to enable the clip. If you play back this section, you'll hear that the dialogue no longer overlaps.

FIGURE 10.31
Snapping the
audio to the
playhead.

15. Press the Home key to go to the start and play back what you've edited so far. There is too long a pause between Katie's line "If Jason comes back, I'll deal with him myself" and the cut to Joyce's reaction. Also Joyce's line "What?" can be heard twice on the soundtrack at around 30 seconds into the sequence. This can easily be fixed with a Ripple edit, but Joyce's reaction shot is now a Connected clip and will need to be placed back into the Primary Storyline before we can trim it. To do this, Control-click the Connected clip (Scene 11 Slate 21 Take 3) and choose Overwrite to Primary Storyline from the shortcut menu or select the Connected clip and press Option+⌘+Down Arrow.

16. With Joyce's reaction shot incorporated into the Primary Storyline, we're now free to use our trim tools to tighten the edit. Select the first instance of Scene 11 Slate 23 Take 3 in the Timeline and press Control+S to expand its audio. Select the video Out point for Scene 11 Slate 23 Take 3 and ripple it to the left for 1 second and 6 frames so that it ends at 29 seconds and 6 frames in the Timeline (see Figure 10.32).

FIGURE 10.32
Rippling the
video Out point
by 1 second and
6 frames.

17. The cut to Joyce is much tighter, but we still have two instances of Joyce saying "What?" Position the playhead at 29 seconds and 18 frames in the Timeline just after Katie says, "If Jason comes back, I'll deal with him myself," and press M to place a marker. Make sure snapping is turned on; then select the audio Out point for Scene 11 Slate 23 Take 3 and drag it to the left so that it snaps to the marker (see Figure 10.33).

FIGURE 10.33
Snapping a clip to a marker on the Primary Storyline.

18. If you play the sequence from when Joyce says, "What?" you'll notice that we're missing part of Katie's line when we cut back to Katie's medium shot. Expand the audio for the second instance of Scene 11 Slate 23 Take 3 in the Timeline (if it's not already expanded), select the audio In point, and drag to the left by 1 second and 19 frames so that the audio starts at 30 seconds and 15 frames in the Timeline (see Figure 10.34). The first part of Katie's dialogue ("He wants his room back. But he's not getting it.") plays over the shot of Joyce. Katie's explanation has some meaning for Joyce because Katie is talking about Joyce's deceased son (which is revealed at the end of the story). Staying on Joyce's reaction shot as Katie speaks provides the audience with a subtle clue as to who could be behind the disturbances in the house.

FIGURE 10.34
Moving an audio track into the previous clip.

19. However, Katie's dialogue now comes in too quickly after Joyce says "What?" Let's move her dialogue a second later by extending Joyce's medium shot. Make sure the audio of Scene 11 Slate 21 Take 3 is expanded, select its video Out point, and drag it to

the right by 1 second (see Figure 10.35). Let's also tidy up the audio. Select the audio Out point of Scene 11 Slate 21 Take 3 and drag it to the left so that it snaps to the front of the audio for Scene 11 Slate 23 Take 3 at 31 seconds and 14 frames in the Timeline.

FIGURE 10.35
Extending a
clips video with
a Ripple edit.

20. Play back the previous section. The timing of the dialogue works well, but the cut back to Katie as she says "But he's not getting it" could do with some refining. We don't want to alter the timing of the audio, so we'll use a Roll edit to move the picture back by a few frames, which should give us a smoother edit. Press T to bring up the Trim tool and select the video edit points between Scene 11 Slate 21 Take 3 and Scene 11 Slate 23 Take 3 (the seventh and eight clips in the sequence). Press the comma key five times to roll the edit point to the left by 5 frames. The picture edit should now begin at 33 seconds and 5 frames in the Timeline (see Figure 10.36). Press A to switch back to the Select tool and press Shift+/ (forward slash) to play back the edit.

FIGURE 10.36
Moving the
picture back
with a Roll edit.

21. All that's left to do is add a shot of Joyce's response to Katie's theory. Select Scene 11 Slate 20 Take 1 (second favorite) in the Event Browser and play the clip. This medium shot of Joyce provides further evidence that she knows who Katie is speaking about and is a good shot to end on because it raises a new question to take us into the next scene. Position the playhead at 34 seconds and 14 frames in the Timeline, just after Katie says, "He wants his room back. But he's not getting it," and press D to overwrite Scene 11 Slate 20 Take 1 to the Primary Storyline. Choose View➜Collapse All Clips to collapse any expanded audio tracks, and press Shift+Z to fit the entire sequence in the Timeline. Press the Home key to go to the beginning and play your completed sequence.

A cut to a new shot should always deliver new information to an audience, and in a dialogue scene this information is expressed both verbally and through the facial expressions of the characters on-screen. The nuances of the actors' performances often tell the editor when to cut; this is especially true when editing a dialogue scene. An editor should cut when it feels right, based on her emotional sense of what the characters are experiencing in the story. It's never simply a case of cutting to the character who's speaking next, because the character who's listening is also imparting important information through facial expressions and reactions to what's being said. After all, if a character were receiving bad news in a scene, wouldn't you rather see how that character responds to the news rather than watch the person delivering it? Of course, this all depends on the context of the scene. Just remember that what a character says with body language is just as important as what a character says with words.

You've just worked through two example dialogue scenes and, hopefully, you've picked up a few techniques that you can apply to your own work. You've seen that cutting picture and sound together when switching between characters is best avoided. You've also learned that a scene flows more naturally when the pictures either precede or follow the audio with the use of L-cuts and J-cuts. Experiment with your own edit of the previous two scenes, but cut when it feels right to you. You'll end up with completely different versions that reflect your own sensibilities as an editor.

chapter 11
Editing Action

IN THIS CHAPTER, we take a look at editing action. When you think of an action scene, you may think of car chases and fistfights, but for our purposes, action is simply any scene that features a character involved in some kind of activity. This can be anything from a secret agent involved in a high-octane car chase to a hapless chef attempting to bake a cake. Unlike dialogue scenes, which usually employ similar coverage, action scenes are constructed from different types of shots that are unique to the activity that is being carried out in the scene. Even though each action scene is distinct and individual, the focus is always on the character attempting to execute the activity and whether that character will achieve what she has set out to do. This character objective is inherent to all action scenes, and it's what you work with as an editor to escalate suspense and tension by making it seem unlikely that the character will attain her goal.

The Staircase Sequence

In this chapter, we'll work on the staircase sequence from *Pranks*. This sequence concerns Katie's attempts to snap a photograph of Jason so that she can prove to Joyce that there has been someone else in the house playing tricks on her. The sequence is made up of scenes 12, 14, 15, and 16. Scene 13 was a short scene that featured Katie peeking into Joyce's bedroom to check that she is sleeping and was dropped from the final film.

Before we begin to work on this sequence let's break it down into four smaller sections:

- ○ **Scene 12 - INT. KATIE'S ROOM - NIGHT:** Katie is awakened by the sound of a ball bouncing repeatedly against the wall. Katie slips out of bed, grabs the camera, and goes in pursuit of the culprit with the objective of obtaining photographic evidence that she can show Joyce.

- ○ **Scene 14 - INT. STAIRCASE (SECOND LEVEL) - NIGHT:** Katie creeps along the top landing looking for Jason. She sits at the top of the stairs, winds her camera, and waits for Jason's reappearance. The sound of the bouncing ball alerts Katie to Jason's presence at the bottom of the staircase, and she carefully poises herself to take the photo. Jason runs off and Katie chases down the stairs after him.

- ○ **Scene 15 - INT. THE LANDING (FIRST LEVEL) - NIGHT:** Katie sneaks along the bottom landing and is clearly starting to enjoy this cat-and-mouse game with Jason.

- ○ **Scene 16 - INT. STAIRCASE (FIRST LEVEL) - NIGHT:** Katie ducks down behind the stairs and giggles to herself as she watches Jason, demonstrating that she may be finally coming out of a shell and be more willing to play with others.

The remainder of this chapter walks you through Scenes 12 and 14 of this sequence, leaving Scene 15 and 16 for you to try for yourself.

Evaluating the footage

Mount the *Craft of the Cut* disc image and launch Final Cut Pro. Open the Event Library and select the Editing Action Collection inside the Pranks Media Event to display the clips that you'll be working with in the Event Browser. You may want to organize the files for Scenes 12 and 14 into keyword collections to make the media easier to find.

Make sure the Event Browser's Filter pop-up menu is set to All Clips and mark the following clips in the Editing Action Collection as Favorites using these timecodes:

○ **Scene 14 Slate 40 Take 2:** Between 56:03 and 58:16 and between 01:06:23 and 01:08:19

○ **Scene 14 Slate 40 Take 3:** Between 38:01 and 41:17

○ **Scene 14 Slate 43 Take 1:** Between 42:09 and 43:19

○ **Scene 14 Slate 43 Take 4:** Between 00:11 and 01:09 and between 15:01 and 20:01

○ **Scene 14 Slate 47 Take 2:** Between 13:02 and 31:03

○ **Scene 14 Slate 47 Take 3:** Between 01:13 and 07:07

○ **Scene 14 Slate 48 Take 2:** Between 04:05 and 16:16

○ **Scene 12 Slate 62 Take 5:** Between 05:00 and 27:03

○ **Scene 12 Slate 63 Take 4:** Between 19:21 and 31:15

○ **Scene 12 Slate 64 Take 1:** Between 02:01 and 05:21

○ **Scene 12 Slate 64 Take 3:** Between 25:12 and 31:22

Let's start by creating a new project in the Project Library and naming it Editing Action.

Exploring the edit

Our sequence begins with Katie being disturbed from her sleep by the constant pounding of a bouncing ball. She grabs the camera from the bedside dresser and goes after the source of the sound in the hopes of obtaining evidence. This section of the sequence has been covered with three angles:

○ **Scene 12 Slate 62 Take 5:** Starts with a tracking shot across the side of the bed that slowly reveals the bouncing ball in the doorway. Katie rouses from sleep, grabs the camera, and makes for the door. This action is shot from behind Katie as she walks away from the camera with her back to us (see Figure 11.1).

○ **Scene 12 Slate 63 Take 4:** A second tracking shot, this time moving across the front of the bed. The clip ends on a side view of Katie as she picks up the camera from the dresser and walks out of frame.

○ **Scene 12 Slate 64 Takes 1 and 3:** Two takes of this angle that are shot from outside, looking through the doorway and into the room. Katie peeks through the doorframe and then walks toward the camera into a silhouette. The main noticeable difference between this and the other angles is that Katie puts on a dressing gown as she walks toward the door (see Figure 11.2). Katie is seen wearing the gown for the rest

of the sequence and this is the only angle that shows her putting it on, so we would need to use this clip to keep continuity. Let's make a note of this in the Event Browser's notes field.

FIGURE 11.1
A tracking shot
across the side
of the bed.

FIGURE 11.2
A medium shot
of Katie putting
on a dressing
gown as she
leaves the room.

Watch the four clips and think about which sections you would like to use in the opening sequence. You should experiment with your own variation of this scene after completing this chapter, but for now, lets run through what we used for the final film.

1. Scene 12 Slate 62 Take 5 is a good shot to open with because it establishes the situation straight away. An incessant thud can be heard on the soundtrack as Katie sleeps and the camera gradually tracks across the side of the bed to reveal the source of the sound. Select this clip and play it in the Event Browser. Most of the action we need is covered in this clip, and one option would be to let it play up until the point where

Katie grabs the camera and starts for the door. We could then cut to the angle from outside the door as Katie puts on her gown and goes to investigate. Even though the action of the scene would be served by using just these two shots, we would be missing out on some nice coverage. The tracking shot across the front of the bed as Katie wakes offers some great opportunities to milk the suspense a little longer, as does the angle of her peaking through the doorframe. Let's see if we can put these to good use.

Make sure the Event Browser's filter pop-up menu is set to Favorites, and then select Scene 12 Slate 62 Take 5 and press E to append the clip to the Timeline. Double-click the clip's waveform in the Timeline to expand the audio, select the audio's Out point, and drag it to the right by 5 seconds to reveal the two extra ball hits as shown by the peaks in the clip's waveform (see Figure 11.3). We can use this extended audio track to continue the ball hits into the following clip.

FIGURE 11.3
Extend the audio track to reveal two more waveform peaks.

2. Select and play Scene 12 Slate 63 Take 4 in the Event Browser. Because we're continuing the ball bounces from the previous clip, we don't need to use any audio from this clip. Position the playhead at 22 seconds and 4 frames in the Timeline (at the video Out point for Scene 12 Slate 62 Take 5) and press Shift+2 to select Video Only as the source media. Press E to append Scene 12 Slate 63 Take 4 to the end of the Primary Storyline, and press Shift+1 to switch the source media back to All (see Figure 11.4).

FIGURE 11.4
Appending a Video Only clip to the Primary Storyline.

3. Play back the edit to see the result. Katie rolls onto her back two times before sitting up in bed. Obviously, some trimming is needed to get rid of this extraneous material. The best place to cut is during the motion of an action, and Katie's roll onto her back provides us with a good opportunity to do this. Make sure snapping is turned on and position the playhead at 23 seconds and 6 frames in the Primary Storyline (on Scene 12 Slate 63 Take 4). Press M to place a marker, and press S to turn on skimming if it isn't already enabled. Position the skimmer at 21 seconds and 6 frames inside the Timeline (on Scene 12 Slate 62 Take 5), and press M to place another marker at the skimmer position (see Figure 11.5).

FIGURE 11.5
Placing a marker at the skimmer position.

Raise the cursor into the toolbar area and then back inside the Timeline using the marker to snap the skimmer to this position. When the cursor is inside the Timeline, the Viewer displays the marked position at the playhead for Scene 12 Slate 62 Take 5 (see Figure 11.6); when the cursor is raised into the Toolbar, the Viewer displays the marked position for Scene 12 Slate 63 Take 4 (see Figure 11.7). As you move the cursor back and forth between these areas, you can compare the two positions on the Timeline to see if they match. As you can see in this example, Katie's arm is raised in a similar posture in both clips as she turns over onto her back.

Select the video Out point for Scene 12 Slate 62 Take 5, snap the skimmer to the marker at 21 seconds and 6 frames in the Timeline, and press Option+] (right bracket) to ripple the Out point to that position. Position the skimmer at the next marker (now at 22 seconds and 8 frames due to the ripple) and press Option+[(left bracket) to ripple the In point of Scene 12 Slate 63 Take 4 to that position also. Press Shift+/ (forward slash) to play back the edit.

FIGURE 11.6
The Viewer displays the marked position for Scene 12 Slate 62 Take 5.

FIGURE 11.7
The Viewer displays the marked position for Scene 12 Slate 63 Take 4.

4. Let's see if we can incorporate the shot of Katie peeking through the doorframe. We can try adding it as a Connected clip partway through Scene 12 Slate 63 Take 4 to see if it works. Select the favorite for Scene 12 Slate 64 Take 1 in the Event Browser, and position the playhead at 25 seconds and 23 frames in the Timeline. Press Q to connect Scene 12 Slate 64 Take 1 to the Primary Storyline (see Figure 11.8). Press the Home key to go to the beginning and play the edited sequence so far. Our Connected clip works just fine.

FIGURE 11.8
Adding a
cutaway as a
Connected clip.

5. This would be a good time to add the shot of Katie walking toward camera while slipping into her dressing gown. **Remember:** We need to include this for continuity reasons, so we may as well cover this part of the action from this angle. We have two takes of this angle to choose from. Set the Event Browser's filter pop-up menu to All Clips and watch Scene 12 Slate 64 Takes 1 and 3. As you can see, Katie has a few activities that she has to perform before walking out the door. First, she gets out of bed; then she picks up the camera; and finally, she grabs her dressing gown, ducking out of shot for a few seconds as she does so. We need to use this angle so that we see her put on the dressing gown, but to include this whole section would really slow down the pace of the scene. Luckily, we don't have to. We can simply cut to her approach to the door, with the camera already in hand and the dressing gown partway on. Normally, this would result in a *jump cut,* an abrupt cut between two shots that makes the onscreen subject appear to jump. Jump cuts can be used intentionally (the most famous example being Jean-Luc Godard's *Breathless* [1960]), but most of the time, they should be avoided. Jump cuts usually occur when the camera position and angle of two sequential shots only vary slightly (less than 30%) from each other. However, this isn't the case here and the audience will surmise that the previous actions have simply happened off-screen.

Let's view the approach to the door from both takes to see which one we prefer. The framing in Take 3 is much better, and the gown slips on quicker and with less fumbling than in Take 1, so that's the preferred take. Switch the Event Browser's Filter pop-up menu back to Favorites and select Scene 12 Slate 64 Take 3. Press E to append the clip to the end of the Primary Storyline.

The next section of the sequence shows Katie creeping across the top landing after Jason in an attempt to capture him on film. She reaches the end of the landing and sits on the steps

to wind her camera as she waits for him to reappear. This section is covered with the following clips:

○ **Scene 14 Slate 47 Takes 2 and 3:** Two takes of a wide master that shows the entire action from one end of the landing

○ **Scene 14 Slate 41 Take 2:** A side view from the lower landing looking up at Katie as she peeks over the banister to find Jason.

○ **Scene 14 Slate 44 Take 2:** A point-of-view shot looking over the banister down to the hallway below.

○ **Scene 14 Slate 48 Take 2:** A medium shot of Katie at the end of the landing as she sits down into frame and winds her camera (see Figure 11.9). The clip continues into the first part of the next sequence during which she spots Jason and stands to take a photo.

FIGURE 11.9
A medium shot of Katie winding her camera.

1. Set the Event Browser's Filter pop-up menu to All Clips and play Scene 14 Slate 47 Takes 2 and 3. In both takes, Katie walks into the frame and is seen in silhouette from behind. This would make a great matching cut following on from the similar silhouette at the end of our previous clip (Scene 12 Slate 64 Take 3). Both takes are fairly similar, but we prefer Katie's approach in Take 3 because it's less hurried than in Take 2 and we want to draw out her walk across the landing in order to build suspense. Select Scene 14 Slate 47 Take 3 in the Event Browser, and click the green Favorite line on the clip's icon to select the rated section of the clip (see Figure 11.10). Press E to append Scene 14 Slate 47 Take 3 to the end of the Primary Storyline.

FIGURE 11.10
Clicking the
green Favorite
line to select the
rated section of
the clip.

2. Play the previous edit to see the result. Scene 14 Slate 47 Take 3 ends as Katie places her hand on the banister to peek down at the hallway below. Scene 14 Slate 41 Take 2 is a different angle of the same action but shot from the lower landing looking up. Select and play Scene 14 Slate 41 Take 2 in the Event Browser. We could continue with Scene 14 Slate 47 Take 3 until Katie reaches the end of the landing, but that would require that we view most of the scene from behind Katie. In order to achieve any identification with a character, you need to be able to see the character's face and, more important, her eyes. Cutting to Scene 14 Slate 41 Take 2 would allow the audience to reconnect with the character and help to protract the approach across the landing a little more. Press E to append Scene 14 Slate 41 Take 2 to the end of the Primary Storyline and play back the section to see how it works.

3. The only option we now have available is to cut back to the wide master. We have two takes of this, and we've already used a section of Take 3 for the start of Katie's approach. Let's look at Scene 14 Slate 47 Takes 2 and 3 again to see what they offer in terms of the next part of the scene. The part that we're most interested in is when Katie reaches the end of the landing and looks over the banister for a second time. **Remember:** We have a point-of-view shot of the hallway below (Scene 14 Slate 44 Take 2) that we can use for the look over the banister, so let's watch the takes with this in mind. We prefer Take 2 in this case because Katie's lean over the banister closely resembles the camera movement in the point-of-view shot. Set the Event Browser's Filter pop-up menu to Favorites, select Scene 14 Slate 47 Take 2, and press E to append the clip to the end of the Primary Storyline.

4. Play back Scene 14 Slate 47 Take 2 in the Timeline, and look for a good place to insert the point-of-view shot. Katie begins her lean over the banister at around 54 seconds and 6 frames, so position the playhead at that position. Switch the Event Browser's Filter pop-up menu back to All Clips, and select Scene 14 Slate 44 Take 2. Press W to insert the clip into the Primary Storyline at 54 seconds and 6 frames. Play back the last three clips in the Timeline to see the result. When we cut back to Katie after the point-of-view shot, we still see the continuation of her first lean over the banister. Because

this action is a repeat of the camera movement shown in the point-of-view shot (which is representing Katie's view), we need to trim the start of the clip so that the flow of action makes sense. Select the In point for Scene 14 Slate 47 Take 2 (the last clip in the Timeline), and ripple to the right by 20 frames (see Figure 11.11). Play back the edit to see the result.

FIGURE 11.11
Rippling the edit point by 20 frames.

5. The sequence ends with Katie sitting on the steps, winding her camera. We could continue using the master to cover the rest of this action, but we also have a closer angle that we can use as well. Select and play Scene 14 Slate 48 Take 2 in the Event Browser. The clip begins as Katie sits down into the frame, which gives us some motion to cut on for the edit between this clip and the master. Select the Favorite section for Scene 14 Slate 48 Take 2, and append the clip to the end of the Primary Storyline.

First we need to find the point on both clips where Katie connects with the floor as she sits. For the wide master (Scene 14 Slate 47 Take 2), this is at 1 minute, 1 second, and 5 frames in the Timeline. Place the playhead at that position and press Option+] (right bracket) to perform a Ripple edit to that point.

6. Next, we'll find the same point in the following medium shot (Scene 14 Slate 48 Take 2). Because this clip is a medium shot that shows only Katie's head and shoulders, we'll have to guess by Katie's posture when she actually connects with the floor. Luckily, one of the peaks on the clip's audio waveform provides us with a useful visual clue, and we can deduce that this happens at 1 minute, 3 seconds, and 4 frames in the Timeline. Select the In point of Scene 14 Slate 48 Take 2, and ripple to the right by 1 second and 23 frames.

Play back the edit, and you'll see that this gives us a hard cut at the point when Katie sits down. The cut would be a lot smoother if it took place during her move, and now that we've figured out the timing of the character's movement, we can simply move the edit point back with a Roll edit. Press T to bring up the Trim tool, and keep your

finger pressed down on the keyboard. Select both edit points between Scene 14 Slate 47 Take 2 and Scene 14 Slate 48 Take 2 (the last two clips in the Timeline) and roll to the left so that the edit point occurs during Katie's movement (see Figure 11.12). Around 20 frames should be enough, but experiment with different amounts to see how they affect the cut. Finally, release your finger from the T key to return back to the Select tool. This works with all tools found in the Tool menu. Keeping a tool's keyboard shortcut pressed allows you to use a different tool and then quickly return back to the Select tool after the key is released.

FIGURE 11.12
Roll back the edit point by 20 frames so that the cut happens during Katie's action.

In the next section of the sequence, Katie spots Jason playing with his football on the stairs and tries to snap a photo of him. This section ends when Jason runs off and Katie chases after him. This section is covered with the following clips:

○ **Scene 14 Slate 36 Take 5:** A wide angle from the top of the stairs looking down on Jason as he bounces his ball. A flash from the camera causes Jason to run away, and Katie runs into frame and down the stairs after him, stopping when she reaches the bottom.

○ **Scene 14 Slate 38 Take 1:** A close-up of the ball hitting the floor.

○ **Scene 14 Slate 40 Takes 2 and 3:** Two takes of a wide angle from the bottom of the stairs looking up at Katie that covers the entire action. She walks into the shot, sits down on the steps to wind her camera, and then stands to snap off a photo when she notices Jason. The clip ends with Katie running down the stairs toward camera.

○ **Scene 14 Slate 43 Takes 1 and 4:** Two takes of a medium shot of Katie on the stairs. Covers the same action as the previous shot, but the clip ends on Katie taking the photo and doesn't include her run down the stairs (see Figure 11.13).

FIGURE 11.13
A medium shot
of Katie on the
stairs.

So, with just four angles to play with, let's see how we can turn this into a suspenseful scene.

1. For the next part of the sequence, we want to suggest that some time has passed between the previous section and the one that we're about to edit. Of course, we could bridge the two sections with a dissolve, but let's see if we can create the impression of time passing with the footage that we have at our disposal. Scene 14 Slate 40 Takes 2 and 3 shows a wide angle of Katie sitting at the top of the stairs. Play the clips to see if there are any sections that we can use to imply that some time has passed.

 Set the Event Browser's Filter pop-up menu to Favorites and play the rated section of Scene 14 Slate 40 Take 3. Katie's posture in the shot and the way she shifts her legs to get comfortable suggest that she's been waiting for a while and is starting to get bored. The winding sound from the camera detracts from the effect, so let's not use the audio from the clip. Press Shift+2 to select Video Only as the source media, and press E to append Scene 14 Slate 40 Take 3 to the end of the Primary Storyline. Press Shift+1 to switch the source media back to All.

2. The following clips involve Jason bouncing the ball at the bottom of the stairs. We want the ball bounces to have an eerie and almost unnatural feel to them, so we've created an audio clip that has the ball hits occurring every two seconds to give them a more repetitive quality. Let's first add the audio clip to the Timeline and then cut the following clips to the rhythm of the ball hits. Switch the Event Browser's Filter pop-up menu to All Clips, click the Sound FX Collection inside the Audio folder in the Event Library, and select the Bouncing Ball audio clip. Press ⌘+2 to select the

Timeline window, and press the End key to take the playhead to the end of the edited sequence. Press Q to connect the Bouncing Ball audio to the Primary Storyline. This creates a gap clip with the audio connected below it (see Figure 11.14). Click the Editing Action Collection in the Event Library to display its contents in the Event Browser.

FIGURE 11.14
Connecting an audio clip to the Primary Storyline creates a gap clip above it.

3. The next step is to add the close shots of the ball hitting the floor so that they match the hits of the Bouncing Ball audio clip in the Timeline. Select Scene 14 Slate 38 Take 1 in the Event Browser, and press I to mark an In point at the position of the first ball hit. You can visually see this by the tall spike on the audio waveform at 17 frames. Position the playhead at 1 minute, 15 seconds, and 15 frames in the Timeline, and press D to overwrite the clip to the Primary Storyline. If you play back this section, you'll notice that the first ball bounce is in sync with the Bouncing Ball clip and the second bounce is also fairly close, but the rest of the bounces are way off (see Figure 11.15). This is fine because we plan to show only the first two ball bounces in close-up, and we can use other angles from our footage for the rest of the bounces.

FIGURE 11.15
Lining up two audio tracks in the Timeline.

Select the Out point of Scene 14 Slate 38 Take 1, and drag it to the left so that the clip ends at 1 minute, 19 seconds, and 13 frames in the Timeline. If you play back this section, you'll notice that the third ball bounce is still visible at the end of the clip. Because we plan to intercut the ball bounces with shots of Katie's reaction, we can leave this third bounce in, secure in the knowledge that we'll be covering it with different footage later. Now we need to remove the audio from Scene 14 Slate 38 Take 1 so that only the Bouncing Ball clip is heard. Select Scene 14 Slate 38 Take 1 in the Timeline, and press ⌘+4 to open the Inspector. Choose the Audio tab and uncheck the check box for the audio found under Channel Configuration (see Figure 11.16).

FIGURE 11.16
Removing a clip's audio in the Inspector.

4. There is a gap clip just before Scene 14 Slate 38 Take 1 in the Timeline that we need to eliminate. However, we're faced with a few problems if we simply delete it from the Primary Storyline. Deleting the gap clip also removes the Bouncing Ball clip that is attached to it. We could always solve this by linking the Bouncing Ball audio to another clip in the Primary Storyline, but this still wouldn't allow us to simply delete the gap because doing so would move the following clip (Scene 14 Slate 38 Take 1) down in the Timeline, and it would no longer be in sync with the Bouncing Ball audio. The same would be true if we closed the gap with a Ripple edit. This is where the Position tool comes in handy. Press P to bring up the Position tool and use it to select the In point for Scene 14 Slate 38 Take 1. Drag the In point all the way to the left so that the clip snaps to

the end of Scene 14 Slate 40 Take 3 and the gap has been completely replaced (see Figure 11.17). Press A to switch back to the Select tool and play back the edit to see the result.

FIGURE 11.17
Using the
Position tool to
close a gap.

5. Let's continue to sync some more pictures to the Bouncing Ball audio in the Timeline. This time we'll use Jason's wide angle from the top of the stairs. Position the playhead at the third ball hit on the Bouncing Ball waveform, which can be found at 1 minute, 20 seconds, and 5 frames in the Timeline. With the Event Browser's Filter pop-up menu set to All Clips, select Scene 14 Slate 36 Take 5 and add an In point just before the first ball hit at 15 frames into the clip. Press D to overwrite Scene 14 Slate 36 Take 5 to the playhead position on the Primary Storyline. Just as before, we have another gap clip before Scene 14 Slate 36 Take 5 in the Timeline. Press P to bring up the Position tool, select the In point for Scene 14 Slate 36 Take 5, and drag all the way to the left until you run out of material and the In point displays a red bracket (see Figure 11.18). We still have a small gap before the clip, but we can easily cover this with another clip later in the edit. Press A to switch back to the Select tool and play back the section.

FIGURE 11.18
A red bracket
shows that the
clip has no
further handles.

6. If you compare the audio waveform for Scene 14 Slate 36 Take 5 with the Bouncing Ball clip in the Timeline, you'll notice that most of the ball bounces don't line up (see Figure 11.19). We only need to make sure that the bounces that are visible on-screen line up correctly, and we can work out which these are after we've added more clips to the scene. Around 12 seconds into Scene 14 Slate 36 Take 5, the camera flash goes off

and Jason runs off into the shadows. This happens during Jason's last ball bounce, and we would obviously need to include this in the shot. However, this last bounce doesn't line up with the Bouncing Ball clip, so we would need to fix this first. Let's do that next.

FIGURE 11.19
Comparing the audio waveforms between two clips.

Position the playhead at 1 minute, 31 seconds, and 20 frames in the Timeline so that the camera's white flash frame is visible in the Viewer, and press ⌘+B to cut Scene 14 Slate 36 Take 5. Press the left arrow key four times to take the playhead back by 4 frames, and press ⌘+B again to make another cut. This cut should line up with the last bounce on the Bouncing Ball clip. Place the cursor between the two cuts, and press C to select the clip in between (pressing C selects any clip beneath the cursor). Press Delete to remove the four frames between the cuts and ripple the two clips on either side together (see Figure 11.20). Play back the edit, and you'll see that even though the last ball bounce is now in sync with the Bouncing Ball clip, we've created a slight jump cut by removing four frames from Scene 14 Slate 36 Take 5. This isn't a problem, because we'll be adding a shot of Katie snapping the photo to cover the jump cut.

FIGURE 11.20
Deleting a section of a clip.

7. Let's see how many ball bounces we now have in sync. Out of the eight bounces, only the ball hits for the first, second, third, fifth, and eighth line up with the hits in the Bouncing Ball clip. This means we need to cover the bounces for the fourth, sixth, and seventh with Katie's reaction shots. Before we do that, we need to make sure that the video clips that we've just added and the Bouncing Ball audio remain in sync as we

work. Our Bouncing Ball clip is attached to the Primary Storyline as a Connected clip, and it would be very easy for us to accidentally move it and lose sync with the pictures above. A safer option would be to place all the clips that make up this Bouncing Ball section inside a Compound clip to help keep the audio locked to the pictures and also allow us to treat it as a single clip.

Using the mouse, draw a selection box over the last three clips in the Timeline, making sure to include the connected Bouncing Ball audio clip in the selection (see Figure 11.21). With these four clips selected, press Option+G to place them inside a Compound clip. To rename the Compound clip, select it in the Timeline and press ⌘+4 to open the Inspector if it isn't already open. In the Inspector's Info panel, highlight the name field, type **Bouncing Ball on Stairs**, and press Return (see Figure 11.22).

FIGURE 11.21
Selecting clips in
the Timeline.

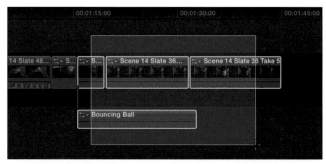

FIGURE 11.22
Turning selected
clips into a
Compound clip.

8. If we play the Bouncing Ball on Stairs clip, we can still hear the sound of the original ball hits that were recorded with the video clips. We need to turn off this audio so that we hear only the sound from the Bouncing Ball audio clip. Double-click on Bouncing Ball on Stairs to open the Compound clip in the Timeline, and select the second clip in the sequence (the first instance of Scene 14 Slate 36 Take 5). In the Inspector's Audio pane, drag the Volume slider all the way to the left so that it reads –96. Select the third clip in the sequence (the second instance of Scene 14 Slate 36 Take 5), and press Control+S to expand the clip's audio. Select the audio's In point, type **+ 10**, and press

Return to remove the first ten frames and the sound of the first ball bounce (see Figure 11.23). Press ⌘+[(left bracket) to take you out of the Compound clip and back into the original sequence. Play back the section, and you'll no longer hear the audio from the video clips.

FIGURE 11.23 Shortening the audio track inside a Compound clip.

9. We can now start to add the shots of Katie reacting to the boy on the stairs. Set the Event Browser's Filter pop-up menu to Favorites, and select Scene 14 Slate 43 Take 4 (first favorite). Press Shift+2 to select Video Only as the source media and ⌘+2 to make the Timeline active. Position the playhead at 1 minute, 16 seconds, and 1 frame just after the first ball bounce. Press Q to connect Scene 14 Slate 43 Take 4 to the Primary Storyline over the Bouncing Ball on Stairs clip (see Figure 11.24). Position the playhead at 1 minute, 18 seconds, and 5 frames in the Timeline, and select Scene 14 Slate 43 Take 1 (favorite) in the Event Browser. Press Q to also connect Scene 14 Slate 43 Take 1 to the Primary Storyline. Position the playhead at 1 minute, 20 seconds, and 22 frames in the Timeline, and select Scene 14 Slate 40 Take 2 (first favorite) in the Event Browser. Press Q to also connect Scene 14 Slate 40 Take 2 to the Primary Storyline. Play back the selection, and you'll see not only that we've managed to hide some of the bounces that don't line up with the audio, but also that we're starting to build the tension in the scene.

FIGURE 11.24 Adding a Connected clip to a Compound clip.

10. Let's now cover the jump cut that we created before the on-screen camera flash with a shot of Katie about to take a photo. Select Scene 14 Slate 43 Take 4 (second favorite) in the Event Browser and play the clip. The shot ends just after Katie snaps the photo, so all we need to do is back-time this clip from the flash-frame in the Timeline. With Scene 14 Slate 43 Take 4 still selected, press Control+D to display the clip's duration in the Dashboard. The clip is 5 seconds and 1 frame in duration. Press Esc to clear the Dashboard's duration field, and position the playhead on the flash-frame in the Primary Storyline. This can be found at 1 minute, 31 seconds, and 16 frames in the Timeline. Type **–5.1**, and press Return to take the playhead back by 5 seconds and 1 frame (the duration of our clip in the Event Browser). The playhead should now be at 1 minute, 26 seconds, and 15 frames in the Timeline. Press Q to connect Scene 14 Slate 43 Take 4 to the Primary Storyline. Play back the section to see the result. The boy runs off just as Katie snaps the photo; then Katie comes into frame and runs down the stairs after him.

11. To complete this section, let's add one more shot of Katie rushing down the stairs toward the camera. You'll find this section as the second marked favorite for Scene 14 Slate 40 Take 2. Position the playhead at 1 minute and 33 seconds in the Timeline, select Scene 14 Slate 40 Take 2 (second favorite) in the Event Browser, and press Q to connect the clip to the Primary Storyline (see Figure 11.25). To tidy up the Timeline, select the five Connected clips that are attached to the Bouncing Ball on Stairs clip and press ⌘+G to place them inside a Secondary Storyline (see Figure 11.26). Press the Home key to go to the beginning and play the edited sequence.

FIGURE 11.25
Four clips connected to a Compound clip.

FIGURE 11.26
Tidying up Connected clips inside a Secondary Storyline.

Now that you've followed along with the examples for Scenes 12 and 14, finish the rest of the sequence by completing Scenes 15 and 16. The clips for these scenes are available in the Editing Action Collection inside the Pranks Media Event. Before you start to edit the scene, tag the clips with a keyword of your choice to make them easier to find.

The last section of the sequence is made up of the following clips:

- **Scene 14 Slate 45 Take 2:** A high, wide-angle master looking down on the lower landing. Katie creeps across the landing in a cat-and-mouse game with Jason. The shot ends with Katie walking down the last set of stairs to the hallway below. However, watch out for the continuity error at the end of the clip. In this shot, Katie takes the camera with her when she goes down the stairs, whereas she leaves the camera on the top step in all other takes.

- **Scene 15 Slate 49 Take 3:** A tight medium shot that follows Katie along the first section of the landing.

- **Scene 15 Slate 50 Take 1 :** A moving point-of-view shot through the landing.

- **Scene 16 Slate 51 Take 2:** A tight medium shot of Katie's hand moving along the banister, ending with Katie crouching down behind the railings to watch Jason.

- **Scene 16 Slate 52 Take 1:** A tight medium shot that follows Katie along the second section of the landing that also ends with her crouching down behind the railings to watch Jason.

- **Scene 16 Slate 53 Take 4:** A front-facing angle of Katie crouching down behind the railings that ends with her walking out of the frame.

By now you should have picked up a few techniques that you can use to complete the rest of the sequence and apply to your own work. Mastery of any craft comes from continual practice. By attempting to cut your own scenes from the rushes provided, you'll become more proficient in the craft of the cut than simply following along with this book. However, if you do get stuck, you can always open the completed Project we've provided and learn by re-creating the shots from the final film. When you've finished the sequence, move on to the next chapter, where we walk you through the edit of the film's climax.

chapter 12
Building the Climax

WE HAVE NOW reached the third and final act of our movie. This is where all the questions that were raised at the beginning of the story are answered and any conflicts between the characters are resolved. The audience has taken a journey through the eyes of the main character and wants to see how things turn out for them at the conclusion of the story. At the end of the first act, the main character was faced with a problem that spurred her into action toward a goal or purpose. The third act reveals whether the main character achieves that goal and shows how the main character has been impacted by the events of the story.

There are many different types of endings: happy, sad, bittersweet, or just plain ambiguous. Just because a character achieves her goal, doesn't mean she'll be happy about it at the end of the story. There are many stories where characters achieve their purpose only to be corrupted along the way and end up worse off than when they started. Some characters are changed for the better during their quest, even if they don't attain their goal. As you can see, there can be many nuances to the conclusion of a story. Let's look at the ending for *Pranks* and see how things turn out for Katie.

The Final Act

At the conclusion of *Pranks,* Katie achieves her goal and comes face to face with Jason, the young boy who has been playing tricks on her all night. Katie's character arc also reaches its conclusion at the same time. In the first act of the story, Katie was established as an independent girl who doesn't play nice with others, but by the time she finally meets Jason, her attitude has changed and she is even willing to share her room with him. Katie has learned to open up and accept others through the cat-and-mouse games she has inadvertently been compelled to play with the Jason. Despite seeing the proof for herself, Jason disappears as soon as Joyce makes an appearance, and Katie is still unable to convince her of his existence. The final piece of the mystery is revealed when Joyce explains that Jason was her son and that he died many years ago, leading the viewer to conclude that Katie has been playing with a ghost all along. The story ends with a final coda and bittersweet note, a single shot of Katie waiting for Jason to reappear, uncertain whether her newfound friend will come back to play or not.

This last act is predominantly made up of Scene 17 and consists of two sections. The first section deals with Katie's encounter with Jason, and the second consist of two dialogue exchanges between Katie and Joyce (one at the stairs and another at the photo display). Scene 18 makes up the coda of Katie waiting for Jason to reappear.

Evaluating the footage

Double-click the *Craft of the Cut* disc image to mount it and launch Final Cut Pro. Select the Building the Climax Collection inside the Pranks Media Event to display the clips that you'll be working with in the Event Browser. To follow along with the exercise, drag a selection range at the times specified below, and rate these areas as Favorites:

- ◯ **Scene 17 Slate 24 Take 1:** Between 15:03 and 28:12, between 29:20 and 31:17, and between 40:00 and 42:03

- ◯ **Scene 17 Slate 24 Take 4:** Between 02:20 and 15:09 and between 38:16 and 40:11

- ◯ **Scene 17 Slate 25 Take 1:** Between 14:04 and 14:16

- ◯ **Scene 17 Slate 25 Take 3:** Between 08:03 and 10:05

- ◯ **Scene 17 Slate 28 Take 3:** Between 01:20 and 02:18

- ◯ **Scene 17 Slate 29 Take 2:** Between 10:11 and 12:18

In the Project Library, create a new project and name it Building the Climax.

Exploring the edit

In the first half of the sequence, Katie sneaks down the stairs and find's Jason's discarded ball in the hallway. As Katie examines the ball, Jason appears from behind and scares her with a loud "Boo!" Both children laugh, leading to reconciliation between them. This section of the sequence is covered with only two angles:

○ **Scene 17 Slate 24 Takes 1 and 4:** Two takes of a moving shot that starts out on Katie then reframes to a shot of Jason. The camera follows Katie through the stair rails as she creeps down the steps, framing her in a medium angle once she reaches the hallway and examines the ball. The camera continues to move around Katie, revealing Jason behind just as he is about to pounce. The camera reframes to a medium shot of Jason for the remainder of the shot to cover his reactions to Katie's questions (see Figure 12.1).

○ **Scene 17 Slate 25 Takes 1, 2, and 3:** Three takes of a medium angle on Katie. The shot starts with her examination of the ball and includes all her dialogue with Jason. The shot ends with Joyce rushing down the stairs to see if Katie is okay.

FIGURE 12.1
A long moving shot that starts out on Katie and then reframes to a shot of Jason.

On the surface, it may seem that we don't have a lot of coverage for this part of the scene with only two angles to play with. However, Scene 17 Slate 24 Takes 1 and 4 is a lengthy clip that transforms into three different framings throughout its running time (a moving shot of Katie through the rails, a medium shot of Katie examining the ball, and a medium shot of Jason's reactions), so realistically we have four angles and not two.

Let's see how we can use these in practice:

1. The sequence starts with a moving shot that follows Katie's feet as she walks down the stairs and discovers Jason's discarded ball in the hallway. The camera widens to include Katie as she kneels down to pick up the ball and then pulls back to reveal Jason lurking in the shadows behind her. We have a choice of two takes for this shot — Scene 17 Slate 24 Takes 1 and 4 — so let's take a look at both clips in the Event Browser.

 The camera that follows Katie in the first half of Scene 17 Slate 24 Take 1 moves faster than the actress and soon gets ahead of her, unlike Take 4 where the camera moves along with Katie at the same pace. However, we prefer Jason's reveal in the second half of Scene 17 Slate 24 Take 1 to the one in Take 4 because the actor's performance is better. He sneaks up on Katie more slowly in Take 1 and so is far more effective. This shot was originally intended to play as one continuous take, but because we prefer two different halves of each take, we need to make a decision on whether to keep the shot as one uninterrupted, but flawed, shot or use the best parts from each take and separate the two with a cutaway. We decide to break up the continuous shot and use the best sections from each take.

 Set the Event Browser's Filter pop-up menu to Favorites, select Scene 17 Slate 24 Take 4 (first favorite) in the Event Browser, and press E to append the clip to the Timeline. Next, select Scene 17 Slate 24 Take 1 (first favorite) in the Event Browser and append that clip also to the Timeline.

2. Press ⌘+2 to make the Timeline the active window and play back the two clips. As expected, there is a jump cut as the sequence goes from Take 4 to Take 1, but this can easily be remedied by adding a cutaway shot between the two clips. Position the playhead at the start of the second clip in the sequence (this should be at 12 seconds and 14 frames in the Timeline) and press ⌘+1 to make the Event Browser the active window. Let's see if we can find a section from another clip to use as a cutaway. We only have one other angle that we can choose from (the medium shot on Katie), but we just need a short segment of Katie picking up the ball from this angle to cover the jump cut in our sequence.

 Set the Event Browser's Filter pop-up menu to All Clips and select Scene 17 Slate 25 Take 2. Make a selection from the start of the clip to 08:00, and press W to insert the section between the two clips in the Primary Storyline.

3. Play back what we have so far in the sequence. Obviously some trimming of the top and tail of Scene 17 Slate 25 Take 2 is needed, but this can be done easily with a simple Ripple edit on each side of the clip. Select the In point for Scene 17 Slate 25 Take 2, and drag to the right for 3 seconds and 21 frames. Next, select the Out point for Scene 17

Slate 25 Take 2, and drag to the left for 2 seconds and 9 frames (see Figure 12.2). Scene 17 Slate 25 Take 2 should now end at 14 seconds and 9 frames in the Timeline. Press the Home key to go to the beginning and play the sequence.

FIGURE 12.2
Trimming the end of the clip by 2 seconds and 9 frames.

4. Let's try to build up some suspense as Jason creeps up on Katie. In the sequence, the second half of Scene 17 Slate 24 Take 1 focuses on Jason's approach with Katie partially visible in the foreground. As the viewer has been identifying with Katie throughout the story, we should continue to keep the focus on her and also create some anxiety in the audience as she examines the ball, unaware that Jason is behind her and ready to pounce. Once again, we'll need to find a section from Katie's medium shot, because this is the only other angle that we have at our disposal.

Set the Event Browser's Filter pop-up menu back to Favorites, and select Scene 17 Slate 25 Take 3. This is a short section of Katie examining the ball that we can cut to just after Jason starts to move toward her. Position the playhead at 22 seconds and 2 frames in the Timeline, and press W to insert Scene 17 Slate 25 Take 3 into the Primary Storyline. Play back the section. The viewer now catches only a glimpse of Jason before we cut back to Katie with the ball. By holding back from showing too much of Jason straightaway, it helps add more tension to the scene, because this reveal is what the viewer is hanging on to see.

However, you may have noticed that Jason's "Boo!" is abruptly cut off at the end of Scene 17 Slate 25 Take 3. We don't need this piece of audio just yet, because we're still building up Jason's approach, so let's remove it. Skim over Scene 17 Slate 25 Take 3 and press C to select the clip in the Timeline. Press Control+S to expand Scene 17 Slate 25 Take 3 and select the clip's audio Out point. Drag the Out point to the left by six frames to remove the unwanted audio (see Figure 12.3), and play back the section. There's a short dip to silence during the missing audio, but we can fix this later by adding some background ambience.

FIGURE 12.3
Removing
unwanted audio
from a clip.

FIGURE 12.3
Removing
unwanted audio
from a clip.

5. Following the shot of Katie that we just inserted, the sequence cuts back to Scene 17 Slate 24 Take 1 and Jason's approach. Jason needs to be a lot closer in the frame, since he has presumably continued to sneak up on Katie while we've been on her with the other angle. We now need to shorten the first part of Jason's walk to be consistent with the amount of time that has passed. Skim through the second instance of Scene 17 Slate 24 Take 1 in the Timeline to find a suitable point to cut back to; 27 seconds and 9 frames into the sequence seems like a good place in the clip.

Press R to bring up the Range tool and, starting from the beginning of Scene 17 Slate 24 Take 1 (at 24 seconds and 5 frames in the Timeline), draw out a range selection for 3 seconds and 4 frames over the clip (see Figure 12.4). Press Delete to remove the selection, and press A to switch back to the Select tool. Play back the edit to see the result.

FIGURE 12.4
Dragging out a
range selection
to be deleted.

6. At around 25 seconds in the sequence, Jason sneaks up on Katie to scare her with a "Boo!" This moment could do with a little more impact because it's supposed to make Katie jump. Let's see what we can do to improve this section. With the Event Browser set to Favorites, select and play Scene 17 Slate 25 Take 1. This is a short 13-frame

snippet of Katie being startled by Jason. We don't need to hear Jason's "Boo!" in this shot—we can use the audio that's already in the Timeline—so let's choose Video Only as the Source Media by pressing Shift+2.

Let's find the point in the Primary Storyline just before Jason is about to pounce. This should be at 24 seconds and 20 frames in the Timeline. Position the playhead there, and press W to insert Scene 17 Slate 25 Take 1 into the Primary Storyline. Press Shift+1 to switch the Source Media back to All.

7. If you play back this section, you'll notice that Jason pounces again when we cut back to the third instance of Scene 17 Slate 24 Take 1 in the sequence. To remove the repeated action, we need to trim the front of the clip to just before Jason pulls back following the "Boo!" Let's use the Precision Editor to do this. First, make sure that the Show Detailed Trimming Feedback check box is checked in the Preference's Editing pane (see Chapter 6) because we'll be using the Viewer to visually find a suitable edit point.

Double-click the edit point between Scene 17 Slate 25 Take 1 and Scene 17 Slate 24 Take 1 (the last two clips in the sequence) to open the Precision Editor and select the In point for Scene 17 Slate 24 Take 1 (the bottom clip in the window). While dragging the In point to the right, watch the second screen in the Viewer to see the position in the clip where Jason is just about to pull back (see Figure 12.5). This should be at exactly 1 second from the start of the clip (see Figure 12.6). Press the Close Precision Editor button at the bottom of the window to return to the Timeline and play back the section.

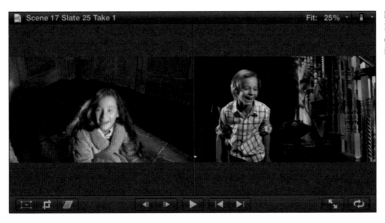

FIGURE 12.5
Finding the correct position in the Viewer.

FIGURE 12.6
Rippling a clip in
the Precision
Editor.

8. We clearly need to do some audio work as Jason's "Boo!" is inaudible, but before we do that, let's complete this little "Boo!" section by adding a shot of Katie recoiling from the scare. Set the Event Browser's filter pop-up menu back to All Clips and select Scene 17 Slate 25 Take 3. We've already used a small section of this clip for the shot of Katie examining the ball. We'll use the second half of this clip for the rest of Katie's dialogue with Jason. Press I to mark an In point at 11 seconds and 17 frames into the clip (see Figure 12.7), and press E to append Scene 17 Slate 25 Take 3 to the end of the Primary Storyline.

FIGURE 12.7
Making a
selection in the
Event Browser.

9. Let's fix the audio for this section. We'll be using the audio from the second instance of Scene 17 Slate 24 Take 1 in the Timeline for Jason's "Boo!" and the laughter between the two children, so first we need to silence the laughing in the two following clips. Select the third instance of Scene 17 Slate 24 Take 1 in the Timeline (the second clip from the end of the sequence) and press ⌘+4 to open the Inspector. Select the Audio tab and uncheck the check box for the audio found under Channel Configuration.

Now let's eliminate the laughter at the head of the next clip (Scene 17 Slate 25 Take 3). Select the last clip in the sequence and press Control+S to expand the clip's audio. Select the In point of Scene 17 Slate 25 Take 3 audio, and position the playhead at 28 seconds and 5 frames in the Timeline, just before Katie says the line "So, you're the one

that's been playing all the tricks on me." Press Option+[(left bracket) to move the audio's In point to just before Katie's dialogue begins (see Figure 12.8).

FIGURE 12.8
Trimming the audio with a keyboard shortcut.

10. With the "Boo!" and laughter removed from the clips, we're now free to use the audio from the second instance of Scene 17 Slate 24 Take 1 for this section of the scene. Select the second instance of Scene 17 Slate 24 Take 1 and press Control+S to expand the clip's audio. Select the clip's audio Out point and drag it all the way to the right until it snaps to the start of the next clip's audio (see Figure 12.9). Press the Home key to go to the beginning and play back the sequence. This short "Boo!" section is now a lot more effective.

FIGURE 12.9
Snapping the clip's audio to the next clip in the sequence.

11. The next segment that we're going to work on is Katie's conversation with Jason. Even though Jason doesn't have any dialogue in this scene, we still need to see his reaction to what Katie is saying to him. This can be done by simply adding a few shots throughout Scene 17 Slate 25 Take 3 in the Timeline. We won't need any audio for this, so press Shift+2 to select Video Only as the source media and make sure the audio for the second instance of Scene 17 Slate 24 Take 1 is expanded in the Timeline. Position the playhead at 27 seconds and 1 frame in the Timeline and, with the Filter pop-up menu set to Favorites, select Scene 17 Slate 24 Take 1 (second favorite) in the Event Browser and press W to insert the clip into the Primary Storyline.

We need to trim the beginning of the clip that follows (Scene 17 Slate 25 Take 3, the last clip in the Timeline) so that when we cut back to Katie, she isn't in the same position that she was in before the cut to Jason. The duration of Jason's inserted clip is 1 second and 22 frames, so we would normally trim this amount off the front of the following clip so that the same amount of time has passed when we cut back to Katie. However, the director tells us that he wants a short pause before Katie speaks again, to create an uncomfortable tension between the characters. Because this pause isn't part of the actors' performance, we need to create it artificially in the edit. Trimming a smaller amount from the start of Katie's next shot would slightly lengthen the time before her first line of dialogue. Select the video In point for the last clip in the Timeline (Scene 17 Slate 25 Take 3) and type **+11** (see Figure 12.10). Press Return to trim 11 frames off the front of Scene 17 Slate 25 Take 3. Choose View→Collapse All Clips to collapse the expanded audio tracks, and press Shift+Z to fit the entire sequence in the Timeline.

FIGURE 12.10
Numerically trimming 11 frames off the front of a clip.

12. Katie asks Jason two questions during the section that follows. Let's add two more shots of Jason's reaction after each question. Position the playhead at 32 seconds and 18 frames in the Timeline, just after Katie says the line "So, you're the one that's been playing all the tricks on me." **Remember:** You can use the clip's audio waveform to visually locate the start of each line of dialogue. Select Scene 17 Slate 24 Take 1 (third favorite) in the Event Browser, and press Q to connect the clip to the Primary Storyline. Next place the playhead at 37 seconds and 22 frames in the Timeline, just after Katie says the line "Is it because I moved into your room?" Select Scene 17 Slate 24 Take 4 (second favorite) in the Event Browser and press Q to connect a second clip to the Primary Storyline. Press Shift+1 to return the Source Media back to All, and then select both Connected clips in the Timeline and press ⌘+Option+Down Arrow to overwrite both clips to the Primary Storyline. Play back the section.

In the second half of the sequence, Joyce rushes down the stairs to find Katie playing by herself. Katie protests that she was really playing with Jason, prompting Joyce to explain to her that Jason died many years ago. The sequence ends with the final shot of the film as Katie waits in her room for Jason to return.

This section of the sequence is covered with the following angles:

○ **Scene 17 Slate 27 Take 1:** A short point-of-view insert of the empty hallway.

○ **Scene 17 Slate 28 Take 3:** A medium shot of Katie that covers all her dialogue with Joyce at the stairs (see Figure 12.11).

○ **Scene 17 Slate 29 Take 2:** A medium shot of Joyce from when she rushes down the stairs up until she exits the frame to make her way to the photo display.

○ **Scene 17 Slate 30 Take 1:** Starts on Katie, and then Joyce enters the frame and the camera follows them over to the photo display. The main purpose of the shot is as a bridge that takes the character from the stairs area of the hallway to the photo display.

○ **Scene 17 Slate 31 Take 2:** A medium two-shot of Katie and Joyce that covers all the dialogue at the photo display (see Figure 12.12).

○ **Scene 17 Slate 32 Take 1:** A static insert shot of Jason's photo.

○ **Scene 17 Slate 33 Take 1:** A slow push in on Jason's photo.

○ **Scene 17 Slate 34 Take 2:** A short insert shot of Katie holding Joyce's hand.

○ **Scene 18 Slate 70 Takes 2 and 3:** Two takes of Katie sitting on the bed waiting for Jason to reappear as the camera tracks back through the doorway. The main difference between the two takes is that Katie holds the ball in Take 2.

★ Scene 17 Slate 28 Take 3 Fit: 41%

FIGURE 12.11
A medium shot of Katie at the stairs.

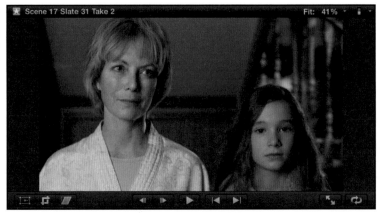

1. After Katie says the line "We can share it if you like. I really don't mind," her attention is drawn to Joyce calling out to her from upstairs. The next shot that should logically follow is the shot of Joyce rushing down the stairs to see if Katie is okay, which is covered in Scene 17 Slate 29 Take 2. When Katie hears Joyce's voice, she glances up toward the sound and begins to get up. This would be a good point in the sequence to cut to this next shot because Katie's glance helps motivate the cut to Joyce rushing down the stairs.

 Position the playhead at 46 seconds and 6 frames in the Timeline, and press ⌘+1 to make the Event Browser active. Set the Filter pop-up menu to All Clips and select Scene 17 Slate 29 Take 2. Skim 8 seconds into the clip, and press O to mark an Out point (see Figure 12.13). Press D to overwrite the selected area to the Primary Storyline. If you play back the edit, you'll notice that Joyce repeats the line "Katie, are you okay?" The line reading is better during Scene 17 Slate 29 Take 2, so let's use the audio from that clip.

FIGURE 12.13
Selecting the
first 8 seconds
of a clip.

Let's first remove the first instance of "Katie, are you okay?" that occurs during Scene 17 Slate 25 Take 3. Select the clip in the Timeline, and press Control+S to expand the clip's audio. Position the playhead just after Katie says the line "We can share it if you like. I really don't mind," at 43 seconds and 20 frames in the Timeline, and press M to place a marker. Make sure snapping is enabled, select the audio Out point for Scene 17 Slate 25 Take 3, and drag it to the left by 2 seconds and 10 frames until the edge of the audio snaps with the marker (see Figure 12.14).

FIGURE 12.14
Snapping the clip's Out point to a marker.

We now want to run Joyce's line from Scene 17 Slate 29 Take 2 beneath Scene 17 Slate 25 Take 3, in place of the audio we've just removed. To do this, expand the audio of Scene 17 Slate 29 Take 2 in the Timeline, select the clip's video In point, and drag it to the right by 2 seconds and 10 frames, until it snaps to the end of the audio track for Scene 17 Slate 25 Take 3 (see Figure 12.15). Choose View➜Collapse All Clips to collapse the expanded audio tracks, skim to 40 seconds in the Timeline, and play back the sequence from there to see the result.

FIGURE 12.15
Snapping the clip to the end of the audio track.

2. It takes too long for Joyce to come down the stairs, so let's trim the start of Scene 17 Slate 29 Take 2. Select the In point of Scene 17 Slate 29 Take 2, and ripple to the right by 17 frames (see Figure 12.16). Let's also punch up Joyce's arrival with a reaction from Katie. Position the playhead at 47 seconds and 5 frames in the Timeline and set the Event Browser's Filter pop-up menu to Favorites. Press Shift+2 to select Video Only as the source media, select Scene 17 Slate 28 Take 3 (favorite), and press Q to connect the clip to the Primary Storyline. Press Shift+1 to return the source media back to All. Skim to 49 seconds and 10 frames in the Timeline, and press Option+] (right bracket) to remove Katie's off-screen dialogue from the last clip. The sequence should end just after Joyce says "What are you doing up?"

FIGURE 12.16
Rippling the In point by 17 frames.

3. Next, we have the first of two dialogue exchanges between Joyce and Katie. In the first, Katie tries to convince Joyce that she has just seen Jason, despite the fact that he is nowhere to be found. Set the Event Browser's Filter pop-up menu back to All Clips, and select Scene 17 Slate 28 Take 3. Mark an In point at 3 seconds and 15 frames, just before Katie says "I'm playing with Jason," and press E to append the clip to the Primary Storyline.

Katie looks over to where Jason was standing to find that he's no longer there. In the rushes, we have a point-of-view insert of the empty hallway, so let's add that next. Position the playhead at 51 seconds and 22 frames in the Timeline, just after Katie looks over and her face registers surprise. Select Scene 17 Slate 27 Take 1 in the Event Browser, and press Q to connect the clip to the Primary Storyline. Let's also add a reaction from Joyce to see how she responds to this. Select Video Only as the source media and position the playhead at 55 seconds and 12 frames in the Timeline. Set the Event Browser's Filter pop-up menu to Favorites, select Scene 17 Slate 29 Take 2 (favorite), and press Q to connect the clip to the Primary Storyline (see Figure 12.17). Switch the source media back to All, skim to 45 seconds in the Timeline, and play back the section.

FIGURE 12.17
Connected clips
on the Primary
Storyline.

4. The next section takes place at the photo display, so we need a shot that shows the characters walking to this location. Set the Event Browser's filter pop-up menu back to All Clips, and select Scene 17 Slate 30 Take 1. If you play the clip, you'll notice that the audio isn't very good and we can barely hear the character's dialogue. However, this is the only clip that we have of them walking to the photo display; because the audio can be re-recorded and replaced later in a process known as automated dialogue recording (ADR), we're still able to use the clip here. We'll show you how to replace the dialogue in Chapter 13, using ADR audio files supplied on the DVD.

Mark an In point and an Out point on Scene 17 Slate 30 Take 1 between 07:16 and 11:21, and press E to append the clip to the Primary Storyline. Let's also tighten the edit point by trimming the end of the preceding clip. In the Timeline, select the Out point for Scene 17 Slate 28 Take 3 (the second clip from the end), and ripple to the left by 1 second and 10 frames to trim the end of the clip (see Figure 12.18).

FIGURE 12.18
Rippling the
clip's Out point
by 1 second and
10 frames.

5. When Joyce says, "There he is, with his football" it would be appropriate to cut to the photo she's referring to next. Select Scene 17 Slate 32 Take 1 in the Event Browser,

and press E to append the clip to the Primary Storyline. The rest of the dialogue exchange between Katie and Joyce occurs in a single two-shot. Select Scene 17 Slate 31 Take 2 in the Event Browser, and mark an In point and an Out point between 07:19 and 33:20. Press E to append the clip to the Timeline. Play back the section, and you'll notice that we haven't included Katie's question "What happened to him?" Let's run this line below the shot of Jason's photo. Select Scene 17 Slate 31 Take 2 in the Timeline and expand the clip's audio. Select the clip's audio In point and drag it to the left for 3 seconds until it snaps to the front of Scene 17 Slate 32 Take 1 (see Figure 12.19).

FIGURE 12.19
Snapping a clip's In point to the start of the preceding clip.

6. Select and play Scene 17 Slate 34 Take 2 in the Event Browser. This insert shot of Katie holding Joyce's hand can be used to further reinforce Katie's change of attitude and show that she's also connecting with Joyce as well as Jason. Let's place it over Joyce's line "That was a long time ago." Position the playhead at 1 minute, 24 seconds, and 10 frames in the Timeline, and press Q to connect Scene 17 Slate 34 Take 2 to the Primary Storyline. Skim to 1 minute and 10 seconds in the Timeline, and play back the section. The edited sequence ends with both characters taking a final look at Jason's photo, giving us the perfect opportunity to cut to the slow push in on Jason's photo. Select Scene 17 Slate 33 Take 1 in the Event Browser, and press E to append the clip.

All that remains now is to add our coda of Katie sitting on the bed waiting for Jason to reappear. We have two takes of this shot to choose from, with the only difference being that Katie holds the ball in Take 2. We think that Katie having the ball further reinforces the idea that she's waiting for Jason, so we choose Take 2. Select Scene 18 Slate 70 Take 2 in the Event Browser, and press E to append the clip to the Timeline. Press the Home key to go to the beginning and play back the completed sequence.

In the last four chapters, we've taken you through the thought process that went into the editing of many of the scenes for *Pranks*. If you've been following along and made it this far, well done! You, too, have completed editing all the sequences in the movie. However, our work is far from done—there's still a lot to do before the movie is ready for an audience. In the last part of this book, we'll introduce you to Final Cut Pro's effects and show you how to build up the soundtrack and put the finishing touches on the movie by color grading and adding titles.

part 4

After the Edit

chapter 13
Building the Soundtrack

MOST OF THE audio that you hear in Hollywood movies
is recorded and added afterward during post-production.
This allows the sound designer to have complete control
over the individual audio elements, enhancing each sound
to heighten the emotional impact of a scene. This is why
gunshots sound more like cannons during action movies.
When footsteps or clothes rustling are heard in a movie,
it's most likely recorded after the shoot by a Foley artist
who has painstakingly reproduced these everyday sounds
on a Foley stage.

Sometimes a production is forced to shoot in noisy loca-
tions, such as airports, or on days when the weather isn't
cooperating and the wind is completely blocking out the
actor's dialogue. In these situations, the best solution is
often to shoot the scene and re-record the actor's dialogue
afterward in a soundproof studio. This process is known
as automated dialogue replacement (ADR) and is some-
times also known as additional dialogue recording or
looping. The sound designer takes all these disparate
sounds and creates the auditory world of the scene.

The DVD accompanying this book includes a collection of
additional audio files, which were used to create the final
soundtrack for *Pranks*. These audio files can be found in
the Event Library and are organized in various Collections,
such as ADR, Sound FX, Music, and Audio Stems. The
Sound FX Collection is provided by the movie's dubbing

mixer, Ken McDowell, and includes everything from camera clicks, door slams, and toy squeaks to an assortment of background ambience sounds for both interior and exterior scenes. We've also included the original mix-downs used for the movie as separate audio stems comprising of Dialogue, Music, and Atmos & FX.

The music score, which was composed, arranged, and performed by Darren Jon Bunting, also has been made available for you and has been separated into individual music cues to make it easier for you to use anywhere in the Timeline. (A *music cue is* a single section of music that makes up the musical score.) We've also included two extra music cues—Photographs and Staircase Chase (reprise)—which were dropped from the final movie. However, feel free to use these in your version of the soundtrack if you wish. You can use all these audio elements on the DVD to create your very own sound design for *Pranks*. This chapter will look at how to use each audio element in a scene.

Replacing Dialogue with the ADR Files

Let's go back to the Building the Climax Project that you created in Chapter 12. You may remember that we encountered some problematic audio while editing the climatic scene in the hallway. The sound on the clips from that sequence were plagued with background camera noise, which unfortunately was unavoidable while shooting in that environment. Because we didn't have the luxury of ADR during the post-production of *Pranks,* we recorded each actor's lines after the shoot in a quieter area on the set, a tactic that is used on many low-budget movies. We've provided these "ADR" recordings on the DVD, and in the following section you'll be using these to replace some of the problematic audio that we encountered on this project.

1. In the Project Library, double-click the Building the Climax Project to open it in the Timeline.

2. Press ⌘+Shift+2 to open the Timeline Index and type **Scene 17 Slate 30 Take 1** into the search field. Select this in the search results to reveal it in the Timeline and play back the clip. As you can hear, the dialogue is barely audible during the clip, but because it was the only take that we had of that particular shot, we had no choice but to use it.

3. In the Event Library, click the Collection Jenny Seagrove (Joyce) to display its contents in the Event Browser. This collection contains all the additional dialogue that actress Jenny Seagrove recorded for us after performing the scene. The line of dialogue that we need for the clip is "There he is. With his football." This can be found on the clips titled "He was my son: football" in the Event Browser. There are 3 different line

readings to choose from, but we need to choose the audio clip that best matches the video in the clip. We've found the best match to be "He was my son: football-1."

4. Press ⌘+2 to make the Timeline active and position the playhead just before Joyce says the line "There he is". This should be at 1 minute, 6 seconds, and 14 frames in the Building the Climax project Timeline (or 1 second and 11 frames into Scene 17 Slate 30 Take 1). To make this easier to locate, open the Clip Appearance panel by clicking the Switch button at the bottom of the Timeline window and select the first button to display audio waveforms only (see Figure 13.1). You also can increase the Clip Height to make the waveforms easier to see.

FIGURE 13.1
The Clip Appearance panel set to show audio waveforms only.

5. Press ⌘+1 to make the Event Browser active and select "He was my son: football-1." Mark an In point at 2 seconds and 59 frames into the clip (just before Joyce says "There he is") and an Out point at 4 seconds. Press Q to connect this selection to the Primary Storyline.

6. Go back to the Timeline and position the playhead just before Joyce says the line "With his football" at 1 minute, 8 seconds, and 3 frames in the Timeline (or 3 second into Scene 17 Slate 30 Take 1).

7. Select "He was my son: football-1" in the Event Browser and mark an In point at 4 seconds and 51 frames into the audio clip. Press Q to connect this selection to the Primary Storyline (see Figure 13.2).

8. Select Scene 17 Slate 30 Take 1 in the Timeline and open the Inspector's Audio pane. Disable the clip's audio by un-checking the Channel Configuration check box. Play back the section to hear the result. If the lip sync is slightly out of sync with the picture, select an audio clip in the Timeline and use the keyboard's comma and period keys to nudge the audio back and forth until the sync is perfect.

FIGURE 13.2
The two ADR files added to the Timeline.

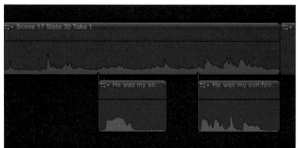

The next clip in the sequence (Scene 17 Slate 32 Take 1) is a cutaway shot of Jason's photo that includes Katie's line "What happened to him?" Katie's dialogue is taken from the following clip (Scene 17 Slate 31 Take 2), which has quite a lot of background noise on it. We can replace the line with ADR using the same procedure. Because the line is spoken off-screen, this will be easier to do because there is no lip sync to match.

1. Open the Timeline's Clip Appearance panel and select the third button so that you can see both video and audio for the clips in the Timeline.

2. Select Scene 17 Slate 31 Take 2 in the Timeline and press Control+S to expand the clip. As you can see, the audio of Scene 17 Slate 31 Take 2 runs across the preceding clip (Scene 17 Slate 32 Take 1).

3. Press N to activate snapping (if it isn't already active). Select the audio In point of Scene 17 Slate 31 Take 2 and drag it 3 seconds to the right until it snaps with the start of Scene 17 Slate 31 Take 2.

4. Select the Ellie Darcey-Alden (Katie) Collection in the Event Library and drag the "What happened to him?" audio clip on to the Timeline so that it connects below Scene 17 Slate 32 Take 1. The clip displays a green connection link to indicate where its placement will be on the Primary Storyline. Because there's no lip sync to match, move the audio anywhere below Scene 17 Slate 32 Take 1 that sounds right to you.

Cleaning Up the Audio

By replacing Katie's line "What happened to him?" with cleanly recorded ADR, we've removed all the background noise that plagued the original recording. However, this noise returns as soon as the sequence cuts back to Scene 17 Slate 31 Take 2 in the Timeline. The bad news is that we haven't recorded any ADR for this section of the scene. The only option we have is to try to clean up as much of the original recording as we can using Final Cut Pro's plug-ins. We've already looked at these plug-ins back in Chapter 8, but now it's time to put them to

use in our project. We recommend that you use a pair of good quality headphones for the following exercise.

1. Select Scene 17 Slate 31 Take 2 in the Timeline and open the Inspector. Select the Audio pane and click the Channel Configuration disclosure triangle. The clip's audio is configured as a single stereo file. Press ⌘+Shift+8 to open the audio meters (if they aren't already open) and play back Scene 17 Slate 31 Take 2 in the Timeline. As you can see from the audio meters, all the dialogue is recorded on the left channel of the file, which is common practice when recording audio on the set. Because the right channel is of no use to us, let's remove it.

2. Under Channel Configuration in the Inspector, choose Dual Mono from the Channels drop-down menu. The single stereo file is replaced by two mono audio strips under the Channel Configuration section. As you can see from the waveforms, there is hardly any audio recorded on the bottom Mono track, so un-check the check box beside the bottom audio track to disable it (see Figure 13.3).

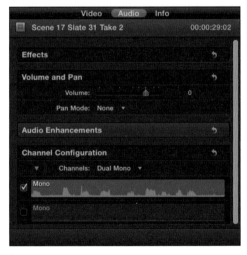

FIGURE 13.3
Disabling a mono track in the Inspector.

3. Choose Window➜Media Browser➜Effects to open the Effects Browser (if it isn't already open) and type **EQ** into the search field. Select Scene 17 Slate 31 Take 2 in the Timeline and double-click the Channel EQ plug-in in the Effects Browser to apply it to the clip.

4. With Scene 17 Slate 31 Take 2 still selected, open the Inspector and click the Audio tab. Under Effects, you'll find the Channel EQ setting for the clip. Click the EQ button to bring up the plug-in interface and then click the Parameters disclosure triangle to access the settings.

5. Click the Analyzer button on the Channel EQ Interface and play back Scene 17 Slate 31 Take 2. The Analyzer shows quite a bit of low-end rumble occurring during the clip. Let's remove these unwanted bass frequencies. In the Inspector's Channel EQ settings, check the Low Cut On/Off check box to activate the Channel EQ's high-pass filter. You can also turn the high-pass filter on by clicking on the first of eight buttons that run across the top of the Channel EQ's interface (see Figure 13.4). As its name suggests, a high-pass filter cuts off low frequencies while allowing high frequencies to "pass" through. A low cut of around 144 Hz should be enough to remove the unwanted low frequencies. Drag the Low Cut Frequency slider to 144 or type the value into the name field and press Return (see Figure 13.5).

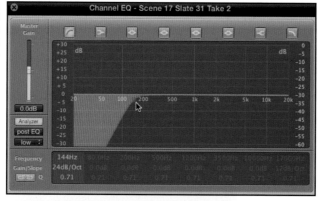

FIGURE 13.4 The Channel EQ's high-pass filter on the interface.

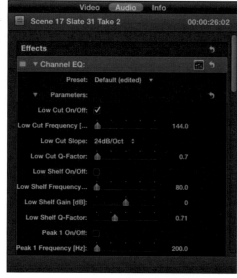

FIGURE 13.5 The Channel EQ settings in the Inspector.

We've cleaned up the low end of the audio, but the sound is far from ideal. If you listen closely, you can hear an annoying buzzing sound as well as a lot of background noise. We can use the Channel EQ plug-in that we've already applied to remove the buzzing sound. A parametric filter will allow us to pinpoint the buzz's particular frequency and reduce it.

1. To activate the parametric filter, make sure Scene 17 Slate 31 Take 2 is still selected, and check the Peak 1 On/Off check box in the Inspector's Channel EQ settings or click on the third button across the top of the Channel EQ's interface. The buzz's frequency that we want to lower is around 2 Khz. Drag the Peak 1 Frequency slider to 2160 Khz to set the frequency that we want to reduce and drag the Peak 1 Gain to –16 to make the reduction (a positive value would increase this frequency).

2. As you can see from the shape displayed on the Channel EQ's interface, the reduction covers a broad range of frequencies. The bandwidth (or Q) needs to be narrower so that we eliminate only the buzzing sound and don't affect the performers' voices. To do this, set the Peak 1 Q-Factor to 6 in the Inspector's Channel EQ settings. This zones in on just the frequency we want and leaves the surrounding frequencies unaffected (see Figure 13.6). Playback Scene 17 Slate 31 Take 2, and turn the Channel EQ on and off in the Inspector to compare the difference.

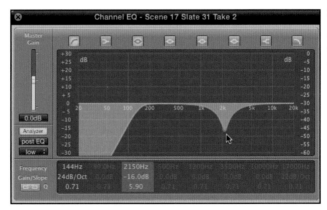

FIGURE 13.6
Removing an unwanted frequency in the audio.

We still have a lot of background noise on the clip's audio, which will be very difficult to remove completely without affecting the tonality of the actor's voices. However, let's see if we can reduce it to an acceptable level. We'll use Final Cut Pro's Expander plug-in to help us. An expander is similar to a compressor, except instead of reducing an audio clip's dynamics, an expander increases the dynamic range. This has the effect of pushing background noise further into the background and making the dialogue louder and more pronounced.

1. Open the Effects Browser and type **Expander** into the search field. Select Scene 17 Slate 31 Take 2 in the Timeline, and double-click the Expander plug-in in the Effects Browser to apply it to the clip.

2. Open the Inspector and select the Audio tab. Under Effects, you'll find the Expander settings for the clip. Choose High Expansion from the Preset drop-down menu and click the EQ button to bring up the plug-in's interface (see Figure 13.7).

FIGURE 13.7
The Expander
settings in the
Inspector.

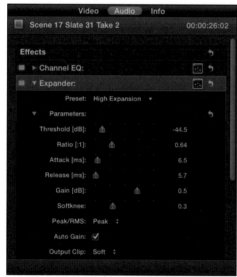

3. First, we'll set the threshold, which will expand any audio signal above this level. On the Expander's interface, drag the Threshold slider all the way to the bottom so that it reads –50 dB. Next, we'll set the relative amount of expansion when the signal exceeds the threshold level. Play back Scene 17 Slate 31 Take 2 and experiment with the Ratio slider on the Expander's interface. Drag the Ratio slider all the way to the left so that it reads 0.5 (see Figure 13.8).

As you play back Scene 17 Slate 31 Take 2, turn the Channel EQ and Expander plug-ins on and off in the Inspector to hear how we've much improved the audio on this clip. The background noise hasn't been completely removed, but we've taken away enough of it to make the clip usable. Adding background room tone and music also will help conceal whatever noise is left. The rest of the clips in this sequence also suffer from varying degrees of background noise, which would need to be removed using the same procedures. However, rather than have you go through the pain of doing this for every clip in the project, we've had the original camera audio professionally processed by the movie's dubbing mixer, Ken McDowell.

This has been provided as a single Dialogue audio stem, which we will be using to build the rest of the soundtrack later in this chapter.

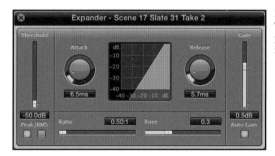

FIGURE 13.8
The Expander plug-in interface.

Adding Ambience and FX

Earlier in the chapter, we replaced the on-set recorded sound for Scene 17 Slate 30 Take 1 and Scene 17 Slate 32 Take 1 with ADR. This section sounds a little unnatural when played back because there is no sense of the location's space. This can easily be remedied by adding an ambience or room tone track that runs throughout the scene. Because each clip in a scene can have a slightly different ambient background, a cut from shot to shot can be more noticeable. A consistent ambience track that runs throughout the entire scene helps mask each cut, giving the illusion that each shot is happening in the same space. A scene's ambience can come from room tone recorded on location during the movie's production or from sound libraries that have recordings of weather and nature sounds. On the DVD's Sound FX Collection, you'll find both interior and exterior ambience for you to use during the project. Let's add some to our scene.

1. Click the Sound FX Collection in the Event Library and type **atmos** into the Event Browser's search field. The search results displays four ambience files. Three of the files are for exteriors so let's select the file named Atmos Interior.

2. Press ⌘+2 to make the Timeline active and position the playhead at the start of Scene 17 Slate 30 Take 1 (this should be at 1 minute, 5 seconds, and 3 frames in the Timeline). Press Q to connect the Atmos Interior audio clip to the playhead position (see Figure 13.9).

3. Play back the section. The ambience clip's volume is too loud, so let's reduce it. Select the Atmos Interior clip in the Timeline and open the Inspector's Audio panel. Drag the Volume slider until the background ambience is at a suitable level (–14 should do the trick).

4. Skim back to the start of Scene 17 Slate 30 Take 1 and play back the section. The background ambience ties the scene together, especially when cutting from shot to shot.

FIGURE 13.9
Adding
background
ambience to the
Timeline.

Incorporating the Music Cues

After the main edit, the director and music composer get together for what's known as a spotting session to discuss the role that music will play in the movie. Aesthetic decisions are made on which scenes require underscoring and which emotional beats need emphasizing to best tell the story. Music can be used to set the tone and mood of the movie, provide a musical theme that relates to an important character, or parallel the action that's occurring on-screen.

Let's continue working on the Building the Climax Project. This time we'll add a music cue and show you how to control the volume using keyframes in the Timeline.

1. Position the playhead at 21 frames into Scene 17 Slate 30 Take 1, just before Joyce says "There he is." (This should be at 1 minute and 6 seconds in the Timeline.)

2. In the Event Library, click the Music Collection and select the clip "13. He Was My Son" in the Event Browser. Press Q to connect the clip to the Primary Storyline. Play back the section to hear how it sounds.

3. The music comes in too loud, so let's reduce it. Select "13. He Was My Son" in the Timeline and open the Inspector's Audio panel. Use the Volume slider to reduce the audio by −7 dB. Alternatively, drag down the horizontal audio level line that runs across the clip in the Timeline.

 Next, we'll vary the music's volume when the characters speak, reducing the audio further so that the music doesn't overpower the dialogue. We'll do this by adding keyframes in the Timeline. To add a keyframe, hold down the Option key and hover the cursor over the clip's horizontal audio level line at the position where you want the keyframe to go. When a diamond icon with a plus sign appears, click the cursor to place

the keyframe (see Figure 13.10). To delete the keyframe, click it again to select it (the diamond turns orange) and press Delete.

When you click down on a keyframe and drag it up or down, two horizontal arrows appear over the top and bottom of the keyframe that indicate you're changing the volume at the position. Final Cut Pro has a safeguard in place that prevents you from moving the keyframe left or right so that you don't accidentally change the keyframe's placement in time while changing the volume. When you click down on a keyframe and drag it left or right, two vertical arrows appear on either side of the keyframe that indicate you're changing the keyframe's placement in time. Once again, you're restricted from moving the keyframe up or down so that you don't accidentally change the volume of the clip while changing the keyframe's placement in time.

4. To make the waveforms easier to see, open the Clip Appearance panel, click the first button to display audio waveforms only, and increase the Clip Height.

5. Place a keyframe at the very start of "13. He Was My Son" by Option-clicking on the clip's horizontal audio level line. Place a second keyframe 2 seconds later.

6. We want to fade the music's volume as Joyce says her first line of dialogue. To do so, click to select the second keyframe and drag it down so that the on-screen display reads –14 dB (see Figure 13.11).

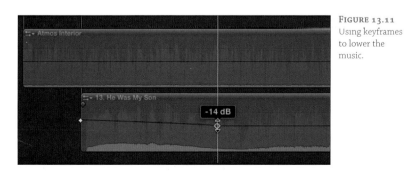

FIGURE 13.11
Using keyframes to lower the music.

7. To fade the music back up after Joyce finishes her dialogue, place a third keyframe 26 seconds into "13. He Was My Son" and a fourth keyframe at the end of the clip. Drag the fourth keyframe up so that the on-screen display reads –7 dB (see Figure 13.12).

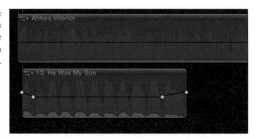

FIGURE 13.12
Four keyframes help duck the music beneath the dialogue.

Obviously this is a very simple example of how to vary audio over time using keyframes, but hopefully you can see how useful keyframes can be when used in this way. Not only can keyframes be used to duck loud passages of music, but the same techniques can be employed to eliminate unwanted pops and clicks on an audio clip, which is a breeze when combined with Final Cut Pro's Zoom to Samples feature (see Chapter 5).

Keyframes also can be used to adjust audio effects over time in much the same way by adding keyframes directly in the Audio Animation Editor (see Figure 13.13). We briefly touched on the Audio Animation Editor back in Chapter 8 when we used it to display the effects applied to a clip in the Timeline. To bring up the Audio Animation Editor, select a clip in the Timeline and choose Clip➜Show Audio Animation or press Control+A.

FIGURE 13.13
Adding keyframes to the Audio Animation Editor.

Constructing Your Own Sound Design

Now that you've worked with each of the different audio elements on a single scene, it's time to apply what you've learned on the complete movie. Mount the *Craft of the Cut* disc image and launch Final Cut Pro. In the Project Library, double-click the Pranks Work In Progress

Project to open it in the Timeline. This project contains a completed edit of *Pranks* and a single stereo audio stem. The stem is made up of the actual sound recorded on location and consists of mostly dialogue spoken by the performers. The background camera noise has been removed, and the audio has been professionally mixed and processed to make it easier for you to work with. Watch the Pranks Work In Progress Project a few times and look for ways to use sound to enhance the visuals. Pay close attention to areas that may need further work. For instance, there's a short dip during the dialogue at 58 seconds and 15 frames that could benefit from some additional ambience.

Look through the Sound FX Collection in the Event Browser and use the files there to create your own sound design in this project. Remember that you also have access to all the sound effects found inside Final Cut Pro's Music and Sound Media Browser. You'll find the original Atmos & FX stem inside the Audio Stems Collection in the Event Library.

In the Music Collection, you'll find all the individual music cues that make up the final score. You can experiment and place these cues anywhere that you want on the Timeline or re-create the score as it appears in the final film. To Do Markers have been placed in the project to indicate where each music cue starts in the original movie. To use these, open up the Timeline Index by choosing Window➜Show Timeline Index or pressing Shift+⌘+2. In the Timeline Index, select the Tags category and click the Show Incomplete To-Do Items button. Use the Index to navigate through the markers in the Timeline and connect each music cue to the marker's position. Tick the marker's Completed check box for each cue that you complete (for more information on using markers see Chapter 5). Table 13-1 lists the music cues used in the final film and the times that they appear on the Timeline.

Table 13-1 Timeline Music Cues

Music Cue	Time
Toy Box	00:00:01:07
Katie's Arrival	00:00:38:18
Katie's New Room	00:01:53:04
Football/Teddy	00:03:15:03
Teddies/Spider	00:04:19:15
Alphabet Blocks/Camera Flashes	00:05:21:09
I'll Deal With Him Myself	00:06:36:22
On The Stairs	00:07:12:21
Staircase Chase	00:08:28:14
I'm Playing With Jason	00:10:13:02
He Was My Son	00:10:25:23
Waiting	00:10:56:14

Creating a Surround Mix

The final audio mix for most of the projects that you'll work on will most likely be in stereo, which is why this is the default setting when you create a new project in Final Cut Pro. Audio clips in the Timeline can be panned in the Inspector, allowing you to determine the position of each sound in a stereo or multi-channel sound field. To pan a sound in Final Cut Pro, you must first apply a Pan Mode to an audio clip. Select the clip in the Timeline and open the Inspector's Audio pane. Under the Volume and Pan section, choose a preset from the Pan Mode drop-down menu. Once a preset has been chosen, a Pan Amount slider becomes available along with the Surround Panner if you've chosen a Surround preset (just click the disclosure triangle to reveal it). For stereo projects choose the Stereo Left/Right preset, which allows you to position the sound between the left and right channels.

Surround mixes give you a 360-degree sound space to play with, but you'll also need the appropriate hardware and speaker set up in order to monitor your audio output. Before starting on a Surround mix, you need to set your project's properties to Surround mode. To do this, follow these steps:

1. Select the project in the Project Library and choose File➜Project Properties or press ⌘+J. This opens the Project Properties pane in the Inspector.

2. Click the wrench icon at the bottom of the window to open the Project Properties dialog box and choose Surround from the drop-down menu under the Audio and Render Properties section.

3. Click OK to apply the change. Final Cut Pro's audio meters will now display six channels instead of two.

The same audio rules apply for working in Surround as they do with Stereo, only you now have six audio levels to keep an eye on. These are for the front left/right speakers, a center speaker, rear left/right speakers, and a low-frequency subwoofer. An audio clip in the Timeline can have its sound panned so that it favors any of these speakers. The Surround Panner provides a visual representation of a sound's placement in the Surround Sound field. If you choose Dialogue as the Pan Mode, for instance, the Surround Panner shows the center speaker as having most of the audio signal (see Figure 13.14). Whereas choosing Ambience shows most of the signal distributed among the left and right rear speakers. The strength of the audio signal is represented by the colored areas emanating from the speaker icons, and this can be increased or decreased by using the Pan Amount slider above the Surround Panner. You can further adjust a preset by manually placing a sound anywhere inside the Surround Panner by dragging the round puck closer to or farther away from the sound channels. The closer to the center the puck is placed, the more evenly the audio is distributed among all the speakers. An audio channel also can be turned on or off by clicking its speaker icon.

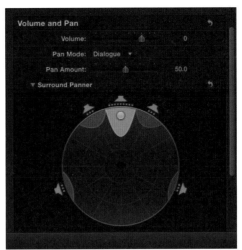

FIGURE 13.14
The Surround
Panner with the
Pan Mode set to
Dialogue.

If you've ever watched a movie with the sound down, you'll recognize how much the sound design adds to the overall experience of the story. The quality of a movie's soundtrack is what separates the amateur from the professional. As you've seen, a lot of work goes into the creation of a soundtrack. Background noise is removed from location recordings, dialogue is equalized and processed, sound effects and background ambience is added, and music is composed and recorded. All these different audio elements are brought together and correctly balanced by the sound designer in a final mix. Use your imagination when working with the audio files that come with the DVD to create a sound design for *Pranks* that reflects your creativity.

chapter 14
Working with Effects

PRANKS DIDN'T REQUIRE much in the way of effects during post-production, but we still wanted to give you an introduction to the effects that are available in Final Cut Pro for you to use in your future projects. Final Cut Pro comes with two kinds of effects. There are the plug-in effects, which are accessible from the toolbar's Media Browsers, and there are also several built-in effects, which are incorporated into the clips themselves once they have been added to the Timeline. Both types of effects come with their own particular settings that are available from the Inspector, and these allow you to manipulate the effect further. Most of the settings allow you to set keyframes, which lets you animate any parameter changes that you make over time. Let's take a closer look at both types of effects.

Exploring the Built-In Effects

Final Cut Pro's built-in effects allow you to directly manipulate each clip in the Timeline via on-screen controls in the Viewer or by changing parameter settings inside the Inspector, enabling you to transform, trim, crop, and distort the image on-screen. These kinds of effects are typically performed during compositing and can be animated using keyframes. Compositing is the process of combining several different images into one image on-screen. This can be anything from superimposed titles to split-screen effects and generally require that a clip, generator effect, or still image be connected above another clip in the Primary Storyline. These composites can be merged using a variety of different Blend modes, which are available via the Inspector.

To access the built-in effects, first select the clip that you want to manipulate in the Timeline; then open the Inspector's Video tab or click one of the first three effects buttons below the Viewer. These buttons activate the on-screen controls, which superimpose handles and borders over the image that allow you to manipulate the image directly with the cursor. In the Inspector, the controls for the Transform, Crop, and Distort effects are uncovered by clicking the blue Show icon (you need to hover the cursor over this area to reveal the Show icon; see Figure 14.1). To conceal them again, just click the blue Hide icon in the same way.

FIGURE 14.1
The built-in effects buttons below the Viewer.

Click Show to reveal an effect's settings

Transform | Distort

Crop

The buttons beside the Show icon act just like the buttons beneath the Viewer and activate the on-screen controls. Once the parameters are uncovered, you can alter the image using

the sliders and dials or by typing in a value directly into the Settings field. Clicking the curved arrow button resets any changed settings to their default values, and you can temporarily turn off any effect by clicking the blue box next to the effect's name. Let's look at how each of these effects works.

Transforming images

The first effect that we're going to look at is Transform, which allows you to change the position, rotation, and scale of an image. To bring up the on-screen Transform controls, select a clip in the Timeline and either click on the first button on the left below the Viewer or press Shift+T. This superimposes eight blue dots around the image in the Viewer, which can be used to alter the image in several ways:

- ⃝ Clicking and dragging on any of the four corner dots allows you to scale the image up or down, while maintaining the image's aspect ratio (the relationship between the width and height). Holding down the Shift key as you drag lets you contort the aspect ratio in many ways.

- ⃝ Clicking and dragging any of the four side dots shrinks or enlarges the image. Holding down the Shift key as you drag maintains the image's aspect ratio, while holding down the Option key allows you to affect just the side that you're dragging.

- ⃝ Clicking and dragging inside the image allows you to move the image and position it anywhere on the screen.

- ⃝ Clicking and dragging on the center handle let you rotate the image (see Figure 14.2). Moving the handle farther away from the center allows you to make finer and more precise adjustments. Holding the Shift key as you rotate constrains the rotations to 45-degree increments.

Clicking the Done button applies any adjustment to the clip. If you prefer to work numerically, you can use the sliders or dials found inside the Transform section of the Inspector's Video pane. Settings also can be adjusted by scrolling up and down (or sideways) over the parameter's Number field. X changes the image horizontally, Y, vertically. To reset any parameter, click the down arrow at the end of any setting and choose Reset Parameter.

The Inspector provides an additional setting not available in the on-screen controls of the Viewer and that is the ability to change the Anchor position. The Anchor is the point where the image scales or rotates from, with the default Anchor point being the center of the screen. If you want to scale or rotate from another position, the Anchor can easily be changed using the X and Y controls in the Inspector.

FIGURE 14.2
Rotating an
image using the
Transform
controls.

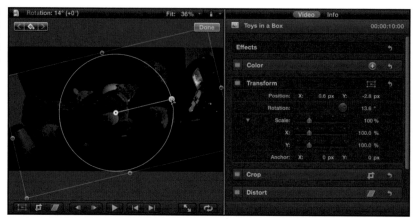

Trimming and cropping images

The next built-in effect that we're going to look at allows you to trim, crop, and create the Ken Burns effect. To bring up these on-screen controls, select a clip in the Timeline and either click on the second button below the Viewer or press Shift+C. Doing so overlays three buttons over the image in the Viewer where you can choose the effect that you require. To access these effects from the Inspector, choose Trim, Crop, or Ken Burns from the Type pop-up menu, under the Crop category.

Clicking the Trim button places eight blue rectangle handles around the image in the Viewer. Clicking and dragging on these handles lets you trim the edges of the image, enabling you to hide areas from view. Dragging with the Shift key held down maintains the image's aspect ratio, while dragging with the Option key allows you to trim both adjacent sides at the same time. Any areas that are hidden become transparent and show as black on-screen. If you're trimming the image of a Connected clip above the Primary Storyline, the clip below shows through the trimmed area. In order to remove a section of the image and scale it up to fit the frame, you would need to crop the image instead.

When we were editing the Setting Up the Story sequence back in Chapter 9, we came across a shot that had a boom mike drop into frame at the end of the clip. We ended up using an alternative clip in the edit, but what if this were the only clip available to cover the scene? If we were forced to use the clip, we would need to zoom into the shot to avoid seeing the microphone. Let's see how we can do this using Final Cut Pro's Crop feature.

1. Double-click the *Craft of the Cut* disc image to mount it, and launch Final Cut Pro. Select the Setting Up the Story Collection in the Event Library and search for Scene 3 Slate 13 Take 2.

2. Control-click Scene 3 Slate 13 Take 2 in the Event Browser and choose Open in Timeline. The clip opens in the Timeline as a video clip with a connected audio clip below it.

3. Position the playhead at 37 seconds in the Timeline. In the Viewer, you can see the microphone prominently in the frame.

4. Select the video clip in the Timeline and click the Crop button below the Viewer or press Shift+C to display the on-screen controls.

5. Choose Crop from the on-screen buttons in the Viewer. Four blue handles appear on each corner of the frame, which you can use to reframe the image.

6. Click and hold on the top, left handle and slowly drag it down. As you drag, a rectangular border over the image shows you the new framing of the shot. Position the border so that the top horizontal edge sits just below the boom mike (see Figure 14.3).

7. Click Done to apply the crop. The cropped area scales up to fill the frame.

When creating any kind of effect that calls for the image to be scaled up, take care not to zoom in too much, because excessive scaling can cause image degradation and blurry pictures. As with the Transform effect, trimming and cropping also can be performed using sliders inside the Inspector.

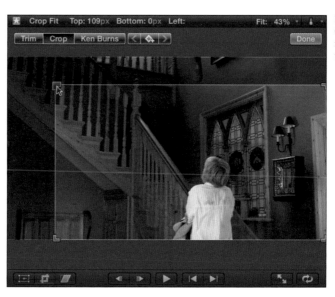

FIGURE 14.3
Cropping out a microphone in the Viewer.

Creating the Ken Burns effect

The Ken Burns effect is a popular technique used to add movement to static images by slowly panning and zooming over them. This effect generally is used in documentaries and can be achieved very easily right inside Final Cut Pro.

To bring up the Ken Burns on-screen controls select a clip or still image in the Timeline, click the second button below the Viewer (or press Shift+C), and click the Viewer's Ken Burns button. Two color rectangles appear over the image in the Viewer. The green rectangle represents the starting position and the red rectangle represents the ending position. By dragging the corner handles, you can position each rectangle to indicate the start and end framing of the move. An on-screen arrow shows the direction of the pan and zoom across the image and can be reversed by clicking the double-arrow button at the top of the Viewer. Figure 14.4 shows a still image of both Joyce and Katie (we've included the still on the DVD for you to experiment with; it can be found in the Images Collection). The green starting rectangle is set up to include both characters in the frame and the red ending rectangle is set up to include only Katie, resulting in a zoom-in and pan to the left that ends on a close-up of Katie.

FIGURE 14.4
The direction of
the Ken Burns
effect in the
Viewer.

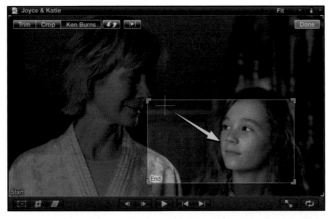

The speed of the Ken Burns effect is dependent on the duration of the clip or still image in the Timeline. For a faster move, simply shorten the clip in the Timeline. To preview the effect, click the Play button at the top of the Viewer. As before, clicking Done applies the effect. When using the Ken Burns effect, aim to use images that are larger than your video project's frame size. This gives you a larger area in which to pan and zoom across and avoids unnecessary scaling, thus improving image quality.

Distorting images

The Distort effect allows you to reposition all four corners of an image to warp and skew the shape of the frame. This can be used to place an image inside another object in the frame, such as a television set, or to simulate depth or create the illusion of perspective in a composition.

To bring up the on-screen Distort controls, select a clip in the Timeline and click the third button below the Viewer or press Shift+⌘+D. This places eight blue rectangle handles around the image in the Viewer. Dragging any of the corners allows you to skew the image in the shape that you require. The x- and y-coordinates for each of the four corners also can be altered numerically inside the Distort section of the Inspector's Video pane.

Animating with keyframes

The changes that you make to the Transform, Crop, and Distort parameters can be animated over time using keyframes. A keyframe specifies an effect's parameter value at the position of the playhead in a similar way to audio keyframes (discussed in Chapter 13). To change this value over time, you need to have at least two keyframes at different positions in the Timeline: one keyframe that sets the starting value and another keyframe that sets the ending value.

Keyframes can be added in the Inspector, the Timeline, or via the on-screen controls in the Viewer. To create an animation, select a clip in the Timeline and place the playhead where you want the animation to begin. Add your first keyframe, move the playhead to another position on the clip, and adjust a value in the Inspector or make a change via the Viewer's on-screen controls. Final Cut Pro automatically adds another keyframe whenever you change the playhead position and adjust an effect's parameter. When you've finished your animation click Done.

The on-screen controls for the built-in effects include a Keyframe button, represented by a diamond icon with a plus sign. Clicking the Keyframe button adds a keyframe and turns the icon orange with an X (see Figure 14.5). To delete a keyframe, position the playhead on the keyframe and click the orange X icon. The left and right arrows on either side of this icon jump the playhead to the previous or next keyframe position. The Viewer in Figure 14.5 shows a picture-in-picture effect that uses the Transform's Scale and Position parameters to shrink and reposition a Connected clip in the corner of the frame. When played back, the Connected clip begins as a full frame (the first keyframe) and then scales down and moves into the corner (the second keyframe).

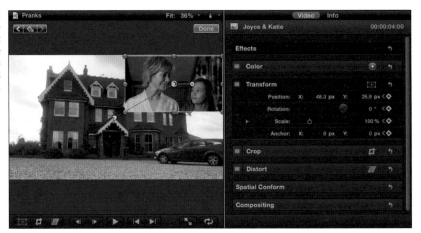

FIGURE 14.5
A picture-in-picture effect using the Transform's on-screen controls.

Transform effects display a red, dotted line to show the path that the animation takes over time. You can choose between a Linear and Smooth path by Control-clicking on a keyframe (see Figure 14.6).

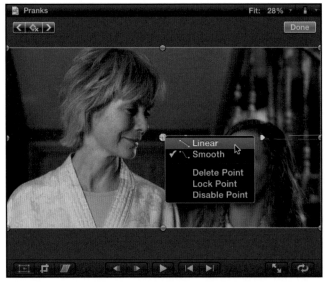

FIGURE 14.6
Choosing between a Linear and Smooth animation path.

Choosing Smooth allows you to create curved paths, which you can control using Bezier handles (see Figure 14.7). Arrows on each end of the dotted line indicate the starting and ending keyframes. The same process can be achieved directly in the Inspector, allowing you

to animate any parameter that has a diamond keyframe button next to it, including transitions, text, and filters.

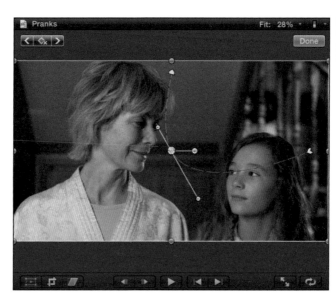

FIGURE 14.7
Creating curved
paths with
Bezier handles.

Working with the Animation Editor

Any keyframes that you apply via the Viewer's on-screen controls or the Inspector can be manipulated in the Timeline using the Animation Editor. To open the Animation Editor, select a clip in the Timeline and choose Clip➡Show Video Animation or press Control+V. The Animation Editor opens above the clip and lists all the built-in effects, plus any other effects that have been applied to the clip. Active effects are highlighted in blue, and effects that have been disabled in the Inspector are grayed out (see Figure 14.8). Effects can be turned on and off using the blue button next to the effect's name.

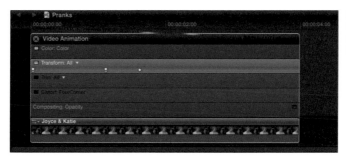

FIGURE 14.8
The Animation
Editor in the
Timeline.

Small diamonds that run across a dotted line in the Animation Editor represent the keyframes that have been applied. You can add additional keyframes by Option-clicking the line. Clicking and dragging on a keyframe lets you reposition the keyframe and control the speed of the animation. The shorter the distance between keyframes, the faster the speed of the animation. Final Cut Pro restricts the keyframe's movements horizontally or vertically, as discussed in Chapter 13.

If you want to focus on a single effect in the Animation Editor, select the clip and, with its Animation Editor already activated on the Timeline, choose Clip➜Solo Animation or press Control+Shift+V. Soloing the Animation Editor hides all the effects except for the default Opacity effect, but you can easily change this to an effect of your choice by using the pop-up menu at the top of the effect (see Figure 14.9). Bringing up the Opacity control in this way allows you to easily create fade-ins and fade-outs using handles available inside the Animation Editor (see Figure 14.10). To show these, expand the effect using the disclosure triangle on the top-right corner of the effect.

FIGURE 14.9 Choosing a new effect in the Animation Editor.

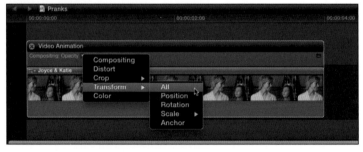

FIGURE 14.10 Creating fades using the Opacity control inside the Animation Editor.

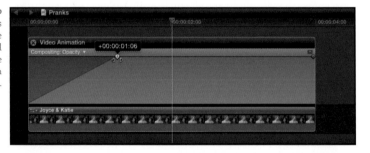

Creating Effects for the Movie

In addition to the built-in effects, there are many plug-in effects available in Final Cut Pro, and you can find them within the Effects Browser in the Toolbar. These work in the same way

as the audio plug-ins and transition effects that were discussed in Chapters 7 and 8. To open the Effects Browser, choose Window➔Media Browser➔Effects or press ⌘+5. Effects are organized into categories such as Blur, Distortion, and Tiling, and additional plug-ins can be purchased and installed from third-party vendors such as Red Giant Software and CrumplePop.

To preview an effect, simply select a clip in the Timeline and skim the cursor over the effect's thumbnail in the Effects Browser. This allows you to see what the effect will look like when applied to that specific clip. To apply the effect to the clip, double-click its thumbnail or drag and drop it directly on the clip in the Timeline. The effect's parameters can be found inside the Inspector's Video tab and can be adjusted in the usual way.

Flipping Shots

Let's see how this works in practice. In Chapter 1, we discussed how the opening shot had to be recorded with the camera placed upside down, requiring the editor to flip the clip back in the edit. The clip in question is Scene 1 Slate 1 Take 5, and because it's unlikely that we would ever use this shot upside-down, let's add the effect to the clip directly in the Event Browser. Any effect that we apply to a clip in the Event Browser remains with the clip when it's added to the Timeline. In this way, the shot will be flipped the right way whenever we want to use it in a sequence.

1. Double-click the *Craft of the Cut* disc image to mount it, and launch Final Cut Pro.

2. Select the Pranks Media Event in the Event Library, and type **Scene 1 Slate 1 Take 5** into the Event Browser's Search field.

3. Control-click Scene 1 Slate 1 Take 5 and choose Open in Timeline.

4. Select the clip in the Timeline and press ⌘+5 to open the Effects Browser. Type **Flipped** in the Search field.

5. Double-click the Flipped thumbnail or drag and drop it onto Scene 1 Slate 1 Take 5 in the Timeline.

6. With Scene 1 Slate 1 Take 5 still selected, press ⌘+4 to open the Inspector.

7. Click the Inspector's Video pane. Under the Effects section, you'll find the settings that control the Flipped effect.

8. The Direction drop-down menu allows you to choose from Horizontal (flipping the clip sideways), Vertical (flipping the clip upside-down), and Both (flipping the clip in both directions). For our purposes, choose Both from the drop-down menu (see Figure 14.11). Our shot is now the correct way around.

The Flipped settings also include an Amount slider, which can be keyframed, allowing you to animate the movement of the flip.

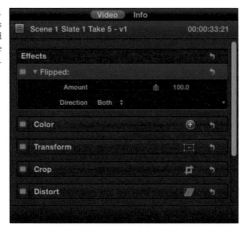

Creating a camera flash effect

Digital cameras that use CMOS sensors and rolling shutters can be susceptible to flash banding when recording shots that feature short bursts of light, such as flash bulbs or strobes. This causes a partial exposure where the light flash is split between two frames (see Figure 14.12). The figure shows a flash-band occurring on a single frame during Scene 14 Slate 43 Take 4 that was used during the Editing Action sequence that you worked on back in Chapter 11.

FIGURE 14.12
An unwanted flash band that occurs during Scene 14 Slate 43 Take 4.

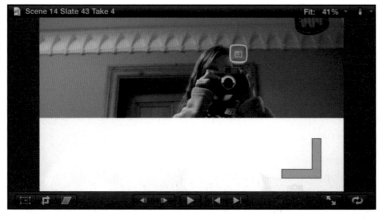

Let's create a flash effect to hide this unwanted band using one of Final Cut Pro's transitions.

1. In the Project Library, double-click the Editing Action Project to open it in the Timeline.

2. Press ⌘+Shift+2 to open the Timeline Index and type **Scene 14 Slate 43 Take 4** into the Search field. Select the last instance of Scene 14 Slate 43 Take 4 in the search results to reveal it in the Timeline.

 In the clip, Katie aims her camera and fires off a shot. If you take a look at the last frame of the clip, you'll see the partial exposure of the flash bulb as featured in Figure 14.12.

3. Choose Window➡Media Browser➡Transitions and select the Lights category.

4. Locate the Flash transition in the Transition Browser and drag and drop it over the edit point between Scene 14 Slate 43 Take 4 and the Bouncing Ball on Stairs Compound Clip in the Timeline.

5. Let's shorten the transition's default duration to 18 frames. Select the Flash transition in the Timeline and press Control+D. Type **18** into the Dashboard's Duration field and press Return.

6. Play back the transition to see the effect. We've successfully hidden the partial exposure, and we only need to add a camera shutter sound to complete the effect. (We've provided some camera sounds for you to use on the DVD.)

We also could have chosen to freeze the image during the camera flash to embellish the effect further. This can be done by creating a Hold Frame on the following shot. We'll show you how to make freeze frames in the next section.

Creating freeze frames

Final Cut Pro allows you to freeze and hold a particular frame on any clip in the Timeline. To do this, place the playhead or skimmer over the frame that you want to freeze and choose Hold from the Retime menu (the second menu icon on the toolbar below the Viewer) or press Shift+H. This extends the clip by the duration of the freeze, and the Retime Editor displays above it with a red bar representing the length of the held frame. Final Cut Pro calls this a Hold Frame and the default duration is 2 seconds. The duration of the freeze can easily be altered by dragging the handle at the end of the red bar. Green bars in the Retime Editor indicate the sections of the clip that are at normal speed.

If you want the frame to be held for a specific duration, select a clip and use the Range tool to drag a selection over the clip that is the length that you require (see Figure 14.13). Then press Shift+H to create the hold.

FIGURE 14.13
Specifying a
hold duration
with a selection
range.

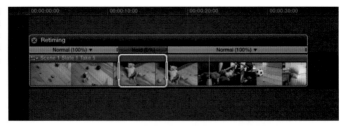

FIGURE 14.13
Specifying a
hold duration
with a selection
range.

When you choose Hold from the Retime menu, the first frame of the selection becomes the frame that is held. You also can change a clip's Hold Frame after creating a freeze. To do so, click the menu on the green bar before the freeze frame and choose Change End Source Frame (see Figure 14.14). This brings up a film frame icon over the clip that represents the frame being frozen (see Figure 14.15). To change the Hold Frame, simply move the icon to a new frame on the clip. This will slide the hold to the position of the new frame without altering the overall duration of the freeze frame.

FIGURE 14.14
How to change a
clip's Hold
frame.

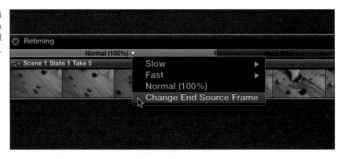

FIGURE 14.15
Move the film
frame icon to
change the
frozen frame.

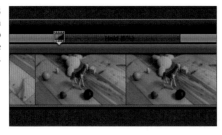

To remove a freeze frame, select the clip in the Timeline and choose Normal 100% from the Retime menu or press Shift+N. If a clip has multiple retime effects, you can remove them all

by choosing Reset Speed from the Retime menu or by pressing ⌘+Option+R. To close the Retime Editor, choose Hide Retime Editor from the Retime menu or press Shift+R.

Let's go back to the opening shot that we flipped earlier (Scene 1 Slate 1 Take 5) and create a freeze on the last frame of the clip. We can use the freeze to superimpose the *Pranks* title.

1. Mount the *Craft of the Cut* disc image, and launch Final Cut Pro.

2. Select the Pranks Media Event in the Event Library and type **Scene 1 Slate 1 Take 5** into the Event Browser's Search field.

3. Control-click on Scene 1 Slate 1 Take 5 and choose Open in Timeline. The shot should be flipped the right way around from the earlier exercise.

4. Position the playhead at 22 seconds and 15 frames in the Timeline and, with the video clip selected, press Option+] (right bracket) to trim the end of the clip. With the clip still selected, park the playhead just before the last frame of the clip.

5. Choose Hold from the Retime menu or press Shift+H to create a Hold Frame. The Retime Editor displays a red hold frame above the clip (see Figure 14.16).

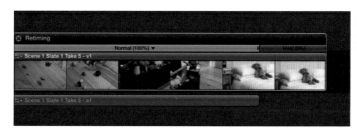

FIGURE 14.16
The Retime Editor in the Timeline.

6. Let's lengthen the freeze to 4 seconds and 18 frames. Position the playhead at 33 seconds and 7 frames in the Timeline. Then drag the end of the red Hold Frame up to the playhead. Finish off by trimming the end of the audio clip to the end of the video clip. Play back the clip to see the effect.

Retiming Clips

In addition to freeze frames, Final Cut Pro allows you to change the speed of a clip to create a slow-motion or speeded-up effect. This is created in the same way as a Hold Frame by selecting a clip or dragging out a Range Selection in the Timeline and choosing either Slow

or Fast from the Retime menu. From here, you can choose to slow down a clip by 10 percent, 25 percent, or 50 percent, or multiply the speed by 2, 4, 8, or 20. Choosing Slow lengthens the clip in the Timeline and displays an orange bar to represent the slowed section in the Retime Editor. Fast shortens the clip and displays a blue bar to represent the speeded-up segment. Once applied, the speed can be adjusted further by selecting a new speed from the bar's drop-down menu or by dragging the handle at the end of the bar. Dragging to the left speeds up the clip, and dragging to the right slows it down. Checking Preserve Pitch in the Retime menu ensures that the pitch of the retimed clip's audio remains the same.

Final Cut Pro has to generate additional frames when creating a slow-motion effect and, depending on the amount of slow motion, this can sometimes result in jerky images. When this is the case you can smooth out the effect using the Video Quality option found in the Retime menu. This gives you a choice of Normal (the default setting), Frame Blending, and Optical Flow. Frame Blending smoothes out the slow-motion effect by cross-dissolving (blending) between the additional frames, but it requires additional rendering. Optical Flow analyzes the movement within the clip and uses the results to generate the extra frames needed to create the slow-motion effect—a process known as interpolation. This produces better results than Frame Blending, especially for clips that have been slowed down a lot, but it can result in unwanted artifacts depending on the movement within the frame. Optical Flow takes longer to generate because of the analysis; it also requires rendering.

Let's retime one of the clips in the Bump in the Night edited sequence that you created earlier in the book.

1. Mount the *Craft of the Cut* disc image, launch Final Cut Pro, and open the Bump in the Night Project that you created earlier.

2. Press Shift+⌘+2 to open the Timeline Index and type **Scene 8 Slate 59 Take 1** into the Search field.

3. Select Scene 8 Slate 59 Take 1 in the search results to locate it in the Timeline and play the clip back. As you can see there is a very long pause before Katie kicks the alphabet blocks, which really slows down the action. Let's speed up the middle section to keep things moving along.

4. Press R to bring up the Range tool, and draw a Selection over Scene 8 Slate 59 Take 1, starting at 1 second and 6 frames into the clip and ending at 5 seconds and 7 frames. The selection should have a duration of 4 seconds and 1 frame.

5. Choose Fast➜4x from the Retime menu. The Retime Editor displays above the clip, with a blue bar representing the speeded-up area (see Figure 14.17).

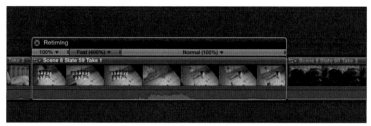

FIGURE 14.17
Speeding up a section of a clip with the Retime Editor.

6. Press ⌘+R to hide the Retime Editor and play back the clip to see the result.

Other effects that play with time also are available from the Retime menu. These include Instant Replay, which duplicates and replays a selected area in the Timeline, and Rewind, which duplicates a selected area and plays it back in reverse with a choice of different speeds. Variable speed changes also can be applied to a clip by using the Speed Ramp option.

There are plenty of different effects and filters for you to explore inside Final Cut Pro. We've only been able to scratch the surface in this brief overview. The best way is to dive in, explore for yourself, and experiment with each effect's parameters in the Inspector. Have fun!

chapter 15
Applying the Finishing Touches

COLOR CORRECTION AND adding titles and credits are usually the last phase in the post-production process. Color correction or grading can have a huge impact on your completed movie, and there are many reasons why you would choose to color-correct your footage. It may be to correct exposure or color balance errors, to match each shot within a scene to achieve a consistent look, or to create a specific mood and atmosphere for the film. You do this by manipulating the brightness, contrast, color, and saturation of each shot in the Timeline. Final Cut Pro has an assortment of color correction tools that can help you achieve this.

Color correction is a vast subject, which we can't possibly do justice in a single chapter, but we hope to provide some basic tools and techniques for you to build on and encourage you to explore this subject further.

Color Correction and Grading

All the colors in the video spectrum are made up of red, green, and blue, with pure white made up of all three of these colors in equal amounts. If you reduce each of these three color channels equally by half, you'll produce gray. Reducing the red, green, and blue channels to zero produces black. Unless you're aiming for a stylized look for a film, you're normally seeking a realistic representation of the colors on screen. For instance, to avoid any color-cast issues, the brightest parts of an image should be balanced to pure white without any trace of color, and the darkest parts of an image should be balanced to pure black without any trace of color.

Color manipulation can be achieved manually by making adjustments in Final Cut Pro's Color Board. Before we visit the Color Board, let's look at some of the other, simpler ways that Final Cut Pro allows us to play with color.

In the Effects Browser, under the Looks and Basics categories, you can find a selection of color filters, which you can use to affect the color of your shots. These filters are applied in the same way as other effects in the Effects Browser (see Chapter 14). Many of the filters found here, such as the Bleach Bypass or 50s TV filters, give your shots a highly stylized look, while others, such as the Broadcast Safe filter have more practical uses. The Broadcast Safe filter helps keep your video's white levels from exceeding 100, which is an important requirement when distributing your movie to television or on DVD. To apply the Broadcast Safe filter, place your entire movie inside a Compound clip and drag the Broadcast Safe filter onto the Compound clip.

Final Cut Pro offers other automatic color correction solutions, which can provide a quick fix to a minor color balance issue or quickly match the look of one shot to another. These solutions may be all you need to resolve an issue and save you time from having to make corrections manually.

Fixing color balance issues

Final Cut Pro provides two simple ways to automatically color-balance your clips. The first method requires the clip to be analyzed by Final Cut Pro before being added to the Timeline. This analysis examines a shot's color values, with a view to improving contrast and removing any overall color casts, while still retaining detail in the image. As you saw in Chapter 3, Final Cut Pro can perform this analysis during import when you have Analyze for Balance Color checked in the Import Preferences. The same analysis can be performed on clips in the Event Browser after clips have been imported. To do this, select a clip in the Event Browser and choose Modify➡Analyze and Fix. Select the Analyze for Balance Color check box and click OK.

When clips are analyzed in the Event Browser, Final Cut Pro examines the entire clip and doesn't apply the color balance until the clip has been enabled in the Inspector. To enable the color balance, select the clip in the Event Browser or Timeline, open the Inspector (press ⌘+4), and select the Inspector's Video tab. Under Color, you'll find the Balance setting followed by its status (either Analyzed or Not Analyzed). If the clip has been analyzed, you can apply the color balance by clicking the Balance check box and turning it blue.

The second method doesn't require the clip to be analyzed before it's added to the Timeline. Select the clip in the Timeline and choose Balance Color from the Toolbar's Enhancements menu (see Figure 15.1) or press Option+⌘+B. When using this method, Final Cut Pro examines the frame on which the playhead is currently positioned and then automatically applies the color balance, saving you a visit to the Inspector. A color balance can be turned on or off at any time with the Balance check box in the Inspector.

FIGURE 15.1
The Toolbar's Enhancements menu.

Color matching between shots

Scenes are often shot over a number of days under varying lighting conditions, which can result in differences in color and exposure between shots when they're eventually assembled. This can break the illusion that the action on-screen is occurring at the same time and place. Final Cut Pro's Match Color feature can provide an easy fix for this and works similarly to the Match Audio feature we looked at in Chapter 8.

To match the color between two shots, select the clip that you want to adjust in the Timeline and choose Match Color from the Toolbar's Enhancements menu or press Option+⌘+M. (You also can activate this function in the Inspector's Video pane by clicking the Choose button next to Match Color.) This brings up a two-window display in the Viewer with the chosen clip on the right side. Skim over clips in the Event Browser or Timeline to find a frame that has the color that you want to match. As you do so, the cursor displays a camera icon and clicking on a clip takes a "snap" of the frame at the cursor position. The chosen frame displays on the left side of the Viewer with the color-matched clip previewed on the right (see Figure 15.2). If you don't like what you see, you can simply click on another clip to preview a different match. To apply the color match, click the Apply Match button beneath the Viewer.

FIGURE 15.2
Matching color
from one shot to
another.

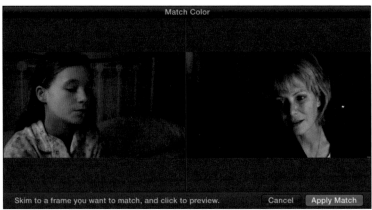

Manually Color-Correcting Shots

As useful as these automatic solutions are, you'll generally want to make color corrections manually to achieve the look you require. These corrections are usually broken down into two stages: primary color correction and secondary color correction. Primary color correction refers to corrections that are applied to the entire image, while secondary color correction refers to corrections that are applied to just a portion of the image. Both types of correction are achieved with Final Cut Pro's Color Board, but before we get to this, we need to show you how to evaluate your images using Final Cut Pro's video scopes.

Working with scopes

When manually color-correcting your movie, monitoring plays a crucial factor in the assessment of your shots. An image viewed on one monitor may look completely different on another. However, using video scopes in conjunction with properly calibrated broadcast monitors will allow you to make accurate judgments on color, saturation, and exposure and gain more satisfying results. Video scopes also help ensure that your movie's video levels fall within accepted broadcast television standards.

There are three video scopes included with Final Cut Pro: the Waveform Monitor, Vectorscope, and Histogram. To access the video scopes, choose Window➜Show Video Scopes, press ⌘+7, or click the switch in the top-right corner of the Viewer and select Show Video Scopes. The scope that was last used opens to the left of the Viewer; you can select a different scope from the Settings drop-down menu. Let's take a closer look at each scope.

The Waveform Monitor

The Waveform Monitor is a display that represents the luminance (luma) value of an image, which corresponds to the lightness and darkness of the individual pixels. This is useful when making adjustments to the contrast or exposure of your image. The Waveform Monitor displays the brightest parts on the top and the darkest parts on the bottom. Of the three video scopes, the Waveform Monitor is the only scope whose values are presented left to right and directly correspond to the left to right of the image being examined. The levels of a video signal are represented by what's known as the trace. When the trace is near the top of the display, it represents the brighter elements of the picture and should not exceed 100 (White) on the Waveform Monitor. When the trace is near the bottom of the display, it represents the darker areas and should not go past zero (Black).

Select Scene 18 Slate 70 Take 2 in the Event Browser to view it with the Waveform Monitor, making sure you have Luma selected from the Settings drop-down menu. Slowly skim through the clip of Katie sitting on the bed. Notice how, as the camera pulls back, the brighter areas represented by the trace decrease as the camera moves into a darker area (see Figure 15.3).

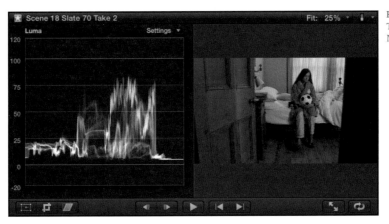

FIGURE 15.3
The Waveform
Monitor.

The Vectorscope

The Vectorscope helps you analyze color hues in your video, can help reveal color-cast issues, and shows you the intensity (or saturation) of the colors in a shot. The angle and direction of the trace area emanating from the center help determine which colors the image contains. Working clockwise around the circular scale, from the top, you have Red, Magenta, Blue, Cyan, Green, and Yellow. The box next to each color is known as a target, and the center of the display represents zero saturation. The more saturated the colors are, the more the trace area extends toward these targets. Colors should never extend beyond their target; otherwise, they become oversaturated and your movie won't meet TV broadcast requirements.

Select Scene 1 Slate 1 Take 5 in the Event Browser to view it with the Vectorscope. This shot of the toy box has a variety of color objects inside, including a green, yellow, and red baton. A red teddy bear is also prominent. If you skim to the middle of the clip so that the entire toy box is included in the frame, you can clearly see these colors represented on the Vectorscope by the lines extending from the center toward the Green, Yellow, and Red target boxes (see Figure 15.4).

FIGURE 15.4
Colors represented in the Vectorscope.

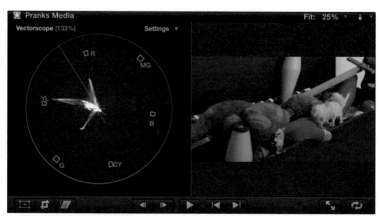

One of the key objectives in color correcting is to produce accurate skin tones for the actors, and a Vectorscope can help with this. The diagonal line extending from the center out to the top-left corner of the Vectorscope is the Skin Tone indicator line; people's skin tones are represented either on or around this line. Select Scene 17 Slate 31 Take 2 in the Event Browser to view it with the Vectorscope. In this two-shot of Joyce and Katie looking at the camera, you can see their skin tones clearly represented around the skin tone line (see Figure 15.5). For a better view, you can enlarge the scale of the display by choosing 133% Scale from the Settings drop-down menu.

FIGURE 15.5
Examining skin tones with the Vectorscope.

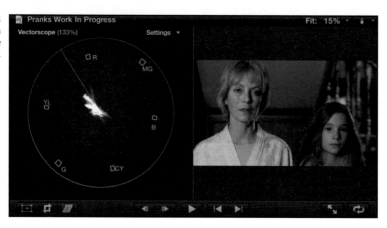

The Histogram

The Histogram gives you a graphical display of the number of pixels of a certain luminance or color in an image. It displays the value of luma or color on its horizontal axis, and the corresponding pixel count at each value on the vertical axis. Select Scene 14 Slate 43 Take 1 in the Event Browser to view it with the Histogram, making sure you have RGB Overlay selected from the Settings drop-down menu. This shot of Katie is predominately blue; however, observe the red pixels peaking due to Katie's pink dressing gown (see Figure 15.6). If you skim to the point when Katie's camera flash goes off and position the skimmer on the white flash frame (at 55:12 if you're viewing this clip in the Event Browser), the Histogram displays the pixel count at 100. From the Settings drop-down menu, you also can choose to view just the Luma, the RGB Parade (the red, green, and blue channels displayed separately), or the individual Red, Green, and Blue channels of the video signal.

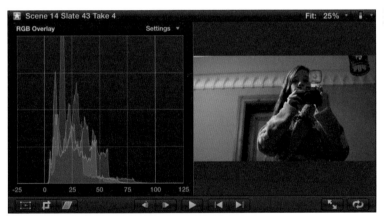

FIGURE 15.6
The Histogram.

Working with the Color Board

Manual color adjustments are made using the Color Board. Once you've selected the clip that you want to work with in the Timeline, you can go directly to the Color Board by choosing Window➔Go to Color Board or by pressing ⌘+6. The Color Board also can be accessed from the Inspector's Video pane, and you'll most likely use this method when making multiple corrections to a clip. In the Inspector, under the Color section, you'll find a strip with four buttons named Correction 1. The first two buttons relate to color masks and shape masks, which we'll be discussing later in the chapter, and the third button is the familiar curved arrow that resets all corrections back to their default settings. The fourth gray button opens the Color Board; this button changes color when adjustments have been made to the selected clip.

Further Corrections can be added by clicking the + button at the top of the Color section. These appear as sequentially numbered strips below the first Correction and each Correction

has access to its own Color Board (see Figure 15.7). Separating Corrections in this way allows you to use one Correction to make primary corrections to the entire image and a second Correction to make secondary corrections to just an isolated color on the image. To delete a Correction, simply select it in the Inspector and press the Delete key.

FIGURE 15.7
Three Corrections listed in the Inspector. The second Correction has a Shape Mask and the third Correction has a Color Mask.

The Color Board is made up of three panes—Color, Saturation, and Exposure—which can be selected by clicking the buttons at the top of the window (see Figure 15.8). Each pane includes four circular pucks, which allow you to control the Shadows, Midtones, and Highlights independently, plus a Global control for making adjustments to the entire image. For instance, in the Exposure pane, you would use the Shadows puck to adjust the exposure for just the darker areas of the image.

FIGURE 15.8
The Color Board.

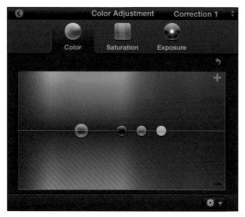

When making changes to the color properties of an image, aim to start with the Exposure settings, because these can have a dramatic effect on the color. As a general rule, get the blacks of your image close to the zero line on the Waveform Monitor, and then work with the highlights and midtones as required. After adjusting exposure, move on to make color adjustments and then finish with saturation.

In the Color pane, a horizontal line across the middle of the Color Board separates the area into two halves. Moving a puck over a color in the upper (+) area, adds that color to the setting that the puck represents. Moving the puck over a color in the bottom (–) area subtracts that color in the same way. For example, to add an overall blue tint to the entire image, you would move the Global puck toward the blue color in the upper area. To subtract the color blue from just the image's midtones, you would move the Midtones puck toward the blue color in the lower area. The pucks in the Color pane can be moved up, down, left, or right with the cursor or by using the corresponding arrows on your keyboard to make more precise adjustments. The Saturation and Exposure panes work in the same way, but you can only move the pucks up or down. In these two panes, the Global puck is represented by a slider on the left side of the pane. In all cases, to return back to the Inspector, use the back button at the top left of the Color Board.

Let's use an example from *Pranks* to demonstrate how to make a simple correction for exposure. As you know, the staircase scene takes place at night, but some of the shots that were recorded ended up looking a little too bright. We can remedy this by reducing the exposure of the darker areas of the image.

1. Double-click the *Craft of the Cut* disc image to mount it. In the Project Library, double-click the Pranks Work in Progress Project to open it in the Timeline.

2. For this example, we'll be using Scene 14 Slate 41 Take 2, which occurs at 7 minutes, 34 seconds, and 23 frames in the Timeline. Select Scene 14 Slate 41 Take 2 and open the Inspector's Video pane. Click the Color Board button next to Correction 1 to open the Color Board and go to the Exposure pane. Press ⌘+7 to open the Video Scopes, if they aren't already open, and select the Waveform Monitor from the Settings drop-down menu, making sure Luma is also selected.

3. As you can see, this clip looks too bright to be taking place at night. Click and drag the Shadows puck slowly up and down, and watch how it affects the darker areas of the image. Notice in the Waveform Monitor how the further up you raise the Shadows puck, the further away the bottom part of the waveform, which signifies the black areas, moves away from the zero line. If you take the Shadow puck all the way to the top to 100, you've taken away all the blacks from the image and the shot in the Viewer becomes white.

Because we're trying to reduce the exposure of the darker areas of the image, we need to lower the Shadows puck below the horizontal line so that the bottom part of the waveform is close to the zero line. Move the Shadow puck down to a value of around –7% in the Exposure pane (see Figure 15.9) so that the blacks in the Waveform Monitor sit on the zero line.

FIGURE 15.9
Adjusting the
exposure of the
darker areas of
the image.

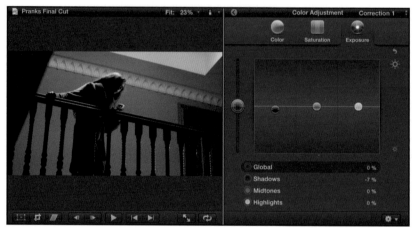

The rest of the shots in the scene also need to be adjusted to match the shot we just corrected. Final Cut Pro gives you the ability to copy a clip's color-corrected attributes and paste these on to another clip in the Timeline. To do so, select a clip that contains the color corrections that you want to copy and press Option+⌘+C. To paste these corrections onto another clip, select a clip in the Timeline and press Option+⌘+V. Using this method will most likely require some additional tweaks in the Color Board, but this is a fast and easy way to make a similar adjustment.

At the bottom right of the Color Board, you'll find a Gear button that gives you access to a collection of Color Board presets, which can provide a good starting point for your color grading work. These can be tweaked further in the Color Board, and any adjustment you make can be saved as a preset by choosing Save Preset at the top of the preset list.

Using color masks

Earlier in the chapter we explained how secondary color corrections are applied to just a portion of the image. This is achieved through the use of color masks or shape masks. A color mask enables you to target a particular color and isolate it from the rest of the image. This could be used to make color adjustments that affect only the chosen color or that affect the overall image but exclude the chosen color. You've probably seen this technique in action

many times in films, such as *Sin City* (2005), directed by Frank Miller, Robert Rodriguez, and Quentin Tarantino, in which a single color object exists in a black-and-white image.

Open the Inspector's Video pane and, under Color, click the Add Color Mask button (the first button on the Correction) to add a color mask to your image. A Color Mask icon is added below the Correction, and the cursor becomes an eyedropper, allowing you to pick a color from a shot in the Viewer. Clicking with the eyedropper and dragging over an area of the image reveals two concentric circles beneath it. The outer circle determines the range of colors to be included in the selection. As you drag the eyedropper over the image, the size of the outer circle increases and the surrounding image turns monochrome with only the selected colors highlighted on screen.

Once you've made a selection, release the mouse and the selected color appears next to the Color Mask icon in the Inspector. You can then use the slider next to the icon to soften the edges of the mask. With the color mask now in place, click the Correction's Color Board button to open the Color Board and make your adjustments. To restrict your adjustments to just the selected color, click the Inside Mask button beneath the Color Board before making your corrections. To exclude the selected color from any adjustments, click the Outside Mask button.

Let's use a simple example from *Pranks* to demonstrate. The opening shot features a camera move across a toy box filled with various colorful toys, which includes a green baton at the front of the box. Let's create a color mask from the color green and use it to change the baton to a different color.

1. Double-click the *Craft of the Cut* disc image to mount it. In the Project Library, double-click the Pranks Work in Progress Project to open it in the Timeline. Select the first clip (Scene 1 Slate 1 Take 5), and position the playhead at around 13 seconds and 16 frames in the Timeline so that the green baton is fully visible on-screen. Open the Inspector's Video pane and under Color, click the Add Color Mask button. A Color Mask icon is added below the Correction and the cursor changes to an eyedropper.

2. Click the green baton with the eyedropper and slowly drag outward to reveal the two concentric circles beneath the eyedropper. As you drag, keep the selection to just the green area of the baton, and try to avoid including any of the surrounding colors (see Figure 15.10). The more precise you are with this selection, the more effective your Color Mask will be when replacing the color. Release the mouse and your selected color appears below the Correction in the Inspector.

3. Click the Correction's Color Board button to open the Color Board and click the Color pane. Make sure Inside Mask is selected and click and drag the Global puck to move it across the different colors in the upper section of the Color Board. Notice how the

baton changes to the color selected in the Color Board, while the rest of the image remains unaffected. Choose any color you prefer. For the Pranks Final Cut Project included on the DVD, colorist John McMullin turned the baton's green color to a gray by reducing the selected color's saturation down to zero in the Saturation pane.

FIGURE 15.10
Isolating the
green baton
with a color
mask.

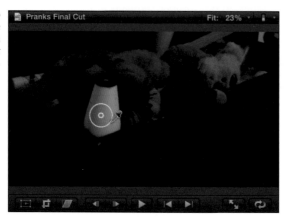

Using shape masks

You also can mask an area in an image by using a shape. Open the Inspector's Video pane and under Color, click the Add Shape Mask button (the second button on the Correction) to add a shape mask to your image. A Shape Mask icon is added below the Correction, and two circles display over the image in the Viewer. These circles represent the shape mask and allow you to control the shape. The inner circle contains five handles—one white and four green—which let you control the shape and size of the mask. By dragging any of the green handles at the top, bottom, left, or right of the inner circle, you can affect the shape's width and height. Holding down the Shift key as you drag scales the four sides of the shape proportionally. Dragging the white handle toward the left allows you to make the shape more rectangular.

The outer circle controls the softness of the shape's edge. By clicking and dragging the outer circle, the softness of the edge increases the further you drag from the inner circle. Softening the edge helps conceal the shape mask, helping it to blend in with the rest of the image. A center circle with a green handle sits in the middle of the shape. Clicking and dragging the center circle enables you to position the shape over the section of the image that you want to mask, while dragging on the green handle enables you to rotate the shape.

Once you've created your shape and positioned it over the area that you want to mask, go to the Inspector's Video pane and click the Correction's Color Board button to open the Color Board and make your adjustments. Just as with color masks you can make separate

adjustments to both the inside and outside of the shape mask by using the Inside Mask and Outside Mask buttons at the bottom of the Color Board.

Let's put this into practice with an example from *Pranks*. Scene 2 Slate 7 Take 1 is an exterior wide shot that shows Katie's arrival at the house. Because this is a ghost story, let's see if we can add some atmosphere by making the house a little creepier. This should help establish the genre of the movie and introduce a sense of dread and foreboding to the start of the movie.

1. Double-click the *Craft of the Cut* disc image to mount it. In the Project Library, double-click the Pranks Work in Progress Project to open it in the Timeline. Select Scene 2 Slate 7 Take 1 (the third clip in the Timeline), and press ⌘+4 to open the Inspector. Before working with the shape mask, let's first make some adjustments to improve the overall image. Open the Inspector's Video panel and under Color, click the Color Board button next to Correction 1 to open the Color Board.

2. Click the Exposure pane. First, we'll lower the exposure of the brighter areas of the image. Select the Highlights puck and using the down arrow, lower the highlights to –12. We'll do the same for the shadows, select the Shadow puck and lower it to –8. Finally, select the Midtones puck and raise it to 7. Next, we'll add a very subtle blue tint to the image's midtones. Click the Color pane and select the Midtones puck. Raise the midtones to just 2, and move the puck to the right into the blue area of the Color Board—a value of about 227 should be just fine. Click the Back button at the top of the Color Board to take you back to the Inspector.

3. Under Color, click the + button to add a second Correction. Click the Add Shape Mask button for Correction 2 to add a shape mask to the image. The two circular, on-screen controls appear over the image in the Viewer. Use the top and right green handles to increase the width and height of the shape so that it looks like the oval in Figure 15.11; then click and drag out the outer circle to soften the shape's edges. Click the Color Board button next to Correction 2 to open the Color Board and go to the Exposure pane.

4. Let's darken the area around the house to give it an aura of gloom by adjusting the exposure outside the shape mask. Click the Outside Mask button and drag the Highlight Puck downward to lower the highlights to –43. Lower the midtones to –22 by dragging down the Midtones puck in the same way.

5. Our house is already looking quite spooky, but we can accentuate the effect by punching up the exposure inside the shape mask. Click the Inside Mask button and select the Highlights puck. Drag the puck up to increase the highlights to 45. To complete the effect, lower the exposure of the shadows inside the shape mask to –5. The darkened edges around the house along with increased highlights inside the shape mask help to draw the viewer's eye to the center of the frame.

FIGURE 15.11
Applying a
shape mask.

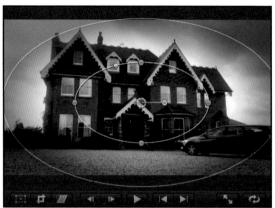

With the use of a simple shape mask and a few exposure adjustments, we've managed to give the house in our shot a really menacing look, but you'll also need to make similar adjustments to the rest of the shots in the scene to keep the scene's look consistent. To delete a color mask or shape mask, simply select it in the Inspector and press the Delete key. Generally, when you apply a shape mask to an image, the subject of the shot will more than likely be moving, resulting in the subject drifting in and out of the shape. You can get around this by using keyframes to animate the shape mask along with the movement of the subject. To learn more about animating with keyframes, see Chapter 14.

Color masks and shape masks often are used together in the same shot. An example of this would be when you want to change the color of a single object but the same color exists in other areas of the shot. In this case, you would use a color mask to isolate the color that you want to change and a shape mask to conceal the areas that you want to remain unaffected. When using multiple Corrections, keep in mind that their stacking order in the Inspector will have an impact on the final image. To change the order of any Corrections in the Inspector, simply select a Correction and drag it up or down to a new position in the Inspector.

The Pranks Final Cut Project available on the DVD has been specially color-graded for the book by colorist John McMullin. Serious color work is performed using the highest quality files available, while monitoring on a properly calibrated broadcast monitor. However, for the purposes of this book, John has had to use ProRes Proxy files due to space limitations of the DVD. Use this Project to study his techniques by examining the Color Board to see the adjustments he made. Notice how John used shape masks to create interesting vignettes and how he brought down the blacks throughout the movie so that the shots look richer.

Adding Titles and Credits

Most of the projects you'll work on will require on-screen text in some form. You may want to use text to create the opening titles for your movie, provide on-screen subtitles when a different language is spoken, or as a lower third to identify an interview subject in a documentary. Final Cut Pro comes with numerous prebuilt titles, many with animated elements or backgrounds, ready for you to use in your projects. These can be customized further in the Inspector to suit the needs of your movie.

Working with titles

To see the prebuilt titles that are available, click the Title Browser button in the Media Browser area of the Toolbar or choose Window➔Media Browser➔Titles. The Title Browser window opens with the titles arranged in categories such as Bumper/Opener, Credits, and Lower Thirds. Skimming over the title thumbnails allows you to preview each title in the Viewer, just as you can with transitions and effects.

To apply a title at the start of the playhead position in the Timeline, simply double-click a thumbnail in the Title Browser or drag it directly over the clip. A purple title clip connects above the clip in the Timeline and can be moved or trimmed just like a regular Connected clip (see Figure 15.12). Titles with black backgrounds superimpose the text over the clip that they connect to, but you also can place a title between clips in the Timeline if you prefer to display the text full frame without superimposing it over an image.

FIGURE 15.12
A title on the Timeline.

Once a title has been added, you can change the text that's displayed directly in the Viewer. Select the title in the Timeline, double-click the text in the Viewer, and enter the text that you want. Double-clicking the text also reveals a round button in the Viewer. Use this to position the text anywhere on-screen (see Figure 15.13).

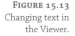

FIGURE 15.13
Changing text in
the Viewer.

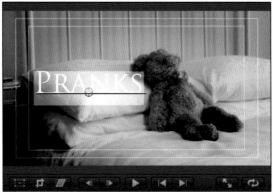

When working with text elements in a project, always remember to turn on *Show Title/ Action Safe Zones* from the switch button at the top-right of the Viewer. Placing any text within the inner yellow boundary ensures that the text won't be cropped when shown on a television. A title's duration can be adjusted by trimming it like any other clip. Shortening or lengthening a title affects the speed of any animation elements that the title may contain. Shortening the title speeds up any animated text.

A simple title or lower third can be added to a project without having to access the Title Browser. To add a simple text title at the playhead position in the Timeline, choose Edit➜ Connect Title➜Basic Title or press Control+T. To add simple lower third text at the playhead position, choose Edit➜Connect Title➜Basic Lower Third or press Shift+Control+T.

Adjusting titles in the Inspector

Titles can be modified in the Inspector in the same way as you can with transitions and effects. To do so, select a title in the Timeline, making sure to park your playhead over the title, and open the Inspector (⌘+4). There are two areas in the Inspector where you can affect the look of your title: the Title pane and the Text pane.

The Title pane

The parameters available in the Title pane are unique to the particular title being used, but here are some examples of the kind of settings you'll find.

Some titles include background elements that can be changed to a different texture or turned off entirely. An example of this is Ink, which allows you to select a different background from a pop-up menu and includes such textures as Marble, Linen, Bamboo, and many others. A few titles include a drop zone box, which lets you include clips from the Event Browser

within the title itself (see Figure 15.14). To do so, simply click the Drop Zone in the Inspector and then click the clip you want to add. The selected clip displays on the left side of the Viewer with the title image displayed on the right. Clicking the Apply Clip button adds the clip to the drop zone and is included within the title when it plays. Examples of titles that use drop zones are Team and Push. Most animated titles give you the ability to switch the opening and closing animation on or off, and this is done by selecting or deselecting the Build In and Build Out check boxes in the Inspector. You can see examples of these Build In and Build Out options in Boogie Lights and Four Corners.

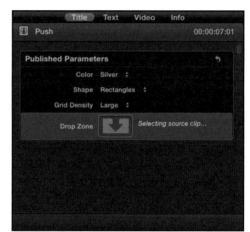

FIGURE 15.14
A Drop Zone in the Inspector allows you to place a clip within a title.

The Text pane

The Text pane in the Inspector lets you change the style of the text being employed and gives you control over such things as font, size, alignment, and spacing of the text. Clicking the Font pop-up shows all the fonts available to you. You can preview fonts by running the cursor over each name in the list; a preview of the font dynamically updates in the Viewer. Below these basic settings are four panels for affecting the face, outline, glow, and drop shadow of the text. Each of these panels has similar settings that let you change such things as color, blur, and opacity of text elements. At the top of the Inspector's Text pane, you'll also find a pop-up list of style templates to choose from.

Creating the opening credits

Let's create some opening credits for *Pranks* using the tools we have available in Final Cut Pro. We can superimpose these credits over the opening toy box shot (Scene 1 Slate 1 Take 5) that starts off the movie. You can see a completed version of this credit sequence on the

Pranks Final Cut Project included on the DVD, but for now we'll use the Pranks Work in Progress Project and start afresh. We'll open with a credit for the production company, followed by the names of the three actors in the movie, and finally, we'll superimpose the movie's title over the teddy bear at the end of the shot. **Remember:** We created a freeze frame of the teddy bear in Chapter 14 for just this reason.

We need to create five titles for the opening credit sequence:

- ○ A Pranks Media Production
- ○ Ellie Darcey-Alden
- ○ Jenny Seagrove
- ○ Joseph Darcey-Alden
- ○ Pranks

To follow along, double-click the *Craft of the Cut* disc image to mount it and launch Final Cut Pro. In the Project Library, double-click the Pranks Work in Progress Project to open it in the Timeline.

1. To create the first credit, position the playhead at 17 frames on the Timeline and press Control+T to connect a title over the clip.

2. Click the title to select it and press Control+D to see its duration in the Dashboard. The default duration is 10 seconds, which is far too long for our needs. Enter **4.12** and press Return to reduce the length to 4 seconds and 12 frames.

3. With the title still selected in the Timeline, Press ⌘+4 to open the Inspector and click the Text pane. In the Text field type **A Pranks Media Production**, making sure to add a Return after the words *A* and *Media* so that the text is spread over three lines (see Figure 15.15).

4. From the Font pop-up, choose Trajan Pro from the list. You'll most likely recognize this font from many Hollywood movies.

5. In the Text field, highlight the letter *A* with your cursor and change the size by typing **66** into the Size field. Do the same for the word *Production*. Next highlight the words *Pranks Media* and change the size to 120. Double-click the text in the Viewer and use the round button to center the text in the frame.

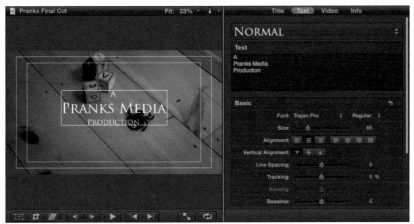

FIGURE 15.15
Creating the
opening credits.

6. To complete the first title, select it in the Timeline and press ⌘+T to add cross-dissolves on either side of the title. The title is placed inside a Secondary Storyline in the same way as any other Connected clip (see Figure 15.16). Press the Home key and play back the Project to see the result.

FIGURE 15.16
Adding dissolves
to the titles.

7. To create the next title, you can simply duplicate the first title and change its text and size in the Inspector. This will keep the same font and save you the trouble of adding cross-dissolves. To duplicate the first title, select the Secondary Storyline that contains the first title and drag while holding down the Option key.

Complete the exercise by creating titles for the four remaining credits. You may want to create an end credit sequence for the end of the movie. You can easily do this using the Scrolling title found under the Credits category in the Title Browser.

chapter 16
Sharing and Exporting Your Movie

ONCE YOU'VE FINISHED editing your movie and are ready to share it with the world, Final Cut Pro allows you to export your project in a number of different ways. The option you choose will depend on your movie's final destination. Are you exporting a QuickTime movie file so that a client can review your work? Do you intend to play your movie on an iPhone or iPad? Or do you want to post it to the web for the world to see? The answer to these questions dictates which option you choose.

To share or export your movie, you must first select the Project in the Project Library or open it in the Timeline with the Timeline window active. You can export only one Project at a time, and Final Cut Pro X doesn't allow you to export a selected portion the way you could in previous versions. Before we get into some of the main sharing options, let's look at how you can monitor the progress of your export.

Working with the Share Monitor

When you share a movie, Final Cut Pro launches the Share Monitor, a separate application available in the Dock, which allows you to monitor the progress of your export (see Figure 16.1). To bring up the Share Monitor, click the Share Monitor button under the progress bar that appears when sharing is taking place. You also can access the Share Monitor via the Background Tasks window (press ⌘+9) by clicking the arrow next to the Sharing option.

FIGURE 16.1
The Share
Monitor.

On the left side of the Share Monitor window is the Cluster List, which lists all the computers available on your network. Click This Computer to display the tasks currently running on your main computer in the Batch Display area on the right side of the window. The Batch Display shows you the rendering, transcoding, and exporting that's being carried out; you can view more detailed information by clicking the disclosure triangle by the task's name. The blue progress bar tells you how much time has elapsed; clicking it displays the time remaining on the task. Tasks can be paused or cancelled by using the circular icons at the end of the progress bar. Clicking the *i* icon displays additional information. You can open the Mac's Console to track down any processing issues by pressing the Show Log button. The Share Monitor's Toolbar provides you with various sorting options. You can select which tasks to view by clicking All, Active, or Complete from the Status buttons.

Once you've shared a Project, a share icon appears next to the Project's name in the Project Library and Timeline. If changes were made to the Project after it was shared, an exclamation

point symbol also appears next to the share icon (see Figure 16.2). Clicking the share icon in the Project Library opens the Sharing pane in the Inspector and displays details of how the Project was shared and the dates the Project was published (see Figure 16.3).

FIGURE 16.2
Share icons indicate that a Project has been shared and changed.

FIGURE 16.3
Sharing in the Inspector.

Sharing Movies

Final Cut Pro gives you the ability to share your movies in many ways in just a few easy steps. You can share your movie with other applications, burn the movies to disc, or even publish your movie to the web directly from your Project's Timeline. By choosing one of the Share options from the menu, Final Cut Pro applies the correct settings and handles any transcoding necessary to produce your chosen result. Once it's finished creating the movie, Final Cut Pro goes ahead and delivers it to the required destination, such as sending the movie to iTunes or publishing it to the website of your choice. Let's look at some of the most common sharing options that you're likely to use.

Sharing to the Media Browser and Apple devices

If you use any of Apple's iLife or iWork suite of applications, such as GarageBand, Keynote, or iPhoto, you can make your movie available inside the Media Browser of these applications by choosing Share➜Media Browser. You also can prepare your movie for playback on an iPhone, iPad, and Apple TV by choosing Share➜Apple Devices.

Let's walk through how to share to an Apple device, because the same settings and procedure applies to sharing to the Media Browser as well.

1. Select the Project you want to share in the Project Library or have it open in the Timeline and choose Share➔Apple Devices. A dialog box opens and displays thumbnail images of various Apple devices for you to choose from. Clicking a thumbnail displays an image of the device below with your movie presented inside. You can skim through the movie in the usual way by running your cursor over the image. The file's size and other compatible devices are shown next to the image.

2. Selecting the iTunes check box sends the movie to iTunes after it has finished encoding. Deselecting this check box changes the Share button to a Next button, allowing you to navigate to a location on your computer to store your file.

3. Clicking the Show Details button reveals more settings for you to choose from (see Figure 16.4). Here you can select additional devices to share to, change the Project's name in the Title field, and add the movie to a specific iTunes playlist by selecting one from the Add To Playlist pop-up menu.

FIGURE 16.4
Sharing your
Project with
Apple devices.

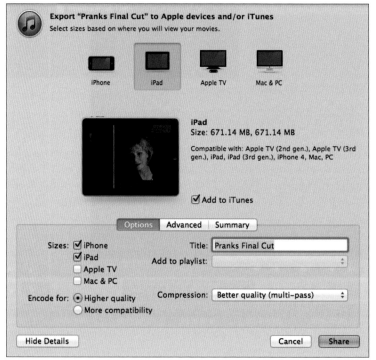

4. Next, you have a choice between Higher Quality encoding or More Compatibility with older generations of Apple devices. Choosing More Compatibility results in a reduced-quality image when the movie is played back on newer devices that employ Apple's retina display. As you switch between different combinations of settings, the file size and device compatibility information updates next to the device's image.

5. Select a Compression method from the pop-up menu. You can choose between Better Quality (Multi-Pass), which takes longer to process, or Faster Encode (Single-Pass), which encodes more quickly but produces a lower-quality video image. There's also an Advanced button, which gives you background rendering options, which enables you to keep working in Final Cut Pro during export, the ability to send the project to Compressor, and a Summary button, which provides details of your output files. (For more on Compressor, see "Exporting with Compressor," later in this chapter.)

6. Once you've selected your settings, click the Share button to complete the process.

Creating DVD and Blu-ray discs

Final Cut Pro lets you burn your project to a standard-definition DVD or a high-definition Blu-ray disc. Burning to Blu-ray requires that you have a dedicated Blu-ray burner connected to your Mac, because Apple doesn't currently support this format.

Both formats have similar settings and follow the same procedure, with just a few minor differences.

DVD

With your project opened in the Timeline or selected in the Project Library, choose Share➜ DVD. A dialog box opens with your Mac's drive listed in the Output Device pop-up menu (see Figure 16.5). If you have an external DVD burner connected to your Mac, you'll also be able to select it from the same pop-up menu and use it to burn the disc instead. There's also an option to save the DVD as a disc image by selecting Hard Drive from the Output Device pop-up menu. This is similar to the disc image included with this book's DVD; once it's mounted, you can play this like a regular DVD using the Mac's DVD Player or burn it to disc at a later date using an application such as Roxio Toast.

Final Cut Pro gives you a choice between single-layer and double-layer discs; the type you choose will depend on the length of the movie you want to burn and the quality of the results that you're after. A single-layer DVD has a capacity of 4.7GB and can hold around 70 minutes of high-quality video. Longer movies can be burned to a single-layer DVD, but the video quality begins to suffer due to the compression Final Cut Pro needs to perform to fit the movie on the disc. If you have a lengthy piece and quality is a concern, you can burn to

a double-layer DVD, which has a capacity of 8.5GB. You can choose between single-layer and double-layer disc from the Layers pop-up menu. **Note:** If you have the Layers pop-up menu set to Automatic, Final Cut Pro will base its settings on the type of disc you've inserted in the drive.

FIGURE 16.5
Burning your
Projects to DVD.

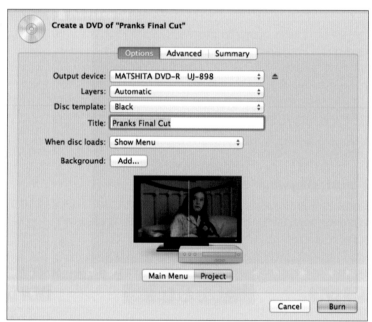

The rest of the settings apply to the DVD's menu. You can choose a Black or White background from the Disc Template pop-up menu and enter a name for the DVD in the Title field. When the disc loads in the player, you can choose to have it Show Menu or Play Movie by selecting either option from the drop-down menu. A background image can be added to the menu by clicking the Add button and navigating to an image file on your computer. Clicking the Preview button brings up a thumbnail of your movie, allowing you to skim through the movie for a final check before burning. There's also an Advanced button, which gives you background rendering options and the ability to send the project to Compressor. Final Cut Pro automatically places chapter markers every 30 seconds to help you navigate your movie, but you can add your own markers by sending the project to Compressor (we show you how to do this later in the chapter). To complete the process, insert a blank disc into your DVD drive and click Burn.

Blu-ray

To create a Blu-ray disc choose Share➡Blu-ray. A dialog box appears with the same settings as you get when burning a DVD, but with some additional backgrounds to choose from in

the Disc Template pop-up menu. A logo and title graphic also can be added to the menu—this is done in the usual way, by clicking the Add button and navigating to an image file on your computer. You also have the option to add a loop icon to the menu by selecting the Include Loop Movie Button check box. If you don't have access to a Blu-ray burner and your project's running time is reasonably short—around 15 minutes—you have the option of burning an AVCHD disc to a regular DVD, and the disc will play back in HD in most Blu-ray players. To do this, simply select your Mac's DVD drive from the Output Device pop-up menu. Once you've chosen your settings, insert a blank disc and click Burn.

Publishing to the Web

With the popularity of social networking, you'll likely want to upload your work to some of these sites at some point. Final Cut Pro lets you publish your movie to four popular websites—YouTube, Vimeo, Facebook, and CNN iReport—directly from the Project's Timeline. To upload your video to any of these websites, you need to first create an account with the site in question, because you'll be prompted for your account details the first time you publish to the site.

Publishing to all these websites follows the same procedure, so let's use YouTube as an example to walk you through the process:

1. Select the Project you want to publish to the web in the Project Library or have it open in the Timeline and choose Share➔YouTube. A dialog box opens with a thumbnail image of your movie that you can skim through (see Figure 16.6).

2. If this is your first time uploading to YouTube via Final Cut Pro, you need to add your account details by clicking the Add button and entering your user account name in the dialog box that appears. You can add more than one user account, and you can choose which account to upload to from the Account pop-up menu, whenever you publish to the site.

3. Enter your password in the Password field. This is required every time you publish to the website, for security reasons.

4. Choose a category from the pop-up menu and enter a title, description, and any relevant tags in the fields provided.

5. Select the Make This Movie Private check box if you want the movie made available only to people you approve and not to the general public.

6. Final Cut Pro will automatically size your published movie based on your Project's media, giving you the highest optimized settings required by the site that you're publishing to. However, you can set a size of your choice by deselecting the Set Size Automatically check box and choosing a size option from the Size pop-up menu.

Placing your cursor over the blue *i* icon will show you the finished movie's frame rate, bit rate, and final file size for the size option that you choose.

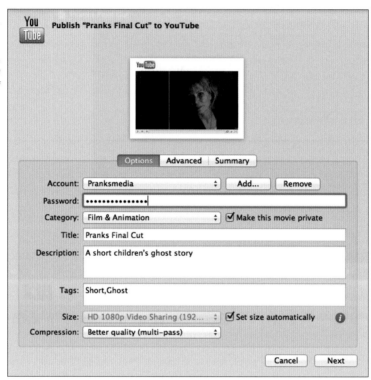

FIGURE 16.6
Publishing your
Project to
YouTube.
*YouTube is a
registered
trademark of
Google™.*

7. Next, choose a setting from the Compression pop-up menu. Most of the time, you'll want to choose Better Quality (Multi-Pass), but you can choose Faster Encode (Single-Pass) for faster processing if video quality isn't a concern.

8. After you've selected your settings and entered the required information in the relevant fields, click the Next button. This takes you to YouTube's Terms of Service, which states that by clicking Publish you agree to owning all copyrights in the video or have permission from the copyright owners to publish the video to the site.

 This would be a good time to remind you that you do not have permission to upload the film *Pranks* or its associated footage and resources as per the licensing details in this book.

9. To complete the process, click the Publish button. Final Cut Pro compresses the Project and automatically posts it to your YouTube account.

Exporting Movies

As convenient as some of these sharing options are, there will be situations when you'll want to export your Project as a self-contained file. For example, you may need to export the Project as an Audio Only file to produce a single audio stem of the sound effects assembled in the Timeline or create a high-quality master file of your edited movie after the project has been completed. You could then use this master file to make future copies of the movie in different formats using an application such as Compressor, without having to go through Final Cut Pro. This will allow you to archive the movie's Project, safe in the knowledge that you can return to the master file to make additional copies.

To export your Project as a QuickTime movie file, do the following:

1. Select the Project in the Project Library or have it open in the Timeline and choose Share➜Export Media or press ⌘+E. A dialog box opens with four drop-down menus, the first of which is the Export menu (see Figure 16.7). This is where you select the kind of file you want to export. To export a movie file choose Video and Audio (or Video Only if you want a movie without sound).

FIGURE 16.7
Exporting QuickTime movies.

2. The next drop-down menu is for Video Codec, which allows you to select the video format for your movie. You'll typically keep this set to Current Settings, because this will create a movie with the exact settings used as the Project. However, you can select a different a codec from the drop-down menu (for example, when you want to compress your movie to a smaller file size, such as H.264).

3. The Audio File Format drop-down is dimmed because this applies only to exporting audio. This leaves the Open With menu, which lets you choose what to do with the file once it has finished exporting. The default for movie files is to open the exported movie in QuickTime Player, but you can choose to open it in another application, send the file to Compressor, or do nothing.

4. Click the Next button to name your file and navigate to a location on your computer to store your movie. Click Save to complete the process.

To export an audio file, follow the same procedure, but choose Audio Only from the Export drop-down menu. The Video Codec settings dim and the Audio File Format settings become available, allowing you to choose an audio format from the drop-down menu. AIFF or WAV are your best options, because both these formats are uncompressed, but you can choose other audio formats such as AAC, AC3, CAF, and even MP3 as well. Click the Next button to name your file and choose a location to store your audio. Click Save to complete the process.

You also can export your media by the roles that have been assigned to your clips (for more on roles, see Chapter 4). For example, you could use this to easily export a separate music and effects track, which can be used to dub a foreign language version of your movie when it's distributed to different markets. There are four options available from the Export drop-down menu:

- ○ **Roles As Multitrack QuickTime Movie** embeds the individual audio roles inside a single QuickTime movie.

- ○ **Roles As Separate Files** creates individual video and audio files from each role, such as Dialogue, Music, Titles, and so on.

- ○ **Video Roles Only As Separate Files** exports the video roles in your Project as individual movie files.

- ○ **Audio Roles Only As Separate Files** exports the audio roles in your Project as individual audio files.

Selecting any of these four options from the Export drop-down menu reveals a Roles button. Clicking this button presents each role as a drop-down menu that allows you to choose the roles or subroles you want to export (see Figure 16.8). You can add additional roles to export

by clicking the Add Video File or Add Audio File buttons and choosing a new role from the drop-down menu. To remove a role from the export process, click the minus button next to the role. Click the Next button to choose a location to store your files and click Save. Once completed, Final Cut Pro labels each individual file with a suffix containing the role name so that the files can easily be identified on your computer.

FIGURE 16.8
Exporting roles
as separate files.

Exporting with Compressor

Compressor is a video and audio transcoding application that is available separately from the App Store on the Mac and is a very useful tool to add to your video arsenal. Compressor comes with a selection of presets for common encoding tasks, allowing you to convert your finished projects to a number of output formats. These presets can be accessed directly from Final Cut Pro by choosing Share➜Export Using Compressor Settings. A window opens with the Compressor presets organized into folders, such as Apple Devices, Disc Burning, and so on. You simply select the preset that you require and click Next to take you to the next window, where you can name and save your file.

Using Compressor in this way has the disadvantage of tying up Final Cut Pro while the export process takes place, preventing you from doing any editing work until the encoding has completed. A way around this is to click the Advanced section and choose This Computer from the Background Rendering drop-down list, or send the project to Compressor by choosing Share➜Send to Compressor. This launches the Compressor application and makes the sent project the source media file that is to be encoded by Compressor. This method also gives you the option to customize and tweak the presets further.

Understanding the Compressor workflow

Compressor's Batch window, found in the top-left corner of the interface, is where you manage the files that are to be encoded. When a source media file is added to Compressor, a job is created, which is represented by the light gray tile inside the Batch window. The source media file is shown on the left side of the job, and you can scrub through it with the slider below. Additional jobs with different source media files can be added to the batch by dragging a new file onto the Batch window, choosing Job➜New Job from File or pressing ⌘+I, and navigating to the file that you want to add. A batch made up of many jobs can be submitted together and processed at the same time.

A job can have many targets applied to it. A target tells Compressor how to encode the source media file and is made up of a setting, a destination, and an output filename, with each target displayed as a strip in the job area. Figure 16.9 shows four targets applied to a single job. The clapper icon in the source media area tells us that this is a project that has been sent from Final Cut Pro.

FIGURE 16.9
A job in the Batch window with four targets.

Preset settings and destinations are available from the Settings and Destinations windows below the Batch window (see Figure 16.10) and can be applied to a source media file by dragging a preset onto a job. These are the same presets that can be accessed from within Final Cut Pro when using the Export Using Compressor Settings menu. To change a job's setting or destination, Control-click the relevant area on the target and choose a new option from the shortcut menu. Settings and destinations can be modified inside the Inspector, which is a context-sensitive window that displays the currently selected target or preset. This is where you can really get under the hood to tweak the file format settings, transcode to a different frame rate, or crop and resize your media. Compressor also includes a split-screen preview window that displays the source media file in both its original and encoded versions for a side-by-side comparison.

FIGURE 16.10
A selection of
presets available
from the
Settings
window.

With your Batch created, you can send the jobs to be encoded by clicking the Submit button. This opens a dialog box, allowing you to name the batch. Once the batch has been named, click the Submit button again to begin encoding. You can monitor the progress of any batches that are encoding in the History window (see Figure 16.11).

FIGURE 16.11
The progress of
a job in the
History window.
The first target
is transcoding
while three
more targets
wait in a queue
behind it.

Creating chapter markers for DVD and Blu-ray

Compressor's Preview window includes a Timeline with a playhead that allows you to scrub through a job that is selected in the Batch window. A new job can be chosen from the Batch Item pop-up menu at the top of the Preview window. In and Out points can be marked in the Preview window's Timeline, enabling you to encode a smaller section of the source media

file, something that can't be done when exporting directly from Final Cut Pro. In and Out points are added using the I and O keys in the usual way.

As we've seen, Final Cut Pro can create a DVD or Blu-ray disc directly from your project Timeline, but unfortunately it doesn't give you the ability to add specific chapter markers from within the application. To add chapter markers to your disc, you need to create them in Compressor. These, too, are added in the Preview window's Timeline by choosing Add Marker from the Marker pop-up menu or by pressing M to add a marker at the playhead position (see Figure 16.12).

Batch Item pop-up menu

FIGURE 16.12
Preparing
chapter markers
for a DVD or
Blu-ray disc in
Compressor.

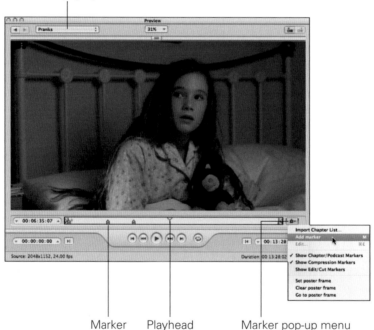

Marker Playhead Marker pop-up menu

Let's walk through the steps for producing a DVD or Blu-ray disc with chapter markers:

1. In Final Cut Pro, select a project in the Project Library and choose Share➜Send to Compressor. Compressor opens with a new job created and the Project added as the source media file.

2. In Compressor's Settings window, open the Disc Burning folder and select either the H.264 for Blu-ray preset or the MPEG-2 for DVD preset, depending on the type of disc that you're creating. Also, select the Dolby Digital Professional preset, which will create a separately encoded audio track. Drag the presets onto the job in the Batch window.

3. Select the job in the Batch window and click the Job Action tab in the Inspector. From the When Job Completes pop-up menu, choose Create DVD or Create Blu-ray Disc.

4. With the job still selected in the Batch window, position the Preview Timeline's playhead to where you want the first chapter marker to be added. Press M to add a marker or choose Add Marker from the Marker pop-up menu. Name the chapter marker by choosing Edit from the Marker pop-up menu or pressing ⌘+E and typing a name in the dialog box that appears, then choose Chapter from the Type drop-down menu. Repeat this process for the rest of the chapter markers that you want to add.

5. Submit the job from the Batch window. When Compressor finishes encoding, a dialog box displays with the message `Please insert the media to burn the disc`. Insert the relevant disc to your drive or Blu-ray burner to create the disc.

Exporting to XML

Exporting an XML (Extensible Markup Language) file from Final Cut Pro creates a plain text file that contains all the data related to your Project. You can use this file to transfer project data from Final Cut Pro into other compatible applications (such as DaVinci Resolve for more advanced grading work, for instance). Third-party utilities use this XML file to expand Final Cut Pro's ability to integrate with other applications. X2Pro Audio Convert from Marquis Broadcast converts the Final Cut Pro X XML into an AAF file, which can then be imported into Avid Pro Tools for more complex audio work. Similarly, Intelligent Assistance's Xto7 allows you to import a Final Cut Pro X project into Final Cut Pro 7 (or back again using its 7toX tool). To export an XML file simply choose File➜Export XML.

part 5

Appendixes

appendix A
Resources

Red Giant

www.redgiantsoftware.com

Red Giant has been creating useful plug-ins for Final Cut Pro and After Effects since 2002. Its Magic Bullet Looks 2 is an awesome color application that works right inside Final Cut Pro X and comes with a large number of preset looks to apply to your projects. Additional looks can be added with Red Giant's large collection of Guru Presets. Magic Bullet Mojo allows you to quickly give your movie that blockbuster look that's prevalent in modern Hollywood movies.

CrumplePop

www.crumplepop.com

CrumplePop has a large number of effects plug-ins built specifically for Final Cut Pro X. TransiMatic is a suite of transitions that lets you add animated swings, flips, and slides to your clips. You can easily add light-leak transitions with CrumplePop's Lumineux plug-in. SplitScreen X is a fast way to create split screens for you movies. CrumplePop also has a number of great plug-ins that help you manipulate the look of your movie. Make sure to check out Platinotype, Tonegrade, and Finisher.

Noise Industries FX Factory

www.noiseindustries.com/fxfactory

FX Factory is a free software download that comes with some free effects and lets you try out trail versions of a large number of commercial visual effects before purchase. Our favorites include Ripple Training's Call Outs, which allows you to add animated arrows, shapes, and speech bubbles to your projects, and Yanobox Moods, which is a great color-grading plug-in that works with Final Cut Pro X.

Intelligent Assistance

http://assistedediting.intelligentassistance.com

Intelligent Assistance produces a number of useful tools for users coming from legacy versions of Final Cut Pro. Xto7 For Final Cut Pro converts the Project XML of Final Cut Pro X to a Sequence XML that can be imported into Final Cut Pro 7. Similarly, its 7toX For Final Cut Pro gives you the ability to import older Final Cut Pro 7 projects into Final Cut Pro X. Event Manager X is another useful utility that helps control which Events and Projects are visible in Final Cut Pro X.

X2Pro Audio Convert

www.x2pro.net

X2Pro Audio Convert from Marquis Broadcast is a conversion utility for exporting Final Cut Pro X's XML into an AAF file, which can be imported into Avid Pro Tools for audio finishing. X2Pro Audio Convert is available via the Mac App Store.

appendix B
What's on the DVD?

THIS APPENDIX PROVIDES you with information on the contents of the DVD that accompanies this book. For the latest and greatest information, please refer to the ReadMe file located at the root of the DVD.

If you're reading this in an electronic format, please go to `http://booksupport.wiley.com` for access to the additional content.

System Requirements

Make sure that your computer meets the minimum system requirements listed in this section. If your computer doesn't match up to most of these requirements, you may have a problem using the contents of the DVD with Final Cut Pro X.

○ A Macintosh computer with an Intel Core 2 Duo processor or better

○ 2GB of RAM (4GB of RAM recommended)

○ OpenCL-capable graphics card or Intel HD Graphics 3000 or later

○ 256MB of VRAM

○ Display with 1280 x 768 resolution or higher

○ OS X 10.6.8 or higher

○ 30GB of disk space

○ A DVD-capable SuperDrive

○ Final Cut Pro X Version 10.0.4 or later

Trajan Pro font is required for the Pranks Final Cut Project opening titles and for the Chapter 15 exercise "Creating the Opening Credits."

Note: It may take up to 45 minutes to render the Pranks Final Cut Project.

What's on the DVD

The following sections provide a summary of the software and other materials that you'll find on the DVD:

○ The Documentation folder containing the following:

- Shooting Script

- Continuity Shot List

- Continuity Script

○ The Craft of the Cut disc image file, which you mount the disc to access the following files:

- `Audio` folder (ADR, audio stems, music, and sound FX files)

- `Images` folder

- `Video` folder (video rushes from the movie *Pranks* in Apple ProRes 422 [Proxy] format)

- `Final Cut Events` folder

- `Final Cut Projects` folder

Using the DVD

To access the content from the DVD, follow these steps:

1. Insert the DVD into your Macintosh's DVD drive.

2. Copy the Documentation folder and the `Craft of the Cut.sparseimage` file to your Mac's Desktop and eject the DVD.

3. Double-click the `Craft of the Cut.sparseimage` file to mount it. The disc image should appear as a "drive" under the devices section in the Mac's Finder.

4. Launch Final Cut Pro X. Once launched, Final Cut Pro treats the mounted disc image just like any normal hard drive, and the Events and Projects from these folders become available from within the application.

5. If Final Cut Pro views the Event and Project files as offline media (displaying a red background with an exclamation point icon), relink the media by following steps 4 through 6 in the following list.

The disc image gives you approximately 7GB of disc space to work with once the two Projects have rendered. If you require more space or simply prefer to work with the files directly from your Mac's hard drive rather than from the disc image, do the following:

1. If this is your first time using Final Cut Pro X, copy the `Final Cut Events` and `Final Cut Projects` folders from the mounted `Craft of the Cut.sparseimage` disc image to the `Movies` folder inside your User's Home directory or to the root level of an external hard drive that is connected to your Mac.

 Warning: If you have previously used Final Cut Pro X and already have `Final Cut Events` and `Final Cut Projects` folders at this location, to avoid overwriting any previous work, do the following:

 - Place the `Pranks Media` folder (from the DMG's `Final Cut Events` folder) inside the `Final Cut Events` folder on your hard drive.

 - Place the `Pranks Final Cut` and `Pranks Work In Progress` folders (from the DMG's `Final Cut Projects` folder) inside the `Final Cut Projects` folder on the same drive.

2. Copy the `Media Files` folder to a location on your computer of your choice.

3. Eject the `Craft of the Cut.sparseimage` file to unmount it, and then launch Final Cut Pro X.

4. In the Event Library, select the Pranks Media Event and choose File➡Relink Event Files. In the Relink Files dialog box, click the Locate All button and navigate to the location where the files are stored on your computer. In this case, it's the `Media Files` folder that you copied in Step 2.

5. Navigate to the `Video` folder and select the first folder inside (`Building the Climax`). Click the Choose button and wait a few seconds as Final Cut Pro verifies the files.

6. The number of Files Matched is displayed at the bottom of the Relink Files window. Click the disclosure triangle to reveal the matched files. Uncheck the Copy Files to Final Cut Events Folder check box and click the Relink Files button. If you have any other missing files, repeat the process by relinking with the remaining folders in the `Media Files` folder.

You can also move the `Events` and `Projects` folders to a drive of your choice from within the Final Cut Pro interface (see Chapters 3 and 5).

Troubleshooting

If media is missing from the Pranks Media Event in the Event Library, follow steps 4 through 6 above to relink any missing files. Projects that are referencing files from the Pranks Media Event will automatically update in the Project Library.

If all the files in the Pranks Media Event are available, but media is missing from Projects in the Project Library, do one of the following:

○ Select the Project with the missing media in the Project Library and choose File➡Relink Project Files. In the Relink Files dialog box, click the Locate All button and navigate to the folder that contains the missing files. Click the Choose button and wait a few seconds as Final Cut Pro verifies the files. Uncheck the Copy Files to Final Cut Events Folder check box and click the Relink Files button.

○ Select the Project with the missing media in the Project Library and open the Inspector (if it isn't already open) by choosing Window➡Show Inspector. In the Inspector, select Properties and click the Modify Event References button. In the dialog box that appears, select Pranks Media and click OK.

Customer Care

If you have trouble with the DVD, please call the Wiley Product Technical Support phone number at (877) 762-2974. Outside the United States, call 1(317) 572-3994. You can also contact Wiley Product Technical Support at `http://support.wiley.com`. John Wiley & Sons will provide technical support only for installation and other general quality control items. For technical support on the applications themselves, consult the program's vendor or author.

To place additional orders or to request information about other Wiley products, please call (877) 762-2974.

Index

End-User Licence Agreement

You should carefully read these terms and conditions before opening the DVD packet ("Product") included with this book ("Book"). This is a licence agreement between you and John Wiley & Sons Ltd ("Wiley"). By opening the accompanying DVD packet, you acknowledge that you have read and accept the following terms and conditions. If you do not agree and do not want to be bound by such terms and conditions, promptly return the Book and the unopened DVD packet to the place you obtained them for a full refund.

The rights licensed to you under this Agreement by Wiley cannot be transferred or sub-licensed to a third party.

Copyright

The entire contents of the Product are protected by copyright (unless otherwise indicated on the Product). As a user, you have certain rights set forth below; all other rights are reserved.

Terms of Use

You may download, view, save to hard disk or diskette and store or print out the material contained in the Product ("Material") for your own personal and non-commercial use, scholarly, educational or scientific research or study. In addition, you have the right to use brief excerpts from the Material in your own scientific, scholarly and educational works or similar work products (including articles for academic and professional journals) provided you include a notice in the following form:

[figure/table/exercise etc reproduced from [title of Book, copyright year, name of copyright owner/author] published by John Wiley & Sons Ltd, with permission from the author".

You may not use any of the Material for any commercial gain.

You must seek the consent of the copyright owner in respect of all other use of the Material.

Certain components of the Material may be owned by third parties and you must abide by such parties' terms of use as indicated on the DVD.

Unauthorised and unlawful use of the Material is a breach of copyright.

Except as expressly provided above, you may not copy, distribute, transmit or otherwise reproduce the Material or systematically store such Material in any form or media in a retrieval system; or store the Material in electronic format in electronic reading rooms or print out multiple copies for inclusion in course packs; or transmit any Material, directly or indirectly, for use in any paid service such as document delivery or list serve, or for use by any information brokerage or for systematic distribution of material, whether or not to another user and whether for commercial or non-profit use or for a fee or free of charge.

In order to protect the integrity and attribution of the Material, you agree not to remove or modify any copyright or proprietary notices, author attribution or disclaimer contained in the Material or on any screen display, and not to integrate the Material with other material or otherwise create derivative works in any medium based on or including the Material. This is not meant to prohibit quotations for purposes of comment, criticism or similar scholarly purposes.

Finally, you may not do anything to restrict or inhibit any other user's access to or use of the Product.

Additional Terms

Wiley is not responsible for any charges associated with accessing the Product, including any computer equipment, telephone lines, or access software.

The Product may provide links to third party websites. Where such links exist,

Wiley disclaims all responsibility and liability for the content of such third party websites. Users assume the sole responsibility for the accessing of third party websites and the use of any content appearing on such websites.

Warranty Limitations and Liability

(i) THE PRODUCT AND ALL MATERIALS CONTAINED THEREIN ARE PROVIDED ON AN "AS IS" BASIS, WITHOUT WARRANTIES OF ANY KIND, EITHER EXPRESS OR IMPLIED, INCLUDING, BUT NOT LIMITED TO, WARRANTIES OF TITLE, OR IMPLIED WARRANTIES OF MERCHANTABILITY OR FITNESS FOR A PARTICULAR PURPOSE;

(ii) THE USE OF THE PRODUCT AND ALL MATERIALS CONTAINED THEREIN IS AT THE USER'S OWN RISK;

(iii) ACCESS TO THE PRODUCT MAY BE INTERRUPTED AND MAY NOT BE ERROR FREE;

(iv) NEITHER WILEY NOR ANYONE ELSE INVOLVED IN CREATING, PRODUCING OR DELIVERING THE MATERIALS CONTAINED IN THE PRODUCT, SHALL BE LIABLE FOR ANY DIRECT, INDIRECT, INCIDENTAL, SPECIAL, CONSEQUENTIAL OR PUNITIVE DAMAGES ARISING OUT OF THE USER'S USE OF OR INABILITY TO USE THE PRODUCT, AND ALL MATERIALS CONTAINED THEREIN; AND

(v) LICENSEE RECOGNIZES THAT THE PRODUCT IS TO BE USED ONLY AS A REFERENCE AID BY RESEARCH PROFESSIONALS. IT IS NOT INTENDED TO BE A SUBSTITUTE FOR THE EXERCISE OF PROFESSIONAL JUDGMENT BY THE USER.

The Material has been compiled using reasonable care and skill however neither Wiley nor the author of the Product can guarantee the accuracy of such Material and accept no responsibility for any error or misrepresentation. All liability for loss, disappointment, negligence or other damage caused by the reliance on the Material is hereby excluded to the maximum extent permitted by law.

Jurisdiction

This Licence will be governed by English Law as if made and wholly performed in England and the parties agree to submit to the non-exclusive jurisdiction of the English courts.

General

This agreement constitutes the entire understanding of the parties and revokes and supersedes all prior agreements, oral or written, between them and may not be modified or amended except in a writing signed by both parties hereto that specifically relates to this agreement. This agreement shall take precedence over any other documents that may be in conflict herewith. If any one or more provisions contained in this agreement are held by any court or tribunal to be invalid, illegal or otherwise unenforceable, each and every other provision shall remain in full force and effect.

Acceptance Procedure

On installing the Product on your personal computer you will see the following notice which you will need to respond to before being allowed access to the Product.

If you have read and consent to all of the terms and conditions of this Licence, please click the button below marked "ACCEPT". You will then have access to the Product. If you do not consent, select "DO NOT ACCEPT", in which case you will not be allowed access to the Product.